The Intellectual Life of
the Early Renaissance
Artist

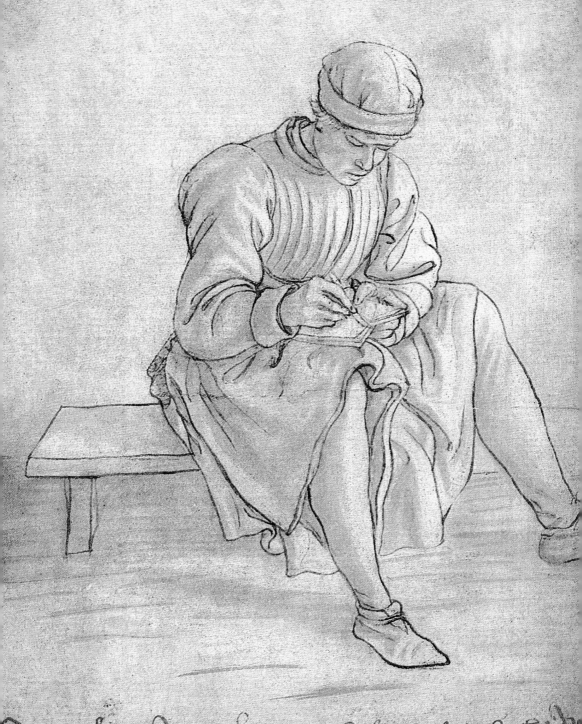

Maestro buono disegnatore. e b...
...ntare buono buono architettore

The Intellectual Life of the Early Renaissance Artist

Francis Ames-Lewis

Yale University Press
New Haven & London

PUBLISHED WITH THE ASSISTANCE OF
THE GETTY GRANT PROGRAM

Designed by Gillian Malpass

Printed in Singapore

Library of Congress Cataloging-in-Publication Data

Ames-Lewis, Francis, 1943–
The intellectual life of the Early Renaissance artist/Francis Ames-Lewis.
p. cm.
Includes bibliographical references and index.
ISBN 0-300-08304-1 (cloth: alk. paper)
1. Artists–Europe–Intellectual life–15th century.
2. Artists–Europe–Intellectual life–16th century. 3. Art, Renaissance.
I. Title.
N6370.A58 2000
709'.02'4–dc21 99-086289

A catalogue record for this book is available from
The British Library

Frontispiece Maso Finiguerra, *Seated Boy Drawing* (detail),
*c.*1460. Florence, Uffizi

in memory of

Marcus

1979–1998

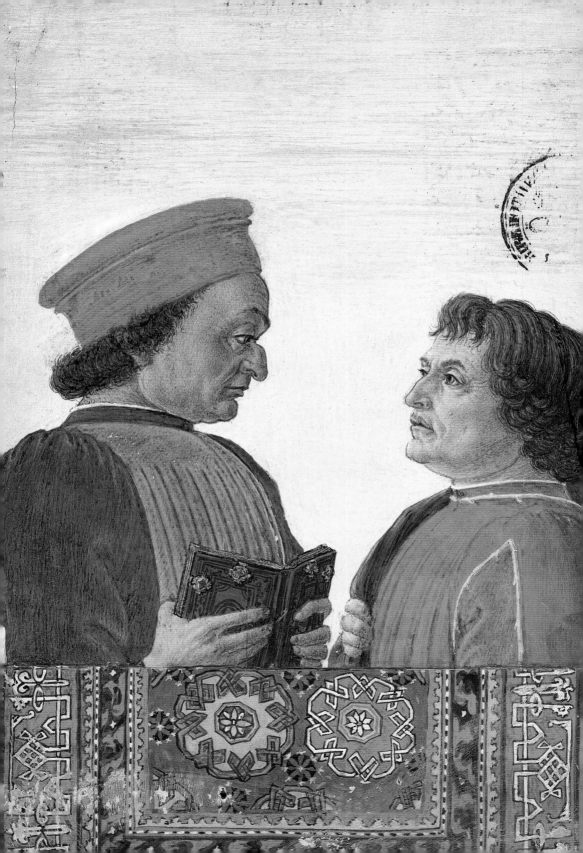

Contents

Preface ix

1 Introduction 1

2 The Artist's Education and Training 17

3 The Social and Cultural Activities of the Renaissance Artist 61

4 Commemoration of the Early Renaissance Artist 89

5 The Artist and Archaeology 109

6 Image and Text: The *Paragone* 141

7 Painting and Poetry 163

8 Artistic Licence, Invention and *Fantasia* 177

9 *Ekphrasis* 189

10 Self-portraiture 209

11 Artists' Display 245

12 Conclusion: The Reputation of the Renaissance Artist 271

Notes 280

Bibliography 293

Photograph Credits 306

Index 307

Detail of fig. 126

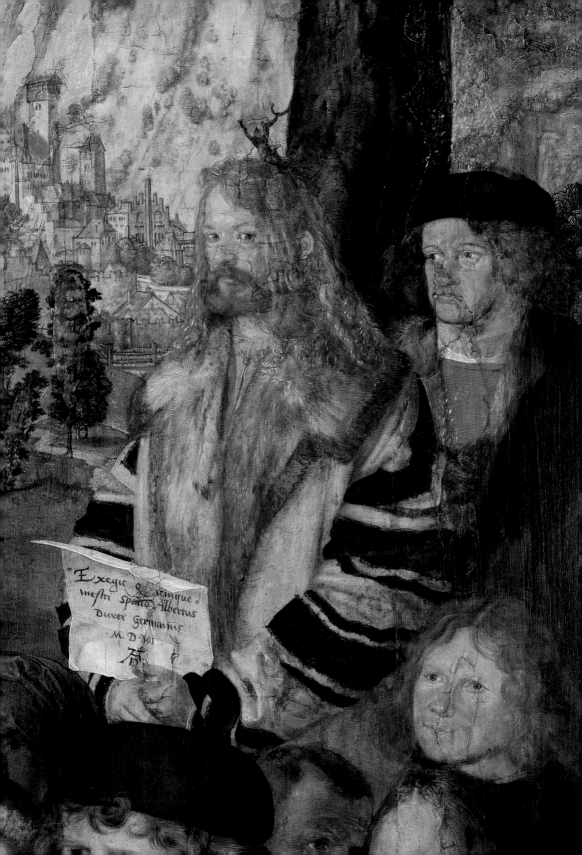

Exegit quinque
mestri spacio Albertus
Durer Germanus
M.D.XI

Preface

Early on in my academic career I tended to encourage in my students the view that early Renaissance painters and sculptors were essentially artisans in outlook. Painters were apprenticed, I suggested, and experienced in the craft practices commended by Cennino Cennini in his *Craftsman's Handbook*. They had little time or inclination to engage with ideas that circulated in the world beyond the confines of their workshops. Indeed, the need, in Leon Battista Alberti's view, for painters to be exposed to such ideas was acknowledged in his attempt–in the vernacular translation in 1436 of his *On Painting*–to open their eyes to broader artistic issues. But, I suggested also, this attempt had only limited effect: in large measure, I argued (I now think mistakenly), painters and sculptors continued throughout the fifteenth century to aspire to be no more than high-quality craftsmen. A number of important publications during the past quarter-century have helped me towards revision of these views: I think, for example, of the work of Michael Baxandall and Martin Warnke, and of David Chambers's and Creighton Gilbert's invaluable collections of sources and documents. Books such as these help us to recognise that there was at least an élite group of early Renaissance painters and sculptors who had much higher aspirations. Maybe these men were the icing on the gingerbread, but they were of great importance in advancing the social status of the artist. During the course of the fifteenth century artists also engaged increasingly in the intellectual activities that are of especial interest here. As a result, they encouraged a wider recognition among their public of the validity of claims that painting and sculpture should be seen as liberal arts.

This book provides an overview of these ideas, a springboard for further discussion and reinterpretation of both texts and images of the early Renaissance period. In bringing the material together and ordering it in the way that I have chosen, I have gained much from the work of the scholars named above, and of many others

1 Albrecht Dürer, *Rosenkranzfest* (1506), detail: self-portrait. Oil on panel. Prague, Narodni Galerie

whose publications I have quarried. I owe a large debt of gratitude to Peter Humfrey and Paul Joannides who offered good and valuable advice on the initial proposal, and who have since made many helpful suggestions and corrections. For better or worse I have not felt able to accept all these suggestions, but I have corrected the errors that they (and a third, anonymous reader) pointed out to me. I am conscious that not even they may have spotted other errors, and for these of course I alone am responsible. I am also very grateful to all my colleagues and students for their positive and constructively critical responses to ideas that I have raised with them both formally in seminar and informally in general conversation. I am grateful both to the British Academy Humanities Research Board and to Birkbeck College for grants that allowed me to carve periods of time from the increasing pressures of the everyday routine of the university teacher; to my colleagues in the College's Department of History of Art who have been ready to shoulder extra burdens during my periods of study leave; and to my family for supporting me steadfastly while I completed this book. Delia Gaze proved to be an admirable copy-editor. Finally, Gillian Malpass has been characteristically enthusiastic and helpful throughout: like many other Yale University Press authors I am deeply indebted to her, to Sally Nicholls and to their colleagues at 23 Pond Street, for much assistance and encouragement.

January 1999

Chapter 1

Introduction

I should like us to discuss something else . . . which, since I con-
sider it highly important, I think our courtier should certainly not
neglect: and this is the question of drawing and of the art of
painting itself. And do not be surprised that I demand this ability,
even if nowadays it may appear mechanical and hardly suited to a
gentleman . . . So let it be enough simply to state that it is fitting
that our courtier should also have a knowledge of painting, since
it is a worthy and beneficial art, and was greatly valued in the times
when men were greater than now.[1]

By the time that Baldassare Castiglione wrote this passage in his
celebrated *Book of the Courtier* (*Il cortigiano*), perhaps as the book
reached completion around 1516–18, painters and sculptors had
become skilful in many fields of intellectual life. Indeed, the point had
been reached when painting and sculpture could justifiably be num-
bered with the 'liberal arts' and no longer graded merely as
'mechanical arts'. Castiglione's close friend Raphael himself had by
that date demonstrated through his range of social and intellectual
abilities that he deserved to be called not only 'painter' but also
'courtier'. If a painter can reach the social level of any other courtier,
why should a courtier not also be a painter, as Castiglione proposes?

Painting and (though less evidently) sculpture could aspire to inclu-
sion as liberal arts on account of the new intellectual demands that
they imposed on their practitioners. But despite the enhancement of
its status throughout the fifteenth century, for Castiglione, 'nowadays
[painting] may appear mechanical'. Leonardo da Vinci reacted
against this view in a group of the most passionate outbursts in the
notes for his never-completed Treatise on Painting. 'You have placed
painting amongst the mechanical arts', he declared accusingly,

Certainly if painters were capable of praising their works in
writing, as poets have done, I do not believe that painting would
have been given such a bad name. Painting does not speak but is

self-evident through its finished product, while poetry ends in words with which it vigorously praises itself. If you call painting mechanical because it is primarily manual, in that the hands depict what is found in the imagination, you writers draft with your hand what is found in your mind. With justified complaints painting laments that it has been excluded from the number of the liberal arts, since she is the true daughter of nature and acts through the noblest sense. Therefore it was wrong, O writers, to have left her outside the number of the liberal arts, since she embraces not only the works of nature but also an infinite number that nature never created.[2]

In his comparison of painting with poetry, always numbered among the liberal arts, Leonardo finds that painting is in fact superior in communicating expression and human emotion.[3] By the time that he wrote, around the turn of the fifteenth and sixteenth centuries, painting had clearly become for him – and progressively for many others – an art that demanded intellectual as well as manual activity. In this book I shall present evidence, both written and visual, that traces changes in how painting and sculpture were evaluated during the early Renaissance, both by practitioners and by the societies within which they worked. I want to track the development of painters' and sculptors' consciousness that they deserved better than to be classified as craftsmen, which was in general terms their social position at the beginning of the period to be explored. I shall show how they exercised their growing intellectual capabilities in producing their works. And conversely I shall show also how their works manifest painters' and sculptors' intellectual acumen, and their engagement with literary and other issues included within the liberal arts. I make no claims for originality in these objectives. Much of the material to be considered, and most of the interpretation, will be familiar to many readers. I have of course had to be selective: when I started on this project I was blissfully unaware of how much material there is that I could have drawn on. In a book of this length it is not possible to cite, let alone to discuss, all relevant material. Rather, my aim is to provide an introduction for the general, non-specialist reader to some of the principal intellectual themes and issues that caught the attention of early Renaissance painters and sculptors.

In these opening paragraphs I have guardedly avoided the terms 'artist' and 'work of art'. The latter I shall seldom use, on the grounds that the vast majority of paintings and sculptures produced during the early Renaissance were not perceived as being 'works of art' in

the modern sense. Throughout the early Renaissance, paintings were seen predominantly as functional objects – stimuli to devotion, perhaps, or decorations on furniture or in interiors. It is, however, a facet of my argument that by the end of the period under discussion a few paintings and sculptures were being produced that were not mere artefacts but 'works of art' in our usual meaning of the term. In 1510, for example, Isabella d'Este's agent Taddeo Albano reported that the owners of two paintings by Giorgione that Isabella was interested in acquiring '. . . had them painted for their own enjoyment'.[4] Other examples may have been the finished drawing of 'Neptune' that Leonardo da Vinci presented to Antonio Segni in 1502, and small bronze replicas of celebrated classical carvings, such as Antico's *Apollo Belvedere* (fig. 68). Such works have no self-evident function, but appear to serve in an abstract way as visual stimuli to intellectual activity. But these are exceptions: for the most part 'work of art' is an anachronistic concept, however self-conscious the artist may have become about his special creative gifts.

But, it may be objected, 'artist' is also an anachronistic concept. *Artista* is a term used already by Dante, but not in reference to a painter or a sculptor. The relaxed way that today we use the word 'artist' to describe a practitioner of the visual arts would have been unintelligible in the late medieval or early Renaissance world. In the fifteenth century *artista* denoted a university-level student of the liberal arts. Not until after the end of the period surveyed in this book does it come to be used as a general term meaning a painter or a sculptor, as in Michelangelo's usage in, for example, the celebrated sonnet that opens 'Non ha l'ottimo artista alcun concetto / c'un marmo solo in sé non circonscriva / col suo superchio . . .'.[5] However, in this book I shall use the term 'artist' for convenience, as a portmanteau term to cover all practitioners of two- and three-dimensional representational arts. It should be understood in this spirit: in other words, it should be understood that it is not a loaded term – it carries no connotations of creative self-consciousness unless this is specifically suggested in particular cases. I might have chosen to use the general term 'craftsman', but this has opposite connotations: the craftsman shows often highly developed manual skills but by implication only sporadic evidence of intellectual activity. 'Artist' is preferable, I think, because even when unloaded of its twentieth-century baggage it does suggest what this book seeks to trace: the synthesis of growing intellectual activity with the manual skills of the painter, the sculptor and their fellow practitioners in the representational arts. It is this synthesis, which becomes progressively more subtle and

more complete during the early Renaissance, that entitled artists to press that their activity be numbered among the liberal arts.

I have twice used the term 'representational arts', with the intention thereby of excluding architecture. Not universally but usually included as a liberal art during the Middle Ages, architecture certainly had a higher status than the 'representational arts'. It was rightly seen as requiring the exercise of the intellectual skills of mathematics and geometry by definition, not merely out of choice as with painting. It was therefore an art practised by those who possessed developed intellectual skills, just as did poets, orators or astronomers. Not surprisingly, therefore, architecture was an occupation to which artists aspired, as a means to advance their social status and their acceptance within intellectually sophisticated circles. In this sense, architecture is in fact a field of activity that is considered here, and occasional reference will be made to works of architecture, architectural treatises and architectural drawings. Architects themselves, however, are not included within the term 'artists' and play little part in the discussion that follows. It should also be said that most of the discussion revolves around the two-dimensional arts – painting, drawing, print-making and relief sculpture. Figure sculpture is not an art form that offers as much opportunity for applying the sort of acquired intellectual interests that early Renaissance art theorists debated. It is the problems of representing nature and reality on the flat surface that preoccupy writers such as Leon Battista Alberti. However, my use of the term 'artist' embraces the figure sculptor as well as those who make two-dimensional works, because sculpture in the round does make significant entries into the discussion in certain areas that I would not wish to exclude. Most of the works considered in this book, however, were made by those trained as painters.

Chronological Scope

The period with which this book is concerned extends from about 1390 to about 1520. As usual when a time-span is defined, the 'abouts' are almost as important as the terminal dates themselves. As usual again, these dates have more or less clear reference points that do not and cannot take into consideration the different circumstances of different centres of production. The year 1390 is the approximate date of important early stirrings of 'Renaissance' artistic life at the court of Francesco II da Carrara in Padua, stimulated by the intellectual activities earlier of Francesco Petrarch. This

may appear an arcane point of reference, but it does in fact have a double virtue, part negative and part positive. Negatively, it seeks to wean the reader from the simplistic notion that it was in Florence that the activity that can be labelled 'Renaissance' first arose; and more particularly from the view that it was the competition of 1401 for the reliefs of the second doors of the Florentine Baptistery, a commission won by Lorenzo Ghiberti against such competitors as Filippo Brunelleschi, that triggered the Renaissance. Admittedly, few still see this event – which conveniently but irrelevantly coincided with the new century – as having the catalytic influence with which art historians have endowed it in the past. None the less, by setting a start-date of 'about 1390', a date that has far less significance for the history of Florentine art than almost any date in the fifteenth century, I deliberately seek to remove from Florence the sole responsibility for initiating those artistic developments later termed 'Renaissance'.

But, positively, 'about 1390' is the time when the Carrara court in Padua was reaching its intellectual zenith, even though Petrarch had already been dead for fifteen years. It is about the date of two coin-like medals (fig. 50) of Francesco II and his father that were cast in the guise of classical coins, clearly reflecting the court's antiquarian atmosphere. Moreover, it is about the date that Altichiero was producing decorations based on classical imagery, in style and subject, for the Carrarese palace. Finally, it was almost certainly in Padua in the 1390s that Cennino Cennini wrote his *Craftsman's Handbook*, as the *Libro dell'arte* is conventionally translated, the first surviving book in Italian about the practice of painting. Affected by what he might have regarded as apostasy amongst the painters of Padua, Cennino sought to re-establish there the great and glorious tradition of Giotto. And perhaps because the prevalent culture in post-Petrarchan Padua was literary, Cennino used the written word, although that medium was evidently unfamiliar to one who was essentially a practising craftsman-painter. He thereby established discussion of the visual arts, which had hitherto occurred only sporadically, as a recognised literary practice, one that guided Renaissance artists in their engagement with intellectual activity.

Admittedly, Cennino's *Craftsman's Handbook* has none of the literary pretension of Leon Battista Alberti's *On Painting* (*De pictura*) written some forty years later, or even of Ghiberti's *Commentaries* of around 1450. It sets out to be no more than a guide to the practice of Giottesque painting written by one craftsman for others. In literary terms it is naïve, often repetitive and not always easy to understand. This is true also of later efforts by artists to impart their

particular knowledge or ideas in words rather than in images. One thinks of Filarete's *Treatise on Architecture*, Piero della Francesca's *On Perspective for Painting* (*De prospectiva pingendi*), or of the weak verse of Giovanni Santi's 'rhymed chronicle' (the *Cronaca rimata*), which includes a series of interesting biographical notes on fifteenth-century artists. But Cennino's *Craftsman's Handbook* does include a few interesting *aperçus* about the painter's imaginative activity that may almost accidentally acknowledge some creative licence. Cennino was, however, little able to respond to the antiquarian spirit of 1390s Padua, which in any case withered after the Venetian annexation in 1405. It was the consistent growth of a humanist-led intellectual climate in Florence and, more sporadically, in Ferrara, Mantua and elsewhere that allowed and encouraged a growing receptiveness to artistic activity as an intellectual endeavour. Petrarch and his legacy were crucially important in this development.

'About 1520' has a more precise point of reference: the death of Raphael. Unlike Cennino, Raphael wrote no treatise: his fragmentary literary activity is in the form of letters and a small group of poetically indifferent sonnets. But Raphael was in various ways the ideal painter of Alberti's *On Painting*. He was a friend of popes, cardinals, princes and intellectuals; like Alberti's ideal painter he was learned in the liberal arts and, above all, had 'a good knowledge of geometry';[6] he was ambitious for personal fame and for the prestige of his art; he was immensely industrious and prodigiously productive; and his pictorial imagination overflowed. His death coincided closely with that of the second High Renaissance pope, his patron Leo X, and after their deaths the mood of creative optimism that prevailed in Central Italy during the first two decades of the sixteenth century began to dissipate with the progress of the historically troubled 1520s. The decade ending in 1520 also saw the departure for France and the death there in 1519 of Leonardo da Vinci, one of the principal figures (or so it seems from our perspective) involved in fostering the notion of the artist as an intellectual. The great Florentine High Renaissance painter Fra Bartolommeo died in 1517; and by 1520 the German painter Albrecht Dürer was settling into a steady productivity after his brilliantly active and thrusting early career had culminated with the second series of master engravings in 1513–14. Outstanding in the first decade, Michelangelo's output also slowed down, with much time wasted on unfinished projects during Leo X's pontificate.

This is not, of course, to propose that 'the intellectual life of the early Renaissance artist' revolved around only the great names,

those unquestionably outstanding individuals whose works mark the climax of the 'High Renaissance'. But the coincidences of changing artistic fortunes in the years before 1520, and the fact that the subsequent generations of artists arose within a much changed historical climate, seem to suggest that 'about 1520' was something of a watershed for artistic practice. Likewise, the contexts of art production also changed: the climate for the activities of both artists and intellectuals after the war-torn 1520s was rather different – sufficiently so to justify a cut-off date for this study of 'about 1520'.

The main exception to this is the Veneto, especially Venice herself and the court at Ferrara. The literary-led work of Titian continued well into the 1520s; and since his series of paintings for Alfonso d'Este, Duke of Ferrara, was a milestone along the path of Renaissance artists' search for intellectual respectability, it cannot be ignored here. This is the principal one among a number of developments after 1520 that will be considered. Equally, some early examples, occasionally substantially before 'about 1390' will be cited, either as precocious examples of developments that reached fulfilment in the early Renaissance, or as sporadic instances of attitudes in the intellectual endeavours of artists that were more systematically struck later. By and large, however, it is during the 130 or so years between the crystallisation of Petrarch's legacy in Padua and the decline of the Renaissance papacy in Rome, or between Cennino's *Craftsman's Handbook* and Raphael's letter to Pope Leo X on ancient Rome, that provide the material for discussion in this book.

Geographical Scope

So much for the period covered here. What of the geographical field covered, and the inconsistencies in the quality and character of the available evidence generated by the different working conditions of different centres of production? Predictably, the quantity of surviving evidence, both visual and textual, increases across the span of the period under review. But it also varies greatly with geographical location. If only because the textual evidence is substantially bulkier and more informative for Italy than elsewhere, the bias of this investigation leans heavily towards Italian art and artists. Although transalpine activity can by no means be excluded, for most of the fifteenth century it regrettably in a sense excludes itself. This is because there is little evidence that transalpine patrons and their artists were concerned that the visual arts should serve as vehicles for

exploring the intellectual preoccupations that are at the heart of this book.

There is a paradox here, for the Netherlandish painters Jan van Eyck and Rogier van der Weyden were apparently among the most celebrated of fifteenth-century artists, and their works were among the most sought after by Italian patrons and collectors. There is no doubt that their influence on fifteenth-century painting throughout Europe was profound – more so, probably, than that of any fifteenth-century Italian artist. But to judge from the terms in which they were praised, it was the mimetic and affective qualities of their art that observers found appealing. Not surprisingly, their art reflected little of the activities of Italian intellectuals, nor did it have significant impact within fields of intellectual endeavour. None the less, the more 'scientific' interests and the more self-conscious social aspirations occasionally shown by Jan van Eyck, Rogier van der Weyden and Jean Fouquet (to name but three major northern European artists of our period) are useful as controls, in a sense, against which to measure the strengths of Italian artists' interests.

But the outstanding reason why this book cannot be limited to Italy is the extraordinary career of Albrecht Dürer. His engagement with the Italian early Renaissance revival of the classical heritage and its intellectual concerns, and his obsessive concern with his intellectual and social status as a painter, were so powerful that they bring various of these developments to their logical conclusions. His contributions in many areas of discussion in this book were often more radical and more extreme than those of his Italian peers, and thus seem to sum up the activities of early Renaissance artists in these fields. Because his wealth and social status were founded to an unprecedented degree on his independent productivity as a printmaker, he was not beholden – to the extent that many of his Italian contemporaries were – to a princely patron or to the business economics of a workshop organisation. But his contributions were not merely individualistic: he operated at such a high level of intellectual activity as to make his works as important to this review of the early Renaissance artist's cultural life as those of Leonardo da Vinci or of Raphael. And more important, I would argue, than those of Michelangelo who, as will be seen, plays a relatively minor role in what follows. It would narrow and enfeeble this book less to omit Michelangelo than to omit Dürer.

The cut-off date of 'about 1520' brings the discussion to a close before the advent of the new style of the courts of Emperor Charles V, François I of France and Henry VIII of England. It was not until around 1530 that they had firmly established a new artistic and intel-

lectual map in Europe. But the early Renaissance Italian courts, and to a lesser extent northern courts such as Burgundy, had already fostered artistic responses to intellectual activity – more, perhaps, than centres of patronage where the regime was oligarchic or republican rather than seigneurial. This is a difficult generalisation to exemplify and to maintain. Nevertheless it is important to emphasise, and to seek to define, the contrasting character and effects of patronage in different centres of production. Padua, with its celebrated university and strong academic tradition, provided the antiquarian seedbed for the growth of archaeological attitudes towards the classical past. Before the establishment of the evolved 'courtly' culture of Lorenzo 'the Magnificent' de' Medici, Florence was foremost in stimulating artists to develop formal, Albertian concerns with geometric perspective, for example, or with the depiction of articulate anatomical forms. The special topographical and constitutional contexts of Venice appear to have encouraged particular, localised 'poetic' qualities in artistic activity. The princely courts, and those predominately of Mantua and Ferrara (but also to some extent those of Milan, Naples and elsewhere), offered artists both the security and often the freedom to develop independent intellectual interests, and to display these through their visual productions. In these courtly environments artists often had the best opportunities 'to take pleasure in poets and orators',[7] musicians and other intellectuals – the practitioners of the liberal arts, towards which status painters and sculptors aspired. The cultural and economic characteristics of different sites of art production are variables of which we should not lose sight when discussing the intellectual life of early Renaissance artists. They may have provided or denied, enhanced or depressed, artists' opportunities for furthering their own special interests. Different artists made different choices as to the contexts that would most favour the fulfilment of those interests, and those choices could be crucial to their contributions towards the development of the early Renaissance artist's intellectual self-consciousness.

The Nature of the Textual Evidence

This book blends textual evidence about artistic activity in the early Renaissance with evidence provided by the visual outcomes of this activity. The aim is to build a framework of evidence within which the artist's intellectual life can be seen to develop, taking new directions over time and in different environments. By considering the range of activity in different art forms together, we can come to a

fuller understanding of how artists responded to intellectual stimulus. Inevitably based on the interpretation of available evidence, this framework is, however, bound to be strong in some places but weak and fallible in others. It will have a built-in elasticity, since different sorts of evidence are reliable (or unreliable) in different ways, places and times. This is almost as true of textual as of visual evidence. The precise meaning – if originally there *was* a precise meaning – of most written records is seldom easy to ascertain. Texts have to be interpreted with caution and with discretion. I cannot spell out all the caveats that might relate to each text cited – be they questions of translation, of local usage and meaning of fifteenth-century language, of intentional manipulation or bias on the writer's part, and so on – in an introductory treatment such as this one. What is important here is to offer as wide a range of evidence, both textual and visual, as can be done within the book's compass. This will provide readers with a framework (however elastic it may be) for their understanding of the artist's changing position and growth in intellectual sophistication during the period. But there are certain ground-rules that can be set out and followed, as far as possible, in interpreting the textual evidence presented here.

First, in this book I work with contemporary, early Renaissance texts whenever possible. Later (or indeed earlier) material is brought into play only when it seems to be the sole evidence available to throw light on particular questions. Contemporary texts generally offer a less insecure basis than others for interpreting the early Renaissance artist's engagement with intellectual ideas. Seldom, therefore, will reference be made, for example, to the rash of art-theoretical texts published in the mid- to late sixteenth century. Although in many instances these build on ideas already formulated in early Renaissance art theory, they do so under different cultural circumstances that may prejudice their value as evidence.

Similarly, I shall not often quote from Giorgio Vasari's *Lives of the Artists*, a text – or rather *the* text – essential to the later, sixteenth-century construction of the concept 'the Renaissance artist'.[8] Vasari includes a wealth of factual information about locations of works of art, practical matters relating to workshop procedures, and of course biographical details of the artists he writes on. Often these items of information can be corroborated from other sources. But conversely, he was often demonstrably mistaken; and historically the more distant from the mid-sixteenth century is his subject, the more fallible he has proved to be. What we read in his *Life* about Michelangelo's early career, for example, is in all probability reasonably accurate, even when denied by Michelangelo himself through his

'official' biographer, Ascanio Condivi.[9] On the other hand, what he says about Giotto is misleading both in biographical details (which are predominantly anecdotal) and in his chronology of Giotto's life and works, even though the earlier sources on Giotto are fuller than for any other fourteenth-century painter.[10] In the *Lives* of fifteenth-century artists, too, he could be seriously mistaken, as when he reported that Domenico Veneziano, who died in 1461, was murdered by Andrea dal Castagno, who died in 1457.[11] Vasari's activity as a biographer was guided, and to a degree constrained, both by the conventions of biographical writing in the Renaissance and by his residence and employment in Florence. Since he worked for – and dedicated his *Lives* to – Duke Cosimo I de' Medici, his book is biased towards the lives and achievements of Tuscan, and especially of Florentine, artists. Comments on artists working elsewhere (in Venice, for example) are sometimes conditioned by reservations suggesting that their work would have been better if they had been more responsive to their Tuscan contemporaries. Equally, since for Vasari art progressed steadily from Giotto to its zenith in Michelangelo, artists who in his view did not fall in with this straight line of progress are less highly regarded. Each *Life* describes the artist's work and his praise-worthiness in comparison with the yardstick of progress towards the peak of Florentine art and, following literary convention, is also used to demonstrate some moral point. Each *Life* is therefore moulded to shape the particular expectations both of Vasari's biographical method and of his audience. Crucial though Vasari is to our knowledge of early Renaissance art, his opinions need to be used with caution. If other, preferably contemporary, evidence survives it is usually better to overlook Vasari in its favour.

Seeking to avoid reliance on Vasari's testimony, we are thrown back on the generally more dependable but far less comprehensive material provided by fifteenth-century texts. Reliability and usefulness vary, of course, with the nature of the text; and again we need to exercise caution in deciding in what ways they may be informative – and indeed if, in some cases, they are informative at all. Legal or financial documents offer 'hard' evidence that may be taken as read unless there is good reason to believe that the scribe positively sought to mislead. But this evidence is nevertheless open to interpretation: although presumably clear enough for its purposes in the fifteenth century, its meaning may no longer be transparent. In any case, intelligible or not, such writings normally provide purely factual data that may not be very helpful for our purposes. It is a paradox of historical investigation that the more objective the information, the less it is of any real interest. Seldom, for example, do documents

offer evidence about the intentions that lay behind artistic activity, which are the sorts of things ideally we would like to know about.

Conversely, what from our point of view constitutes more interesting and productive information – accounts, descriptions and other similar records of artistic activity – is more subjective, and therefore more liable to be biased at source. This sort of material is found in treatises, biographical writings, letters to and from artists, daybooks and other commentaries, poems and prose descriptions in which artists and artistic activity are referred to, or other writings that may reflect artistic activity in a broad range of ways. Such texts are inevitably sporadic, and variable in quality and informativeness in different places at different times during the early Renaissance. For example, the Medici archive in Florence, one of the best preserved from the fifteenth century, contains a remarkable number of artists' letters. Unfortunately, however, hardly any Medicean replies survive; and it is often the patrons' responses, or the exchanges between patrons about artists and their activities, that prove more useful to a discussion of attitudes towards art and artists than the artists' own letters. In this respect, the material available from the archive of the Gonzaga of Mantua, which is of course also open to interpretation but contains much data on patrons' attitudes, is significantly more valuable.

The fragmentary and inconsistent character of surviving textual information inevitably affects the depth and evenness of discussion in this book. For example, surprisingly little is known from contemporary sources about the intellectual life of Donatello, who was rightly recognised by Vasari as the most independent-minded and artistically creative early Renaissance sculptor. The textual materials deriving from court circles are generally fuller and more varied than those of republican Florence, despite the relatively high quality of the Florentine archives. Almost all the treatises, biographies, poems about artists, humanists' commentaries, patrons' surviving letters, and so on were produced in and for court centres such as Mantua, Ferrara, Urbino, Rome and Milan. Ghiberti's *Commentaries* are a notable exception, and become that much the more extraordinary for it.

Similarly, almost the only information that survives on Rogier van der Weyden (one of the major forces in fifteenth-century painting), apart from generally bland, uncritical documentary references, perversely comes not from a Netherlandish source but from the writings of Italian humanists such as Bartolomeo Fazio. It is thus impossible to integrate Rogier into the place in this book that the quality and influence of his art deserve. By contrast with Italy, a tradition of

humanistic scholarship based on re-editing and reinterpreting classical texts, with an attendant growth of interest in activity in the visual arts, scarcely began to develop north of the Alps during the fifteenth century. Virtually no discussion of northern artistic activity is recorded before the mid-sixteenth century. Although we may sense in the mid-fifteenth-century French painter Jean Fouquet a mind oriented towards problems of pictorial representation that echo the theoretical ideas of Alberti's *On Painting*, we have no textual evidence to bear this intuition out. These are examples of the unevenness of the spread of textual evidence across location and time that make it more difficult to generalise about the development of intellectual activity among painters and sculptors.

The Nature of the Visual Evidence

In introducing the period covered in this book I stressed the importance of literary activity as a measure of the Renaissance artist's intellectual life. This may seem perverse, not least given my emphasis on the relative inarticulacy of such men as Cennino Cennini and Giovanni Santi with the written word. But the written word is to an important extent more concrete, less open to diverse interpretation, than the visual image. When a document or an inscription states that a painting was made by a given artist in a given year, this may generally be seen as definitive evidence of an undeniable fact. But to assess, for example, what were Leonardo da Vinci's artistic intentions when he painted the *Mona Lisa* in the way that he did, has been and remains tantalisingly open to interpretation. Some readings of paintings like this one may seem abstruse, even absurd; but it may not be possible to reject them on evidential, factual grounds.

Some types of information provided by visual images are of course at least as hard, if not 'harder', evidence than, say, a painter's letter to his patron. Scientific analysis, for example, can establish incontrovertibly what medium and pigments the painter used. Similarly, the degree to which his perspective scheme is mathematically accurate may be a measure of the quality of a painter's engagement with geometry. But for the most part the visual evidence is by definition 'soft', and needs to be interpreted with great tact. Often views will differ as to what we can and what we cannot actually read in a visual image, let alone what the artist's intentions may have been in making it. Who, for example, *are* the three figures at the right-hand side of Piero della Francesca's *Flagellation* (fig. 136)? From their prominence in the painting it looks as though this might matter. Without a written

explanation, preferably in Piero's own hand, however, we shall never know for sure whether their identities are indeed significant, let alone who they are. If in cases like this questions of identification cause problems, how much more problematical may be the search to define an artist's intention in an image for which we have no textual gloss. Why did Botticelli paint his *Calumny of Apelles* (fig. 94) the way he did; indeed, why did he paint it at all? So provoking is the ambiguity of the more complex, unexpected early Renaissance paintings and sculptures that most possible explanations have been canvassed. If not openly contradictory, these explanations are at least nuanced differently, and highlight different aspects of the image to support different readings. I think of the discussion, even controversy, that has continued in recent decades over, for example, the meaning(s) of Donatello's bronze *David* (Florence, Bargello), or even over the subject represented in Giorgione's *Tempesta* (Venice, Accademia), let alone this painting's meaning.

Fortunately, not all images that offer evidence of the artist's intellectual interests cause such problems as these examples. None the less, in analysing a good many images, sometimes even those with apparently straightforward subjects and pictorial structures, like a Fra Angelico *Annunciation*, for example, there are risks of over-interpretation. At times, readers may feel that I have sought to extract too much evidence from an image and have not applied rigorously enough the principle of 'parsimony' in interpreting it.[12] Nevertheless, my readings of visual images at least conform with or complement whatever textual and historical evidence we have, even though few of them are either original or universally acknowledged.

To sum up: the quality of the evidence, both written and visual, that can be usefully considered in the sort of investigation pursued in this book varies according to both time and place; and a fair amount of it is subject to variable interpretation. On the more positive side, working on this book has shown me, as I indicated earlier, that a greater wealth and range of material relevant to the investigation survives than I had imagined at the outset. It is in many ways the nature of this material – its emphases and its selectivity – that has guided if not dictated the structure of this book. The initial premiss is that the development of intellectually based activity among artists led to the emergence of the visual arts from their roots in the craft tradition towards integration into the intellectual consciousness of Renaissance patrons and men of letters. The visual arts gradually became accepted as liberal arts, and were not habitually suppressed as the mere mechanical arts of Leonardo da Vinci's plea. Given this, the material that impinges on this investigation falls naturally into

a series of thematic studies. In a book of this length and scope it is impossible to pursue all the possible lines of enquiry that might support the general argument. I decided therefore not to discuss, for example, the 'science' of perspective as fully as this subject deserves. There seems to me to be no doubt about the theoretical and practical importance of perspective for early Renaissance painters. How and why they came to grips with perspective, and how they exploited it as a demonstration of their knowledge of geometry, continues however to stimulate specialist studies of a quality and comprehensiveness that I neither can nor need to compete with or to reiterate here. In the areas of intellectually demanding activity that are discussed here, I have sought to use the evidence with tact and caution. It is plainly risky to generalise too broadly from isolated instances, and caveats are often required. I have, however, attempted to build up a case to suggest that, by the end of the early Renaissance, the life and work of many artists was on a sufficiently high intellectual plane for their art in large measure to deserve to be considered the equal of the liberal arts.

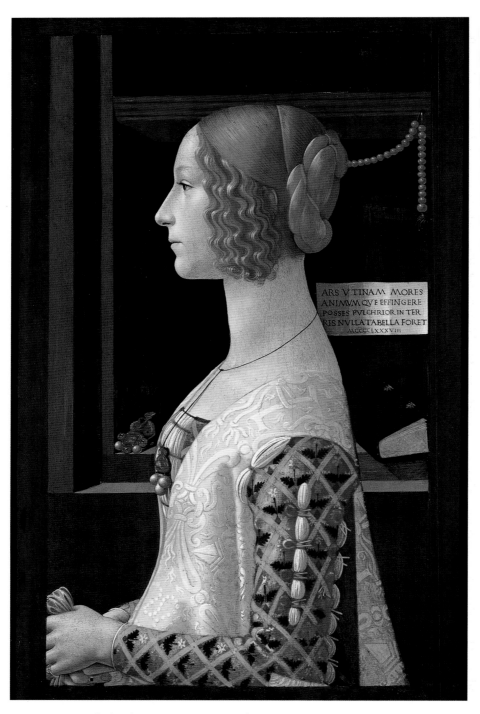

Within the painting:

ARS VTINAM MORES
ANIMVM QVE EFFINGERE
POSSES PVLCHRIOR IN TER
RIS NVLLA TABELLA FORET
MCCCCLXXXVIII

2 Domenico Ghirlandaio, *Giovanna Tornabuoni* (1488). Tempera on panel. Madrid,
© Museo Thyssen-Bornemisza

Chapter 2

The Artist's Education and Training

Background and Schooling

King of Naples until he was ousted by Alfonso of Aragon in 1443, René d'Anjou held a high reputation as a painter. In his *Cronaca rimata* the Urbino court painter Giovanni Santi wrote that 'in our time the aged King René / Painted better than many who 'are famous',[1] citing him as an example comparable with painters of high social status recorded in classical times. Another example is Baldassare d'Este, the Ferrarese painter and medallist, if he was indeed, like Duke Borso d'Este, an illegitimate son of Niccolò III d'Este of Ferrara.[2] But these cases are very unusual in the early Renaissance when painting and sculpture were generally not practised by members of the aristocratic or learned classes, even though Castiglione could declare drawing and painting as activities worthy of the courtier.[3] The epitaph of Giovanni Antonio Boltraffio, a Milanese aristocrat who was a follower of Leonardo da Vinci in the early decades of the sixteenth century in Lombardy, stressed that although a painter he was an amateur, not a professional: his social status would be lowered if it was thought that he earned his living by painting.[4]

According to tradition, Michelangelo had to persuade his father, who came from a higher social stratum than most painters' fathers, that he should leave grammar school, to become apprenticed in Domenico Ghirlandaio's workshop.[5] It was still unusual for Giulio Campagnola, the son of a patrician man of letters and gifted at an early age in painting, illuminating, engraving, sculpture and the cutting of gems, to be encouraged by his father to follow an artistic career. Giulio's father Girolamo was a friend of the Mantuan court painter Andrea Mantegna, and through humanist friends helped his son to be accepted into court circles in Mantua and Ferrara.[6] It is perhaps an indication of the growing status of painting and the graphic arts that it was possible for this young patrician to become an artist who specialised in printmaking. Conversely, that he came

from an intellectual background may help to explain the sophistication of the classical and allegorical imagery of his engravings.

Leon Battista Alberti, who was also the son (although illegitimate) of a patrician father, wrote in 1435 in his important treatise *On Painting*: 'I speak . . . as a painter'.[7] Although many attempts have been made to attribute paintings to him, none is persuasive. His statement should perhaps be seen as a rhetorical claim by which his discussion of the scientific principles of the art of painting might appear more acceptable to an intellectual readership. His treatise was primarily intended for use as a textbook at Vittorino da Feltre's school in Mantua, the Casa Giocosa, at which princes and courtiers of the next generation were educated.[8] For this reason, and for this audience, Alberti cites many anecdotes from classical texts that vouch for the high regard in which painting was held in ancient times, as a worthy occupation for princes and emperors. Writing in praise of the late Gothic painter Antonio Pisanello around 1427, the great Ferrarese court humanist Guarino da Verona had already observed that both Socrates and several eminent Romans practised the art of painting, and that 'many emperors and kings' were also skilled in such arts.[9] Likewise, Alberti wrote:

'L. Manilius, a Roman citizen, and the nobleman Fabius were painters . . . [and] the philosophers Socrates, Plato, Metrodorus and Pyrrho achieved distinction in painting . . . The excellent custom was especially observed among the Greeks that free-born and liberally educated young people were also taught the art of painting together with letters, geometry and music . . . the art of painting is indeed worthy of free minds and noble intellects.[10]

This list of practitioners of classical times is drawn largely from Pliny the Elder,[11] and is followed by Castiglione, who recalled in *The Book of the Courtier* that 'in Greece especially children of gentle birth were required to learn painting at school, as a worthy and necessary accomplishment'.[12] Nevertheless, few during the early Renaissance would have seen the practice of painting or sculpture as a vehicle for demonstrating their intellectual qualities. Indeed, even in the case of the exceptional Giulio Campagnola it may have been his abilities as a poet, singer and lutenist that won him his position at court.

Conversely, however, many painters and sculptors aspired to higher intellectual and social status, although their background and education seldom favoured such advancement. Some artists came from rich or socially reputable families. Donatello, for instance, was a member of a cadet branch of the Bardi family, but was only distantly related

to those who were celebrated for their wealth and high civic status. Others were the sons of well-educated, professional men. Leonardo da Vinci's father Ser Piero da Vinci was a notary, but Leonardo was an illegitimate son who therefore was not given a grammar-school education. Most Renaissance painters and sculptors, however, came from the artisan class, and often were brought up in family workshops. Filippino Lippi was trained by his father, Fra Filippo; and both Giovanni and Gentile Bellini matured in their father Jacopo's successful workshop in Venice. Dynasties of sculptors, like the Bon and Lombardo families in Venice, or the della Robbia and da Maiano family workshops in Florence, handed their experience of working in specialised materials or techniques down the generations. It follows that artists were seldom educated beyond the basic training provided by the curriculum of the abacus school.

Humanist schools such as Vittorino da Feltre's were the province of boys from the upper and wealthier strata of society – those who were destined for intellectual careers in the church, for example, in law or in the city chancelleries. Capable boys from the artisan classes learned to read and write at primary school (the *botteghuzza*), and from the ages of about seven to eleven almost all but the boys of privileged or professional families went to the abacus school. Here they were taught essential vernacular literary skills, and the mathematical skills needed by the merchant class. The best abacus school in Florence around 1400 was run by the Silk Guild (Arte della Seta), the guild to which goldsmiths belonged. The appointment of abacus masters was a civic responsibility associated with the city's aspiration to play a part in international commerce. Originally established therefore to teach commercial arithmetic and the rudiments of geometry, the abacus schools were distinguished from the humanistic schools by the exclusive use of the vernacular. Thus educated, Renaissance artists acquired basic literacy and useful mathematical skills, but were seldom taught Latin. Although initially trained as a goldsmith, Filippo Brunelleschi was perhaps an exception. His biographer Antonio Manetti wrote that he 'learned to read and write at an early age and to use the abacus. He also learned some Latin [*qualche lettere*] perhaps because his father, who was a notary, thought of having him follow the same profession'.[13] More typical was Donato Bramante who became an architect but trained as a painter, and who, so we hear from Vasari, 'besides reading and writing ... was continually doing the abacus'.[14] Leonardo da Vinci too 'began to learn arithmetic, and after a few months he had made so much progress that he used to baffle his master with the questions and problems that he raised'.[15] By implication, before being apprenticed as painters

Bramante and Leonardo, and doubtless innumerable others like them, went to the abacus school and studied vernacular reading and writing, but not Latin. Like most painters, Piero della Francesca, the son of a provincial merchant, almost certainly went to the abacus school: despite its Latin title, his treatise *De prospectiva pingendi* was originally written in the vernacular.[16]

In general, therefore, those who became painters or sculptors had not been taught to read and write in Latin. When in 1335 Pietro Lorenzetti needed a text of the life of St Savinus so that he could design paintings for the predella of his *Birth of the Virgin* altarpiece for Siena cathedral, Maestro Ciecho, a grammar-school teacher, was paid to translate the life from Latin into the vernacular for him.[17] Texts written with an artist readership primarily in mind were always in the vernacular. Leon Battista Alberti rapidly translated the Latin original of his treatise, *De pictura*, into Italian and in 1436 dedicated the vernacular *Della pittura* to Brunelleschi and to his contemporaries Ghiberti, Donatello and Luca della Robbia, and to Masaccio.[18] This implies both that it was written originally for an educated, intellectual readership, and that Alberti wished to make it accessible also in Italian for the practising artist. An artist like Donatello may well, however, still have found the numerous classical references and examples arcane and obscure. Similarly Ghiberti's *Commentaries*, Giovanni Santi's *Cronaca rimata*, Michelangelo's poems, and almost all the many letters and other short writings of Renaissance artists are in the vernacular. When probably in 1519 or 1520 Raphael wrote his celebrated letter to Pope Leo X he thought it sufficiently important to call on Castiglione for help even with composition in the vernacular. Although it is clearer in putting across his ideas, Raphael's own version is less elegantly written than the text delivered to the Pope.[19]

Fluency in Latin was, however, an essential qualification of the cultured, literate man who sought to move within the higher social circles. Painters who, like Andrea Mantegna, had aspirations towards high intellectual status, must have sought to gain at least a reading knowledge of Latin, for many important classical texts were not yet available in vernacular translation. If the inventory of Ludovico Mantegna's library in 1510 indeed records which books he had inherited from his father, the evidence is that Mantegna had succeeded in learning enough Latin to read many classical and humanistic texts in the original, perhaps with the help of Niccolo Perotti's much-used primer, which is also listed among these books.[20] To judge from the range of the classical textual sources used by Ghiberti in his *Commentaries*, he, too, had by the end of his career learned to read Latin; but despite

its literary pretensions the book was of course written in the vernacular. Piero della Francesca may have needed the help of his fellow townsman Matteo di ser Paolo d'Anghiari to put his treatise *On Perspective for Painting* (*De prospectiva pingendi*) into Latin acceptable to readers at Federigo da Montefeltro's court at Urbino, but his careful study of Euclid would have required some reading knowledge of Latin. It seems possible, moreover, that later in life he had learned enough also to read Archimedes in a Latin translation.[21] Albrecht Dürer wrote that young artists should be taught 'how to read and write well, and be also instructed in Latin so far as to understand certain writings'.[22] But Dürer himself had little Latin: like many artists he depended on educated friends like Konrad Celtis to write inscriptions for his paintings. To gain full access to Euclid he had to await the German edition, for he had not mastered the language well enough to be able to read the Latin Euclid that he bought in Venice in 1505; and in 1520 he asked to be sent the German, rather than the Latin, editions of Luther's new pamphlets.[23] Similarly, Raphael was unable to understand Vitruvius in the original well enough, and he had the text translated for him by his friend Fabio Marco Calvo.[24]

By conceding in the late 1490s that he was not 'a man of letters', Leonardo admitted his lack of Latin. 'I do not have literary learning', he wrote, '[but] my concerns are better handled through experience rather than bookishness.'[25] Nevertheless, he seems to have worked hard at learning Latin. The list of the 116 books in his library around 1503 is a useful indicator both of the wide range of his interests but also of his growing linguistic competence.[26] His determination to improve his Latin is suggested by listed copies of such standard grammar books as that by Donatus, which he probably owned in the parallel Latin and Italian edition published in Venice in 1499. He had Italian translations of many classical texts, such as the works of Livy, Ovid and Pliny, but his copies of Euclid and Ptolemy, and of such contemporary treatises as Alberti's *De re aedificatoria*, must have been in Latin. The size and scholarly character of Leonardo's library was exceptional for a Renaissance artist. The inventory of the estate of the engraver and cartographer Francesco Rosselli, drawn up several years after his death in 1513, lists only nine books, seven religious texts, a Dante and a copy of Josephus, presumably in the vernacular.[27] Filippino Lippi's study, according to the inventory written after his death in April 1504, contained twelve books – a Bible, Ovid in the vernacular, nine recent texts (principally works of Dante, Petrarch and Boccaccio) and a Livy 'in penna anticho'.[28] The inventory of the property that the painter Rosso Fiorentino left with the

Compagnia di SS Annunziata when he left Florence for France in 1529 included a copy of Castiglione's *Il cortegiano*, published the year previously, and editions of Pliny and Vitruvius which presumably Rosso was able to read with the assistance of his copy of Niccolò Perotti's Latin primer.[29] Another list of artists' books, the twenty-eight volumes recorded in the shared *scrittoio* of Giovanni and Benedetto da Maiano in 1498, shows a similar profile.[30] Almost all were in the vernacular: apart from three volumes of Livy and a *De vita patrum*, those of the da Maiano books that can be identified from the laconic inventory records were almost exclusively biblical or devotional manuscripts, Boccaccio's *Decamerone* and, predictably, a copy of Dante.

It seems unlikely that either Filippino Lippi or the da Maiano brothers had any Latin, and they were probably typical of the artisan painter or sculptor. But although they may have had larger libraries than other artists, Mantegna and Leonardo da Vinci were not unique in their acquisition of some Latin. Giulio Campagnola was exceptionally gifted linguistically: he was fluent in Latin, Greek and Hebrew. Antonio Averlino, who transliterated the Greek for 'lover of virtue' (ΦΙΛΑΡΕΤΗ) and adopted 'Filarete' as his pseudonym,[31] probably had a more extensive understanding of Greek, as well as of Latin, than most fifteenth-century artists. On a small, informal plaque (fig. 3) representing the fight between Ulysses and Iro, as described by Homer in the *Odyssey* (XVIII, 46–49), he added the inscription in Greek, 'ΑΝΤΙΝΟΟC.ΙΡΟS.ΟΔVCΕUC'.[32] On the other hand, Mantegna probably had to have his signature translated as 'ΤΟ. ΕΡΓΟΝ.ΤΟΥ.ΑΝΔΡΕΟΥ . . .' for his *St Sebastian* in Vienna (fig. 135);[33] and the precociously early transliteration of the name of Jan van Eyck's sitter in the 1432 *Portrait of Tymotheos* (London, National Gallery) is a straightforward conversion into Greek letters that required no knowledge of the language.[34] That artists understandably had problems when using Greek is indicated by the inaccurate inscription on one of Giovanni Boldù's *all'antica* self-portrait medals (fig. 130). The Latin signature on the reverse 'OPUS IOANIS BOLDU PICTORIA VENETUS XOGRAFI' is self-consciously but incorrectly transliterated on the obverse as: 'ΙѠΑΝΕΣ ΜΠѠΛΝΤΟΥ ΖѠΓΡΑΦΟΥ ΒΕΝΑΙΤΙΑ'.[35] On the other hand, the inscription '+ΙѠΑΝΝΗC.ΒΑCΙΛΕVC.ΚΑΙ.ΑVΤΟ. ΚΡΑΤѠΡ.ΡѠΜΑΙѠΝ.Ο.ΠΑΛΑΙΟΛΟΓΟC.' on the obverse of Pisanello's medal of Emperor John VIII Palaeologus (fig. 4), perhaps the earliest in Greek on an Italian work, must have been provided by a Byzantine visitor (perhaps the emperor himself) to the Council of Ferrara/Florence of 1438–9.[36] And however learned Botticelli was for a painter of his time, the extraordinarily long, apocalyptic inscription

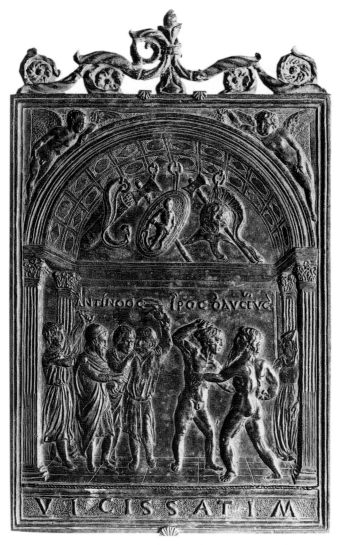

3　Filarete (Antonio Averlino), *Ulysses and Iro* (*c*.1445).
Bronze. Vienna, Kunsthistorisches Museum

in Greek on his *Mystic Nativity* (London, National Gallery) must
surely have been written out for the painter by a Greek speaker and
copied without comprehension on to the panel.[37]

Equally, it seems likely that many inscriptions in Latin on Renais-
sance paintings and sculptures, beyond standard forms of signature,
were – like Dürer's – provided or composed by educated, humanistic

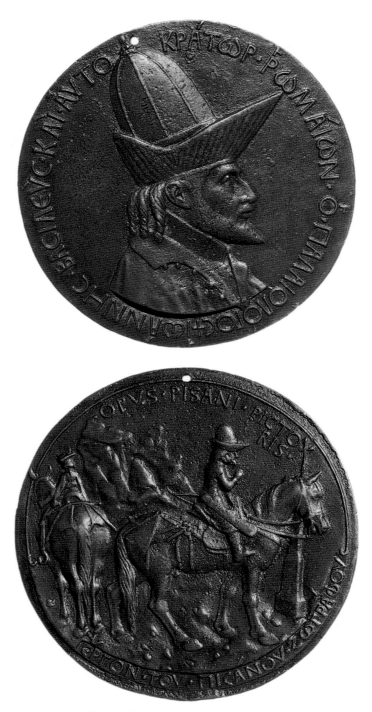

4 Antonio Pisanello, medal of Emperor John VIII Palaeologus (1438–9),
obverse and reverse. Bronze. London, © The British Museum

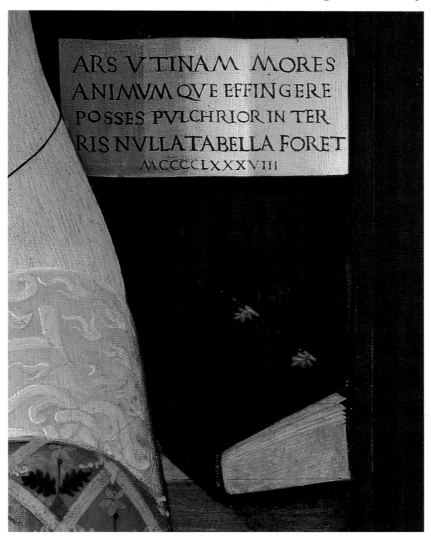

ARS VTINAM MORES
ANIMVMQVE EFFINGERE
POSSES PVLCHRIOR IN TER
RIS NVLLA TABELLA FORET
MCCCCLXXXVIII

5 Detail of fig. 2

contemporaries. A good example is the epigram from Martial, a first-century Roman poet, inscribed by Domenico Ghirlandaio on his posthumous portrait of Giovanna Tornabuoni (fig. 2), which reads in translation: 'O art, if thou were able to depict the conduct and the soul, no lovelier painting would exist on earth'.[38] Others are the inscription, 'When these swelling eyes evoke groans, this work of

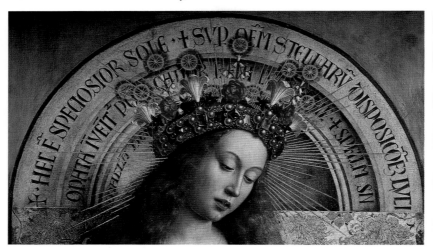

6 Hubert and Jan van Eyck, Ghent altarpiece (1432), detail: head and halo of the Virgin Mary. Oil on panel. Ghent, cathedral of St Bavon

Giovanni Bellini could shed tears', on Bellini's *Pietà* (Milan, Brera),[39] and that on Mantegna's late *St Sebastian* (Venice, Ca d'Oro): 'nothing but the divine is stable; the rest is smoke'.[40] Texts transcribed straight from the Bible or other religious literature, however, may well have been selected by the artist himself. A Latin version of an evocative description of the Virgin Mary – 'she is more beautiful than the sun, and above all the order of stars; being compared with the light, she is found before it. For she is the brightness of everlasting light [and] the unspotted mirror of the power of God' – is inscribed around the Virgin's halo in Hubert and Jan van Eyck's Ghent altarpiece of 1432 (fig. 6), and reappears in other paintings by Jan van Eyck.[41] The range and complexity of the numerous inscriptions in his paintings suggest that, for an artist, Jan not only understood Latin well but also had an unusually sophisticated knowledge of theological and doctrinal questions.

Another indicator that a good, if intellectually relatively elementary, schooling was often available to early Renaissance artists is the character and quality of their handwriting. Although the autograph manuscript of Lorenzo Ghiberti's *Commentaries* does not survive, a letter of 1425 shows that he wrote with a small, blunt pen in a neat hand (fig. 7).[42] That earlier he was already skilled in shaping letters *all'antica* is shown by the good Roman majuscule lettering on the scroll carried by his bronze *St John the Baptist* of 1412 on

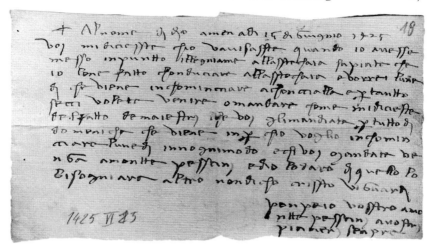

7 Lorenzo Ghiberti, letter of 26 June 1425, detail of handwriting. Pen and ink on paper. Siena, Opera del Duomo, Libri di documenti degli artisti, 54

Orsanmichele, Florence.[43] The first inscriptions truly based on Roman letter forms are, however, those by the medallist Matteo de' Pasti and the sculptor Agostino di Duccio when they were working around 1450 on the Tempio Malatestiano in Rimini.[44] Perhaps the finest examples of Roman capitals used on early Renaissance medals are those of the pretentiously self-named Lysippus the Younger, a medallist working in Rome during the time of Pope Sixtus IV (1471–84), such as on his self-portrait medal (fig. 122).[45]

However, very few letters and documents written by painters early in the fifteenth century show any awareness of the new humanistic script that was developed by Poggio Bracciolini during the first decade. Masaccio's round-formed letters of uneven size and spacing not surprisingly lack the neat consistency of later handwriting such as Leonardo da Vinci's.[46] Tax records of Florentine late Gothic painters such as Rossello di Jacopo Franchi and Bicci di Lorenzo are written in round, undisciplined mercantile hands.[47] A similar, wayward script was used for the short inscription on a drawing (fig. 8) from the goldsmith Maso Finiguerra's workshop.[48] Domenico Veneziano used a free, disorderly script for the much abbreviated Venetian dialect in his letter of 1438 to Piero 'the Gouty' de' Medici,[49] and Fra Filippo Lippi's letter of 1439, also to Piero de' Medici, shows ill-trained, mercantile letterforms.[50] More developed in the direction of the *lettera antiqua* used by the scribes of humanistic manuscripts is Benozzo Gozzoli's handwriting, as seen in the letters he wrote in

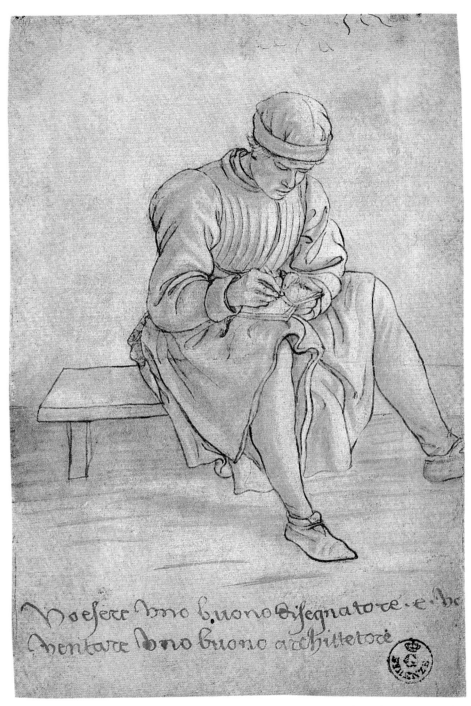

8 Maso Finiguerra, *Seated Boy Drawing* (*c.*1460). Pen, ink and wash on paper. Florence, Uffizi

Andreas mantinia. V.

9 Andrea Mantegna, letter of 26 August 1484 to Lorenzo 'the Magnificent' de' Medici, detail of handwriting. Pen and ink on paper. Florence, Archivio di Stato, Medici avanti il Principato, fil. 39 inserto 298

1459 about the fresco decoration of the chapel in the Palazzo Medici in Florence, or in the lengthy inscription on a drawing for the scene of *St Augustine Suffering from Toothache* in the fresco cycle in S. Agostino, San Gimignano.[51] In the autograph manuscript of his vernacular abacus treatise, the *Trattato d'abaco*, Piero della Francesca also wrote in a humanist roman script, the handwriting taught in Latin schools.[52] This seems paradoxical, since abacus schools taught a mercantile handwriting, and most abacus book manuscripts are therefore also written in mercantile scripts. The implication seems to be that the *Trattato d'abaco* was not intended for use in abacus schools, but was directed towards a more humanistic audience. By the end of the century, indeed, other intellectually aspiring artists had developed sophisticated humanistic hands. Mantegna's letter of 1484 to Lorenzo 'the Magnificent' de' Medici is written in a refined, even humanistic italic (fig. 9), developed perhaps through contact with a professional scribe such as his Paduan contemporary Bartolomeo Sanvito.[53] The individual, learned-looking script of Bertoldo di Giovanni's letter of 1489 to the same patron lends weight to the view that his relations with the Medici were particularly close; and his erstwhile pupil Michelangelo wrote in a fluent, easily legible italic (fig. 85), which also suggests that by the turn of the century the most aspiring artists naturally adopted a hand inspired by the early Renaissance humanistic script.[54]

Early in the Renaissance period artists began to recognise that education in more intellectual fields was vital to the advancement of painting and sculpture from craft to profession. Lorenzo Ghiberti proposed that 'painters and sculptors should study grammar, geometry, arithmetic, astronomy, philosophy, history, medicine, anatomy, perspective and "theoretical design"'[55] – a substantial intellectual curriculum. More pragmatically, the bronze sculptor Pomponius Gauricus stated early in the sixteenth century that the ideal sculptor should be well read (*literatus*) and skilled in arithmetic, music and geometry.[56] In this he perhaps followed Alberti, who wrote in his influential treatise *On Painting*: 'I want the painter, as far as he is able, to be learned in all the liberal arts, but I wish him above all to have a good knowledge of geometry.'[57] If early Renaissance painters and sculptors were able to act on such advice as this, it would have been after their basic education at the abacus school, and perhaps after their initial apprenticeship. At the beginning of the fifteenth century the painter's apprenticeship would seldom, if ever, have included this wider intellectual syllabus. Cennino Cennini's *Craftsman's Handbook* offers some general advice on how the novice should conduct himself, such as that his 'life should always be

arranged just as if [he] were studying theology, or philosophy, or other theories'. Nothing in the book suggests the painter's need of study beyond the essential craft practice of the painter: he is, rather, to 'begin by decking [himself] with this attire: Enthusiasm, Reverence, Obedience, and Constancy'.[58] On the other hand, for Leonardo da Vinci writing at the very end of the fifteenth century, 'a youth should first learn perspective, then the proportions of things'.[59] Perspective, fundamental to painting, embraced two further fields of study for Leonardo: 'Those sciences are termed mathematical which . . . are certain to the highest degree . . . The first is arithmetic and the second geometry . . . from these is born perspective, devoted to all the functions of the eye'.[60]

By the end of the fifteenth century the study of geometry was seen as an indispensable foundation for an artist's necessary skill in perspective construction. Clearly, however, in this respect there was a significant difference between Cennino's and Leonardo's attitude, and indeed already between Cennino's and Alberti's. Shortly after Cennino wrote, the construction of pictorial space using geometrical perspective came to be a powerful weapon in the armoury of the early Renaissance artist. It was a centrally important means for generating a convincing appearance of three-dimensional reality on the two-dimensional picture surface. But early experiments show that it was not an easy skill to acquire. Even as late as 1506, by which time he had mastered many aspects of Italian early Renaissance pictorial method, Dürer wrote from Venice to his friend Willibald Pirckheimer: 'I want to ride to Bologna to learn the secrets of the art of perspective, which a man is willing to teach me'.[61] To draw up an accurate perspective construction requires an understanding of geometry that probably goes beyond that gained in the abacus school. Abacus books usually end with a short section on Euclidean geometry, following the practical arithmetic essential to the novice merchant, in which, however, problems are posed in numbers rather than in diagrams.[62] Moreover, these problems are generally concerned with two-dimensional issues that can be applied in practice, such as those relevant to calculating the area of a crop-bearing field. A mathematically accurate method for constructing a three-dimensional pictorial space was worked out around 1413 by Filippo Brunelleschi in a painted study of the Florentine Baptistery, as described by Antonio Manetti in his biography.[63] The painting has not survived, but it may be reflected in the *Presentation* (Paris, Louvre) from the predella of Gentile da Fabriano's Strozzi *Adoration of the Magi* of 1423.[64] Brunelleschi's method (or something very like it) was set down in words by Alberti in his *On Painting* (1435), although the procedure

is not described in full and precise mathematical terms. By this time, Brunelleschi had almost certainly helped Masaccio to draw up the perspective of the *Trinity* in S. Maria Novella, Florence, probably of 1427, and perhaps also Donatello with his early mathematically calculated perspective settings such as that for the relief of the *Feast of Herod* on the Siena Baptistery font.[65] Other artists, however, had no such help to hand: Masolino, for example, when painting his version of the *Feast of Herod* at Castiglione Olona generated a round-arched arcade that sweeps out of control into deep pictorial space and belies the structure's architectural logic.[66] Working, like Masolino, in northern Italy, Pisanello (in a perspective drawing in the Codex Vallardi in the Louvre) and Jacopo Bellini, (in for example, the *Nativity* (fig. 10) in his book of drawings in Paris) produced equally incongruous perspectival spaces, perhaps because they were grappling with Alberti's incomplete explanation.[67]

Despite his later reputation of having wasted time on 'fanatical studies' of perspective,[68] the Florentine painter Paolo Uccello never

10 Jacopo Bellini, *Nativity* (c.1450). Pen and ink on parchment. Paris, Louvre, Bellini book of drawings, fol. 33

fully mastered the principles of Brunelleschi's geometrical construction, although he did produce highly expressive, spatially experimental compositions, as in *The Flood* in the Chiostro Verde of S. Maria Novella. Other painters of Alberti's generation working in Florence, however, such as Fra Angelico and notably the Venetian-born Domenico Veneziano (a fellow apprentice of Jacopo Bellini in Gentile da Fabriano's workshop during the 1420s), appear to have fully understood and masterfully applied the method. Ghiberti, too, produced an exemplary perspectival space in the *Story of Isaac* panel (fig. 76b) of the east doors of the Florentine Baptistery, cast at much the time that Alberti dedicated his vernacular translation of *On Painting* to Brunelleschi and his fellow artists. On his visit to Italy in the mid-1440s, the French painter and manuscript illuminator Jean Fouquet also engaged with the issue of perspective construction of pictorial space. A number of illuminations that he produced on his return to Paris, especially those in the Book of Hours of Etienne Chevalier, suggest that he had learned to good effect perhaps from these Florentine students of Alberti's treatise.[69] Yet others of the generation, however, such as Fra Filippo Lippi and Donatello in late works such as his pulpits in San Lorenzo, Florence, fought shy of the Albertian construction, perhaps finding that it imposed a rather inflexible straitjacket on their pictorial practice. The mathematician-painter Piero della Francesca's scrupulously precise analysis of perspective construction in his *On Perspective for Painting* could have served as a corrective to Alberti's incomplete demonstration. By the time (around 1455–60) that Piero painted his *Flagellation* (fig. 136), the perspective construction of which can be proved to be mathematically correct, many painters in Florence and some elsewhere were sophisticated enough in their knowledge and application of the geometrical construction of perspective to decide according to circumstances in what ways to follow or to depart from Alberti's system. Around 1470, for example, a Florentine draughtsman somewhat self-consciously displayed his skill, and incidentally anticipated diagrams in Piero's perspective treatise, when drawing up a foreshortened polygonal structure (fig. 145). Indeed, already in the early 1450s the Paduan painter Mantegna also manipulated Albertian perspective by varying the observer's assumed viewing level in his Ovetari chapel frescoes. It is especially difficult to achieve constructional accuracy when working on a large wall surface, as fresco painters had to do: perhaps for this reason, detailed perspective constructions (fig. 11) appear in the *sinopia* underdrawings for Benozzo Gozzoli's frescoes in the Camposanto at Pisa, which were revealed after war damage in 1944.

11 Benozzo Gozzoli, *sinopia* for the *Marriage of Isaac and Rebecca* (1473–7).
Pisa, Museo delle Sinopie

Leonardo da Vinci's advice to apprentices to start by learning per-
spective was an acknowledgement of what by the end of the fifteenth
century was standard workshop practice. But in emphasising the fun-
damental importance of arithmetic and geometry, Leonardo did not
face the novice painter with the broad intellectual curriculum that
Alberti had set forth for him. There was, it seems, a difference of edu-
cational expectation between the art theorist and the painter con-
cerned with the studio practice of his art. Nevertheless, practice in

the *bottega* provided a range of opportunities and contacts from which the painter or sculptor could absorb intellectual ideas and understanding. Increasingly during the early Renaissance the artist's desired objective was to develop his intellectual range, so these opportunities were seized with growing readiness and frequency.

Training in the Artist's Bottega

The young artist's early experience of intellectual endeavour was gained in the *bottega* in which he was apprenticed. Although apprenticeship changed in character and experience during the early Renaissance, as will be clear later in this section, it remained firmly the standard system of training for the aspirant artist. Writing around 1400, Cennino Cennini makes clear that enthusiastic novices come 'to want to find a master; and they bind themselves to him with respect for authority, undergoing an apprenticeship in order to achieve perfection'.[70] He advises the new apprentice to 'begin to submit yourself to the direction of a master for instruction as early as you can, and do not leave the master until you have to'.[71] Apprenticeship started when a boy left his abacus school. Cennino advises the ten- or eleven-year old

> to begin as a shopboy studying for one year, to get practice in drawing on the little panel; next, to serve in the shop under some master to learn how to work at all the branches which pertain to our profession . . . for the space of a good six years. Then to get experience in painting . . . for six more years . . . if you follow other systems, you need never hope that they will reach any high degree of perfection.[72]

Not all apprenticeships were with a single master, or lasted as long as the thirteen years recommended by Cennino. For example, Giusto d'Andrea wrote in a memoir that from 1458 he had worked for two years with Neri di Bicci; and at the age of 21, after a further year in Filippo Lippi's workshop, he joined Benozzo Gozzoli on a three-year contract to assist him with frescoes in S. Agostino, San Gimignano, and at Certaldo.[73] Although perhaps not typical, such a range of experience could provide opportunities for working under different intellectual stimuli. But Cennino's ideal apprentice worked in a single master's *bottega* for thirteen years, between the ages of ten and twenty-three. He had plenty of time not only to perfect his craftsmanship in the production of altarpieces, for example, but also to benefit from whatever stimuli the *bottega* might offer for intellectual

development. The character of the work that Cennino's apprentice undertook changed, of course, with the growth of his experience. Equally, his experience within the workshop changed and developed in a number of intellectually more demanding directions as the fifteenth century progressed.

Perhaps the most important aspect of the painter's apprenticeship, from our point of view, is the training and experience – artistic and also intellectual – that he gained through the processes of drawing and copying. As Cennino says, 'Those who are moved to enter this profession . . . will take delight in drawing'. He makes clear that after getting used to handling the silverpoint by experimenting in drawing on a prepared boxwood panel, the apprentice should 'take pains and pleasure in constantly copying the best things which [he] can find done by the hand of great masters'.[74] When advising the novice about practising drawing by 'copying from nature', Cennino writes of going out from the *bottega* to copy scenes or figures in churches or chapels. Evidence that copy-drawing was standard workshop practice for the novice comes not only from numerous drawings but also from texts in which the painter's training process is used as an exemplar. Writing to Francesco Bicharano around 1420, the Paduan humanist and teacher Gasparino Barzizza cited the experience of an apprentice painter as an analogy for education in general. '. . . whenever . . . something is to be learned from the master, before they have got the theory of painting', he wrote, 'they are in the habit of handing them some very good figures and pictures, as models of this craft, and taught by these, they can progress a bit by themselves'.[75] Another analogy, this time between the aspiration for the imitation of God and the apprenticeship of a novice painter, shows that in a sermon of 1493 Savonarola recognised the artist's creativity rather than merely his craftsmanship:

> What does the pupil look for in the master? I'll tell you. The master draws from his mind an image which his hands trace on paper and it carries the imprint of his idea. The pupil studies the drawing and tries to imitate it. Little by little, in this way, he appropriates the style of his master . . .[76]

Different though their language and purposes are, both these texts show intellectuals' awareness of the crucial part played by copy-drawing in the painter's *bottega*.

Early in the fifteenth century the principal – but not the sole – sources of visual experience for the apprentice painter were two-dimensional works, such as drawings by his master. The evidence from the workshops of Jacobello del Fiore and Niccolò fu Michele

di San Lio suggests that large collections of drawings existed already at the start of the fifteenth century, at least in Venetian painters' *botteghe*.[77] Such collections from the workshops of Pisanello and Jacopo Bellini a few decades later still survive.[78] A characteristic source for learning by copying two-dimensional models is the late Gothic model-book. These collections of 'pattern' drawings, principally of animals, birds and plants, were an essential property first found especially in Lombard workshops.[79] There are many instances of such drawings being copied and recopied, probably often while workshop assistants built up their own collections of animal models for reuse in panel paintings or in the borders of illuminated manuscripts. Even within the finest surviving model-book, inscribed with the name of the late fourteenth-century Milanese painter Giovannino de' Grassi, the quality of the draughtsmanship varies.[80] Some less experienced artists evidently used the pages of this book to copy out workshop prototypes, perhaps as one facet of their training.

Occasional textual references to such drawings support the evidence of surviving sheets that their use was widespread. In 1530 Marcantonio Michiel recorded in Gabriele Vendramin's collection in Venice a 'quarto-sized parchment book with animals coloured by the hand of Michelino' – that is, Michelino da Besozzo, another important Milanese painter of the early fifteenth century.[81] Copying 'model' drawings continued throughout the century to be a standard feature of the dissemination of artistic ideas in Tuscany as well. At the time of his death in 1438 the Sienese sculptor Jacopo della Quercia, for example, owned a 'sheet of animal drawings', and a decade earlier Lorenzo Ghiberti asked 'that he might have back the sheets of birds that he had lent to Ghoro'.[82] The animals emerging from the ark in the *Noah* panel of Ghiberti's second Baptistery doors indeed appear to be based on model-book drawings. When Pinturicchio needed oriental types to provide authentic-looking staffage figures in the frescoes of the Piccolomini Library in Siena, and of the Borgia Apartments in the Vatican, he made use of copies of drawings made in Constantinople by Gentile Bellini.[83] He also at least once used a model-book drawing copied after Pisanello, and Vittore Carpaccio used drawings from the same source for many details in his *Portrait of a Young Knight* (fig. 12).[84] Similarly, certain figure types, studies of heads and even landscape motifs recur in a range of paintings in the workshops of both Gentile and Giovanni Bellini, again suggesting transmission of motifs through copy-drawing.

Artists' wills sometimes include references to books of drawings, and those of Jacopo Bellini, for example, were evidently highly valued workshop properties.[85] These books include many drawings showing

12 Vittore
Carpaccio, *Portrait
of a Young Knight*
(1510). Oil on
canvas. Madrid, ©
Museo Thyssen-
Bornemisza

systems of narrative composition that often include complex per-
spectival schemes and antiquarian and other details from which
workshop assistants could gain much insight into Jacopo's intellec-
tual preoccupations. The fourteen volumes of drawings bequeathed
at his death by Maso Finiguerra to his goldsmith brother, on the other
hand, were probably principally figure-drawings, to judge from sur-
viving examples (figs 8 and 22) in which the draughtsman explored
what Alberti called 'circumscription' (sketching the outlines of an
object).[86] As late as the 1480s Domenico Ghirlandaio was in-
serting standard details, especially of birds, into the frescoes in the
Sassetti and Tornabuoni chapels in Florence, which suggests that
among his workshop properties he kept copies of earlier model-book
drawings. But alongside these he presumably also had portfolios of
drawings after classical architecture and sculpture, to provide the
all'antica motifs that frequently appear in his frescoes. The so-called
Codex Escurialensis (Madrid, Escorial) is a late example, probably
produced by a member of Ghirlandaio's workshop after the master's

13 Master ES, *St John the Evangelist* (*c*.1460–65). Engraving. London, © The British Museum

14 Baccio Baldini, *Libyan Sibyl* (*c*.1470). Engraving. London, © The British Museum

death in 1494, of this type of 'pattern' book.[87] It has its ancestry in drawings of classical sculpture and architectural details made in albums in the workshops of Pisanello, Benozzo Gozzoli and others.[88] These examples suggest that the process of copying drawings within the *bottega* could have provided the apprentice painter with important information about his master's increasingly learned artistic concerns.

Throughout the Renaissance, therefore, two-dimensional models were vital both in training and in the regular practice of the painter's workshop. One of the most significant developments for these *bottega* processes was the introduction of the printed image, especially in the form of copper-plate engravings. Visual information and motifs could be communicated more rapidly and more widely by engravings than through the practice of copy-drawing. Engravings by the important mid-fifteenth century German engraver, the Master ES, were certainly available in Florence by the 1460s, when some were copied more or less verbatim by Baccio Baldini (figs 13–14) for his series of

15　Martin Schongauer, decorative motif
(*c*.1475). Engraving. London, © The British
Museum

Sibyls,[89] and in northern Italy probably even earlier. While an apprentice in Ghirlandaio's workshop around 1490, Michelangelo copied Schongauer's *Temptation of St Anthony* engraving; and Pontormo was criticised by Vasari for making too liberal a use of Dürer prints.[90] Most engravings were intended to communicate devotional or intellectual ideas, but some were made to circulate decorative forms for reuse in artists' workshops, or as stimuli to decorative inventiveness. A good example is the plant-like form shown in a print by Martin Schongauer (fig. 15): this 'template' may have been intended for use by woodcarvers or other craftsmen whose trade demanded a wide vocabulary of decorative motifs.

Other engravings look like updated versions of the late Gothic model-book, though of course they lack the ingredient of colour. The animal studies enclosed within twenty-four roundels on a curious sheet printed in Florence around 1470 are almost too small and too crudely engraved to be of much value to the aspiring artist.[91] Like model-book motifs they could, however, have been traced or copied into manuscript borders for colouring, or perhaps used in the workshops of other craftsmen working on a small scale, such as embroiderers. In a few prints that show aspects of the hunt and the chase, for example, a range of model-book motifs are speciously brought together in a single scene.[92] Other contemporary Florentine prints, like the *Creation of the World* (fig. 16), may also have been devised with the dissemination of animal studies primarily in mind, for many of the forms are drawn discretely, without overlapping, for ease of reproduction.

With the growth of engraving the range of images that reached artists' workshops and were copied there by apprentices increased. For example, the workshop properties listed in Albrecht Altdorfer's will, written in 1538, include a collection of Italian engravings by

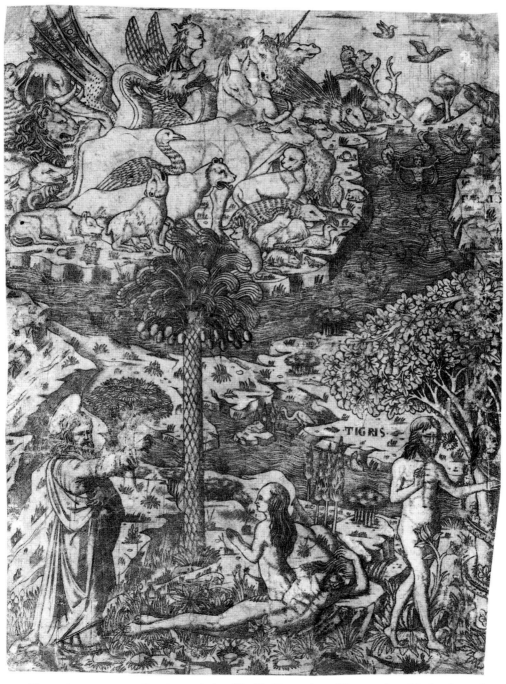

16 Florentine, *c*.1470. *Creation of the World*. Engraving. Vienna, Graphische Sammlung
Albertina

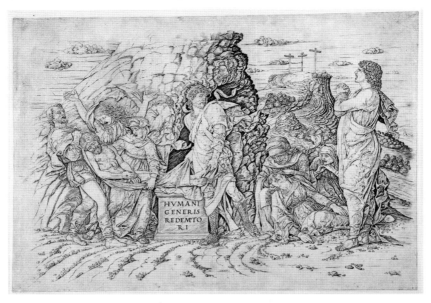

17 Andrea Mantegna, *Entombment* (*c*.1470). Engraving. London, © The British Museum

Mantegna, Jacopo de' Barbari and others.[93] Prints could serve as exemplars of up-to-date compositional design. Mantegna's early plate of the *Entombment* (fig. 17) is rightly often seen as an ideal exercise in the principles of Albertian *istoria*.[94] If Mantegna published this print in an edition large enough for wide dissemination, he may have intended it as a model for others to imitate.[95] But the most important, and perhaps most deliberate, example of what might be termed the 'model-engraving' is Antonio Pollaiuolo's *Battle of the Nudes* (fig. 18), dating from around 1470. Pollaiuolo's fame as a draughtsman of human form is attested in several early references: as early as the 1470s he was recorded as a 'maestro di disegno' by the Florentine merchant Giovanni Rucellai in his *Zibaldone*;[96] and the *Battle* engraving's primary purpose was to demonstrate Pollaiuolo's skill in figure-drawing and to provide a wide public – and not least *bottega* apprentices – with exemplars of the male nude figure in active poses.

The success of Pollaiuolo's instructional graphic works can be measured by the extent to which they were copied and imitated. A woodcut copy of the *Battle* engraving is signed by one 'Johanes de francfordia', who was perhaps a German blockcutter working in Italy around the turn of the century.[97] A North Italian – probably Paduan

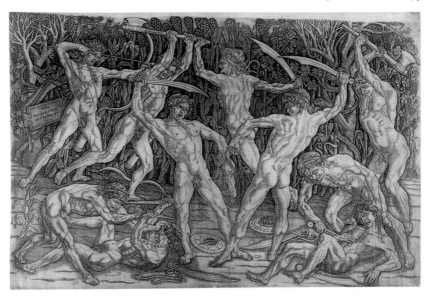

18 Antonio Pollaiuolo, *Battle of the Nudes* (*c*.1470). Engraving. London,
© The British Museum

– engraver produced a crude but influential print after a Pollaiuolo
drawing of *Hercules and the Giants*. This is already reflected in the
Venetian illuminated decoration of incunables printed around 1470,
and in drawings of the early 1470s by the Paduan Marco Zoppo.[98]
The speed with which Pollaiuolo's figure-drawings circulated is also
indicated by the record of a *cartonum* – presumably a large sheet –
'with certain nudes' (*con quisdam nudis*) by Pollaiuolo among
Francesco Squarcione's Paduan workshop properties in 1474, six
years after Squarcione's death.[99] Pollaiuolo's ideas also travelled
rapidly northwards across the Alps. Engravings such as the *Hercules
and the Giants* were certainly known by the 1490s to Dürer, who
interpolated figures evidently derived from such prints into his own
early engravings. Pollaiuolo's method of representing a pose twice,
from front and from back, was already imitated during the 1470s by
Michael Pacher in the *Attempted Stoning of Christ* on his altarpiece
at St Wolfgang in the Tyrol. A little later perhaps, a printmaker
known as the Master PM made a 'pattern' engraving (fig. 19) of two
pairs of nude figures of Adam and Eve seen from different angles.[100]
Dürer also showed interest in Pollaiuolo's reversal system in his
drawing, signed and dated 1495, of the *Abduction of the Sabine*

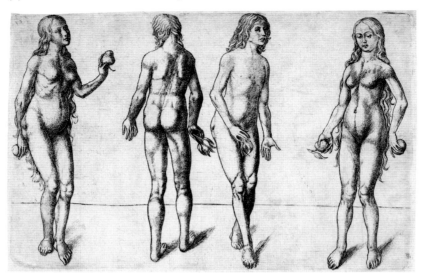

19 Master PM, *Adam and Eve* (*c.*1500). Engraving. London, © The British Museum

Women (fig. 20), and as late as 1528 Barthel Beham was quarrying Pollaiuolo's figure-types in his small-scale *Battle* engravings.[101] These examples demonstrate that Italian engravings became gradually more important early in the sixteenth century as vehicles for spreading Renaissance ideas northwards.

From the last quarter of the fifteenth century printed images communicated not only artistic ideas but also images associated with the new intellectual interests of the time. Dürer, for example, drew copies of prints like the *Battle of the Sea-Gods* by Mantegna. Perhaps the most significant images disseminated through engravings, however, were of classical works of interest to connoisseurs and artists alike. A good example of this practice is an engraving made by a printmaker in Marcantonio Raimondi's circle after the *Apollo Belvedere* (fig. 21).[102] Discovered around 1490 and rapidly absorbed into the collection of Cardinal Giuliano della Rovere and thence into the papal collection in the Vatican Belvedere, the statue was inaccessible to most people. This engraving is, of course, by no means the first two-dimensional copy of this celebrated marble: a copy had, for example, already appeared by the beginning of the sixteenth century in the Codex Escurialensis.[103] But for fuller, clearer dissemination of the forms of classical sculpture, the three-dimensional model served better than the engraving. At the top end of the market, discerning

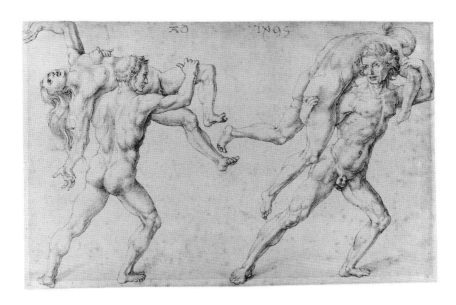

20 (*above*) Albrecht Dürer,
*Abduction of the Sabine
Women* (1495). Pen and ink on
paper. Bayonne, Musée Bonnat

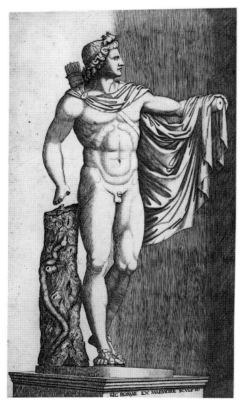

21 Circle of Marcantonio
Raimondi, *Apollo Belvedere*
(*c.*1520). Engraving. London,
© The British Museum

and wealthy patrons could commission small bronze versions of celebrated classical works, such as Antico's parcel-gilt bronze (fig. 68) closely based on the *Apollo Belvedere* and made for Bishop Ludovico Gonzaga.[104] Editions of copies were also made in various lesser materials, notably clay or plaster, for wide diffusion in artists' *botteghe*. Although they were more expensive to make and more difficult to circulate than engravings, three-dimensional models became increasingly popular within workshops as prototypes both for training and practice, and as reproductions of images that were highly regarded by intellectuals.

Studying the Three-dimensional Image

Copying from the two-dimensional image clearly had a role in the painter's *bottega* that lasted throughout the fifteenth and into the sixteenth century. Practice in the sculptor's workshop was inevitably different. Some drawings were certainly made in preparation for sculptural works, for these are often mentioned in contracts and other documents. Attributions of drawings to prominent fifteenth-century sculptors such as Ghiberti and Donatello, however, are problematical, and only a handful of early drawings can be associated with sculptural practice with any certainty. Progressively during the fifteenth century sculptors worked more and more from models in clay, plaster or wax rather than from drawings on paper. Many clay or terracotta models for carving survive from late fifteenth-century Florence: notable examples are the full-scale models, now in the Victoria and Albert Museum, London, by Benedetto da Maiano for the narrative reliefs on the pulpit in S. Croce, Florence. Documents for the project of 1439 for altarpieces by Luca della Robbia for the cathedral of Florence, for example, show that such models were produced earlier in the century.[105] At the time that exploratory drawing on paper was becoming a common practice for painters, modelling similarly became a more standard process used by sculptors when preparing their works. This development had important implications for painters' practice, for their *botteghe* increasingly included three-dimensional models among their properties. As Alberti wrote in *On Painting*:

> if it is a help to imitate the works of others, because they have a greater stability of appearance than living things, I prefer you to take as your model a mediocre sculpture rather than an excellent painting, for from painted objects we train our hand and likeness,

whereas from sculptures we learn to represent both likeness and correct incidence of light . . .[106]

The three-dimensional models available in the painter's workshop were of several types: jointed wooden lay-figures or manikins, models in wax, clay, plaster or bronze, and of course the live model – usually the studio apprentice himself. By studying this range of models, the apprentice painter gained experience of figure-drawing and thus responded to some of the issues that were becoming important in Renaissance *bottega* practice. Foremost among these were the understanding and faithful representation of the human form, both active and at rest, and the awareness of classical precedent in representing form, expression and movement.

As the convincing depiction of the human form in movement – both physical and emotional – increasingly preoccupied the early Renaissance artist, study from three-dimensional models became progressively more important. Such study is most clearly apparent from the evidence provided by surviving drawings made in Central Italian, and especially in Florentine, workshops. The most productive period of Florentine exploration of form and movement using the studio apprentice as model dates from the 1470s and 1480s.[107] Some drawings made rather earlier in the workshop of Maso Finiguerra already show apprentices drawing. These suggest that drawing sessions when apprentices – always available to each other as models – made studies of each other at work were part of the workshop routine. Different drawing techniques may be distinguished: in one a boy sitting on a plank (fig. 22) makes his study on a reusable boxwood panel of the type described by Cennino;[108] on another (fig. 8) the apprentice apparently draws with a quill-pen on paper. The live model had an important advantage in drawing practice over other types of model, in that his pose could be changed regularly with ease. This flexibility was exploited in workshops such as Filippino Lippi's towards the end of the fifteenth century. Many sheets of figure drawings from his *bottega* appear to be series of brief sketches that had to be rapidly executed so that they were completed before the model changed his pose (fig. 23). This practice encouraged both observational speed and accuracy in representing outlines and surface relief. It also led the draughtsman to gain a sharper understanding of anatomical form in movement. The same principle lies behind Leonardo's advice that the painter should

observe and contemplate the positions and actions of men in talking, quarrelling, laughing and fighting together . . . Record these with rapid notations . . . in a little notebook which you

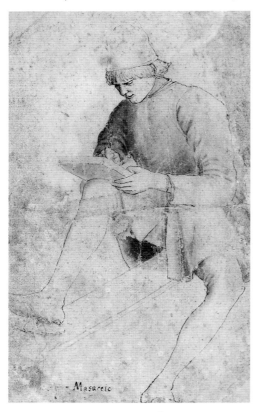

22 Maso Finiguerra, *Seated Boy Drawing*
(*c*.1460). Pen, ink and wash on paper.
London, © The British Museum

should always carry with you. It
should be of tinted paper so that
you cannot make erasures . . .[109]

But conversely, as Alberti had
implied, the human model has
the fundamental disadvantage that
he cannot hold all poses for very
long. Some early Renaissance
figure drawings show that various
devices, such as a box to support
the model's foot, a pole for him
to lean on or ropes to hang on to,
were used to help the model to
hold a difficult pose. But for more
detailed and precise study motion-
less, inorganic models have great
advantages, especially perhaps in
the early stages of training. As
already noted, Alberti advised the
painter to copy sculpture in order
to understand the fall of light on
a relief surface. Cennino Cennini
had already referred to the need
to observe carefully what Alberti
termed the 'reception of light':
'notice where [a figure's] darks and
half tones and highlights come;
and this means that you have to
apply your shadow with washes of
ink; to leave the natural ground in the half-tones; and to apply the
highlights with white lead'.[110] For the study of the fall of light on
draperies a method using linen soaked in glue and draped over a lay-
figure was described with characteristic breathlessness by Filarete in
his *Treatise on Architecture* around 1460:

> Have a little wooden figure, with jointed arms, legs, and neck, then
> make clothing of linen . . . and dress it in this, in the pose that you
> want . . . And if the cloth doesn't hang the way you want, take
> melted glue and wet it thoroughly over the whole figure, and then
> arrange the folds your own way, and let it dry, and they will stay
> in place, and then if you want to do it in another way, put it in
> hot water, and you can change it to another form, and draw from
> this the figures that you want . . .[111]

23 Filippino Lippi, studies of nude and draped figures (*c.*1475). Silverpoint on prepared paper. Oxford, The Governing Body, Christ Church

24 Workshop of Fra Filippo Lippi, studies of drapery. Silverpoint on prepared paper. The Royal Collection © Her Majesty Queen Elizabeth II

According to Vasari, a similar practice was employed by Piero della Francesca who 'was very fond of making clay models which he would drape with wet cloths arranged in innumerable folds, and then use for drawing and similar purposes'. In his life of Lorenzo di Credi Vasari records also a parallel practice in Andrea del Verrocchio's Florentine workshop: among other drawings by Credi, Vasari owned 'some copies of clay models draped in waxed cloth, finished with incredible patience and diligence'.[112]

Early drawings from Fra Filippo Lippi's workshop (fig. 24) suggest that already around 1450 artists copied from models made by some such process as this. These drawings were probably made by apprentices, to be filed as exemplars in workshop portfolios like the 'pouch' recommended by Cennino.[113] They may later have served as models

25　Domenico Ghirlandaio, study of drapery (*c.*1480). Brush on linen. Paris,
Louvre

for drapery forms in paintings produced in the workshop. Closely
similar – if not identical – procedures were still practised in
Ghirlandaio's workshop some forty years later. A well-known
group of drapery studies drawn with the brush on linen, including
some usually attributed to Leonardo da Vinci, was made in the
Verrocchio workshop. One of these, of a sheet of fabric cast over a
prop – perhaps, but not necessarily, a lay-figure – to look like the
drapery falling across the knees and legs of a seated figure (fig. 25),
closely matches the lower half of the Virgin in an altarpiece by

Ghirlandaio, now in the Uffizi, Florence. Using unchanging models of this sort, lengthy and concentrated effort could be put into studying how the relief of the folds could be shown by the cast of shadows and in particular by the fall of light. This was essential if the painter was not only to understand the structure of the anatomical forms beneath, but also to make them crystal clear by carefully defining the folds of the draperies. In his stress on understanding the 'reception of light' Alberti had already emphasised the importance of this practice.

The use of inorganic models had, of course, a much wider application than merely the study of draperies. The use of the cast drapery model from the 1450s at the latest seems to have stimulated the production of other types of sculptural model. Introduced as a *bottega* property perhaps sometime during the first half of the fifteenth century, the jointed lay-figure was a versatile and valuable tool for the study of problematical poses. Fra Bartolommeo's inventory of 1517 records two lay-figures, one of life size, in his workshop.[114] It is difficult to distinguish figure-drawings that were made from the posed lay-figure, but a possible case is the figure of the running maid-servant in the early compositional sketch for Ghirlandaio's *Birth of the Virgin* in the Tornabuoni chapel of S. Maria Novella.[115] The angularity of the outlines and the thin, meagre forms of arms and legs suggest a rather literal reading of the workshop aid. More evidently, a sheet of fabric was cast over a lay-figure in Ghirlandaio's study (fig. 26) for the drapery of the Virgin in his Louvre *Visitation*.

In his *Commentaries*, Lorenzo Ghiberti declared: 'I have done very great favours to many painters and sculptors and carvers in their works. I have made many preparatory models of wax and clay, and drawn a great many things for painters'.[116] Models of the human form in plaster, and sometimes even cast in bronze by goldsmith-sculptors such as Antonio Pollaiuolo (fig. 27), were indispensable visual aids in painters' workshops by the end of the fifteenth century. They contained more information on surface muscular anatomy than could be offered by the more flexible lay-figure. Inventories of workshop properties and other references often record such objects. In a legal judgement of 9 October 1455 it was stated that Marco Zoppo had supplied his master Francesco Squarcione with a large quantity of 'gesso bolognese' for making casts of statuary: he could therefore expect to gain access to 'picturis, improntis, [et] medaleis' in Squarcione's possession. It seems that his apprenticeship fees were paid in kind, in terms of plaster 'for making models . . .'.[117] Squarcione seems indeed to have owned not only drawings but also a quantity of casts after the antique: on 30 October 1467 these casts were described as 'diverse figure toche de biacha'.

26 Domenico Ghirlandaio, study for the drapery of the Virgin in a *Visitation*. Pen, brush, water-colour and white heightening on paper. Florence, Uffizi

'Plaster figures' are already recorded in 1446 in the possession of the Ferrarese painter Niccolò di Alemagna.[118] Casts perhaps similar to these were available in Jacopo Bellini's workshop: in 1471 Anna Bellini, Jacopo's widow, bequeathed to her elder son Gentile not only the books of drawings for which Jacopo is best known but also 'all works of plaster, marble and relief . . . which belonged to the said late Master Jacopo'.[119] Jacopo's plaster casts may have resembled also the '3 heads and one foot of plaster' or the '2 hands of wax and a head of wax' listed in Neroccio de' Landi's inventory of 1500;[120] or the '63 pieces comprising heads, feet and torsos of plaster' recorded in the inventory drawn up after Fra Bartolommeo's death in 1517;[121] or again the '7 heads modelled in plaster' recorded among the work-shop properties left after the death of Francesco Rosselli in 1513.[122] It has been persuasively suggested that the Pollaiuolo drawing of a 'Nude man seen from front, side and back' (fig. 28) was made from a sculptural model.[123] It follows that many figure drawings dating from as early as the middle of the fifteenth century are careful studies

27 (?)Antonio
Pollaiuolo, *Fluting
Marsyas* (*c.*1470–80).
Bronze. Modena,
Galleria Estense

28 (*below*) Antonio
Pollaiuolo, study of a
nude man seen from
front, side and back
(*c.*1475). Pen on paper.
Paris, Louvre

of human anatomy probably derived from plaster or bronze figures. The eleven nude figures placed on a polygonal podium in a drawing in Stockholm (fig. 145) were probably also made from plaster or wax models. Several of these are distantly dependant on classical figure formulae: one resembles a surviving bronze sculptural model (fig. 27), based on the classical *Fluting Marsyas*, that is often attributed to Antonio Pollaiuolo. The indifferent quality of this drawing suggests that even a relatively unaccomplished artist sought in this way to show his engagement with the more intellectually demanding processes and practices of the Renaissance artist's workshop.

Many of Fra Bartolommeo's sixty-three plaster heads, feet and torsos were probably casts of fragments of classical sculpture. Such fragments were probably included among the properties of Squarcione's Paduan workshop. Objects such as the classical sandalled foot with which St Sebastian's real foot is pointedly compared in Mantegna's Paris canvas (fig. 79) might well have been copied from a plaster cast of a marble fragment. Drawings of feet in a sketchbook used in Benozzo Gozzoli's workshop around 1460 (fig. 29) were also

29 Benozzo Gozzoli, studies of casts of feet (*c*.1460), 'Gozzoli Sketchbook' fol. 53. Silverpoint on prepared paper. Rotterdam, Museum Boijmans Van Beuningen

evidently copied from classical fragments, probably known in his workshop in the form of plaster casts.[124] Describing practice in Verrocchio's workshop, Vasari writes about casts produced presumably of alabaster – 'a soft stone quarried in the districts of Volterra and Siena and in many other parts of Italy'. This Verrocchio baked, crushed and mixed with water into a paste that he used 'to cast various natural forms, such as knees, legs, arms and torsos, which he kept by him for copying purposes'.[125] Sculptural aids to drawing practice such as these models are reflected in drawings made in Verrocchio's *bottega*, such as a sheet perhaps by Francesco Granacci which includes a study of a foot-cast much like those in the Gozzoli workshop sketchbook.[126] Roberto Weiss suggested that many artists 'were moved to gather pieces of ancient sculpture . . . for utilitarian purposes . . . a desire to have alongside their pattern books of drawings a selection of models which they could copy, adapt or paraphrase '.[127] The inventory of the estate of the Sienese painter Sodoma, made after his death in Florence in 1529, includes a list of antique objects removed by his pupil Girolamo Magagni. It is a miscellany of classical bits and pieces probably brought together as suitable models for the workshop to use, in a manner characteristic of *bottega* 'working collections' of the early sixteenth century.[128] It included a small bronze of *Apollo*, and several marble feet or parts of feet, both male and female (again perhaps of the sort cast in plaster and studied in Gozzoli's or Verrocchio's workshops), two marble heads without noses and some small terracottas.

Rather than relying on reproductions of classical sculpture, whether two- or three-dimensional, some fifteenth-century artists visited Rome to make drawings after the antique *in situ*. Progressively during the century more drawings, models and engravings were made in Rome itself: through these images knowledge of classical sculpture could be disseminated. The ways in which study of the material culture of classical Rome became a vital aspect of the intellectual enhancement of the Renaissance artist will be the subject of a later chapter. But few *bottega* apprentices could have had the chance to spend much time in Rome. Generally they had to depend on the drawings, casts and occasional fragments of antique statuary that numbered among the properties of their masters' workshops, to provide the lexicon of classical motifs that guided their understanding of human form and movement. Such study was the natural outcome of the growing expectation on the part of Renaissance observers of paintings and sculptures that human figures would be convincingly represented in both images and narrative compositions. As artists sought to communicate their expressive intentions in more

varied and more affective ways, figure poses and movements became increasingly dynamic, and their expressions increasingly dramatic. A growing quantity of visual sources for apprenticeship training that emphasised the need for intellectual evaluation and appreciation became available. Over the course of the early Renaissance period there was a parallel shift in the intellectual purpose and nature of the artist's workshop. From being a centre of craft practice, the Renaissance workshop became the locus of activities that were recognised as intellectually valid.

From Bottega to Accademia

At the time that Cennino Cennini wrote his *Craftsman's Handbook*, at the very end of the fourteenth century, the painter's *bottega* was a site of craft activity. Cennino stressed the manual, artisanal processes that had to be followed by the painter, and wrote only a little about his imaginative licence and expressive powers, or about the pictorial content of finished paintings. Gradually, however, the workshop evolved into a site of more sophisticated artistic practice. In an agreement signed on 30 October 1467, the Paduan painter Francesco Squarcione set out the curriculum of his workshop training course, which included such skills as perspective, foreshortening and anatomical drawing needed by the aspiring Renaissance painter. Squarcione agreed

> to teach [a new apprentice] . . . the principle of a plane with lines drawn according to my method, and to put figures on the said plane, one here and one there, in various places on the said plane, and place objects, namely a chair, bench or house, and get him to understand these things, and teach him to understand a man's head in foreshortening . . . and teach him the system of a naked body, measured in front and behind, and to put eyes, nose, mouth and ears in a man's head at the right measured places . . . and always keep him with paper in his hand to provide him with a model, one after another, with various figures in lead white, and correct these models for him, and correct his mistakes as far as I can . . . [129]

In 1447 Squarcione's Paduan contemporary Michele Savonarola wrote rhetorically of painting as a 'studium', probably referring obliquely to Squarcione's workshop:

> Thus our city owes very much to the university. Nor do I belittle the university [*studium*] of painting; it provides a particular embel-

lishment for our city, as it is to be associated with the study of
letters and the cultivated arts more than the other arts are, as it
is a part of perspective, which deals with the projection of rays.
And this is a part of philosophy . . .[130]

The previously mentioned document of 1455 records two rooms,
each called a 'studium' not a *bottega*, in Squarcione's house in which
apprentices could pursue their studies.[131] Squarcione kept casts and
fragments of classical sculpture in these study rooms to foster his
ambition to upgrade his Paduan *bottega* into a *studium* through the
introduction of an antiquarian approach to classical forms and
objects.

Partly no doubt this reflects the types of study that took place there,
given the plaster casts, the fragments of classical sculpture and the
prints and drawings by Pollaiuolo and others that appear to have
been used as models for study. Already on 28 May 1431 Squarcione
had agreed to instruct a new pupil, one Michele 'figlio di Bartolom-
meo barbiere da Vicenza', and to give him 'commoditatem suorum
exemplorum' – in other words, free access to make use of his work-
shop exemplars.[132] As noted earlier, on 9 October 1455 it was agreed
that Marco Zoppo could look forward to studying 'picturis, impron-
tis, [et] medaleis' in Squarcione's *studium*. The evidence of drawings
suggests that the workshops of Benozzo Gozzoli in the 1460s,
or of the Pollaiuolo brothers certainly by 1475, were similarly, if
perhaps less portentously, concerned to establish their credentials
as proto-academies.

At the end of the fifteenth century Botticelli's workshop was, admit-
tedly ironically, called 'un accademia di scioperati' (an academy of
idlers).[133] By this time the concept of the *studium* or 'accademia' was
becoming more institutionalised, for example in the celebrated
Giardino di S. Marco, and in the 'Accademia leonardi vinci'. The
Giardino di S. Marco – 'the first academy known to the history of
art'[134] – was established by Lorenzo 'the Magnificent' de' Medici on
a site looking on to the Piazza S. Marco in Florence. It was intended
in a sense as an art school where promising young artists – notably
Michelangelo, but including briefly Leonardo da Vinci in the very
early 1480s, Francesco Granacci, Pietro Torrigiano and others –
studied under the tutelage of Lorenzo's 'house sculptor' Bertoldo
di Giovanni.[135] Available to them were pieces of classical sculpture
from Lorenzo's own collection lodged there for study purposes.
Writing in his life of Pietro Torrigiano, Vasari described it as a 'school
and academy for young painters and sculptors and for all the
others who devoted themselves to drawing'.[136] He may, however, have

overstated the case in his eagerness to present the Giardino di S. Marco as a deliberate percursor, under Lorenzo's patronage, of the Accademia del Disegno, which he encouraged Cosimo I de' Medici to establish in 1563. It is in fact unlikely that there was any formal, systematic programme of study at the Giardino di S. Marco. It was nevertheless important in that it provided opportunities for intellectual development without the constraints of *bottega* organisation. Pupils were not formally apprenticed as in the *bottega* system, for the Giardino had no commercial organisation and was not established to produce merchandise. There were therefore no manual labours to be performed in support of the master in the workshop's production. The Giardino existed solely to enable young artists to study.

The 'Accademia leonardi vinci', on the other hand, was more notional than real, for it had no physical location. But Leonardo's use of the term 'accademia' suggests that he sought for a context in which the apprentice's training would be intellectually more sophisticated than it was in the *bottega* of the quattrocento painter. Perhaps he hoped that it would be seen as the painters' intellectual equivalent to the philosopher Marsilio Ficino's Accademia Platonica in Medicean Florence. His advice to novice painters – 'first study science, then follow the practice born of that science'[137] – indicates that he believed that some academic education was a necessary preliminary to a workshop training in the practice of painting. Although probably no formal curriculum for his 'accademia' was ever drawn up, Leonardo's notebooks indicate some of the areas of the study of science that he would recommend to the novice: 'A youth should first learn perspective, then the proportion of things. Next he should learn from the hand of a good master, to gain familiarity with fine limbs . . .'; and scornfully he wrote: 'there is a certain breed of painter who, having studied little, must spend their working lives in thrall to the beauty of gold and azure'.[138]

Baccio Bandinelli's 'Academia . . . in Roma in luogo detto Belvedere', illustrated in Agostino Veneziano's engraving of 1531 (fig. 30), may be seen as the exemplar of the fully established academic art school at the end of the period treated in this book. Drawing practice here, in which artists studied nude figures and statuettes, followed the precedents set in Lorenzo de' Medici's Giardino di S. Marco. Two of the Bandinelli 'academia' artists shown in the engraving are copying a bronze by Bandinelli himself, extrapolating from practice in the later quattrocento *bottega*. In the early sixteenth century – indeed, until institutionalised in the Accademia del Disegno – the 'academia' was still a free, informal gathering of men of common interests for discussion and study. Another descendant of

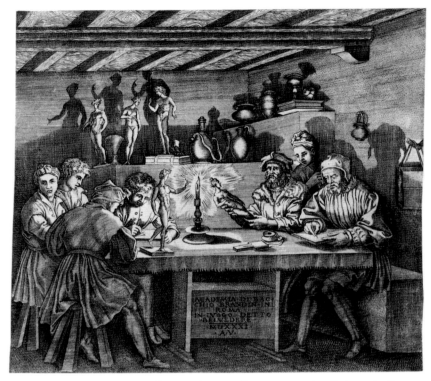

30 Agostino Veneziano, *The 'Academia' of Baccio Bandinelli* (1531). Engraving. London, © The British Museum

Lorenzo's Giardino was the Roman sculpture garden established by his son Giovanni (later Leo X), in which he located a collection of classical sculpture, and where Vasari probably studied when in Rome in 1532.[139] The Accademia del Disegno was a development of a generation later, and two generations later than the period covered in this book. But it was a natural outcome of the increasingly intellectual characteristics of the early Renaissance apprentice's training. This progressively incorporated areas of study such as perspective, the understanding of anatomy, and the general principles of classical art learned through copying. Moreover, early Renaissance *bottega* practice developed an increasing concern with issues such as the artist's creative licence, hitherto proper perhaps only to the established liberal arts. This development demonstrates a parallel growing ease of interchange between painting and those fields of study.

Chapter 3

The Social and Cultural Activities of the Renaissance Artist

During the early Renaissance, shifts in attitudes towards the artist affected both his social status and the extent to which he was valued as an intellectual. The favoured court artist in the early fifteenth century might be made a *valet de chambre* or a *familiaris*, the title bestowed, for example, on Pisanello by Gianfrancesco Gonzaga of Mantua in 1439.[1] This position gave him a somewhat higher standing within court society than that of other artisans, a position from which he could aspire to become a courtier, but he did not yet rank intellectually alongside the courtiers. Similarly, Cennino Cennini's *Craftsman's Handbook* offers little sense that the painter who worked in an urban context around 1400 aspired to be more than an artisan. Early in the sixteenth century, however, the Mantuan court sculptor Giancristoforo Romano, who was sufficiently learned and respected to advise Isabella d'Este on the purchase of antiquities, was adopted by Castiglione as one of the courtiers who joins in the discussion of court manners in *The Book of the Courtier*. His position in the entourage of Beatrice d'Este, the wife of Ludovico Sforza of Milan, included singing in her travelling choir. Ability as a musician was one of the measures of the courtier: Leonardo da Vinci was celebrated at the Sforza court in Milan for his talents as a player of the *lira da braccio*, an early form of the violin.[2] The mathematician Luca Pacioli, who elsewhere described Leonardo as 'the prince today amongst mortals', reports on a debate that took place in the Sforza court in 1498 and in which Leonardo promoted the status of painting.[3] By the turn of the century, the aspirations towards intellectual recognition of such artists as these were increasingly fulfilled especially by courtly patrons. Artists were more and more likely to be given titles and other signs of nobility; they were increasingly able to afford fine houses and dress; they were more frequently asked for advice or opinion about works of art; and more frequently they formed their own art collections. It is such

developments as these that provide the material for consideration in this chapter.

Honours and Titles

The title of *valet de chambre*, used in northern courts for those close to the prince, was given as a kind of promotion, and the holder of this title could hope for higher titles in the future. He bore responsibilities concerned with the maintenance of the ruler's well-being, but his status did not necessarily carry implications of special intellectual ability. On the other hand, at the Italian courts the *familiaris* could gain respect for his special abilities. When Giotto was described as 'our familiar and faithful servant' by King Robert of Anjou in January 1330, the letter of appointment states that he 'brilliantly performs honest acts and fruitful services' and speaks of his 'extraordinary skill' (*virtus discretiva*): that he produced a painting of distinction conferred distinction in turn on the painter.[4] Also in Naples, in 1355, the Sienese painter Andrea Vanni signed a work of his as 'painter and most familiar servant to our lady Queen Joanna';[5] and a century later in 1449 Leonardo da Besozzo was appointed 'familiarem et pictorem ordinarium primum et maiorem camere nostre' by Alfonso of Aragon.[6] When he moved to Rome in the late 1420s Gentile da Fabriano was granted the status of 'dilectus familiaris' to Pope Martin V,[7] and Mantegna was already called 'carissimum familiarem nostrum' to Ludovico Gonzaga in the appointment charter of 30 January 1459.[8] Even in Florence, a firmly republican city, Bertoldo di Giovanni, Lorenzo de' Medici's bronze sculptor and teacher in his Giardino di S. Marco, became his *familiaris* in 1480:[9] an indication, perhaps, or a result of the increasingly courtly character of Lorenzo's regime.

However, to hold these titles, and to enjoy the security and princely benevolence implied by them, could not fulfil the growing pretensions of some later quattrocento artists. Clearly their motives for seeking – and even, when necessary, for purchasing – titles varied. Nevertheless, to gain a title of nobility became increasingly an aspiration, not merely through personal vanity and ambition but also because reaching the level of nobility conferred a higher status on their art and on their activity as artists. It was traditionally argued that nobility was not only inherited by birth and blood, but also could be granted in recognition of an individual's spiritual and intellectual qualities. From the point of view of this discussion, however, the fact that knights or nobles were not permitted to engage in activities regarded as suitable

only for craftsmen and artisans, but only in the liberal arts, is the most important.[10] The acquisition of a title therefore met one of the expectations of Renaissance art theory already loudly enunciated in Alberti's *On Painting*: if an artist gains a title his art cannot be mere craftsmanship. Painting and sculpture could not then be merely artisanal occupations, but deserved to be numbered among the liberal arts.

In the fifteenth century the only artists to be knighted were Italian, and seven of the twelve recorded knighthoods were conferred by foreign princes – three, for example, including the sculptor Giovanni Dalmata, by Matthias Corvinus, King of Hungary.[11] In 1446 Dello Delli was knighted in Spain, and this status was confirmed even in republican Florence on his return there.[12] In Naples, too, knighthoods were conferred by King Ferrante on Pietro da Milano in 1458 and on Guglielmo Monaco, the sculptor of the bronze doors of the Castel Nuovo, around 1470.[13] In a letter of 1458 Ludovico Gonzaga wrote that Mantegna's salary in his service in Mantua would be 'the least of his rewards'. Amongst other 'rewards' and inducements offered to Mantegna to attract him from Padua were the use of the Gonzaga motto, and the coat of arms that appears on the first seal he used in Mantua, to be replaced in 1472 by a second seal with the head of Caesar.[14] In 1469 Mantegna went to Ferrara to meet Frederick III, in the hope of obtaining the title of Count Palatinate, which only the Holy Roman Emperor could confer. A letter of 2 February 1469 records that 'Andrea Mantegna says that he too will be made a Count, and hopes for the privilege'.[15] Ludovico Gonzaga's secretary reported that optimistically Mantegna had 'hoped to get the title free'.[16] Described as 'spectabilis eques' on 13 March 1484, he had also by then acquired the title of 'Knight of the Gilded Militia', a title of questionable validity that nevertheless Mantegna displayed proudly, as though a signature, in the (lost) decoration of Pope Innocent VIII's chapel in the Vatican Belvedere.[17] He was also made Count by Innocent VIII in recognition of this work. A knighthood was purchased for him from Emperor Frederick III by Francesco Gonzaga in 1488, apparently, Vasari implies, to make him a more fitting envoy to the court of Rome.[18] There seems no doubt that Mantegna pressed hard for ennoblement, presumably seeing the acquisition of titles as a means of enhancing his social status and his relations with other intellectuals at court.[19] As in many matters, Mantegna is perhaps a special case; but his case may be seen as an extreme example of a general pattern.

Like his brother-in-law Mantegna, Gentile Bellini purchased the title of Count Palatinate from Frederick III in 1469. When in

Constantinople in 1479–81 he was also given the title of 'eques auratus' in honour of a portrait he had painted of Sultan Mehmet II. As a result of this he used 'eques' in his signature on paintings after 1481,[20] but he was criticised by Andrea Michiel as a 'puffed-up knight of the Golden Spur'. Carlo Crivelli was knighted by Ferdinand, Prince of Capua (later King Ferdinand II) on 9 April 1490; hence his signature CAROLUS CRIVELLUS VENETUS MILES PINXIT on the *Madonna della Rondine* (London, National Gallery). In 1518 Sodoma was also entitled by Leo X to style himself 'eques'. Further afield, in 1491 Candida had been appointed 'Conseilleur du Roy' to Louis XI of France: he was perhaps the first artist to hold this position, which presumably brought him into close association with the monarch and his affairs; and the sculptor Guido Mazzoni was ennobled in 1495 by Charles VIII of France.[21] Sometimes artists were rewarded with honours and titles as a result of the civic and ambassadorial responsibilities that they took on. Jacopo della Quercia, for example, was knighted by the city of Siena on 1 August 1435 for his activities as prior and advocate for the city. The position he gained within Sienese society was perhaps the platform from which he was appointed to report to the Sienese authorities on the political situation in north Italy while he was in Bologna from 1435 to 1438, working on the portal of S. Petronio. Jacopo della Quercia's knighthood also allowed him to see himself as a 'designer' rather than as an artisan when in Bologna.[22]

It is difficult to assess the significance of these titles and positions of trust, in the absence of comparative material. What can perhaps be concluded is that later in the fifteenth century the conferment of titles and responsibilities by kings and princes on artists became more frequent; and the artist's desire to acquire such honours and titles was sharpened. To acquire titles was a sign of social enhancement in the direction of nobility; to take on court or civic duties implies a certain learning, responsibility and perhaps even intellectual achievement. It may be seen then as one more vehicle for the artist to seek to show his social and intellectual advancement.

Civic and Courtly Responsibilities

The Florentine sculptor Nanni di Banco held a number of important civic appointments that reduced the amount of time he had available to accept commissions for sculpture. He was consul of the Stoneworkers' Guild on two occasions (January–April 1411, and May–August 1414), which may explain why he was chosen by the

guild to carve the group of the *Four Crowned Saints* for their niche on Orsanmichele. More importantly, he held the post of *podestà* in small towns in Florentine territory: from August 1414 to January 1415 in Montagnana Fiorentina and from June to December 1416 at Castelfranco di Sopra.[23] Serving the oligarchy by taking on posts like these indicates both that Nanni di Banco enjoyed the political patronage of the ruling elite, and that he saw it as a route to gaining important commissions, such as the *Assumption of the Virgin* relief on the Porta della Mandorla of Florence cathedral.

A number of artists were elected to their local town councils: Perugino was a prior in Perugia; Piero della Francesco was a town councillor in Borgo Sansepolcro. The Sienese sculptor Jacopo della Quercia also took on civic duties, being elected a prior in Siena in 1420 and again in 1435.[24] On 30 July 1480 Federigo da Montefeltro petitioned the Sienese government on Francesco di Giorgio Martini's behalf, asking them to admit 'my excellent architect to its excellent government, for this is what his spirit, his goodness, his wisdom and his quality demand'.[25] As a member of the *priori* in Cortona, Signorelli was sent to Florence after the restoration of the Medici in 1514 to pay Cortona's respects to the new regime.[26] These positions gave the painters enhanced status within their own communities. Examples from northern Europe also suggest that artists saw the undertaking of civic duties as a means of raising their social status, even though they might take time from their artistic activities. In 1509 Dürer was made a *Genannter*, a member of Nuremberg's Great Council, and the limewood sculptor Tilman Riemenschneider became mayor of Würzburg in 1520. On the other hand, Albrecht Altdorfer rejected an invitation to become mayor of Regensburg in 1529 on the grounds that he was preoccupied with painting the *Battle of Alexander* (Munich, Altepinakothek), one of his most important works.

Another aspect of the civic or courtly administrative activities that artists might be called upon to undertake was working as diplomats, or even as spies. Simone Martini was authorised to undertake negotiations on behalf of the Sienese government when he moved to the papal court at Avignon in 1336;[27] and Andrea Vanni was 'imbaciadore da Qumuno' – of the commune of Siena – in Avignon, Naples and Florence during the 1370s.[28] When the city of Constance sent a diplomatic mission to Emperor Frederick III in 1464, the painter Gebhart Dacher was one of its members: the emperor gave him a new coat of arms, and on his return the town council granted him tax exemption for the rest of his life.[29] In 1480 Leonardo da Vinci and the lutenist Atalante Migliorotti were sent by Lorenzo de' Medici to

Milan to deliver a gift to Ludovico Sforza,[30] which may suggest that the painter, although aged only 28, already had much the same status and responsibility as a musician. Similarly, Michelangelo was sent to Rome by the Signoria as 'ambassador of the Republic' to Julius II in 1506, a title that (according to Condivi) was, however, bestowed on the artist to protect him from the pope's wrath.[31] While in Rome painting the chapel for Pope Innocent VIII, Mantegna also took on a diplomatic role on Francesco Gonzaga's behalf;[32] and Jan Gossaert, too, was in Rome in 1508–9 on a diplomatic mission in the entourage of Philip the Fair of Burgundy.[33]

Sometimes the peripatetic character of some artists' activities could be exploited for less open purposes: Marcello and Agostino Fogolino spied for Venice in Trento;[34] Francesco di Giorgio Martini reported back to Siena on papal and Florentine troop movements;[35] and Jan van Eyck journeyed south of the Alps 'for various secret purposes'.[36] However, van Eyck also visited Portugal with the Duke of Burgundy's embassy to negotiate his betrothal to Isabella of Portugal in 1428. This may suggest that the painter was considered with special regard by his patron, but van Eyck's presence may have been required principally in order that a portrait of the princess could be brought back to the duke. Perhaps the most celebrated example of this practice is Hans Holbein's portrait of the Duchess of Milan (London, National Gallery), which is one of several portraits of prospective brides made for Henry VIII of England. Portraits of Beatrice d'Aragona were sent out in 1474 to Charles VIII of France, to Filibert of Savoy and to King Matthias Corvinus of Hungary, to whom Beatrice was married two years later;[37] and more generally, Francesco Laurana's Aragonese portrait busts may also have served as diplomatic gifts. The movement of artists and their works in the service of diplomacy had the potential advantage of increasing both knowledge and appreciation of the artists' abilities and the general regard in which they were held by possible new patrons.

The Artist as Architect and Householder

An aspiration of some artists was to progress towards a practice as an architect. The inscription on the Finiguerra workshop drawing (fig. 8) noted in the last chapter runs 'How to be a good draughtsman and to become a good architect'.[38] This offers an interesting insight into how the novice (perhaps optimistically) saw future possibilities opening up before him once he was skilled in drawing. Given that architecture was one of the liberal arts, whereas painting and

sculpture figured merely as 'mechanical arts', architectural practice was regarded as a higher level of artistic activity. Vasari later wrote of artists rising 'from the depths to the heights, especially in architecture', for architecture 'can only attain perfection in the hands of those who . . . have had great experience in painting, sculpture and wood-carving'.[39] The transition from sculpture to architecture was perhaps a more natural one than from painting. It was often the sculptor's task to design and construct church furnishings or tomb monuments, sometimes on a scale large enough to require the skills of the mason or civil engineer. Trained as a marble carver in Nicola Pisano's workshop in the 1260s, Arnolfo di Cambio designed and started work on building the new cathedral of Florence in 1296.[40] Filippo Brunelleschi started his career as a goldsmith and bronze sculptor, and Lorenzo Ghiberti took on architectural projects such as the Strozzi sacristy of S. Trinita, designed around 1415. The marble-carver Michelozzo di Bartolommeo, Donatello's business partner in the 1420s, established his new career from the mid-1430s as principal architect to Cosimo de' Medici; and the bronze sculptor Filarete, who showed his eager intellectual aspirations in various ways, wrote the first architectural treatise by a practising sculptor.

However, many prominent architects were initially trained as painters and had little or no experience of sculpture when they first undertook architectural projects. Giotto's appointment as *capomaestro* of the Florence Duomo in 1334 set a precedent for painters to emulate, although his achievement remained unmatched until the later fifteenth century. Trained as a painter, the Sienese Francesco di Giorgio Martini had a career that matured through sculpture to architecture by the 1480s, and to the writing of another important architectural treatise. His Sienese contemporary, the painter and sculptor Lorenzo Vecchietta, also undertook architectural projects for the Spedale della Scala in Siena, with which he was closely associated throughout his career. That from this time onwards painters more frequently took on commissions for architectural works indicates their growing success in emulating Giotto's remarkable achievement. From around 1500 there was an increasing tendency for painters to be appointed court architects: Donato Bramante, originally a painter in Urbino, took up architectural work in Milan from about 1480 and later designed perhaps the greatest building of the period, St Peter's in Rome, for Pope Julius II. Cesariano wrote of Bramante that at first he was a painter, and not a bad one either, but then he advanced to architecture ('pervenne alla Architettura').[41] Leonardo da Vinci experimented with questions of architectural design in centralised-plan churches and worked on a number of architectural

projects in Sforza Milan.[42] Perhaps the most impressive example, as
in many other respects, is Raphael: initially trained as a painter, he
was appointed architect of St Peter's in 1514, on the death of Bra-
mante, when he was only 32.[43]

Andrea Mantegna, too, practised as an architect, but only on one
exceptional occasion. Perhaps taking his lead from his Mantuan col-
league the architect Luca Fancelli, who designed a house for himself
in Mantua around 1460, Mantegna also designed his own house in
that city, very close to Alberti's church of S. Sebastiano. Mantegna
appears, however, to have been the only early Renaissance painter
whose high prestige and wealth permitted him this noteworthy
achievement. One of the recognised obligations of the prince who
took in an artist as a member of his household was to ensure that he
had appropriate living and working quarters. Indeed, the court
artist's right to suitable accommodation was one of the perks that
went towards ensuring the security that compensated for his depen-
dence and servitude. While still trying hard to persuade Mantegna to
take up his court position at Mantua as soon as possible, Ludovico
Gonzaga wrote to him on 4 May 1459 'that your house is in order,
and you may arrive at your pleasure'.[44] Cosmè Tura, who in 1457
was similarly given living space in the castle at Ferrara, was able to
escape the pressures of court life when in 1486 he was permitted to
convert a tower on the city wall into a house for himself.[45] A decade
earlier, however, Mantegna was in a position, both financially and in
terms of artistic and architectural skills, to design and construct his
own house. As the only documented case in the fifteenth century, this
is an unprecedented example of the social and intellectual level to
which an artist might aspire.

In his preliminary negotiations with Ludovico Gonzaga between
1457 and 1460 on the terms and conditions of his move to the
Mantuan court, Mantegna had made it clear that he was not pre-
pared to live as a servant in rooms in the Castello. His own house
was begun in 1476 on land given to him by Ludovico; but it was
probably not yet complete when Mantegna had to sell it back to
Francesco Gonzaga in 1502.[46] Although construction was still under-
way in 1494, Mantegna had moved in by 1496, for in that year the
Madonna della Vittoria was carried in procession 'from his house
... in front of S. Sebastiano'.[47] The scale of Mantegna's house and
its gardens were such as to make it appropriate for a noble, rather
than for an artist or artisan, in the last quarter of the fifteenth century:
in size and plan it was equivalent to a small seigneurial palace.
However, some of the theoretical suggestions about the type of build-
ing appropriate as an artist's house in the treatises of Filarete and

31 Mantua, House of Mantegna (1476–96), ground-plan

Francesco di Giorgio Martini were here put into practical application. The plan (fig. 31), with rooms surrounding a central circular courtyard, appears to be based on the plans of houses and palaces drawn by Francesco di Giorgio and inspired by monuments that he had seen in Rome in 1463. Mantegna's intention for the courtyard may have been to emulate contemporary interpretations of Pliny the Younger's description of his Laurentian villa.[48] Moreover, it was perhaps intended to be covered with a lightweight dome, of brick or tufa perhaps, which would have been supported on the rotunda wall. If so, it could be that the courtyard was intended at the start by Mantegna as a display court for his collection of classical statuary.

In Florence it was normal for artists to have living accommodation distinct from their workshops; and often they invested in land and properties outside the city. Sometimes, however, patrons gave property to particularly highly respected artists who worked regularly for them. Palla Strozzi bought a house for Gentile da Fabriano in Florence, for example, and (according to Vasari) Donatello was given a farm in the country by Piero de' Medici; but he could not cope with the problems this created and soon returned it to his patron.[49] On 24 April 1503 the Wool Guild (Arte della Lana) contracted with Michelangelo for the carving of a series of twelve apostles for Florence cathedral. These were expected to take him twelve years, but he was to be paid only two florins a month, a third of the amount

that he was paid for the colossal marble *David*. This, however, was because the contract included provision by the guild of a plot of land and a house that was to be built especially for Michelangelo to a design by the architect Il Cronaca.

On 15 June 1509 Dürer, then aged 38, was in a position to buy the large and prestigious house on the Zisselgasse in Nuremberg that had previously belonged to the celebrated mathematician and astronomer Regiomontanus.[50] Although aged only 30, Raphael was already able in 1517 to buy the Palazzo Caprini (still often known as the 'House of Raphael') in Rome for the substantial sum of 3,000 ducats. This was a small palace, but one built by Bramante only a few years previously in the most up-to-date, classicising taste, and his purchase may be seen as a conscious statement by Raphael both of his wealth and of his wish to display his aesthetic preferences. Apart from these few established examples, however, we have little evidence about the early Renaissance artist's living accommodation, its scale and architectural pretensions, or its internal decoration and furnishings. Once again, the examples of Mantegna, Dürer and Raphael may be exceptional, given indications in other respects that these three pursued their aspirations towards higher status more vigorously than others. Nevertheless, it is predictable that, as with many other aspirant groups within many other societies, for early Renaissance artists their properties may have been sites of display of personal and professional ambition. Evidence survives in the cases cited here perhaps because they were the more ostentatious examples of the period, but it is at least possible that they may have blazed trails for other artists to follow.

Artists' Dress

Renaissance artists seem also at times to have proclaimed their sense of individual and professional identity through the dress they wore. This manner of demonstrating status has, of course, the advantage over display in the form of a house and its contents, in that dress moves with the wearer and does not have to be visited to be appreciated. It had a second advantage for the Renaissance artist: it could be appropriately represented in the form of a self-portrait. At the beginning of the period covered in this book the only form of dress apart from his artisanal workshop clothing likely to be available to the artist was his prince's livery. Although not instrumental in the making of a personal statement, this could, however, in itself offer

opportunities for the display of enhanced social status: the clothing that a painter was permitted to wear could carry important connotations about his position. Once an artist at court, for example, had been accorded the status of *valet de chambre* he was provided with superior clothing 'so that he could cut a better figure in public',[51] and deeds of appointment always mention the entitlement of the *valet de chambre* to dress befitting his position and status. A painter who was appointed to a post as town painter in northern Europe, such as Jacques Cavael at Ypres in 1400,[52] and Rogier van der Weyden in Brussels in 1436, gained permission to wear the robes of a town official. When Gentile da Fabriano moved to Venice to paint his lost fresco cycle in the Doge's Palace in 1408, he was (it is said) granted the right to wear patrician dress, which would have been a prestigious break from convention.[53] The clothing allocated to Francesco Laurana at the court of René d'Anjou and Jeanne de Laval in Provence in 1477 was the equivalent to the dress entitlement of a grand seigneur.[54] Perhaps it was because he feared being obligated to his patron, as a court artist was to his prince, that Donatello considered it inappropriate that he should wear the splendid red mantle and cloak that his great patron Cosimo de' Medici had given him, according to the bookseller Vespasiano da Bisticci:

> because Donatello was wont to go clad in a fashion not to Cosimo's taste, Cosimo gave him a red mantle and a cowl, with a cloak to go under the mantle, all new, and one festal day in the morning he sent them in order that Donatello might wear them. After a day or two of wear he put them aside, saying that he would not wear them again as they were too fine for him . . .[55]

Despite Donatello's perverse example, Vasari reveals his assumption that the artist who has made good will dress well: Jacopo Sansovino, for example, 'loved to dress like a gentleman',[56] and Luca Signorelli 'lived rather like a great lord and gentleman than as a painter . . . he lived magnificently and was fond of fine clothes'.[57] When in Spain the knighted Dello Delli 'could work and live like a noble, always painting in an apron of brocade', and on his return to Florence in 1446 he rode 'to his house on horseback . . . clothed with brocade'.[58] Curiously impractical though it might seem to wear a brocade apron while painting, as a metaphor for success it echoes ways of thinking about the significance of dress and fabrics shown in the writings of painters themselves. In his *Craftsman's Handbook* Cennino Cennini wrote: 'And let me tell you that doing a panel is really a gentleman's job, for you may do anything you want to with velvets on your back'.[59] That the craftsman-painter should wear velvet at all, let alone

when painting on panel, is an indication of the recognition for his craft that Cennino sought – but his remark may be purely metaphorical. Although Cennino may not have known it, a similar use of rich dress as a metaphor for artistic recognition occurs in Pliny's *Natural History*.[60] He wrote of his contemporary Famulus, one of the decorators of Nero's Golden House in Rome, that he painted for only a few hours each day and 'was always wearing the toga, even when he mounted a scaffolding'. In this, Famulus perhaps took his cue from the Greek painters. Again according to Pliny, Zeuxis 'showed his name woven in golden letters into the embroideries of his garments' in order to show off his wealth. His great rival Parrhasius called himself the 'Bon Viveur',[61] and Athanasius of Naukratis added that, as signs of this luxurious life-style, Parrhasius 'wore a purple cloak and had a white fillet upon his head, and leaned on a staff with golden coils about it, and fastened the strings of his shoes with golden latchets'.[62]

If not known by Cennino, comments of this sort were doubtless well known to most late fifteenth-century Italian artists. They may lie behind Leonardo da Vinci's view, expanding upon Cennino's, that one of the advantages that the painter has over the sculptor is that he

> sits before his work at the greatest of ease, well dressed and applying delicate colours with his light brush, and he may dress himself in whatever clothes he pleases. His residence is clean and adorned with delightful pictures, and he often enjoys the accompaniment of music or the company of the authors of various fine works that can be heard with great pleasure without the crashing of hammers and other confused noises.[63]

It is perhaps partly to emphasise the tidiness and comfort of panel painting, as well as to emphasise the painter's relative wealth and social good standing, that in self-portraits of the early sixteenth century the observer seems almost to be invited to imagine the painter seated before his easel wearing remarkably fine clothes. In his now lost, presumed self-portrait (fig. 32) Raphael shows himself in splendid clothes. With his elegant, relaxed pose, his rakishly worn dark beret, and the stress he characteristically placed on the textural contrasts between fur and the silky fabric of the robe cast carelessly over his left shoulder, Raphael displays the *sprezzatura* of Castiglione's ideal courtier. In his celebrated *Self-portrait in a Convex Mirror* (fig. 112), probably painted as a demonstration of his talents when he moved to Rome in 1524, Parmigianino also wears what appear to be elegant cuffs and collar within a fur-trimmed robe.

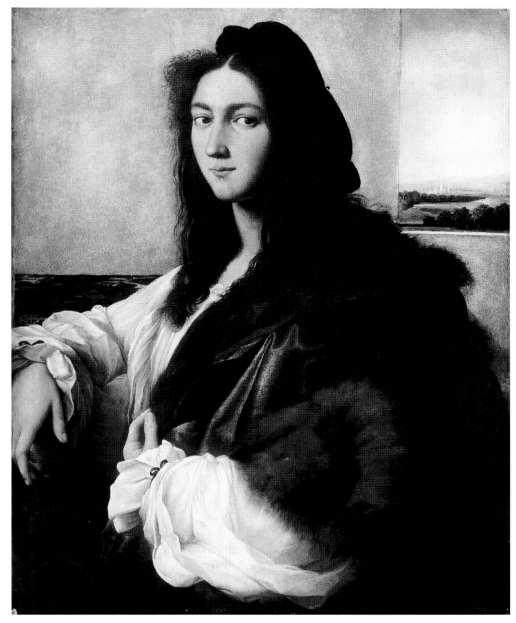

32 Raphael, *Portrait of a Young Man (?Self-portrait)* (*c*.1512). Oil on panel. Destroyed; formerly Kraków, Czartoryski Museum

In his painted self-portraits, Dürer, too, is clearly richly dressed. Neatly bearded in the painting of 1498 (fig. 132), he wears a fashionable, finely tailored, black-and-white striped tunic and a jaunty hat to match. His fine gloves made of grey doeskin,[64] a Nuremberg speciality here worn doubtless to impress his fellow townsmen, suggest that at the age of 26 he was already upwardly mobile in Nuremberg society. In the self-portrait of 1500 (fig. 133) he wears a fine deep brown coat with a brilliantly represented fur collar. It conforms with recent high fashion for noblemen, and indicates the further rise in his social status, since fur-trimmed clothes were regulated by the Nuremberg City Council. His interest in fine clothes is borne out also by the fine coat with light-brown fur that he wears (fig. 1) in the *Rosenkranzfest*, an altarpiece that, as Dürer himself indicates by pointing towards a sheet of inscribed parchment, was 'painted in the space of five months' in 1506.[65] Moreover, the last of his group of ten letters to Willibald Pirckheimer, written from Venice in September–October 1506, gives an account of some of the clothes he had purchased, ready to return to Nuremberg attired in the most elegant fashion. He refers to his French mantle, his Hungarian husseck and his brown coat. A further indication of his desire to rise in society comes in his account of his attempt to learn the socially graceful art of dancing:

> I set to work to learn dancing and went twice to the school. There I had to pay the master a ducat. Nobody could make me go there again. I would have to pay out all that I have earned, and at the end I still wouldn't know how to dance!

The attempt may not have been a success, but it yet again indicates an aspiration to climb socially once Dürer had returned home to Nuremberg.

Patrons' Visits and Artists' Gifts

On occasion the artist (whether or not dressed in velvet) was able to welcome patrons or other interested visitors to his workshop, or to impress visitors with the quality of his living accommodation and its furnishings. On 4 July 1523 Girolamo Genga wrote to the Duke of Urbino that Sigismondo Chigi had visited him in his workshop 'out of a fine desire . . . to see me at work'.[67] By this time, such contacts between princes and their artists were becoming less of a rarity. Philip the Good had made a personal visit to Jan van Eyck's Bruges workshop;[68] according to Jan Gossaert's biographers, Philip the Fair ha-

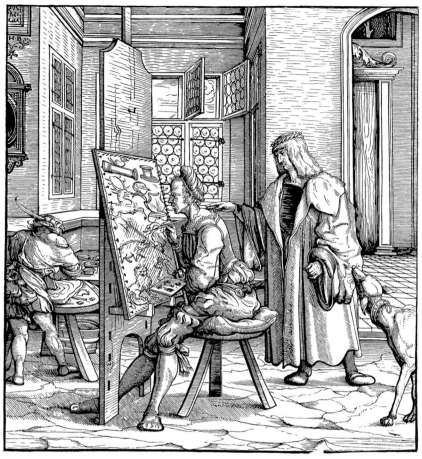

33　Hans Burgkmair, *Weisskönig in a Painter's Workshop* (1512–17). Woodcut, state 1

bitually visited Gossaert in his workshop;[69] and a woodcut of around 1517 by Hans Burgkmair (fig. 33) shows Emperor Maximilian I in the artist's studio.[70] Filarete's description of a visit to his workshop by Galeazzo Maria Sforza, Duke of Milan, is probably a figment of the author's romanticising imagination, but may suggest that such a visit could at least have occurred.[71] The Nuremberg sculptor Peter Vischer (*c*.1460–1529) was, according to Johann Neudörfer writing in 1547, 'so famous that if a prince or a great ruler came to the city he would seldom fail to visit him at his foundry'.[72] Unfortunately, none of these accounts indicates the purpose of these visits or the length of time the visitor may have spent with the artist. On the other

hand, it was reported in 1493 that Ercole de' Roberti drew for hours on end in the company of Ercole d'Este, Duke of Ferrara, sitting opposite him at the desk in the duke's own room.[73] Writing in his *Cronaca rimata* of Federigo's state visit to Mantua on his way to Milan in 1482, Giovanni Santi identified Mantegna as the greatest living painter, telling us that Federigo da Montefeltro

> . . . had the greatest pleasure in admiring
> The marvellous painting and the exalted art
> Of Andrea Mantegna's high and famous genius
> To whom Heaven opened wide its gates
> With gifts in excellent and worthy painting
> Which flourishes in our outstanding age,
> Far more than others, Andrea bears the banner
> Of its great excellent authority.
> Wherefore the Duke, as a distinguished master
> Giving his attention to these paintings
> Of the fine artist, with their great distinction,
> Praised them roundly, and again extolled them
> With words and with praises splendidly.[74]

But perhaps the most celebrated of all visits to an artist's studio was that made to Mantegna by Lorenzo 'the Magnificent' de' Medici on a visit to Mantua in 1483. Mantegna had sent Lorenzo a picture in 1481, a gift acknowledged in a copy-letter in the Medici archive in Florence. This was perhaps the (presumed lost) *Judith* listed in the inventory of Lorenzo's estate taken in 1492.[75] At the date of his visit to Mantua, Lorenzo may already have been thinking about the design of the new villa that he started to build two years later at Poggio a Caiano: he might well have been impressed by Mantegna's sophisticated, centrally planned house that was still under construction. His visit is recorded in a letter from Francesco Gonzaga to his father the Marquis Federigo, in which he writes:

> his Magnificence took himself off to the house of Andrea Mantegna, where he saw with great pleasure various paintings by the said Andrea, and certain sculpted heads and many other antique pieces, by which it seems he was much delighted . . .[76]

It is predictable that Lorenzo would have been pleased to see Mantegna's celebrated collection of antiquities, including presumably the bust of Faustina the Elder (fig. 34) to which the painter was especially attached. Francesco Gonzaga reports that Lorenzo also took pleasure in seeing 'various paintings': these may have included small

34 Roman, second century AD, bust of Faustina the Elder. Marble. Mantua, Museo del Palazzo Ducale

paintings on panel or canvas, several of which (perhaps including the *Madonna of the Quarries* now in the Uffizi) Mantegna gave to Lorenzo de' Medici in the following year.[77]

By presenting these small paintings to Lorenzo, Mantegna evidently hoped to gain Medicean commissions and thus to diversify his patronage and the range of locations of his work beyond the Gonzaga court of Mantua, just as he was able to do later by decorating Pope Innocent VIII's chapel in the Vatican. Gifts made by artists to their patrons, and especially to the princely rulers of the courts in which they worked, were probably seldom disinterested. One that may have been purely light-hearted, however, is suggestive of the intimacy that could develop between patron and artist. Well aware of their great patron's passion for books, in 1411 the Limbourg brothers gave Jean, duc de Berry, a New Year's gift of an illuminated manuscript that

was, however, 'a dummy book, made of a block of white wood painted to look like a book, but in which there were no leaves and nothing was written'.[78] Like this gift, Pisanello's wedding present to Leonello d'Este, who married Margherita Gonzaga in February 1435, of a representation of Julius Caesar may have been purely disinterested.[79] If this 'Julius Caesar' is identical with one recorded in an Este inventory, Pisanello's gift was a small panel painting, perhaps based on a coin of Caesar in the painter's own collection, which Leonello kept in a book-like box.[80] But if Pisanello hoped for a reward, his hope was fulfilled, for on Leonello's orders he was reimbursed with two gold ducats.

Besides the gifts of small paintings that Mantegna sent to Lorenzo de' Medici in 1481 and 1484, he made presents to his Gonzaga patrons. At the end of his life he asked that his late *St Sebastian* (Venice, Ca d'Oro) should be given to Bishop Ludovico Gonzaga; and in 1491 he wrote to Francesco Gonzaga: 'When I presented the little picture to your Grace last Sunday, you responded flatteringly and with a degree of pleasure in your countenance, saying that you would be pleased to give me the parcel of land'.[81] This broad hint suggests that Mantegna sought to place himself in the same position as the humanist who dedicated a text to a prince in the hope of persuading his potential patron to reward his talents suitably. An obvious precedent, surely known to Mantegna, was Leon Battista Alberti's dedication of the Latin version of *On Painting*, the *De pictura*, to Gianfrancesco Gonzaga (Mantegna's patron's great-grandfather) in 1435, in which he wrote: 'And I shall believe my work has not displeased you, if you decide to enrol me as a devoted member among your servants'.[82] Mantegna's letter continues: 'I now beg your Grace to exercise your accustomed and natural generosity ... whereby you would appear as judge, lover and rewarder of *virtù*'. This appeal was rewarded with the celebrated charter dated 14 February 1492 in which Francesco Gonzaga is associated with the King of Syracuse, Alexander and Augustus, and Mantegna by implication with Archimedes, Apelles and Vitruvius.[83] On 13 June 1494 Francesco Bonsignori, a Veronese painter working in Mantua, was given some land by Francesco Gonzaga, probably similarly in response to a gift of paintings for the Castello;[84] and Vasari reported that Sodoma's present to Pope Leo X in 1518 of a painting of 'Lucretia' earned (and was probably calculated to earn) him a knighthood.[85]

By the turn of the century painters were making presents of their works to a wider range of contemporaries, and not necessarily in the hope of rewards. Albrecht Dürer gave his so-called *Four Apostles*

(Munich, Altepinakothek) to the city of Nuremberg in October 1526 'in his own memory and . . . as a tribute to the worshipful Council'.[86] Although Dürer thereby seems to have had licence to select his own subject, and his own firmly Lutheran imagery, he intended the two panels to be a contribution to the predetermined decorative pro- gramme of the council chamber, and the City Council in fact reim- bursed him handsomely for the gift.[87] Much earlier, in the mid-1450s, Donatello gave a bronze relief of the *Virgin and Child with Angels* (London, Victoria and Albert Museum) to his doctor Giovanni Chellini in gratitude for saving his life; and in 1465 the bronze sculp- tor and architect Filarete presented Piero di Cosimo de' Medici with the small-scale replica of the *Marcus Aurelius* (fig. 60) that he had cast in Rome some twenty-five years earlier. Perhaps under the influence of Savonarola's distaste for paintings with secular subjects, Botticelli gave away his *Calumny of Apelles* (fig. 94) to the patrician Florentine Antonio Segni perhaps in the later 1490s;[88] and the *Taddei Tondo* (London, Royal Academy of Arts) was apparently given by Michelangelo to Taddeo Taddei in 1503–5. Segni was also the recipi- ent in 1502 of a drawing of *Neptune* from Leonardo da Vinci, a gesture that anticipates the celebrated 'presentation drawings' that Michelangelo later gave to friends such as Tommaso de' Cavalieri.[89] In making gifts such as these artists may have been consciously echoing Zeuxis who, in Pliny's account,[90] gave away works of art because he felt they were priceless – a story paraphrased by Alberti in *On Painting*:

> The painter Zeuxis began to give his works away, because, as he said, they could not be bought for money. He did not believe any price could be found to recompense the man who, in modelling or painting living things, behaved like a god among mortals.[91]

Artists' Collections

Lorenzo de' Medici was 'much delighted' by Mantegna's collection of antiquities when he visited the artist in 1483. This suggests that for an early Renaissance artist's collection Mantegna's may have been unusually sizeable and fine in quality. He was, however, by no means the only artist of the period who assembled a collection of antiqui- ties, aping an activity that was becoming increasingly popular among antiquarians, intellectuals and princes. As noted, many fifteenth- century artists held in their workshops plaster casts after the antique, which presumably had little intrinsic value, for apprentices to copy

from. The growing need in the developing intellectual climate of the Renaissance for painters to be able to produce representations of a range of classicising forms and motifs led artists also to acquire fragments of classical marble sculpture or small sculptures in marble or in bronze. These were workshop properties rather than 'collectables'. For example, the inventory drawn up on the death of Neroccio de' Landi in 1500 identifies two heads specifically as classical, amongst a group of sculptural fragments.[92] The inventory of 1529 of Sodoma's workshop collection shows that he, too, owned a good many classical fragments. Among these, however, only one piece seems possibly to have been of antiquarian importance: a terracotta plaque showing 'Winter', with a pedum from which hang a hare and two birds, and on the reverse 'Hercules and the Bull'.[93]

The more precise description of this plaque in the Sodoma inventory suggests that artists may have sought to distinguish between gathering objects simply for study purposes, and a more conscious process of 'collecting' antiquities because of their value as relics of the classical past. Pisanello may have assembled his collection of silver coins, which Carlo de' Medici tried to buy for his half-brother Giovanni di Cosimo at the artist's death in 1455,[94] both as stimuli to his own activity as a medallist and also for their resonances of antiquity. The collection of 'works of plaster, marble and relief' bequeathed to Gentile Bellini in his mother's will of 1471 may have included a classical bust later described as of Plato 'with the tip of the nose of wax'.[95] This bust was of sufficiently high quality for the acquisitive but discerning Isabella d'Este to purchase it from Giovanni and Niccolò Bellini in 1512. Isabella also bought busts and statuettes from the collection of the Venetian goldsmith Giovanni Andrea di Fiore in 1498.[96] A classical marble statuette of *Venus* in Gentile Bellini's collection in the mid-1470s was praised by Raffaele Zovenzoni:

> Any who would wish to see the Venus of Paphos with naked
> breasts
> in the ancient marble of Praxiteles,
> Should seek out the shelf of Gentile Bellini where she
> stands;
> even though the limbs are cut off, her image lives.[97]

It seems that it was with the anguish of the true collector on losing a prize piece that Mantegna finally agreed in January 1506 to sell his beloved bust of Faustina the Elder (fig. 34) – 'my dear ancient Faustina of marble' – to Isabella d'Este when infirm and deep in debt shortly before his death later that year.[98] Unfortunately, we know

little about the contents of Mantegna's collection of antiquities, beyond that after his death the Marquis of Mantua put a stop to the dispersal of Mantegna's 'paintings, antique objects or other of his rare things'. If, however, the central circular courtyard in his Mantuan house was indeed always intended as a gallery of classical marbles, it anticipated by three decades the establishment of the famous Belvedere sculpture court in the Vatican. In 1471 Pope Sixtus IV had founded on the Capitol the first public museum since classical times, and his nephew Cardinal della Rovere who, as Pope Julius II, established the Belvedere courtyard, already in the 1480s had a sculpture court at his palace at SS Apostoli. He acquired the *Apollo Belvedere* shortly after it was discovered around 1490 in the face of keen competition from Lorenzo de' Medici, amongst other acquisitive bidders. Lorenzo, too, displayed antiquities in his palace courtyard and garden, such as the two Marsyas figures (one of which is shown in fig. 70) placed on either side of the garden gateway.[99] The courtyard that Mantegna designed for his house may have equated with this pattern of princely, papal and cardinalate display of antiquities. In this respect it would then also have anticipated, and perhaps stimulated, the later purpose-built houses of artists such as Giulio Romano in Mantua and Leone Leoni at Milan, where antiquities were used within architectural settings to create displays representative of those artists' intellectual status.

According to Francesco Albertini, writing rather later in 1510, Ghiberti had possessed 'many antiquities of marble and of bronze'.[100] Ghiberti himself listed some of the works in his collection: a large marble vase said to have come from Greece, a lifesize bronze leg, various busts, vases and sculptural fragments, and a *Letto di Policleto*, an example of a known classical relief type (fig. 35) then believed to be by Polyclitus.[101] This in particular is not the type of classical object that would have been used for workshop copying alone. More records survive of collections of classical works belonging to sculptors than to painters. On a visit to Florence probably in 1433 Ciriaco d'Ancona saw 'at the noble sculptors Donatello and Lorenzo [Ghiberti]'s [houses] a good many old things . . . images of bronze and marble',[102] and Jacopo della Quercia owned 'una testa di vecchio di metallo' and 'due ignudi di metallo'.[103] In 1474 a bronze *Hercules* half a cubit in height and a carnelian with a male head found at Luni were given by the peasant who unearthed them to the Lucchese sculptor Matteo Civitali.[104] Albertini also recorded that in Giuliano da Sangallo's house, amongst others in Florence, 'there are various antique Roman objects',[105] which suggests that Sangallo also brought together a collection for its own sake. On the other

35 Roman, *Letto di Policleto* (sixteenth-century replica). Marble. Rome, Palazzo Mattei

hand, Sangallo and Civitali may have been acting as dealers in the increasingly lucrative trade in antiquities in the late fifteenth century. Unfortunately, apart from Ghiberti's *Letto di Policleto* these works are not identifiable, and we can of course have no idea from generalised references of their quality, or of the reasons why the artists held them.

By the turn of the century, however, antiquities in artists' collections can be more fully characterised. The 'marble figure of a completely draped woman, but without the head and hands, that is antique', recorded by Marcantonio Michiel in Andrea Odoni's collection in 1532, was formerly 'in Tullio Lombardo's workshop [and was] copied by him many times in several of his works'.[106] Although this figure has not been definitively identified, we can perhaps recognise its use as the likely model for such figures as the *Prudence* of the Doge Andrea Vendramin tomb (Venice, SS Giovanni e Paolo). It probably therefore served a double purpose, as a model for Tullio's own style and work and as an object worthy of inclusion in the sculptor's collection. By far the largest and most impressive collection of antiquities owned by a Renaissance artist, however, was assembled by the Milanese sculptor Andrea Bregno at his house on Monte Cavallo in Rome. In his will of 8 July 1503 he distinguished carefully between

36 Hellenistic, *Belvedere Torso* (first-century BC Roman copy). Marble. Vatican, Musei Vaticani

his studio contents and his collection. The former were left to his executors, among whom were several sculptors who could doubtless make good use of these *bottega* exemplars.[107] To his wife, Caterina, Bregno bequeathed his large collection of silver, gems, coins, inscriptions and statues 'antiche e moderne, di marmo, travertino o di altro materie'. This included a number of important pieces including, for example, the celebrated *Belvedere Torso* (fig. 36). In 1500 this was recorded in Bregno's possession by the so-called Prospettivo Milanese:

> Then in the house of a certain Master Andrea
> there is a nude torso without arms or neck
> the equal of which I have never seen in stone . . .[108]

A copy drawn by an Umbrian draughtsman around 1500 bears the inscription 'De maestro Andrea da Milano'.[109] Another drawing of

37 Amico Aspertini, drawings after an *Adonis* sarcophagus (early sixteenth century). Pen and ink on paper. Wolfegg (Baden-Württemberg), Schloss Wolfegg, Codex Wolfegg, fols 34v–35r

the *Belvedere Torso* appears in Amico Aspertini's Codex Wolfegg, in which two other classical works in Bregno's collection are copied in drawings again made around 1500. These are a vase decorated with palmettes 'in casa de maestro andrea scarpellino', and details (fig. 37) of an *Adonis* sarcophagus now in Mantua but then 'in monte chavalo in chasa di maestro andrea scarpellino'.[110] Another fine classical work in Bregno's collection was the so-called Altar of Augustus, now in the Vatican, which Fra Giocondo saw 'in domo magistri Andreae lapicidae'; it was also copied by Aspertini, and on a sheet in Chantilly with the inscription 'Un pilastro che a da ogni canto apri sta 'n casa de maistro andrea scarpe'.[111]

 Andrea Bregno is now a rather little-known artist, although he was a prominent designer and builder of tombs in Rome during the last four decades of the fifteenth century. But from this evidence he emerges as an important figure in the development of the Renaissance artist's wish to demonstrate his interest in exploring the classical past, a subject considered more fully in chapter 5. Bregno assembled a col-

lection of antiquities that was, to judge by his finest pieces, both impressive and valuable, and evidently he made this collection available for others to draw. To have been able to build up this collection at a time when prices were rising fast he must, for a sculptor, have been unusually wealthy. Similarly, Giulio Romano, the principal inheritor of Raphael's workshop, could afford on 5 September 1520 to acquire the collection of the celebrated Roman antiquarian and art dealer Giovanni Ciampolini, who had died two years previously.[112] This included a semi-draped *Venus* and an early imperial frieze of a *Battle of Romans against Gauls*, of which a drawing by Amico Aspertini is inscribed 'in chasa de misero Zoano canpolino'.[113] Both these pieces are now in Mantua and were very probably taken there when Giulio Romano joined the Gonzaga court in 1524. These two examples indicate that artists working in the early sixteenth century in Rome, where a plentiful supply of classical sculpture – both authentic and faked – appeared on the market, were able to build up impressive collections, despite the growing cost of classical works.

Artists as Connoisseurs and Advisers

The increasing respect in which artists were held as the fifteenth century progressed is also suggested by the way in which they were at times called upon to discuss their practices and to offer advice about collectors' holdings or acquisitions. Jean Froissart considered it unusual enough to be worth recording that he had seen Jean, duc de Berry, in close conversation with the sculptor André Beauneveu.[114] Even as early as the late fourteenth century artists were sometimes invited to be travelling companions: Louis d'Orléans, Duke of Touraine, for example, took the draughtsman and medallist Jacquet de Lyon with him on his visit to Italy in 1387.[115] Others were perhaps taken to make visual records of events and personalities encountered during the journey. Both René d'Anjou and Alfonso of Aragon, for example, had painters with them, perhaps as embryonic 'war artists', on their military campaigns.[116]

When regarded as discerning critics of antiquities, Italian artists were sometimes asked to advise on the quality of works. In a letter written from Rome to Niccolò Niccoli in Florence, probably on 23 September 1430, Poggio Bracciolini wrote of classical sculpture, and discussed three marble heads of Juno, Minerva and Bacchus acquired for him on Chios, adding 'I have something here as well, which will be brought home. Donatello saw it, and praised it very highly'.[117] In the same year Nanni di Miniato wrote that Donatello had praised

as 'good things' (*chose buone*) two Roman sarcophagi recently
unearthed between Pisa and Lucca.[118] In 1462 the goldsmith and
medallist Cristoforo di Geremia sent Ludovico Gonzaga from Rome
four antique heads 'reputed good by the experts', by way of apology
for spending a long time working on a commissioned salt cellar.[119]
He also offered to send more antiquities 'if I hear your lordship takes
pleasure in such things' – an offer that Ludovico accepted two weeks
later. Already a year earlier, however, he had warned Ludovico to take
care in acquiring cameos, as a very skilled counterfeiter was active in
Rome.[120] Mantegna was acknowledged as an expert on the gems that
his patrons avidly collected. In a letter of 1472, Cardinal Francesco
Gonzaga asked his father Ludovico to give Mantegna permission to
join him in Bologna: 'With Andrea I will have amusement showing
him some of my cameos and bronze figures and other beautiful anti-
quities, on which we may study and confer in company',[121] and on
28 March 1528 Baldassare Castiglione wrote to Giulio Romano,
also consulting on the subject of cameos.[122]

On 1 June 1489 Lorenzo 'the Magnificent' de' Medici wrote to the
Roman art dealer Giovanni Ciampolini 'that he should show the
heads and other things to Filippino [Lippi]', who was then in Rome
painting the frescoes of the Carafa chapel in S. Maria sopra Minerva.
It seems likely that Filippino was to be asked to give an expert
opinion on the quality of pieces of classical sculpture.[123] In turn, the
medallist Caradosso was sent by Ludovico Sforza from Milan to Flo-
rence in 1495 to acquire some of the works of art in Lorenzo de'
Medici's collection that were being sold off by the new republican
regime.[124] Shortly after 14 January 1506, when the *Laocoön* was
unearthed in a vineyard on the Esquiline hill near the so-called Baths
of Titus, Giuliano da Sangallo was asked by Pope Julius II to inspect
the group in the company of Michelangelo and Giancristoforo
Romano.[125] Giancristoforo Romano also worked in a team with
Antico and Mantegna, advising Isabella d'Este on the quality and
authenticity of classical sculptures, and helped Isabella to get round
the pope's ban on the export of antiquities from Rome.[126] She had
Leonardo da Vinci inspect and advise her on classical vases that were
on offer in 1495 from the Medici collection,[127] and in 1505 she
returned an ivory head to Rome because Mantegna and Giancristo-
foro Romano considered that it was neither good nor indeed
antique.[128] In 1506 Isabella also consulted Antico about buying the
bust of Faustina the Elder (fig. 34) from Mantegna, by then bank-
rupt and close to death. She decided on the purchase, and thence-
forth Antico seems to have taken over from Mantegna as general
adviser on artistic matters. Isabella d'Este was perhaps the most inde-

fatigably acquisitive of all Renaissance collectors, expressing on one occasion her 'insatiable desire' for antiquities.[129] She was only one of many princes and other collectors, however, who recognised that their artists were in a stronger position than they were to evaluate the quality of classical works and to advise on acquisitions.

Various of the examples cited here, and of the points discussed, will arise again in later chapters of this book. This chapter has laid some of the foundations for further consideration of how early Renaissance artists sought the intellectual prestige of contemporaries who practised so-called 'liberal arts'. Later on I shall explore in more depth in which ways these artists made apparent their desire that painting and sculpture should be recognised in the manner that they had been in Pliny's time, and moved towards fulfilling their aspiration that their own intellectual powers should be fully acknowledged by their peers.

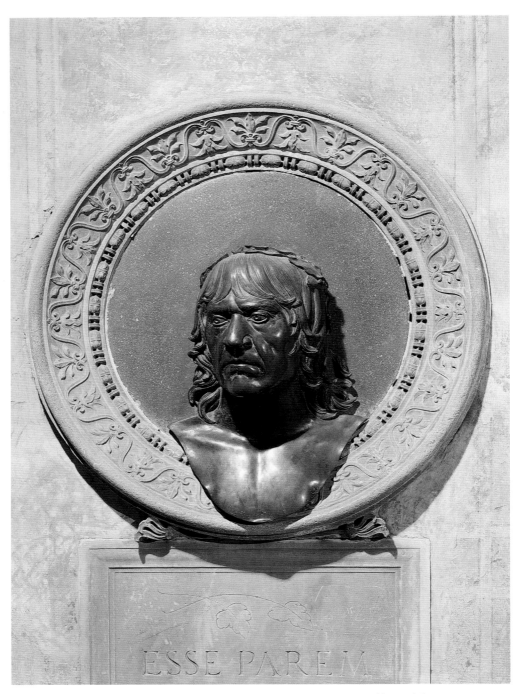

38 Andrea Mantegna, tomb of Andrea Mantegna (?*c.*1504). Marble and bronze. Mantua, S. Andrea

Chapter 4

Commemoration of the
Early Renaissance Artist

Early Renaissance artists had various opportunities during their life-times to enhance their social and intellectual position, and some took advantage of these whenever possible. Their final opportunity came after death, in the form of a visible commemoration. In fact, however, few tombs or commemorative monuments to Renaissance artists survive, although we have evidence of others. It appears from this evidence that over the course of the early Renaissance monuments to artists gradually became more elaborate and complex. Inevitably, the surviving evidence is sporadic, and, as usual, one of the main prob-lems about it is how reliable are Vasari's records. Many of the *Lives* are rounded off with a brief comment on the artist's final resting-place, and sometimes with a transcription of an epitaph. Where these can be checked against surviving tombs – those, for example, of Fra Angelico in S. Maria sopra Minerva, Rome, and of Fra Filippo Lippi in Spoleto cathedral – the transcriptions are accurate.[1] These monuments were clearly well known to Vasari, and both celebrated painters who were favourites of the Medici of the generation of Cosimo 'il Vecchio' de' Medici, the namesake of Vasari's patron Duke Cosimo I. Moreover, the inscription on the second not only commemorates Filippo Lippi and was written by the celebrated Medicean humanist and poet Angelo Poliziano, but also refers to Lorenzo the Magnificent's involvement with the construction of the tomb. It may therefore have been a text of particular interest to Vasari and his Medici patrons.

In other cases of artists' commemoration, however, Vasari evidently did not have reliable information, and he had to invent it. In his often inaccurate *Life of Antonello da Messina*, for example, he recorded that the painter died of pleurisy in Venice, and that 'he received a sumptuous funeral from the artists because of his gift of the new method of colouring to art, as [his] epitaph testifies'.[2] In fact, however,

Antonello died in 1479, shortly after his return to Messina from
Venice; and we know nothing about his burial, his tomb or any
epitaph. An interesting, though relatively minor misunderstanding of
Vasari highlights one of the most remarkable commemorations of
the fifteenth century: the apparently unique proleptic dedication of a
floor-tomb to Benozzo Gozzoli in the Camposanto in Pisa. Vasari
recorded correctly the lengthy epigram that appears on the architrave
of the painted loggia in the scene of *Joseph in Egypt*, of which the
last four lines –

> Who fashioned these images of such varied form
> Was not Nature, her genius engendering that brood.
> This is the work of Benozzo: by his art their visages live:
> O gods above, endow them with a voice as in life

– could alone have served as Gozzoli's epitaph.[3] Vasari also correctly
recorded the inscription on the 'tomb'-cenotaph set into the floor at
the foot of the same fresco: HIC TUMULUS EST BENOTII FLORENTINI
QUI PROXIME HAS PINXIT HISTORIAS. HUNC SIBI PISANORUM DONAVIT
HUMANITAS. MCCCCLXXVIII.[4] But what Vasari evidently did not know
is that Benozzo Gozzoli in fact died, probably of the serious outbreak
of the plague then sweeping through Tuscany, on 4 October 1497,
some thirteen years after completing his parts of the Camposanto
fresco cycle. By that time old and impoverished, he was buried, pre-
sumably in an unmarked grave, in the cloister of S. Domenico,
Pistoia.[5] The inscription on the floor plaque is therefore misleading.
Vasari evidently understood the word 'tumulus' to mean 'tomb', as
it usually does; but he did not realise that the date records the com-
pletion of the *Joseph in Egypt* fresco and, presumably, the allocation
of the tomb to Gozzoli. In fact, the tomb-slab predates the painter's
death by nearly twenty years. Gozzoli was one of the major narra-
tive artists of his day. His vast undertaking in the Camposanto is
seldom today given the credit that it received in the late quattrocento,
when it was clearly highly regarded by the Pisans. Even so, that they
installed this tomb-slab in Gozzoli's 'memory' while he was still alive
is a remarkable tribute to a painter. Commemoration in the form of
a cenotaph – a memorial to one whose remains are entombed else-
where – by others, whether civic authorities or individuals, seems oth-
erwise always to have post-dated the artist's death, and sometimes by
a considerable period.

Many artists were, of course, simply interred in their family tomb.
Paolo Uccello, for example, already made provision in his will of
5 August 1425, before he set out to work for a period in Venice, that
he should be buried in his father's grave at S. Spirito, Florence. His

second will of 11 November 1474 repeats this instruction, and he was indeed interred there on 12 December 1475, half a century after his first statement of the wish.[6] We do not know if a new epitaph was added, but we may be confident that Uccello would not have had an effigy.[7] In republican Florence the decorum of tomb commemoration was strict,[8] and none of the surviving artists' tombs – as opposed to cenotaphs or later commemorations – in Florence before 1530 has an effigy; and conversely, almost all artists' tombs with effigies, or even with bust-length portraits, are located elsewhere. Luca della Robbia, Vasari reports, was 'buried among his relations in San Piero Maggiore in the family tomb; and after him in the same tomb was placed Andrea'.[9] Similarly in Venice, according to Marin Sanudo writing in his diary on 29 November 1516, Giovanni Bellini 'was buried in SS Giovanni e Paolo in his tomb, in which his brother Gentile Bellini, likewise a major painter, had also been buried'.[10] No evidence survives as to the character of this tomb, but it may well have been a family tomb in which their parents Jacopo and Anna had also been buried.

Many artists were buried merely beneath simple floor plaques. Simone del Pollaiuolo, il Cronaca, is commemorated by a floor tomb, and Francesco Granacci by a tomb-marker, in S. Ambrogio, Florence. Even Brunelleschi, who was higher in family status and, as an architect, also in social status, and was perhaps more celebrated than any other Florentine quattrocento artist, was originally interred in the Duomo beneath a simple plaque inscribed 'CORPUS MAGNI INGENII VIRI PHILIPPI S[ER] BRUNELLESCHI FLORENTINI'. However, a year later, in 1447, a commemorative cenotaph (fig. 39) with a classicising portrait bust looking through a roundel in the *imago clipeata* manner, designed and carved by Brunelleschi's adopted son Buggiano, was installed on the wall above his tomb. The elaborate laudatory inscription includes a reference to 'patria' of a type almost obligatory in the rhetoric of the Republic:

> How valiant Filippo the architect was in the Daedalian art is documented both by the wonderful vault of this celebrated temple and the many machines invented by this divine talent. And on account of the excellent qualities of his soul and his singular virtues, his revered body was buried in this soil on 15 May 1446 by order of his grateful fatherland.[11]

Brunelleschi's cenotaph stimulated the commemoration of other Florentine artists. Lorenzo 'the Magnificent' de' Medici seems to have recognised that political capital could be made out of commissioning similar memorials. Although Lorenzo's name tellingly fails to appear

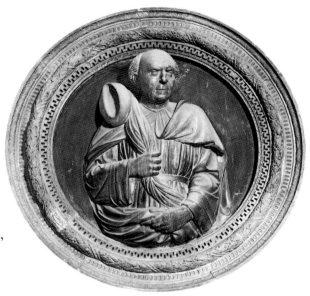

39 Buggiano
(Andrea Cavalcanti),
cenotaph of Filippo
Brunelleschi (1447).
Marble. Florence,
cathedral

anywhere in the inscriptions for the cenotaphs to Giotto and to
Antonio Squarcialupi, the famous cathedral organist, he was appar-
ently responsible for their placement in Florence cathedral in 1490.
Like Brunelleschi's, these have *imago clipeata* bust-length portraits
looking through roundels, a mode that had also been exploited by
Ghiberti for the heads – including a self-portrait (fig. 128) – in the
borders of his second set of bronze doors for the Baptistery. Vasari
reports that Giotto's cenotaph, with a portrait carved by Benedetto
da Maiano and an inscription by Poliziano, in a roundel cenotaph
based on that which commemorates Brunelleschi,[12] was placed in the
Duomo 'by public decree, through the personal devotion and
command of . . . Lorenzo de' Medici',[13] and del Migliore attributed
the bust of Squarcialupi to Lorenzo's patronage on the basis of a
ricordo he found in the grand ducal palace.[14]

At much the same time, a portrait bust was placed in the wall above
the tomb of Il Cecca, the short-lived engineer-architect who died in
1488. Vasari reports:

he was buried by the sisters in S. Pier Scheraggio. Beneath his por-
trait in marble the following epitaph was placed: 'Fabrum magis-
ter Cicca, natus oppidis vel obsidendis vel tuendis, hic jacet. Vixit
an. XXXXI. mens IV. dies XIV. Obiit pro patria telo ictus. Piæ sorores
monumentum fecerunt MCCCCXCIX.'[15]

This is confirmed by Richa in 1755 in his description of S. Pier Scheraggio, in which were 'many tombs of famous men, in particular that of Il Cecca, an architect famous in his time . . . and on the wall was the portrait-bust of the same'.[16] This may be the first portrait bust related to an artist's tomb (as opposed to a cenotaph) in Florence. Il Cecca was unusually honoured, however, perhaps because of the circumstances of his death, referred to in the epitaph in the phrase 'obiit pro patria' (he died for his country), which according to Vasari came about when he was shot while campaigning as an engineer in the Florentine army besieging Piancaldoli.[17] Following the new tradition represented by the tomb of Il Cecca, and stimulated also perhaps by the Duomo cenotaphs, the now-lost tomb of Andrea del Sarto, who died in 1530, on the left pilaster of the triumphal arch of SS Annunziata also had a bust of the painter, carved by Raffaello da Montelupo.[18]

As possibly in the case of Il Cecca, the particular circumstances of the artist may explain two precocious examples of effigies on artists' floor-tombs. Perhaps the earliest surviving artist's effigy in Italy is on the tomb of the obscure Venetian sculptor Giovanni de Santi, who died in 1392. Originally placed at the foot of the unfinished sculpture of the *Madonna dell'Orto*, this floor-plaque is now in the chapel of S. Mauro in the church of the Madonna dell'Orto in Venice. De Santi is represented as a bearded artisan, wearing the dress of a working sculptor. Conventions for representing the dead on their tombs may have been less strict in Venice than elsewhere, but the inscription probably explains why de Santi was permitted what was, for a sculptor, an impressive commemoration:

> Hic jacet Magister Johanes de Sanctis lapidicia de contrata scti severi q.p.suam maximam devotionem obtulit et dedit imaginem Beateam Virginam in eclexia Scti Xphori de Venexia qui obiit in MCCCLXXXXII die VII mensis Augusti.[19]

Giovanni de Santi's situation was extraordinary in that even before he had finished carving his large-scale *Virgin and Child* it started to perform miracles. These peculiar circumstances gave him a special position among Venetian late Gothic artists, and normal rules of commemorative decorum need not have applied. His figurated floor-tomb was installed in an honorific setting as a tribute to the carver of a much-venerated, miraculous image.

The second early example of an artist's effigy is the floor-tomb recording the death and burial of Fra Angelico (fig. 40), placed in S. Maria sopra Minerva in Rome by the Dominican friars. The epitaph, possibly written by the humanist Lorenzo Valla, and

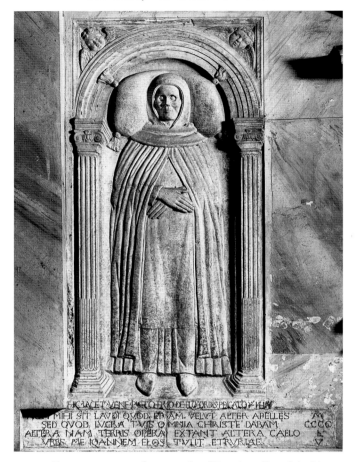

40 Roman, *c*.1455, floor tomb of Fra Angelico. Marble.
Rome, S. Maria sopra Minerva

inscribed around the edge of the floor-plaque, does indeed refer significantly to Fra Angelico's prowess as a painter. It records:

> Here lies the venerable painter Brother Giovanni of
> Florence, O. P., 1455.
> Let it not be said in my praise that I was another Apelles
> But, O Christ, that I gave my reward to all your people:
> The deeds that count on earth are different from those in
> heaven.
> I, John, flourished in the city known as the flower of
> Tuscany.[20]

Fra Angelico's career as a painter both of pious images for Dominican friars and of elaborate narrative frescoes for the popes was already celebrated at the time of his death. Moreover, a number of artists' commemorations suggest that Rome was relatively free of the strict tomb conventions of republican Florence. Nevertheless it may well be that Fra Angelico was granted a floor-plaque with an effigy as much by virtue of his important position within the Dominican hierarchy in mid-fifteenth-century Italy – as prior of the convent of S. Domenico at Fiesole who died in Rome while painter to the pope – as of his artistic skills.

Although in the inscription for the Giotto cenotaph the part played by Lorenzo de' Medici is not revealed, in that (also written by Angelo Poliziano) for the memorial for Fra Filippo Lippi in Spoleto cathedral (fig. 41) it is explicitly stated that Lorenzo was responsible for the commemoration:

41 Filippino Lippi, cenotaph of Fra Filippo Lippi (1488–9). Marble. Spoleto, cathedral

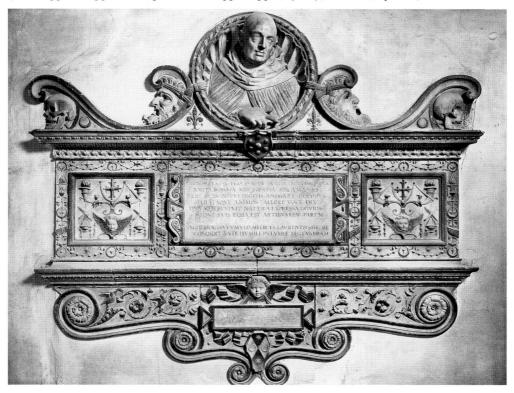

Here in this place do I, Filippo, rest,
 Enshrin'd in token of my art's renown.
All know the wondrous beauty of my skill;
 My touch gave life to lifeless paint, and long
Deceiv'd the mind to think the forms would speak.
 Nature herself, as I reveal'd her, own'd
In wonderment that I could match her arts.
 Beneath the lowly soil was I interr'd
Ere this; but now Lorenzo Medici
 Hath laid me here within this marble tomb . . . [21]

Filippo Lippi had been interred at his death in 1469 beneath a tomb-slab of red and white marble, set in front of the cathedral's central door – an honorific site usually reserved for prelates or rulers. Some twenty years later Lorenzo paid 100 gold florins to Filippino Lippi for the erection of Filippo Lippi's cenotaph.[22] It is a low-relief wall-plaque, equipped with a bust length, high-relief portrait of Lippi as a Carmelite friar, set against a shell within the tondo. He points outward from the roundel with his right hand towards the Medici coat-of-arms on the architrave of the sarcophagus, as though to pay tribute to his major patrons. On either side of the portrait are two *all'antica* flourishes each containing a bearded mask and terminating in a skull: these are characteristic of Filippino Lippi's design vocabulary immediately after his first experience of the recently discovered 'grotesques' in the Golden House of Nero in Rome.[23] The sarcophagus itself has rich low-relief decoration in and around the two panels that bracket the classicising *tabula ansata* with the inscription. Below the two tablets is another coat-of-

42 German, *c.*1432, tomb of Hans Stethaimer. Stone. Landshut, St Martin

arms, presumably invented for this cenotaph, and in each decorative panel a cross, denoting Lippi's status as friar, is joined by the pen and brush of the painter.

This type of memorial had long had its parallels north of the Alps. Recently, for example, the mason Hans Stethaimer (who died in 1432) had designed his tomb in the church of St Martin, Landshut, to include a self-portrait bust (fig. 42) and an inscription listing his principal works.[24] Lorenzo's Duomo cenotaphs and the Filippo Lippi tomb firmly established the convention that Florentine artists' tombs should include a bust-length portrait. Several tombs of Italian artists built during the following forty years take up the theme. The double tomb commemorating the Pollaiuolo brothers in S. Pietro in Vincoli in Rome (fig. 43), for example, includes full-face portraits of both artists set into ovals above the inscription tablet. Unlike the cenotaph of Filippo Lippi, the Pollaiuolo memorial is clearly a tomb monument, and it has a well-defined architectural frame that is built up from floor level. In his will in 1496, Antonio Pollaiuolo (who died in 1498) provided for a funeral in S. Pietro in Vincoli 'cum debito honore atque officiis funeralibus iuxta suam qualitatem et condi-tionem';[25] and the tomb inscription also notes the arrangements he had made for his own burial:

> Antonio Pollaiuolo, Florentine by homeland, renowned painter, whose marvellous skill shaped the bronze monuments of two Popes, Sixtus and Innocent, asked that when his personal affairs had been settled according to his will, he should be interred here with his brother Piero. He lived seventy-two years, and died in the year of our Saviour 1498.[26]

Neither the will nor the inscription, which refers only peripherally to Antonio's brother Piero who had predeceased him in 1496, makes reference, however, to the form of any proposed tomb monument, and no evidence remains as to what influence, if any, either brother may have had on the design of their tomb.

The sculptor Andrea Bregno, who died in 1503, perhaps deserved his elaborate tomb (fig. 44) as much for his high reputation as an antiquarian and collector as for his fame as a sculptor. By the time of his death he had assembled one of the finest collections of classical sculpture outside those of the popes and princes of the time. His tomb in the left transept of S. Maria sopra Minerva, Rome, shows Bregno in a frontal portrait bust of the *imago clipeata* type, resembling a Roman Republican bust. This is placed within an oculus set into a panel between pilasters carrying a plain entablature. Both the pilasters and the panel between them are richly decorated with relief

43 Roman, *c.*1500, tomb of the Pollaiuolo brothers. Marble. Rome, S. Pietro in Vincoli

44 Roman, 1506, tomb of Andrea Bregno. Marble. Rome, S. Maria sopra Minerva

representations of tools of the sculptor's trade – dividers, rulers, a set-square, bow drill, club-hammer, plumbline, chisels, mallets – and swags of fruit; and the inscription draws a complimentary parallel between 'the very famous sculptor' Bregno and Polyclitus.[27]

Artists Designing their own Tombs

By the time that Andrea Bregno died it was not unheard of for an Italian artist to have played at least some part in designing his own tomb. Given that building tomb monuments was his speciality, this may indeed have occurred in Bregno's case. Artists certainly could have some control over the location of their tombs. Donatello's relations with the Medici, and especially with Cosimo 'il Vecchio' for whom he executed numerous works, were sufficiently close that he was able to make the special and rare request that he be buried under the crossing of S. Lorenzo, Florence, in a tomb placed close to that of his great patron who had died some two years earlier in 1464.[28] A documentary reference that locates Donatello's tomb close by Cosimo's 'per comissione di Piero di Cosimo' shows that Cosimo's son Piero acceded to this request.[29] Both the acceptability to his patrons of this choice of burial site, and the site itself, within intimate range of Cosimo de' Medici's tomb, are tributes to the high regard in which Donatello was held by the Medici. Not unexpectedly, examples exist of Renaissance artists who planned their burial place long before their deaths. Alesso Baldovinetti, the illegitimate son of the merchant Baldovinetto Baldovinetti whose family was among the richest in Florence, also acquired a tomb for his family in the crypt of S. Lorenzo, and received burial rights there in 1463, perhaps (like Donatello) seeking interment close to his Medici patrons. However, when he died in 1499 he was buried instead beneath a tomb slab in S. Ambrogio, Florence.[30]

Lorenzo Ghiberti, who died on 1 December 1455, made it clear in his will of 26 November 1455 that he wished to be buried in the tomb in S. Croce, Florence, that he had apparently purchased as early as 1430.[31] In his second, revised, tax return for 1430 reference is made to payments 'a l'opera di sca Croce per uno luogo di sepultura, f.15' and 'a frate francescano frate di detta chiesa per le spese e muratura di detta sepultura, f.6' This suggested to Krautheimer that Ghiberti wished to be 'buried among the patricians he strove to emulate', and that as early as 1430 he was ready to put resources towards the construction of his tomb in S. Croce. Although equivocal, these tantalising references may suggest that, perhaps not surprisingly, Ghiberti

was the first artist of the Renaissance to seek to design his own tomb. No evidence survives of the character of this design, however, and it seems unlikely that it was ever constructed. Vasari reports simply that he was 'honourably buried in Santa Croce',[32] and he was probably commemorated in a floor-plaque since replaced by the one currently *in situ* which bears a brief, apparently nineteenth-century inscription. Another later sculptor who also seems to have put his mind to the question of the design of his tomb was the Venetian marble carver Tullio Lombardo. His will of 13 November 1532 includes a clause stating that 'I wish my corpse to be buried in the cloister of S. Stefano in a tomb that I have made at home, which tomb shall be installed either high or low'.[33] The last phrase suggests, however, that this 'archa' was little more than an inscribed plaque which could be set into either the wall or the floor, although it might have included low-relief carving.

A more elaborate arrangement for self-commemoration, one indeed that forms the most significant precedent for the tombs of Mantegna and Raphael, is the chapel designed and constructed to his memory by the Sienese painter and sculptor Lorenzo di Pietro, il Vecchietta. In his will of 10 May 1479, Vecchietta, the Spedale della Scala's resident artist, required that his body be interred in the new chapel 'that is to be built in the church of the hospital of S. Maria

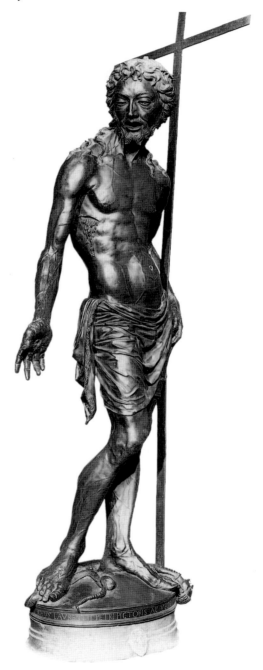

45 Lorenzo Vecchietta, *Risen Christ* (1476). Bronze. Siena, Ospedale di S. Maria della Scala

della Scala in Siena'.[34] On 20 December 1476 – almost thirty years before Mantegna's plans for his funerary chapel began to be put into operation – Vecchietta had asked the Spedale to cede him rights to build a chapel, which was to be dedicated to Christ the Saviour, in the hospital church, designed according to the drawing that he presented to them. He was granted permission to build this chapel on 20 February 1477, and Vecchietta offered to donate his as yet unfinished ('non anco finito') bronze figure of Christ to stand on the altar, and a large panel that he would make 'if God gives me life' to serve as the altarpiece.[35] The bronze *Risen Christ* (fig. 45) is still on the high altar of the hospital church,[36] and the panel painting of the *Virgin and Child with SS Peter, Paul, Lawrence and Francis* (fig. 46) is now in the Pinacoteca in Siena.[37] The now-lost inscription on Vecchietta's tomb read: 'Senensis Laurens vivos de marmore vultus / Duxit, et excussit mollius Aera manu', a couplet in fine humanistic Latin as befits a sculptor-painter who strove to present himself as a learned artist.[38] In what may be a parallel instance to this, the painter Cosmè Tura provided in 1471 for a church dedicated to SS Cosmas and Damian, his name saints, to be built in Ferrara.[39] It is not, however, known if Tura proposed to design this church himself: he died in poverty in 1495 and was finally buried in S. Giorgio fuori le Mura outside Ferrara.

Although Andrea Mantegna was also impoverished by the time of his death, he succeeded in ensuring that a monument was erected to commemorate his life and activity as a painter. Indeed, the funerary chapel that Mantegna acquired, with the support of his Gonzaga patrons, in S. Andrea, Mantua, is the most remarkable example of a Renaissance artist's self-commemoration. In his will of 1 March 1504 Mantegna made provision of 50 ducats for the decoration of the chapel of St John the Baptist (fig. 47), the first chapel to the left of the nave of the important church built by Leon Battista Alberti for his (and Mantegna's) main patron, Ludovico Gonzaga.[40] Ten days later Mantegna endowed the chapel with a further 100 ducats to pay for masses to be said for the souls of himself and his relatives. While a conventionally inscribed tombstone covers Mantegna's grave in the floor at the entrance to the chapel, his commemorative monument set on the wall above is opulent and sophisticated in its imagery (fig. 38). It consists primarily of a bronze portrait bust of Mantegna, three-quarters in the round, which is set against a round plaque of porphyry itself set within a white, Istrian stone rectangle. The bust is so set as to engage the view of the visitor approaching the chapel.[41]

As in the Florence cathedral cenotaphs, the combination of portrait bust and tondo in the *imago clipeata* form has strong classi-

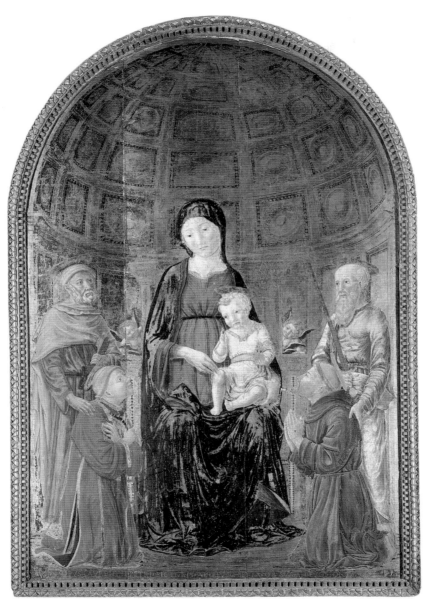

46 Lorenzo Vecchietta, *Virgin and Child with SS Peter, Paul, Lawrence and Francis* (1477–9). Tempera on panel. Siena, Pinacoteca Nazionale

47 Mantua, S. Andrea, chapel of St John the Baptist, view of interior decoration (1506–16)

cising resonances on account of its regular use by Roman emperors, and is characteristic of Mantegna's antiquarian interests. The use of bronze against a disc of purple porphyry, also associated with imperial usage, surrounded by white stone shows Mantegna's sensitivity

both to the play of colour and to the values of precious materials. This commemorative monument was later closely imitated in the memorial set up to Battista Spagnoli, significantly a court poet, probably after 1519.[42] Exceptionally for a painter, Mantegna is represented wearing a wreath of laurel leaves, which was originally gilded. Often adopted as an attribute of fame, the laurel wreath also suggests Mantegna's wish to draw a parallel between himself and the laureate poet. It may moreover have intentionally referred to Pliny's description of the Greek painter Parrhasius, who dressed in purple and wore a golden crown.[43] The bust is generally considered to be a self-portrait dating from the 1480s: Scardeone wrote that Mantegna had cast the bust with his own hands ('sibi suis conflaverat manibus');[44] and diamonds were originally set into the pupils of the eyes.[45] If it is indeed a self-portrait, and from the start intended by Mantegna for his tomb, it is a remarkable and precocious example of an artist's construction of his self-image for commemorative purposes. The deliberately leonine severity of his expression links the bust also with the heroic, warlike imagery current in the court of the Marquis of Mantua, Francesco Gonzaga. By associating himself closely with this court style, Mantegna showed his ambition to achieve high standing at court. The inscription continues the theme of status enhancement by comparing Mantegna with the greatest of classical painters: 'You who see the bronze images of Andrea Mantegna know him to be equal, if not superior, to Apelles.'[46]

Mantegna designed his own memorial, although it was not set in place until after the chapel's fresco decoration had been completed, probably in 1516, some ten years after his death.[47] But the tomb must be seen as just one element within the decoration of the whole chapel, vying for prominence with the altar and its canvas of the *Baptism* which acknowledges the chapel's dedication to St John the Baptist. Although the terms of his will of 1504 leave it to his executors to decorate the chapel 'with paintings and other decorations as they shall think proper', he himself had made a start on two of the paintings by the time he died in September 1506, the *Baptism* and an altarpiece of the *Families of Christ and St John the Baptist*.[48] This indicates that Mantegna was responsible for devising the iconographical programme, but it is not clear whether the design for the decoration as a whole was his or was made by his son Francesco, who was in charge of completing the decoration once the financial confusion that followed Mantegna's death had been sorted out. It seems probable, however, that Mantegna had put a good deal of thought towards the design of the decoration.

As befitted Mantegna's assertive artistic personality, this was the most extensive and impressive funerary chapel decoration to commemorate a Renaissance artist. It was Raphael, however, who aspired to what was perhaps the highest honour available in tomb commemoration: to be buried in the Roman Pantheon – an honour also bestowed later on the Sienese painter and architect Baldassare Peruzzi, who died in 1536. Then the church of S. Maria ad Martyres, the Pantheon was the only Roman temple to survive into the Renaissance in a near-intact state. Raphael and his contemporaries knew that it had originally been dedicated to all the gods of the ancient world. In a letter written on 11 April 1520 to Antonio Marsilio in Venice, Marcantonio Michiel noted the 'universal sadness of all, and especially of the intellectuals' at Raphael's death.[49] Pandolfo Pico wrote to the Marquis of Mantua on 7 April 1520 that 'the said Raphael was buried with the greatest honour in the Rotonda [i.e., the Pantheon] where he had ordained that a tomb should be made to his memory'. He continued that Raphael had provided 1,000 ducats – enough money to buy a house: compare the 3,000 ducats that Raphael paid for the Palazzo Caprini – for the installation of his tomb and for masses to be said for the salvation of his soul.[50] Vasari also indicates that Raphael himself chose the Pantheon as his place of burial and in his will provided funds to restore for this purpose one of the ancient tabernacles (fig. 48).[51] This is an indication both of Raphael's personal wealth at the time of his death, and of the importance he attached to commissioning his own commemoration in a way that aimed to achieve recognition of his artistic importance. Raphael was interred in a late first-century Roman sarcophagus decorated with bucrania and garlands, over which was installed the *Madonna del Sasso*, still extant in the Pantheon, that he had commissioned from the sculptor Lorenzetto for his tomb.

The most significant aspect of this project is its setting in the Pantheon, the 'temple of all the gods'. Perhaps Raphael already sought to suggest the 'divine' status accorded to him later by Vasari, who wrote that 'artists as outstandingly gifted as Raphael are not simply men but . . . mortal gods'.[52] Significant also is the epitaph, written by his friend Pietro Bembo, in which Raphael not only is said to have rivalled classical painters but also in death is directly compared with Nature:

In memory of Raphael son of Giovanni Santi of Urbino: The great painter and rival of the ancients: Whose almost-breathing likenesses if thou beholdest, thou shalt straightway see Nature and Art in league; Who by his deeds in painting and in architecture

48 Lorenzetto, tomb of Raphael (1520). Marble. Rome, Pantheon

did swell the glory of the Sovereign Pontiffs Julius II and Leo X; Who lived in goodness thirty-seven good years, and died on his birthday, April 6 1520.

> This is that Raphael, by whom in life
> Our mighty mother Nature feared defeat
> And in whose death did fear herself to die.[53]

Although some of the evidence surveyed in this chapter has to be interpreted with caution, some patterns can be deduced as to how Renaissance artists were commemorated after their deaths – or, indeed, in one case before his death. Artists' tombs and other forms of commemoration apparently became more usual as the early Renaissance progressed, and the artist's involvement in making provision for and even designing his own tomb also increased. Extant or recorded epitaphs tend to become longer and more fulsome, often evaluating the artist's achievement through comparison with Nature or with classical predecessors. Especially from the middle of the fifteenth century, as they gained in experience of intellectual ideas, the painter and the sculptor were granted progressively more social and intellectual esteem, and this enhancement in status is manifested in the increasingly elaborate ways in which they were commemorated after death.

The Artist and Archaeology

Roberto Weiss introduced *The Renaissance Discovery of Classical Antiquity* (1969) as 'a history of classical archaeology in its early stages, showing . . . how it was developed by the enthusiasm and industry of countless humanists . . . [for] the concrete legacy of classical antiquity'.[1] Renaissance artists played a part in this process of archaeological investigation and discovery. Some artists recognised the pursuit of archaeology as a route towards fulfilling their intellectual aspirations. They perhaps saw the integration of archaeologically derived forms and motifs into their works as the visual equivalent of the humanists' responses to the textual heritage of ancient civilisation. It was in this period that artists first sought to reconstitute and to reconstruct aspects of the classical world in a spirit that may be said to have set the scene for the later development of a 'scientific archaeology'. The early Renaissance artist had no need, of course, to aspire towards the precision of recording that is central to the scientific archaeology practised with increasing sophistication since the Enlightenment. Rather he strove to recreate the spirit of the classical past by copying after the antique, and by learning from these visual records and deploying that knowledge in the light of other factors when working on artistic projects.

We should here seek to discriminate between 'antiquarianism' and 'archaeology'. The antiquarian, I propose, sought to gather visual records of the classical past – coins, sculptural fragments, inscriptions or other artefacts – simply because such objects resonated with ancient history. The archaeological instinct went further than this, however, by searching for ways in which the past and its resonances could be reconstituted in the present. The embryonic archaeologist of the early Renaissance desired not merely to feel those resonances of the ancient past but, further, to generate a 'modern' reconstruction of classical civilisation. Of course, many early Renaissance painters and sculptors responded in general terms to the antique, and especially to classical sculpture, as they sought clearer definitions of

anatomical form, pictorial composition or the treatment of narrative. Alberti's advice on these matters in *On Painting* acknowledged both the development of this general stance towards the classical past and its value in stimulating the evolving pictorial realism of the early Renaissance. But more specifically, artists engaged visually and intellectually with the material culture of the classical past. It is therefore the growth of the artist's sense of historical reconstruction, even of recreation, of the classical past that will be explored here.

Objects and artefacts from the classical past had been known, admired and used as inspiration – formal or iconographic – throughout the centuries before 1400. Sculpture produced for the Triumphal Gateway at Capua, carved for the consciously classicising imperial court of Frederick II Hohenstaufen around 1240, suggests a desire to recreate imperial Roman forms and styles.[2] The styles of Nicola Pisano's Pisa Baptistery pulpit (1258–60), of the *Prudence* and *Fortitude* on his son Giovanni's pulpit in Pisa cathedral (1302–11), and of many of the figures in the reliefs of the façade of Orvieto cathedral (*c.*1310–30) show precocious responses to a classical figure-style.[3] When a classical statue of Venus, signed (according to Ghiberti) by Lysippus, was disinterred in early fourteenth-century Siena, it was set up on the Fonte Gaia as if in tribute to the traditional view that Siena had been founded in classical times; 'and to all the great painters who then lived in Siena it seemed as though the height of perfection had been attained in it'.[4] Ghiberti claimed to have a drawing of this figure by Ambrogio Lorenzetti; and indeed Ambrogio very obviously exploited classical sculpture in his figure-style, as for example in the figures of *Pax* and *Securitas* in the fresco cycle in the Sala dei Nove in the Palazzo Pubblico, Siena. But these are no more than sporadic instances of late medieval responses to classical art, and cannot be considered in any sense 'archaeological' in spirit, or even to indicate any consistent antiquarian thrust. During the early Renaissance, however, new, more sharply focused archaeological attitudes towards the visual heritage of the classical past developed among both intellectuals and artists.

Significant for the future was the increasingly acute historical consciousness developed by Francesco Petrarch in his later writings. These, like the *Africa*, were produced in late fourteenth-century Padua, and early indications of a desire for the exact copying of classical coins and medals are to be found within that same academic environment in Padua under the rule of the Carrara family. The Veronese humanist Giovanni Mansionario had already made drawings of Roman imperial coins in his *Historia imperialis* written between 1310 and 1320.[5] Roman coins were readily obtained, and

49 Altichiero, *Emperor Maximian* (c.1370), detail of frieze.
Fresco. Verona, Palazzo Scaligero, Loggia di Can Signorio

by the late fourteenth century a growing number of humanistically
inclined antiquarians were collecting them. Moreover, coins and
medallions could be easily reproduced in plaster or stucco, and dis-
tribution could make prototypes of classical figures and images
widely available. One of the art forms in which the aspiration for
archaeological exactness was first exercised was indeed the medal or
medallion. Long before the development by Pisanello around 1440
of the early Renaissance medal (fig. 4), classical coins and medals
were represented sometimes verbatim in the border decoration, for
example, of manuscripts of Suetonius's *The Twelve Caesars*.[6] They
were also copied as early as around 1364 in a much more prestigious
work, the frieze (fig. 49) painted in grisaille by Altichiero in the
Loggia di Can Signorio of the Palazzo Scaligero in Verona.[7]

50 Paduan, *c.*1390, medals of Francesco I and Francesco Novello da Carrara, obverses and reverses. Bronze. *Right*: Paris, Bibliothèque Nationale de France; *left*: Berlin, Staatliche Museen zu Berlin–Preussischer Kulturbesitz Münzkabinett

The Roman Republican heroes depicted in Taddeo di Bartolo's frescoes of around 1412 in the Palazzo Pubblico in Siena wear contemporary armour and dress.[8] This was also probably true of the dress depicted in Altichiero's fresco decoration of around 1380 in the Sala Virorum Illustrium of Francesco I da Carrara's palace in Padua, to judge from the illuminations derived from that cycle in a manuscript of Donato degli Albanzani's translation of Petrarch's *De viris illustribus* made in Padua around 1400.[9] But the copying of profile portraits on classical coins resulted, especially at first in the North Italian context, in more authentic representations. Shortly after the Sala Virorum Illustrium had been decorated, the earliest classicising medallions were produced in Padua in 1390 for Francesco Novello da Carrara: he and his father Francesco I da Carrara are represented in profile in Roman imperial dress (fig. 50). At his death in 1455 Pisanello left a collection of silver coins; and presumably his image of 'Julius Caesar', presented to Leonello d'Este of Ferrara as a wedding present in 1435, was based on one such prototype.[10] Another image perhaps derived from a coin in Pisanello's collection is his sketch of *Diva Faustina* (fig. 51).[11] Very unusually for a

51 Antonio Pisanello, sketch of *Diva Faustina* and other studies (*c.*1435), detail. Pen and ink on paper. Paris, Louvre

drawing, this is signed – 'Pisanus hoc opus' – perhaps because it is a conscious exercise after the antique. The coin-like profile of *Diva Faustina* is paradoxically set within a Gothic trilobe niche, suggesting that the drawing was made in preparation for a painting with the image shown ready-framed and inscribed with the painter's name. But the frame in fact serves to emphasise the classicising precision of the profile portrait.

A more antiquarian drawing by Pisanello after a coin of Augustus (Paris, Louvre, Codex Vallardi 2266v) may, on the other hand, have been made while preparing a series of medals with imperial profiles.[12] A similar antiquarian spirit lies behind a series of medallions of Roman emperors produced within the Rome workshop that Filarete set up in order to work on the bronze doors of St Peter's in the mid-1440s.[13] The obverse of the medallion inscribed NERO. CLAVD. IMP. CAES. AVG. COS. VII. PP (fig. 52) shows a profile representation of the Emperor Nero evidently based on a Roman coin, perhaps of Caracalla, while the reverse shows the Death of Seneca; and the reverse of the Faustina medallion, inscribed DIVA FAUSTINA DIV S. ANTONINVS, shows the Empress and Emperor Antoninus Pius seated

with their right hands clasped together, following the classical numismatic iconography of Concord. These medallions reflect a similar antiquarian spirit as the series of imperial profile heads (again based on Roman coin-portraits) and Filarete's self-portrait medallion set into the frames of the bronze doors of St Peter's, although they are artistically more proficient. To modern eyes these medallions are clearly not classical, but they are so classicising that at the time they might have passed as authentically Roman. What might appear to have been the deliberate counterfeiting of classical coins was, however, more probably a conscious process of recreation, because a simpler method of counterfeiting would be to produce new casts after classical coins and medals. Certainly Giovanni Boldù's strikingly antiquarian self-portrait medals (fig. 130) and Cristoforo di Geremia's somewhat later interest in 'reproducing' Roman coins in his *Constantine* medallion (fig. 53) suggest that these were conscious exercises in archaeological correctness.[14] Cristoforo's medal, cast perhaps at the time of Emperor Frederick III's visit to Rome in 1468, also uses the image of Concord. The same reverse was reused by Cristoforo's nephew, known only by his self-consciously classicising, adopted name, 'Lysippus the Younger', in a medal of Pope Sixtus IV which is equally convincingly classical in appearance; and it reappears at the end of the century among the series of imperial profile portraits that decorates the plinth of the façade of the Certosa of Pavia in Lombardy.

The developing interest in numismatics amongst antiquarians within academic circles in the north of Italy around the middle of the

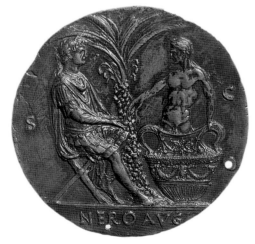

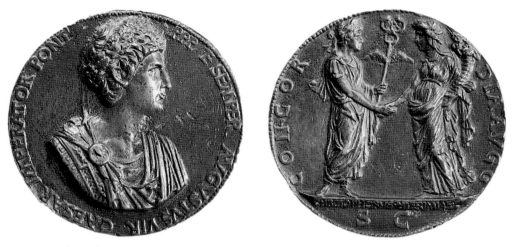

53 Cristoforo di Geremia, medallion of Constantine (?1468), obverse and reverse. Bronze. London, © The British Museum

fifteenth century is illustrated also in Jacopo Bellini's records of Roman coins. Bellini accurately copied both the obverse and the reverse of a sestertius of Domitian on one of his pages of Roman tomb monuments (fig. 54).[15] Several other pages in Bellini's books of

52 (*below and facing page*) Workshop of Filarete (Antonio Averlino), medallions of Emperor Nero and Empress Faustina (*c*.1440–45), obverses and reverses. Bronze. Washington, DC, National Gallery of Art, Samuel H. Kress Collection

54 Jacopo Bellini, *Four Roman Tombs* (*c.*1450). Pen and ink on parchment. Paris, Louvre, Bellini book of drawings, fol. 44

drawings[16] are, like Pisanello's sheet that includes his copy after a coin of Augustus, compass-drawn layout sheets for copy-drawings of Roman coins. Jacopo's interest in preserving a collection of numismatic images was associated with a wider archaeological curiosity. Coins and medals were available in large numbers and were easily moved between collector and artist. But sculpture was inevitably more localised and less accessible. Drawn records therefore became an essential medium for disseminating forms and motifs in classical sculpture. These were necessary to artists who sought to impress observers with their erudition by incorporating such elements into their works. In two pages of his Paris book of drawings Jacopo Bellini recorded Roman tomb-monuments, in part perhaps in a somewhat romanticising spirit but in part closely copying the prototypes under scrutiny.[17] The tomb inscribed T.POMPONENUS.D.L.GRATUS, now in the Kunsthistorisches Museum in Vienna, was accurately recorded by Bellini (fig. 54) presumably at its original location at Carmignano on the outskirts of Padua. Another, the tomb of Metellia Prima then

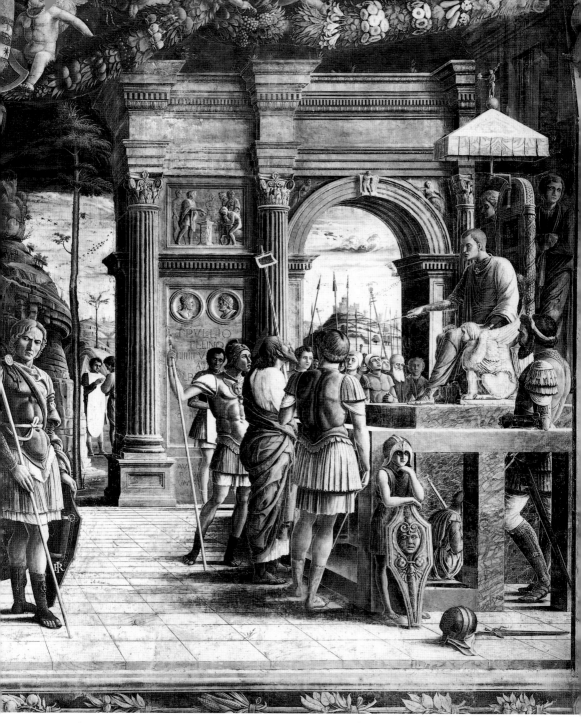

55 Andrea Mantegna, *St James before Herod Agrippa* (1451). Fresco. Destroyed; formerly Padua, Church of the Eremitani, Ovetari chapel

in S. Salvatore, Brescia, is recorded in versions of the *Quaedam antiq-uitatum fragmenta* by the foremost Paduan antiquarian Giovanni Marcanova.[18] Bellini here made copies of classical inscriptions and sculptural motifs current within the antiquarian circles of the Veneto in the middle of the fifteenth century. Several of the complex archi-tectural structures within which Jacopo sets his narratives in the Paris book of drawings are elaborately decorated with quasi-classical reliefs. These suggest that the artist not only knew a range of proto-types in North Italy, but also already possessed drawings in which antiquities in Rome itself were copied.[19]

The delicately painted classical sacrificial scenes set into the wall behind Christ in Giovanni Bellini's early *Christ the Redeemer* (London, National Gallery) mirror his father's antiquarian interests. But they also constitute one of Giovanni's responses to the classi-cising tendencies of his brother-in-law Andrea Mantegna: a similar sacrificial scene appears on the triumphal arch in Mantegna's *St James before Herod Agrippa* (fig. 55), painted around 1451 in the Ovetari chapel in the church of the Eremitani, Padua. Presumably even before he married Jacopo Bellini's daughter in 1453, the young Mantegna himself made, or had access to, drawings after the same classical works that Jacopo recorded. For example, the inscription referring to T PULLIO. T.L. LINO . . . that appears in Jacopo's drawing of Roman tomb-monuments (fig. 54) is also used to increase the clas-sical credibility of the triumphal arch in *St James before Herod Agrippa*.

Mantegna was perhaps the most prominent among the many artists of the mid- to late quattrocento who made drawings of classical sculpture with pretensions towards archaeological accuracy. But even as early as around 1430 the principal artist who drew in the so-called 'Ambrosiana sketchbook' made visually intelligent copies of figures on classical sarcophagi (fig. 56), although he misunderstood the ana-tomical structures of their models and clothed them with flowing, curvilinear draperies in the late Gothic manner. Probably a member of Pisanello's workshop, this draughtsman could, however, have been Gentile da Fabriano, a proposal supported by the evidently classicis-ing figures that Gentile introduced in 1425 into the predella panels of his Quaratesi altarpiece.[20] That the 'Ambrosiana sketchbook' was in use in Pisanello's Rome workshop is verified by studies after a number of sarcophagi that seem always to have been in Rome and after important classical marbles such as the *River Tiber* and one of the Quirinal *Horsetamers*, a drawing perhaps by Pisanello himself.[21] It cannot be claimed that these drawings are 'archaeo-logical' in any exacting sense. They do, however, hint at an evolved

56 (?)Gentile da Fabriano, drawings after classical sculpture (*c*.1427–32). Pen and ink on parchment. Paris, Louvre, Codex Vallardi, 2397v

mode of observation by which a more scrupulous record is made of how the classical sculptor defined anatomical structure and surface musculature. This in turn offers a yardstick against which drawings by the following generations of artists who showed interest in Roman sculpture may be judged.

Benozzo Gozzoli also studied the Quirinal *Horsetamers*, which perhaps were of particular interest to artists since one was apparently 'signed' by Phidias and the other by Praxiteles. In a characteristically Florentine drawing in silverpoint with white heightening on dark blue prepared paper (fig. 57), Gozzoli studied the fall of light over the relief of the human and equine forms.[22] A number of studies after antiquities made by members of his workshop in the so-called Rotterdam sketchbook are similar in technique and purpose.[23] These, such as one after the horse of the *Marcus Aurelius* monument, then located outside S. Giovanni in Laterano in Rome and still widely believed to represent Constantine the Great, are perhaps copies after Gozzoli drawings.[24] Gozzoli certainly made studies of Roman sculpture when he was working with Fra Angelico in Rome for Nicholas V in the late 1440s.[25] One of the finest examples is a detailed drawing (fig. 58), now in Stockholm, of a high-quality Trajanic relief

57 Benozzo Gozzoli, study after the Quirinal *Horsetamers* (*c.*1448). Silverpoint on prepared paper. London, © The British Museum

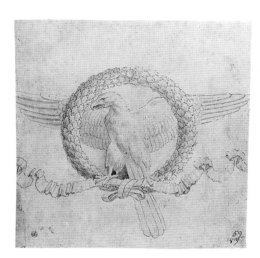

58 (*above*) Benozzo Gozzoli, study after a Trajanic relief (*c*.1448). Pen and ink on paper. Stockholm, Nationalmuseum

59 Benozzo Gozzoli workshop, study after a torso of Venus (*c*.1460). Pen and ink on paper. New York, Cooper-Hewitt National Museum of Design, Smithsonian Institution

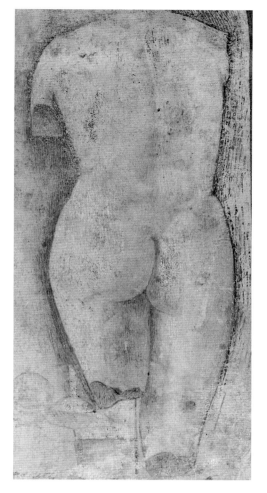

representing an eagle within a laurel-wreath in the portico of SS Apostoli. This study was used as the prototype for the decorative motif on the architecture of Emperor Decius's throne in the fresco of *St Lawrence before Decius* jointly painted by Fra Angelico and Gozzoli in the St Nicholas chapel in the Vatican. The Gozzoli workshop sketchbook also includes several sheets on which drawings of classical architectural details, such as the door-frame of the Pantheon, were copied, again probably after drawings made by Gozzoli in Rome in 1448–9.

Another workshop copy illustrates Gozzoli's developing archaeological instincts. A nude female torso seen from behind (fig. 59) shows

61 Roman, *c.*1460, study after the *Marcus Aurelius*. Pen and ink on paper. Milan, Museo d'arte antica

clearly the points of breakage of the prototype, which was probably a fragmentary classical *Venus*.[26] This drawing brings to mind Mantegna's somewhat later, archaeologically more self-conscious representations of fragments of classical statuary in such paintings as the Vienna *St Sebastian* (fig. 135). At much the same time as Benozzo Gozzoli was making precise copies of classical sculpture in Rome, Filarete cast his *Marcus Aurelius* (fig. 60), the earliest surviving small-bronze replica of a classical statue. According to his own Latin inscription, apparently added when the group was given to Piero 'the Gouty' de' Medici in 1465, this represented the Emperor Commodus.[27] Filarete's archaeological interests here show in his reconstruction of the emperor's windswept cloak and in the way he suggested that the horse's right foreleg and left hindleg were broken above the knee. An early drawing (possibly by Pisanello) of the *Marcus Aurelius* in profile (fig. 61) also shows beneath the horse one of the Egyptian lions that were relocated either during Cristoforo di Geremia's restoration of 1466–8 or later, when under Pope Sixtus IV the monument was set on a new plinth.[28] This drawing is another precocious example of Renaissance artists' increasingly archaeological attitudes to the relics of the civilisation of ancient Rome. A

60 Filarete (Antonio Averlino), *Marcus Aurelius* (*c.*1440–45). Bronze. Dresden, Die Staatlichen Kunstsammlungen

somewhat later and archaeologically more mature group of drawings after classical sculpture is a fragmentary sketchbook, now in Chatsworth, of six sheets (one dated 1467), on which figures, groups and scenes from Trajan's Column were copied. Yet another is a group of pages from a book of drawings after sarcophagi and other Roman reliefs produced by a Central Italian draughtsman now known as the Ambrosiana Master.[29] These drawings are generally dated to around 1460: the collection includes one of the *Marcus Aurelius* before its restoration in 1466–8. Another sheet has copies after details in the *Adonis* sarcophagus, now in Mantua, that was in Andrea Bregno's collection early in the sixteenth century.[30]

A 'book of drawings of Rome, on paper' listed in the inventory of Piero 'the Gouty' de' Medici's library in 1456,[31] but now unfortunately unidentifiable, may have reflected Gozzoli's drawings after the antique and may have shown the way forward to sketchbooks such as the Chatsworth sheets and the Ambrosiana album. This suggests that by the middle of the fifteenth century draughtsmen were assembling books of drawings of antiquities not only for workshop use but also to cater for the acquisitive tastes of collectors or connoisseurs. In turn, this implies a growing interest in the visual culture of ancient Rome parallel in character and date to the work of Flavio Biondo, whose 'archaeological handbook', the *Roma instaurata* of 1444–6, set out to make a textual record of classical buildings and objects.[32] Biondo's book may have provided the sort of intellectual impetus that sharpened the approach to recording the material culture of ancient Rome that pervades Mantegna's mature works. This archaeological spirit prompted Felice Feliciano to dedicate to 'the magnificent Andrea Mantegna, Paduan, the incomparable painter' his 'Inscriptions from the most ancient stones' (*Epigrammaticon ex vetustissimus lapidus*) in which he describes the painter as 'a great lover and student of antiquity'.[33] Mantegna

62 Andrea Mantegna, study after a Trajanic relief (1488–90). Pen and ink on paper. Vienna, Graphische Sammlung Albertina

himself owned drawings like those in the Chatsworth and Ambrosiana Master's sketchbooks: the Florentine connoisseur Andrea Tovaglia asked Ludovico Gonzaga in 1476 to send him a 'book of depictions of certain antique sculptures, which are for the most part battles of centaurs, of fauns and satyrs, and also of men and women on horseback and on foot, and other similar things', or a copy of this book, that he had heard belonged to the painter.[34] A free study after a Trajanic relief (fig. 62),[35] made when he visited Rome in 1488 to decorate a chapel for Pope Innocent VIII, shows Mantegna's increasing artistic sensitivity towards classical form, movement and expression.

Recent analysis of the representation of Jerusalem (fig. 63) in the *Agony in the Garden* predella panel of the S. Zeno altarpiece (1456–9) has demonstrated the clarity of Mantegna's sense of historical time and change.[36] He shows the three sectors of the ancient city divided by successive circuits of walls, as described by Josephus in his *De bellum iudaicum* late in the first century AD. The buildings he represents are, for his time, unusually well-informed reconstructions of what buildings erected at different periods in the urban development of Jerusalem might have looked like. Moreover, he acknowledged not only changes in architectural style but also the effects of the passage of time, and of siege and sack, on the urban fabric. He had a precocious sensitivity for archaeological change and

63 Andrea Mantegna, *Agony in the Garden* (1456–9), detail: townscape. Tempera on panel. Tours, Musée des Beaux-Arts

decay, depicting classical ruins with an almost melancholy sense of the transience of a great civilisation. Mantegna also had an excellently informed understanding of Roman constructional techniques. The pier to which St Sebastian is bound in the Vienna *St Sebastian* (fig. 135), and the arches that spring from it, are constructed of cut and decoratively carved stone fitted over a brick core, a Roman technique first described by Vitruvius in his *De architectura* of around 40 BC. These details in works of the late 1450s show the breadth of scope of Mantegna's already well-developed sense of historical and archaeological accuracy.

Earlier, however, in his frescoes in the Ovetari chapel at the start of the 1450s, Mantegna had already shown his perceptive eye for archaeological detail. In the *St James before Herod Agrippa* (fig. 55), the enthroned king is robed in correctly reconstructed late antique dress, although other features of his apparel derive from different periods.[37] Similarly, the armour is authentic in details but inappropriate: the soldiers' fringed corselets may be derived from drawings of imperial portrait statues and would not have been worn by the foot-soldiers guarding St James. Nor would the armour have been decoratively coloured, as in Mantegna's fresco, at the time of the event depicted. Despite misconceptions, however, Mantegna showed here unparalleled skill in gathering together archaeological details culled from a range of classical sources. He was thereby early in his career already able to reconstruct a more evocative classical past than perhaps any other artist before Raphael.

Mantegna's engagement with the classical past to be seen in details of the *St James before Herod Agrippa* intensified with his move to Mantua in 1460. On the vault of the Camera Picta (1468–74) he painted a series of eight *trompe-l'oeil* stucco roundel busts of Roman emperors (fig. 64).[38] Shown in the classical *imago clipeata* form looking out through wreaths of fruit and flowers, these further demonstrate his ability to revitalise well-known images from the classical past. The trust placed in Mantegna's ability to recreate an authentic classicism is indicated by Federigo Gonzaga's commission in 1483 for a group of urns and vases in the antique style, to be cast probably in silver by the goldsmith Gian Marco Cavalli to Mantegna's designs.[39] Perhaps Mantegna's most ambitious project as an archaeological painter, however, was his reconstruction of a classical imperial victory procession in the *Triumphs of Caesar* (Hampton Court, Royal Collection).[40] For this monumental undertaking he appears to have had access to a range of Latin texts, both classical and contemporary, on triumphal processions: his imagery depends largely on Appian, Plutarch and Flavio Biondo's *Roma triumphans*.

64 Andrea Mantegna, *Emperors Claudius and Nero* (*c.*1470). Fresco. Mantua, Castello, Camera picta, detail of vault

Despite his visit to Rome in 1488, Mantegna's depictions of Roman armour, trophies and other artefacts do not in fact become archaeologically more accurate than the details of military dress in the Ovetari chapel frescoes. Nevertheless, the range and number of artefacts represented suggest both his erudition and his exercise of a fertile imagination in the process of reconstructing the past. The *Triumphs of Caesar* series seems to have had no intended function at the time that work was in progress: the project's apparently gratuitous character suggests that Mantegna was unusually free to undertake a major work for its own sake and to pursue his personal interests. Moreover, it demonstrates his enthusiasm for integrating innumerable studies after classical objects into a recreation in visual terms of a classical celebration. No wonder that he could be described by Isabella d'Este as 'professore de antiquità' in a letter of 28 February 1498.[41]

Perhaps the most engaging account of Renaissance attempts to recapture and recreate the spirit of the classical past is that of the boat trip on Lake Garda in 1464 in which Mantegna was involved.[42]

Mantegna and (probably) a surveyor and engineer named Giovanni da Padova, both acting as consuls, were accompanied by Samuele da Tradate, a Mantuan court official, and Felice Feliciano who wrote the account of their excursion. They 'circled Lake Garda . . . in a skiff properly packed with carpets and all kinds of comforts, which [they] strewed with laurels and other noble leaves, while [their] ruler Samuele played the zither, and celebrated all the while'. Ostensibly the trip had the predictable antiquarian purpose of recording classical inscriptions. But the account suggests that it also became an attempt at an archaeological reconstruction of the life-style of the classical figures whom the four friends sought to emulate. The episode highlights not only Mantegna's aspirations towards humanist learning but also his Paduan antiquarian friends' acceptance of his equal intellectual status.

One of the major difficulties for the archaeologically inclined early Renaissance painter was that his classical sources took the forms almost exclusively of figure- and relief sculpture. For most of the fifteenth century he had very little evidence of how classical painters worked or what their paintings looked like. However, the discovery around 1480 of the Domus Aurea, the Golden House of the Emperor Nero, suddenly made a rich vein of classical decorative motifs available.[43] Painters' enthusiasm for exploring the Domus Aurea interiors, and for recording the motifs for use in their own works, is suggested by the graffiti scratched on to the wall surfaces. Early graffiti include the names of Domenico Ghirlandaio,[44] who may have been among the earliest visitors, because he was in Rome in 1481–2 working on his fresco in the Sistine chapel, and Bernardo Pinturicchio. It is worth seeking to capture in the imagination the difficulties that these artists may have experienced in making the earliest archaeological records of the Domus Aurea decorations. The long and complex sequence of rooms that they explored was buried deep below the surface of the hillside: drawings of the mural decorations had to be made in inauspicious circumstances and presumably under the artificial illumination of torches. The so-called Prospettivo Milanese, who visited Rome in 1500 gave an impression (provided with a dash of exaggeration and improbable attribution) of one such exploration:

> No heart is so hard it would not weep for the vast palaces and broken walls of Rome, triumphant when she ruled, now they are caves, destroyed grottoes with stucco in relief, some in colour, by the hands of Cimabue, Apelles, Giotto. At every season they are full of painters, summer more than winter seems to freshen them, just as the name fresco suggests. They go through the earth with

belly bands, with bread and ham, fruit and wine, so as to be more bizarre when they are with the grotesques, and our guide Master Pinzino makes us bump our faces and eyes, looking to everybody like a chimney sweep, and makes us think we are seeing toads and frogs, owls, baṭs, breaking our backs and knees . . .[45]

Ghirlandaio and such contemporaries as Filippino Lippi and Luca Signorelli adapted the Neronian motifs that they transcribed by interweaving them with quattrocento forms to create personal, hybrid decorative vocabularies. Many drawings demonstrate both these painters' desire to record 'grotesque' motifs, and how they assimilated them into their individual lexicons of decorative forms. Some drawings are straightforward archaeological records, especially those made in albums of copies after the antique. Several copies after Domus Aurea motifs appear in Giuliano da Sangallo's so-called *Taccuino senese* and in his Codex Barberini;[46] and the Ghirlandaio workshop Codex Escurialensis also includes numerous copies.[47] In the very nature of the album, these may well be copies of drawings made by Ghirlandaio himself in the Domus Aurea. The only surviving example of Ghirlandaio's use of a grotesque motif, in the intarsia panelling of St Anne's bedroom in the *Birth of the Virgin* fresco in the Tornabuoni chapel in S. Maria Novella, Florence, dating from around 1490, is strikingly similar to motifs recorded on folio 58 of the Codex Escurialensis (fig. 65). Perhaps the liveliest of the on-the-spot drawings, clearly not intended as exact records but rather as stimuli to his own decorative inventiveness, are by Filippino Lippi, who was in Rome from 1488 to 1493 decorating the Carafa chapel in S. Maria sopra Minerva. Several drawings survive in which Filippino made rapidly sketched copies of 'grotesque' motifs, and some, such as the harpy illustrated in figure 66,

65 Domenico Ghirlandaio workshop, decorative grotesques (*c*.1500–08). Pen and ink on paper. Escorial, Library, Codex Escurialensis, fol. 58

66 Filippino Lippi, studies after the Domus Aurea decorations (1488–93). Pen and ink on paper. Florence, Uffizi

67 Bernardo Pinturicchio, studies after the Domus Aurea decorations (1480–83). Pen and ink on paper. Berlin, Staatliche Museen zu Berlin–Preussischer Kulturbesitz, Kupferstichkabinett

were later adapted for forms used in the decoration of fictive pilasters and friezes in the frescoes of the Carafa chapel and the Strozzi chapel in S. Maria Novella. As noted earlier, the decoration on Filippo Lippi's cenotaph in Spoleto cathedral (fig. 41) also depends on Filippino's recent experience of the Domus Aurea.[48]

Given that a large number of late fifteenth-century drawings after the Domus Aurea grotesques survive, many artists besides Ghirlandaio and Filippino Lippi probably put together their own collections of drawn copies. Pinturicchio's graffito inscription shows that he, too, worked there, and this is clear also from the rapid integration of grotesque forms into the decorative vocabulary that he used in the frescoes of the Bufalini chapel in S. Maria in Aracoeli, Rome, in 1483–5.[49] A drawing by Pinturicchio after the Domus Aurea grotesques (fig. 67) was very probably used for the design of the candelabrum decoration of the fictive pilasters surrounding the Bufalini chapel frescoes,[50] in much the same way as Filippino Lippi was to use such motifs in the Carafa chapel. Vasari notes that Pinturicchio

'painted countless rooms with grotesques' in his (now lost) decorations in the Castel S. Angelo, dating from 1495.[51] Moreover, the contract of 1502 for the decoration of the Piccolomini Library in Siena cathedral lays down that the vault, clearly inspired by the design of the Volta dorata in the Domus Aurea, should be worked 'in the style and design that today they call "grottesche"'.[52] The rich decorative vocabulary used by Luca Signorelli in the fresco decoration of the dado in the Cappella di S. Brizio in Orvieto cathedral, of around 1500, exploits similar grotesque motifs synthesised into a personal formula: satyrs were borrowed from the Volta gialla and goats from the Volta delle civette. The taste for archaeologically accurate decorations emulating the styles of the Domus Aurea murals reached its culmination with Raphael's designs for the decoration of Cardinal Bibbiena's bathroom, or *stufetta*, in the Vatican. Grisaille panels showing such scenes as the *Venus Anadyomene*, a recreation of Apelles' lost painting of 'Venus of Cos', known only from descriptions by Pliny and Cicero, are set into an elaborate grotesque decoration that authentically imitates the forms and colours of the Domus Aurea decorations.[53]

The desires of fifteenth-century connoisseurs to collect faithful, drawn copies of classical antiquities were mirrored at the turn of the century – long after Filarete's precocious, small bronze *Marcus Aurelius* (fig. 60) – by a growing taste for sculptural replicas of celebrated statuary. Shortly after the *Laocoön* was disinterred in 1506 Michelangelo reputedly declared that it was 'a singular miracle of art in which we should grasp the divine genius of the craftsman rather than try to make an imitation of it'.[54] It was, however, copied perhaps as early as 1508 in a now-lost wax model by Jacopo Sansovino, later cast in bronze for the Venetian cardinal Domenico Grimani.[55] In North Italy, too, evidently, the antiquarian spirit of the late quattrocento stimulated sculptors to produce works based on very close attention to, and understanding of, classical sculpture – works that may be described as archaeologically correct. The Mantuan bronze sculptor Pier Jacopo Alari Bonacolsi gained the nickname 'Antico' in tribute to his series of small, bronze copies of celebrated classical statues.[56] Already in the mid-1490s Antico was producing small-scale bronze statuettes of classical statuary in Rome. Several, including (predictably enough) a Quirinal *Horsetamer* and the equestrian *Marcus Aurelius*, but also the *Meleager* now in the Victoria and Albert Museum, are listed in the inventory made after the death in 1496 of Gianfrancesco Gonzaga, Lord of Ródigo.[57] In the following year Antico visited Rome, and on his return to Mantua in 1498 he made the model for a reduced version (fig. 68) of the *Apollo*

Belvedere, which he had seen in Cardinal Giuliano della Rovere's garden at S. Pietro in Vincoli. This required him to reconstruct the left forearm and right hand, missing from the marble until its full restoration by Montorsoli in 1532–3, as shown for example in an engraving from the circle of Marcantonio Raimondi (fig. 21). In 1501 his main patron, Isabella d'Este, acquired from Antico a small bronze modelled on the *Spinario*; and in 1519 he proposed casting for her a set of the small-bronze, modern 'antiquities' that he had earlier made for her uncle by marriage, Bishop Ludovico Gonzaga. This group of bronzes included the *Hercules and Antaeus* in Vienna which is identified as Isabella's in an inscription under its base.[58] Small bronzes such as these were never of course intended to be passed off as antique, but rather to provide the new type of turn-of-the-century collector with replicas that would show off their erudite tastes. They have the same classicising authenticity as the medals of Roman emperors cast in Filarete's Rome workshop earlier in the century, and they demonstrate Antico's growing ability to empathise with the forms and artistic intentions of the classical past.

It was suggested above that such archaeological reconstructions as Filarete's Roman emperor medallions were not intended to deceive or to defraud. However, if Vasari's testimony that Lorenzo Ghiberti 'loved to counterfeit the dies of antique medals'[59] is to be believed, the practice of faking classical antiquities may already have been current early in the fifteenth century. At the end of the century Cardinal Raffaello Riario was taken in by the apparent classical authenticity of Michelangelo's lost *Sleeping Cupid*. Condivi reports that Lorenzo di Pierfrancesco de' Medici suggested to Michelangelo that if he artificially aged his *Sleeping Cupid* he would get a better price for it in Rome as a classical work.[60] After it had been given a fabricated patina and provenance by being buried and 'excavated', the Roman dealer Baldassare del Milanese sold the figure as an antique to Cardinal Riario, but when the latter heard that it was not in fact classical he sold it back. Count Antonio Maria della Mirandola wrote from Rome to Isabella d'Este on 27 June 1496, reporting that the piece was on the market: 'It is held by some to be antique and by others to be modern. Whichever is the case, it is absolutely perfect.'[61] Once she had ascertained that the *Sleeping Cupid* was indeed modern, Isabella lost interest in acquiring it; but coincidentally it was presented to her in 1502 by Cesare Borgia. In 1505 it was joined in her collection by an authentically classical *Cupid*, then attributed to Praxiteles, and the two were displayed together as a *paragone* of ancient and modern. But however archaeologically correct Michelangelo's figure was, the comparison could only favour

68 Antico (Piero Jacopo Alari Bonacolsi), *Apollo Belvedere* (c.1500). Bronze with parcel gilding. Frankfurt-am-Main, Städtische Galerie, Liebighaus

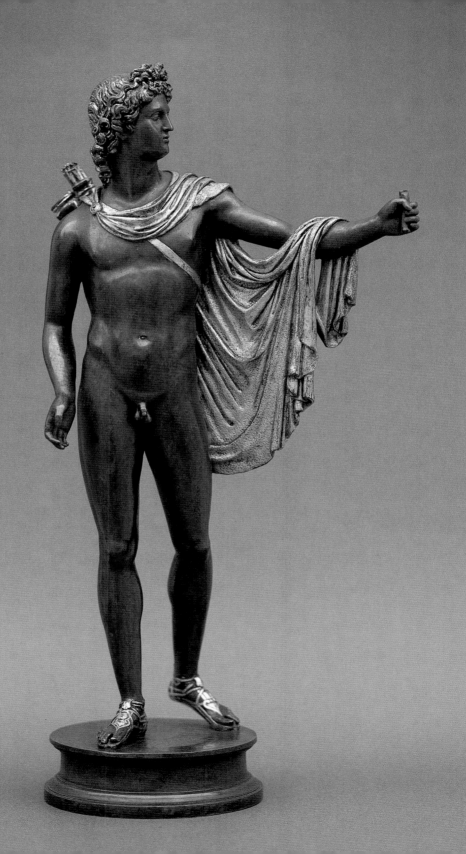

the ancient: although for Isabella Michelangelo's figure 'as a modern piece had no equal', it clearly was not superior to the classical exemplar.

This story of Michelangelo's counterfeited 'antique' is the most celebrated example of the growing trade in 'pseudo' antiquities that grew as the demand for (and therefore the prices of) classical sculptures rose rapidly later in the fifteenth century. Few, however, of these 'new' antiquities were probably intended to deceive collectors. Like Lysippus the Younger, the Venetian Gian Giorgio Lascaris self-consciously adopted a classicising nick-name, calling himself 'Pyrgoteles' after the famous gem-cutter who had held sole rights to carve gemstone portraits of Alexander the Great. In the mid-1490s he carved a marble group of *Venus Flagellating Cupid* based on a painting by Apelles described in a late antique poem.[62] Venice was a significant centre for this activity, and an important group of sculptures was being produced there in the early to mid-1490s by the Milanese carver Cristoforo Solari and by Tullio Lombardo.[63] Two statuettes by Solari, a *Venus* and what must have been an early version of the *Apollo Belvedere*, based perhaps on a derivative clay model, were recorded in Venice in 1494. Given their reduced scale, these were presumably not intended to be passed off as antiques, but, like Antico's bronzes for Bishop Ludovico Gonzaga, they provided for collectors' increasing desire for small-scale replicas of well-known classical statues.

Apparently 'classical' portrait busts were also popular among collectors, and debate continues to this day as to whether a bust of Marcus Aurelius (fig. 69) now in the Museo Archeologico in Naples is authentic or was carved by Tullio Lombardo.[64] During the 1490s Tullio developed a more 'academic' and more impersonal *all'antica* style than perhaps any of his contemporaries. It may have been within his circle that a group of portrait busts bequeathed to the city of Venice by Cardinal Giovanni Grimani in 1586, and now classified as 'pseudo-antique', were carved in a consciously neo-classical style. Carvings like these were probably seen by both sculptor and collector as classicising substitutes for genuine but costly antiquities. A 'modern' classicising bust could also offer a *paragone* with an ancient model. Antico was responsible for casting, perhaps for Bishop Ludovico Gonzaga, four bronze busts of Roman emperors to match a group of four classical marble busts; and Isabella d'Este, too, had Antico cast 'classical' busts in bronze to compare with authentic, Roman busts in her collection.[65]

The Renaissance sculptor's increasingly archaeological engagement with classical sculpture was stimulated by the tendency among later

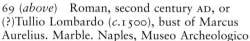

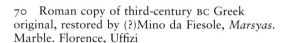

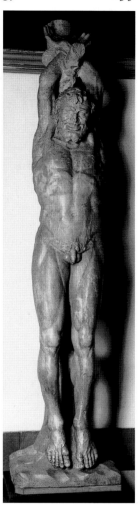

69 (*above*) Roman, second century AD, or
(?)Tullio Lombardo (*c.*1500), bust of Marcus
Aurelius. Marble. Naples, Museo Archeologico

70 Roman copy of third-century BC Greek
original, restored by (?)Mino da Fiesole, *Marsyas*.
Marble. Florence, Uffizi

fifteenth-century collectors to have statuary restored. Cristoforo di
Geremia's restoration of the *Marcus Aurelius* of 1466–8 is perhaps the
first certain example. However, Vasari wrote, perhaps on good
authority, that 'Donatello also restored an ancient statue of Marsyas
in white marble, which was placed at the entrance to the garden [of
the Palazzo Medici]; and very many antique heads, which were placed
over the doors, were restored and embellished by him'.[66] The upper
half of a marble *Marsyas* (fig. 70) that belonged in the fifteenth century
to the Medici, and is now in the Uffizi, was radically restored in the
quattrocento. This is not the 'gnudo rosso' listed in 1496 among work

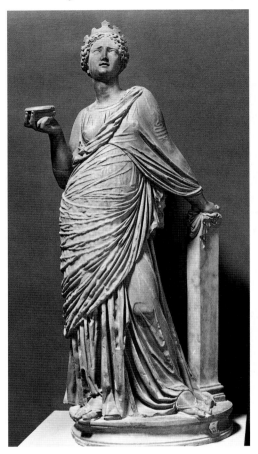

71 Hellenistic, restored by (?)Tullio Lombardo (early 1490s), *Muse of Philiskos*. Marble. Venice, Museo Archaeologico

done by Andrea del Verrocchio for the Medici and for which (so his nephew Tommaso claimed) he had never been paid, but rather the white marble 'Marsyas' that Vasari said that Donatello had restored for Cosimo de' Medici, although the restoration has recently been persuasively reattributed to Mino da Fiesole.[67] In 1512 Isabella d'Este negotiated with Niccolò and Giovanni Bellini to buy from them a classical bust of Plato that had been restored 'with the tip of the nose of wax': this wax restoration may have been carried out in the Bellini workshop, if the bust was among 'the works in plaster, marble and relief' bequeathed to Gentile Bellini by Jacopo's wife, Anna Bellini, in 1471.[68] While artists like Mantegna and Benozzo Gozzoli seem to have appreciated the resonances of classical marbles in a fragmentary state, collectors often preferred their statues complete. Completing them required special sensitivity from the sculptor-restorer who had to carve the pieces to be attached in such a way that they would not contrast stylistically with the original. A Hellenistic *Muse of Philiskos* (fig. 71), now in the Museo Archeologico in Venice, was restored around 1492–3 probably by Tullio Lombardo, to judge by the expressive head that was added in the restoration. Closely based on a Hellenistic style to match the style of the torso, this head was provided with attributes that reconstitute the figure as 'Cleopatra'.[69] Just as Antico had to reconstruct the missing parts of the *Apollo Belvedere* in his bronze statuette, so from the middle of the first decade of the sixteenth century he was much employed by Isabella d'Este to restore classical statuary in her collection.

Drawings and prints made after celebrated classical works also

72 Giovanni
Antonio da Brescia,
Belvedere Torso
(*c*.1515). Engraving.
London, © The
British Museum

sometimes propose 'reconstructions' of antiquities. An engraving (fig.
72; compare fig. 36) of around 1515 by Giovanni Antonio da Brescia
shows the *Belvedere Torso*, probably by that date in the possession
of the Colonna family, with two fully 'restored' legs.[70] The art dealer
Giovanni Ciampolini owned the fragmentary lower half of a
colossal Roman statue of *Jupiter* (fig. 73), now in Naples, which was
restored at some time before 1500 as a seated woman holding a
mirror. The drawing of this piece in the Codex Escurialensis shows
it yet unrestored, but the anonymous writer known as the
Prospettivo Milanese described it around 1500 as 'a nude that is
seated enveloped in a veil save for the left foot', and it appears thus
in a drawing by Amico Aspertini (fig. 74).[71] A classic example of the
restoration of a major piece of Roman sculpture is the *Laocoön*. Even
before the group had been completely disinterred, Giuliano da
Sangallo, Michelangelo and Giancristoforo Romano were called

74a and b (*above and top right*) Amico Aspertini, study after *Jupiter* (restored in the early sixteenth century), and detail. Pen and ink on paper. Wolfegg (Baden-Württenberg), Schloss Wolfegg, Codex Wolfegg, fol. 46v

75 Raphael, study of Roman ruins (*c*.1512). Silverpoint on prepared paper.
The Royal Collection © Her Majesty Queen Elizabeth II

73 (*facing page top left*) Roman, of Hellenistic type, *Jupiter* (fragment).
Marble. Naples, Museo Archeologico

together in 1506 to advise Pope Julius II on its restoration. Early engravings of the group, such as those by Giovanni Antonio da Brescia and Marco Dente,[72] offer inventive suggestions on restoring the missing limbs, and a wax right arm bent at the elbow so that the forearm was held vertically upwards was added to the figure of Laocoön himself in a preliminary restoration of the early 1520s by Baccio Bandinelli.[73]

In 1515 Raphael was appointed 'prefect of antiquities' by Pope Leo X and was commissioned to survey and to chart the classical monuments of Rome. This project emphasised the need to record buildings, rather than paintings and sculptures, with a view to preservation, since their building materials were (and continued to be) highly vulnerable to reuse as Rome developed in size, wealth and prestige. The appointment is a significant indication of the intellectual status that the painter Raphael had attained in papal Rome. After his death he was praised in particular for his abilities as a scholar and as an 'archaeologist' in the modern sense of the term.[74] In his letter to Leo X, probably written in 1519, he sets out his 'archaeological method', which demonstrates his extensive study of Roman monuments, his techniques of surveying and representing them, and his careful, analytical reading of classical texts. Raphael was the first – indeed, before the late nineteenth century the only – scholar to have distinguished clearly, by stylistic comparison, the three phases of work on the Arch of Constantine: in his celebrated letter he defined the arch itself as Constantinian, and the reliefs as belonging to three different periods, those of the emperors Trajan, Antoninus Pius and Constantine. Raphael's nostalgic sensitivity to the past is suggested by a drawing of Roman ruins at Windsor (fig. 75). His concern for understanding and being able to recreate the particular qualities of classical sculpture is suggested by a red chalk drawing after one of the Quirinal horses, in which careful measurements and proportional relationships are mapped out over the surface.[75] As noted earlier, Raphael's decoration of the Bibbiena *stufetta* is perhaps the most archaeologically correct of the many examples of the reuse of the Domus Aurea grotesques in the Renaissance. Although hardly started by the time of his death, the survey of ancient Rome remains, however, the outstanding case of Raphael's engagement with the antiquities of Rome. It was, moreover, the culmination of the growth of archaeological – as opposed to antiquarian – investigation by early Renaissance artists. By engaging more and more in these activities, painters and sculptors sought to enhance their understanding of the principles of classical art, and hence the extent to which they were perceived as scholars by their patrons and their intellectual peers.

Image and Text: The *Paragone*

This chapter and the following three offer discussions of aspects of the relationships between early Renaissance images and art-theoretical and other texts. The principal issue that runs through these discussions is: in what ways did the Renaissance artist respond to written texts, or engage with theoretical or intellectual questions relevant to his art practice that were also discussed in writings of the time? Issues raised in early Renaissance art theory have been extensively discussed in the literature and do not need much rehearsal here. The focus of this chapter will be on artists' contributions to such debate both in their own writings but more pointedly in their painting and sculpture.

There is little evidence that artists themselves were much concerned about theoretical or intellectual issues during the first half of the fifteenth century. There are, for example, no surviving writings by artists, beyond the occasional letter, between Cennini's *Craftsman's Handbook* of the 1390s, which is in intention a primer in good practice for the painter, and Ghiberti's ground-breaking *Commentaries* (*c.*1450). Although not of high literary merit, this is a remarkable text that combines the first coherent history of Italian art, the first artistic autobiography and the first attempt by an artist to discuss in words some of the intellectual and scientific principles of the visual arts, notably optics. A new theoretical grounding for the art of painting was provided in *On Painting* by Alberti, who had a university education and was skilled in a range of intellectual activities. Writings by humanists and others about art and artists sometimes show a recognition that painting and sculpture deserve the enhanced status of liberal arts. This acknowledgment was much encouraged by Alberti's treatise, especially its first version, *De pictura*, written in Latin in 1435 for an educated readership at the court of Mantua. In the late fifteenth century artists themselves occasionally took up the pen to write on the theory or the practice of their arts. They sometimes attempted to gain footholds on the intellectuals' territory by

writing poetry, and in their practice they responded imaginatively to an increasing range of written texts, both classical and contemporary. These examples of artists' growing responsiveness to theoretical and intellectual questions increasingly interweave and overlap as the early Renaissance unfolds.

In the notes for his unwritten Treatise on Painting, Leonardo da Vinci makes the case for the superiority of painting over all other 'sciences' because it is inimitable:

> Those sciences that are imitable are of such a kind that through them the disciple can equal the master . . . [these] are not of such excellence as those that cannot be passed down in this way as if they are heritable goods. Amongst these, painting has first place. It cannot be taught to someone not endowed with it by nature, as can be done with mathematics . . . It cannot be copied as can writing, in which the copy has as much worth as the original. It cannot be reproduced as can sculpture, in which the cast shares with the original the essential merits of the piece. It cannot produce infinite offspring, like printed books. Painting alone retains its nobility, bringing honours singularly to its author and remaining precious and unique . . . such singularity gives it greater excellence than those things that are spread abroad.[1]

The question of the *paragone* between painting and sculpture – which of the two was the superior art, and why – had become a formal debate by the middle of the sixteenth century. In 1546 the Florentine Benedetto Varchi attempted to settle the issue in his lectures on the *paragone*. His views were in part based on the responses he received to a letter he had circulated to a number of leading artists of his day, asking for their opinions on the matter. But various contributions had been made to the discussion by writers on the visual arts, and by some artists themselves through their works, over the 150 or so years before this time. Inevitably, there is classical authority for the discussion. Philostratus the Elder, for example, in the introduction to his *Imagines*, written in the third century AD, claims that by exploiting colour, painting can achieve more than the three-dimensional medium of sculpture.[2] Quattrocento contributions suggest that the *paragone* had once again become an issue of some importance amongst intellectuals concerned with the visual arts. Moreover, the writings of artists themselves, and images recorded in their works, suggest that they understood it to be an issue that deserved artistic exploration.

The noteworthy early fifteenth-century developments that seem to have inspired Alberti to write *On Painting* took place in Florence,

principally – and paradoxically – in sculpture. This is in a sense acknowledged by the list of artists cited by Alberti as Brunelleschi's co-dedicatees of the vernacular translation of his treatise, *Della pittura*, for it comprises three living sculptors and one dead painter. One of Alberti's main aims in *On Painting* was, therefore, to redress this imbalance by asserting the primacy of painting over sculpture. This he sought to accomplish by developing a theoretical and intellectual foundation on which painters could build. But painters depended on sculpture to provide models for their study of the human figure to a degree that sculptors seldom depended on paintings. The higher status that sculpture apparently enjoyed, however, stimulated and was offset by powerfully expressed and keenly argued views about the greater versatility and naturalism of painting as an art form. Some painters in particular were eager to claim the superiority of their art by demonstrating how it could imitate and indeed improve on qualities and effects special to sculpture.

Much of the debate on the *paragone* that survives from the early Renaissance was conducted by the painters and sculptors themselves, either in words or through their artistic works. An important contribution to the debate that comes in a text written by an eminent man of letters, Baldassare Castiglione, is therefore especially significant. *The Book of the Courtier* was not published until 1528, but Castiglione started to write it around 1508, purporting to record intellectual discussion at the Montefeltro court at Urbino in 1506. A section of the dialogue between Emilia Pia, Count Lodovico da Canossa and the Mantuan court sculptor Giancristoforo Romano revolves around the *paragone* between painting and sculpture. Count Lodovico raises the issue at the end of his discussion of the respect in which painting and painters were held in ancient times:

> if the statues which have come down to us are inspired works of art we may readily believe that so, too, were the paintings of the ancient world; indeed, they may have been still more so, because they required greater artistry.[3]

This challenge is taken up by Giancristoforo Romano who maintains that sculpture requires more effort and skill than painting, produces a more faithful imitation of Nature because it is in three dimensions, and cannot be gone over again if a mistake is made in the carving process. Count Lodovico presents the arguments in favour of painting – that it is superior for decorative purposes since it includes light and shade, colour, atmosphere and expressive accents not available to the sculptor. Moreover, the painter has to exercise skill greater

than the sculptor's in showing perspective and foreshortening, and in presenting convincingly on a flat surface a range of motifs not available to the sculptor – metallic gleam, the darkness of night, weather conditions, varied landscape forms and so on. Presumably these arguments confounded Giancristoforo Romano, for the discussion moves directly on to the importance for the courtier of a knowledge of painting without further contributions on the relative superiority of painting or sculpture as art forms.

The arguments offered on both sides of the case are familiar from earlier discussions of the *paragone* between sculpture and painting. At much the time that *The Book of the Courtier* was being drafted, painters themselves engaged with the question, seeking to demonstrate that their art could illusionistically achieve results proper to sculpture. Conversely, in their practice, too, some sculptors sought expressive effects more appropriate to paintings when generating examples of the superiority of sculpture. But more significant is that as well as being artistically problematical the *paragone* issue had evidently gained an intellectual respectability by the early sixteenth century. It had become a matter worthy of discussion by intellectuals and courtiers, and this paved the way for Benedetto Varchi's attempt several decades later to solve the issue by appeal to common consent.

'Is it not true that painting is the mistress of all the arts or their principal ornament?', Leon Battista Alberti had already written in *On Painting*:

> The stonemason, the sculptor and all the workshops and crafts of artificers are guided by the rule and art of the painter. Indeed, hardly any art, except the very meanest, can be found that does not somehow pertain to painting. So I would venture to assert that whatever beauty there is in things has been derived from painting.[4]

In Naples, twenty years later, Bartolomeo Fazio recapitulated Alberti's ideas when he in turn wrote: 'what is true of painting is also true of carved and cast sculpture and of Architecture, all of which crafts have their origins in painting; for no craftsman can be excellent in these branches of art if the science of painting is unknown to him'.[5] Alberti, of course, had a polemical purpose in advancing so strongly the cause of painting as his preferred rival to sculpture or the other arts. Speaking, as he says at several points in the treatise, 'as a painter', he was evidently not unprejudiced in his views. Ghiberti wrote that 'for the sculptor and the painter, drawing is the foundation and the theory of both arts',[6] but for Alberti both derive from the artist's 'genius': 'Painting and sculpture are cognate arts,

nurtured by the same genius. But I shall always prefer the genius of the painter, as it attempts by far the most difficult task'.[7] Further emphasising the relative difficulty of painting, he added that when studying the practice of painting, 'it will probably help also to practise at sculpting rather than painting, for sculpture is easier and surer than painting. No one will ever be able to paint a thing correctly if he does not know its every relief, and relief is more easily found by sculpture than by painting'.[8]

In his treatise *On Sculpture* (*De statua*), written around 1450, Alberti advanced no comparable arguments in favour of the superiority in any respect of sculpture over painting. Perhaps surprisingly, nor did Ghiberti make any such claims in his *Commentaries*, although his remark at the very end of the autobiographical section that 'I have made many preparatory models of wax and clay, and drawn a great many things for painters'[9] may be understood as a gentle reminder of the sculptor's importance for the painter. But Ghiberti is also an important example of a relief sculptor who responded to the concern with the geometrical basis of picture-making that developed during the second and third decades of the fifteenth century, and which was later encoded in theory by Alberti in *On Painting*. The contrast between the traditional, essentially late Gothic system of construction used in the reliefs of his first doors for the Baptistery in Florence (fig. 76a), and the frank pictorialism of the reliefs for his second doors (fig. 76b) – the so-called 'Gates of Paradise' – shows how much Ghiberti was affected by new principles of the art of painting then being developed in the circle of Brunelleschi, notably in the work of Masaccio. Indeed, his consciousness of these questions is indicated by his departure from the programme that had been proposed by the eminent humanist and Chancellor of Florence, Leonardo Bruni, in 1426.[10]

Bruni had provided a list of subjects for twenty narrative reliefs and eight figures of prophets. This shows that he was thinking in terms of a pair of doors that would follow the pattern established nearly a century earlier in Andrea Pisano's doors, and adopted for Ghiberti's first doors at the time of the competition in 1401. But in his *Commentaries* Ghiberti states that despite this programme, which Bruni presumably devised at the request of the Clothworkers' Guild (Arte di Calimala), the Baptistery patrons, he 'was given permission to carry it out in the way I thought would turn out most perfectly and most richly and most elaborately . . . I tried in every way to be faithful in seeking to imitate nature as far as was possible to me'.[11] Clearly one way he did this was to suggest, anticipating Alberti, that the bronze panels were 'an open window through which the subject

76a Lorenzo Ghiberti, *Christ among the Doctors* (c.1404–7). Bronze. Florence, Baptistery, North Doors

76b Lorenzo Ghiberti, *Story of Isaac* (c.1435). Bronze. Florence, Baptistery, East Doors

to be [represented] is seen'.[12] Rather than building up figures in high relief against a flat surface, which was essentially his practice in his first set of doors, Ghiberti set out to generate perspectivally projected spaces for his figures in much the same way as Masaccio had done in his paintings of these same middle years of the 1420s. In generating this new type of pictorial relief, Ghiberti anticipated Leonardo da Vinci's comments on low relief sculpture, although he would hardly have agreed with Leonardo's opinion:

> The sculptor says that low relief is a form of painting. This may be in part conceded as far as drawing is concerned, because it participates in perspective. As far as light and shade are concerned low relief fails both as sculpture and as painting, because the shadows correspond to the low nature of the relief, as for example in the shadows of foreshortened objects, which will not exhibit the depth of those in painting or in sculpture in the round. Rather, the art of low relief is a mixture of painting and sculpture.[13]

Like Ghiberti, Donatello too was striving for pictorial effects in his relief sculpture of the 1420s. The *Feast of Herod* relief on the Siena Baptistery font, modelled at about the same time as Ghiberti was starting work on the designs for the reliefs of his second Baptistery doors, is an early manifesto of Brunelleschian perspective. Moreover, it shows in a masterly way how geometrical spatial construction can be exploited in the interests of pictorial narrative. In this respect, too, Donatello's treatment of relief anticipates both Ghiberti's narrative method and Alberti's evolved theory of picture-making in *On Painting*. Donatello developed a second technique, the so-called *rilievo schiacciato* ('squashed relief'), for making his sculptural reliefs more like monochrome paintings. Leonardo da Vinci later asserted that 'the perspective used by sculptors [in reliefs] never appears correct, whereas the painter can make a distance of one hundred miles appear in his work. Aerial perspective is absent from the sculptors' work'.[14] When writing this he clearly did not bring to mind Donatello's *Ascension and Giving of the Keys to St Peter* (fig. 77), for here the sculptor had proleptically challenged Leonardo's view by creating a convincing, deep landscape recession through subtle grading of the depth of the relief which is used to suggest the tonal change of aerial perspective.

In this way Donatello showed that relief sculpture can suggest effects of landscape space and atmosphere. Ghiberti sought to achieve something similar in his 'Gates of Paradise' panels, grading spatial depth both through varying the height of relief and through proportional diminution – though this was possible only up to a point,

77 Donatello, *Ascension and Giving of the Keys to St Peter* (*c.*1428–30). Marble. London, Victoria and Albert Museum

beyond which the narrative meaning of subsidiary scenes would become invisible. But these two approaches to pictorial relief, and especially Donatello's highly subtle carving technique, made little impression on sculptural practice. Desiderio da Settignano carved a few *schiacciato* reliefs, but in general sculptors found, perhaps, that the result did not justify the time and effort involved – either artistically or commercially. *Rilievo schiacciato* may be a means to approach the painter's achievements in atmospheric landscape, but it still lacks the element of colour through which the painter can achieve infinitely subtle and expressive effects. Polychromy was seldom a viable option for the sculptor. Bright, colourful pigmentation of sculpture is acceptable for devotional madonnas in terracotta or stucco and could also be used to enhance the legibility of narrative reliefs located at a distance from the viewer, as in Donatello's roundels in the Old Sacristy of S. Lorenzo, Florence. But the application of gesso and pigment was not appropriate for finely carved marble (let alone for bronze) reliefs, because it has a coarsening effect on the surface. Much of the fine detail of the carefully graded relief of the *Ascension and Giving of the Keys to St Peter* would have been rendered redundant if it had been polychromed. Despite Donatello's masterly attempts, sculpture could not hope to rival the possibilities offered by painting in this field.

 When in 1546 Benedetto Varchi issued his appeal to major artists of his day for evidence that might enable him finally to decide the *paragone* issue one way or the other, the debate had become rather stale through overwork. But in the hundred or so years after Alberti's initial statement of his preference in *On Painting*, it was an issue of some interest to artists and their patrons. It was pursued both in

written form and in aspects of artistic practice in which both painters
and sculptors sought to demonstrate the superiority of their art in
rivalling the other on its own ground. This suggests that, although
the debate may seem somewhat vacuous to us today, it did engage
the intellectual energies of many Renaissance artists. The presenta-
tion of their arguments offered them opportunities to show their
prowess in intellectual discourse, as well as in the practice of their
art.

Faithful to his concern that he should be taken seriously as a writer
and theoretician, Filarete contributed to the *paragone* debate in his
Treatise on Architecture (c.1460–64).[15] In the light of the intellectual
complexity of the theoretical debate that developed later, however,
much of his discussion and many of his arguments have a rather naïve
quality. In a section of dialogue between the writer and the Duke of
Milan, Filarete takes up the *paragone* theme by proposing further
arguments to those that Alberti had advanced some twenty-five years
earlier. Surprisingly, though, given that he was by training a bronze
sculptor, Filarete does not seek to press the case for the superiority
of sculpture. He puts these arguments into the duke's mouth, while
himself responding at greater length in favour of painting. The duke
declared that he was

> under the impression that drawing and carving in marble or bronze
> was much worthier than painting, since [if] someone carving a
> figure in marble might well happen to have a bit of the nose or
> some other element break off, as it can happen sometimes that a
> piece is knocked off, how can he repair the figure? But a painter
> can cover up with colours, and patch things up even if they were
> spoiled a thousand times . . .

Without objecting disloyally to the duke's arguments, Filarete
develops others as he replies:

> Your lordship speaks truth, for carving in marble is a matter of
> great mastery. In . . . aiming to counterfeit those colours that nature
> makes, [paintings] are great things too. For however good they are,
> [sculptures] always seems to be of the material they really are, but
> what is painted seems to be the actual thing.

Citing well-known anecdotes, both classical and more recent ones,
that describe the deceptiveness of paintings, Filarete concluded that
'this is based on the knowledge of applying colours in the right places,
and such miracles are not seen in sculpture.' These two ideas – that
unlike paintings carved sculpture cannot be corrected, and that paint-
ing is more deceptively realistic because of its coloration – fuelled the

debate that Leonardo da Vinci conducted with himself in numerous notes and drafts for inclusion in the Treatise on Painting.

'Applying myself to sculpture no less than to painting, and practised in both to the same degree', Leonardo wrote, 'it seems to me that I am able to form a judgement about them with little prejudice, indicating which of these two is of greater insight, difficulty and perfection.'[16] His prejudice in favour of painting becomes very clear in the notes for the discussion that was to have followed this preamble. He advances too many arguments to be repeated here: a sample must suffice to suggest the intellectual force of Leonardo's case. Some of them are fairly banal: for example, painting demands more of the intellect if only because carving imposes physical demands on the sculptor. The latter 'undertakes his work with greater bodily exertion than the painter, and the painter undertakes his work with greater mental exertion'; and 'Sculpture is not a science but a very mechanical art, because it causes its executant sweat and bodily fatigue.' Most of Leonardo's arguments are, however, intellectually more considered than this. As elsewhere in his projected treatise, in this discussion (repetitive thought it is) he demonstrates his high level of articulacy on artistic matters. He also shows that he had an intellectually well-founded understanding of the theoretical and practical issues surrounding art production at the turn of the century. He repeats the Duke of Milan's argument in Filarete's *Treatise*, but unlike Filarete he has a riposte:

> The sculptor says that if he removes more marble than he should, he cannot rectify his error as can the painter. To this it is replied that someone who removes more than he should is not a master, because a master is required to understand the true science of his profession . . . We well know that someone with practised skill will not make such errors. Rather, obeying good rules, he will proceed by removing so little at any time that he takes his work along smoothly.[17]

The intellectually most sophisticated part of the discussion revolves, however, around what each art can and cannot represent. Anticipating Count Lodovico's arguments in *The Book of the Courtier*, Leonardo points out:

> The art of painting embraces and contains within itself all visible things. It is the poverty of sculpture that it cannot do this; namely, show the colours of everything and their diminution with distance. Painting shows transparent objects, but the sculptor shows you the things of nature without the painter's artistry.[18]

Painters can show rain, cloudy mountains and valleys; rivers of greater or less transparency; the stars above us; and 'innumerable other effects to which the sculptor cannot aspire'. Sculptors, on the other hand, 'cannot depict transparent bodies, nor can they represent luminous sources, nor reflected rays, nor shiny bodies such as mirrors and similar lustrous things, nor mists, nor dreary weather – nor endless other things'.

Low-relief sculpture, Leonardo concedes, involves 'more intellectual considerations than sculpture in the round . . . because it is indebted to perspective'. But figure sculpture does not require the understanding of geometry and perspective that most writers agreed was a primary need of the painter. It can therefore be learned more quickly by a painter than painting can by a sculptor. The figure sculptor, writes Leonardo,

> has to make each figure in the round with many contours so that the figure will look graceful from all viewpoints . . . but in truth this requirement cannot be said to rebound to the credit of the sculptor, considering that he shares with the painter the need to pay attention to the contours of forms seen from every aspect. This consideration is implicit in painting just as it is in sculpture;

and further

> The sculptor . . . cannot produce the required figure . . . if he does not move around it, stooping or rising in such a way as to see the true elevations of the muscles and the true gaps between them . . . In this is said to reside the mental effort of sculpture . . . [the sculptor] does not need any measure of mental activity – or we may say judgement – unless in rectifying the profiles of the limbs when the muscles are too prominent.[19]

In this, of course, lies the principal challenge of sculpture to painting: as Giancristoforo Romano put it in *The Book of the Courtier*,

> I still do not understand how you can maintain that what is real and is Nature's own creation cannot be more faithfully copied in a bronze or marble figure, in which all the members are rounded, fashioned and proportioned just as Nature makes them, than in a picture, consisting of a flat surface and colours that deceive the eye.[20]

The challenge to the painter was to rival sculpture in its own field – that of generating three-dimensionality of form and plasticity of surface. One way in which this might be achieved was in representing the relief surface with a full range of tonality. Sebastiano del

Piombo worked to Michelangelo's drawings in the *Raising of Lazarus* (London, National Gallery) by exploiting the rich tonality of a Venetian palette. He was thereby able to put into practice the view that Michelangelo later expressed, that painting could be excellent only in so far as it approached the quality of sculpture by possessing *rilievo*. Raphael's response to Sebastiano's challenge in his *Transfiguration* (Vatican, Pinacoteca) was to take up and extrapolate from Leonardo's *sfumato* and his technique of working down to the depths of shadows, with the result that the overall tonality of his works was deepened.[21] In *The Book of the Courtier* Castiglione puts into Giancristoforo Romano's mouth the aphorism about Raphael that 'the excellence you perceive in his work as a painter is so supreme that it cannot be rivalled by any sculpture in marble',[22] although one may doubt if this view of the ultimate superiority of painting was indeed held by the sculptor. It turns on its head Michelangelo's view that painting could at best be only a partial, impoverished imitation of sculpture. Raphael's excellence was at least in part due to his adoption of Leonardo's *sfumato* and use of deeper tonalities. Castiglione also suggests that the painter shows his superiority by his knowledge and understanding of light and shade, and foreshortening. This idea perhaps followed Leonardo's lead, for the creation of relief using light and shade was for Leonardo one of the primary tasks of the painter. Later, Lomazzo suggested that it was through exploiting his 'dark manner' that Leonardo could 'do everything that nature herself can do'.[23] This, too, echoes Castiglione's discussion of the effects that can be achieved in painting but not in sculpture:

> Nature's colours can be reproduced in flesh-tints, in clothing and in all the other objects that are coloured in life . . . still less can [the sculptor] depict the love-light in a person's eyes . . . , the colour of blond hair; the gleam of weapons; the darkness of night; a tempest at sea; thunder and lightning; a city in conflagration; or the break of rosy dawn with its rays of gold and red. In short, it is beyond his powers to depict sky, sea, land, mountains, woods, meadows, gardens, rivers, cities or houses; but not beyond the powers of the painter.[24]

It was not until the early sixteenth century that defenders of sculpture, stung perhaps by critical arguments such as those advanced by Leonardo da Vinci, began to promote those characteristics that make sculpture superior to painting. Benedetto Varchi's academic investigation was shortly followed by Vasari's careful compromise in the first edition of his *Lives* (1550), repeated almost verbatim in the edition of 1568. Vasari chose not to commit himself as to the rela-

tive superiority of the two arts, reverting to Ghiberti's view on the primacy of drawing when writing that 'Design [*disegno*] . . . is the foundation of both these arts [i.e. sculpture and painting], or rather the animating principle of all creative processes'.[25] Perhaps the last recorded word on the *paragone* theme before this masterly balancing act was that of the Venetian sculptor Tullio Lombardo. In a letter of 18 June 1526 to Marco Casalini of Rovigo, Tullio wrote:

> painting is an ephemeral and unstable thing, while sculpture is much more incomparable and not to be compared in any way with painting, because the sculpture of the ancients can be seen up to our time, while of their painting there is really nothing to be seen.[26]

This echoes discussion in *The Book of the Courtier*, where the count suggests that 'if the statues which have come down to us are inspired works of art we may readily believe that so, too, were the paintings of the ancient world.'[27] But this is not intellectually a particularly powerful case in favour of sculpture. The need to cite it suggests that the arguments advanced by Leonardo in his observations, and by Raphael and others in practice, had prevailed. Indeed, Leonardo had considered and refuted this argument too, maintaining that the durability of sculpture derived merely from its material, not from the art that went into its carving.

During the fifteenth and early sixteenth centuries statements were made about the *paragone* between painting and sculpture not only in written form but also in artistic practice itself. Indeed, the theoretical concern with the issue can be partly associated with the growing use of sculptures as prototypes for painting both in workshop drawing practice and in finished works. Only a few of the arguments set down in words could be usefully applied in artistic practice. Nevertheless, they suggest that a number of artists besides Leonardo da Vinci grappled with theoretical questions raised by the *paragone* debate. Donatello's reliefs carved in his *schiacciato* technique were made to appear to be monochrome paintings. Mantegna conversely produced monochrome paintings that deliberately imitated relief sculpture. This practice doubtless developed in part through his preoccupation with classical sculpture, and perhaps also in part because of his excellence in depicting materials, which itself depended on his immaculate painting technique. Early examples of his growing skill in imitating relief sculpture come in the *Circumcision* (Florence, Uffizi) where overdoor lunettes on Old Testament themes appear to be bronze reliefs.[28] Later in his career Mantegna made a group of independent easel paintings that deliberately imitated bronze sculp-

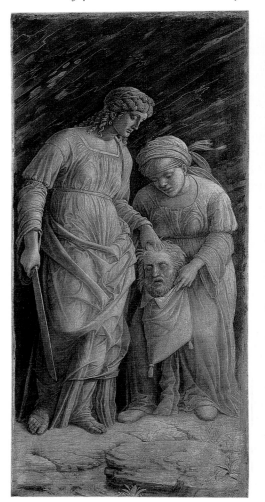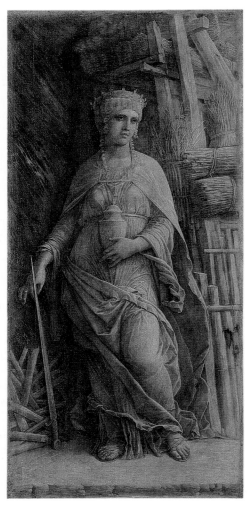

78 Andrea Mantegna, *Judith* and *Dido* (*c*.1490–1500). Distemper on linen. Montreal, Museum of Fine Arts

ture. His *bronzi finti* for Isabella d'Este, which must have closely resembled the pendants of *Judith* and *Dido* (fig. 78), and Antico's parcel-gilt bronzes, such as the later recast of Bishop Ludovico Gonzaga's small bronze *Apollo Belvedere* (fig. 68), must indeed have complemented each other in Isabella's *grotta*. There is here surely a deliberate *paragone*: using shell-gold over a brown underpaint to

model his forms sculpturally, Mantegna emulated in painting very much the effects achieved by a bronze sculptor like Antico.[29]

Mantegna's painted bronze 'reliefs' extrapolate both from the 'reliefs' in the Uffizi *Circumcision* and, more generally, from his earlier interest in suggesting direct comparisons between his painted figures and classical marble statuary. In his Vienna *St Sebastian* (fig. 135) Mantegna seems deliberately to compare the structure of the saint's anatomy with the torso and head fragments of classical sculpture prominently placed in the left foreground. The sharp angularity of the saint's face suggests that Mantegna might even have had in mind Alberti's comment, in his discussion of the 'reception of light', that 'In painting I would praise . . . those faces which seem to stand out from the pictures as though they were sculpted . . .'[30] An even more conscious and pointed comparison is in the Paris *St Sebastian*, where a classical fragment of a sandalled foot is conspicuously placed next to the saint's right foot (fig. 79). By pointing out the source for his forms Mantegna here acknowledged the debt he owed to the

79 Andrea Mantegna, *St Sebastian* (*c*.1480), detail. Distemper on linen. Paris, Louvre

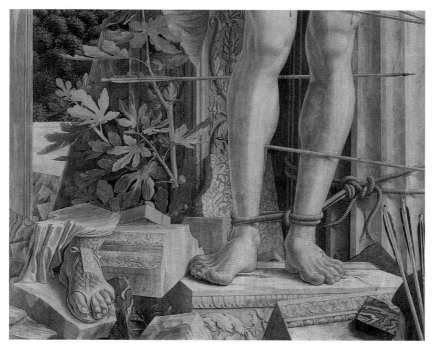

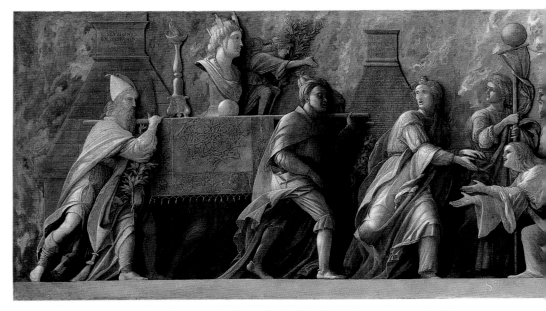

80 Andrea Mantegna, *Introduction of the Cult of Cybele in Rome* (1505–6). Distemper on linen. London, © National Gallery

antique. At the same time, moreover, he demonstrated the superiority of painting in its ability to provide the sculptural form with colour and lifelikeness. Both this demonstrative exercise and his later grisaille paintings may have been responses by Mantegna to the criticism of his master Francesco Squarcione when, according to the sixteenth-century Paduan historian Scardeone (as reported by Vasari), he

> singled out for attack the paintings that Andrea had done in the [Ovetari] chapel, saying that they were inferior work since when he did them Andrea had imitated marble statues. Stone, said Squarcione, was essentially a hard substance and it could never convey the softness and tenderness of flesh and natural objects, with their various movements and folds. Andrea would have done far better, he suggested, if he had painted his figures not in various colours but just as if they were made of marble, seeing that his pictures resembled ancient statues and suchlike things rather than living creatures.[31]

In his *Cronaca rimata*, Giovanni Santi also commented, with however greater appreciation, on Mantegna's representation of sculpture:

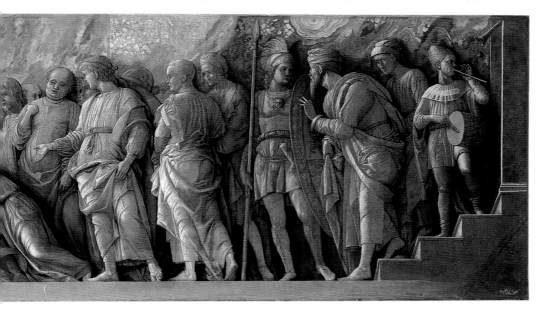

Nor has he overlooked relief, with soft attractive
Methods by which to show to sculpture too
What heaven and good fortune gave to him . . .[32]

Celebrated for his ability to imitate marble and other materials,
Mantegna perhaps predictably established a new genre of painted
'reliefs' that were surely intended to be understood as recreated
classical relief sculpture. In the *Introduction of the Cult of Cybele in
Rome* (fig. 80), painted in 1506 for the Venetian patrician Francesco
Cornaro and still in Mantegna's workshop at his death later that year,
grisaille figures set against a subtly varied background apparently of
brightly coloured marble dramatically act out the narrative.[33] Con-
versely, Antonio Lombardo later introduced coloured stones into his
reliefs for the Camerino d'alabastro of Alfonso d'Este to reproduce
in relief something akin to the effects that Mantegna strove for. In
the *Forge of Vulcan* (fig. 81) Lombardo inlaid areas such as the blue
of the sky and the brown chimney-breast with coloured stones.[34] Here
too is the sculptor's answer to the accusation that sculpture lacks
colour: by this artificial and inevitably unsubtle means he strove to
challenge Leonardo's view that 'the sculptor is not able to achieve
diversity using the various types of colours'.

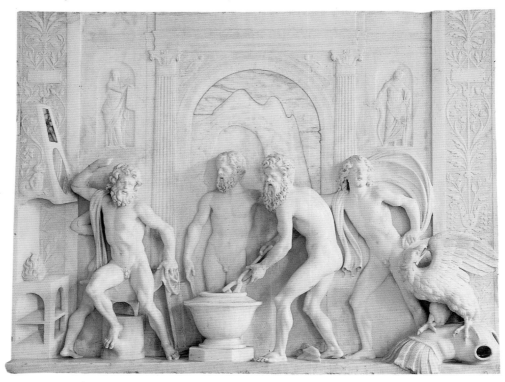

81 Antonio Lombardo, *Forge of Vulcan* (1508). Marble. St Petersburg, The State Hermitage Museum

Another means by which painters sought to counter the apparent superiority of sculpture in the round for showing relief was to study a figure from different angles, so as to build up a composite impression of its three-dimensional reality. That this practice was already in use in the mid-fifteenth-century workshop is demonstrated especially in Antonio Pollaiuolo's exemplary *Battle of the Nudes* engraving (fig. 18) in which several figures are shown twice, pivoted through 180 degrees; and the system was adopted by Dürer, amongst others. It was also later exploited in reverse by Gianlorenzo Bernini, when he received from Van Dyck the triple portrait of Charles I (Windsor Castle), on the basis of which Bernini carved his marble bust of Charles I, destroyed in the Whitehall Palace fire of 1698.[35] If we are to believe Vasari, Giorgione also explored the question of angles of view in a practical contribution to discussion of the *paragone* issue. His demonstration was in response to the arguments of sculptors 'who maintained that since a statue showed to anyone walking

around it different aspects and poses, sculpture was superior to paint-
ing, which could represent only one aspect of any given subject'.[36] In
order to prove 'that painting requires more skill and effort and can
show in one scene more aspects of nature than is the case with sculp-
ture', Giorgione

> offered to show in a single view of one picture the front, back and
> two profiles of a painted figure. After he had made those sculptors
> rack their brains, Giorgione solved the problem in this way. He
> painted a man in the nude with his back turned and, at his feet, a
> limpid stream of water bearing his reflection. To one side was a
> burnished cuirass that the man had taken off, and this reflected his
> left profile . . . ; on the other side was a mirror reflecting the other
> profile of the nude figure . . .

Unfortunately, no visual evidence survives to support the reliability
of Vasari's anecdote. It may be pure invention; but more probably it
derives from Paolo Pino's description of a similar painting by
Giorgione in his *Dialogue on Painting* (*Dialogo di pittura*):

> he painted a full length picture of St George in armour, leaning on
> the broken shaft of a spear, his feet just at the edge of a clear and
> limpid brook in which the whole figure had its foreshortened
> reflection up to the top of the head; then there was a mirror in
> which one could see entirely the other side of St George. He wanted
> to prove by this picture that a painter can show a figure entirely
> at one glance, which a sculptor is incapable of.[37]

The *Dialogue* was published in Venice in 1548, two years after
Varchi elicited responses to his questions about the relative superi-
ority of painting and sculpture from Central Italian painters. Pino's
description may well be a true record of an experiment by Giorgione.
The painter may have been stimulated to undertake this type of
conscious demonstration of artistic skill by the conspicuous use of
reflections in some early Netherlandish paintings. About fifty years
before Giorgione's lost painting was made, Bartolomeo Fazio had
particularly noted in a painting by Jan van Eyck of 'women of
uncommon beauty emerging from the bath' that 'in one of them he
has shown only the face and breast but has then represented the hind
parts of her body in a mirror painted on the wall opposite, so that
you may see her back as well as her breast'.[38] The parallel between
this praise and Antonio Pollaiuolo's interest in pivoted and mirror-
image figures might readily have inspired experiments such as
Giorgione's.

A further, and final, indication of the popularity of the *paragone*

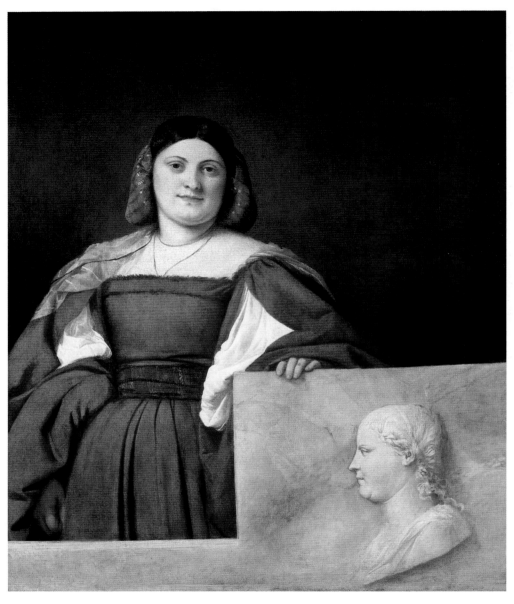

82 Titian, *Portrait of a Woman: La Schiavona* (*c.*1511). Oil on canvas. London, © National Gallery

issue in early sixteenth-century Venice is provided by Titian's *La Schiavona* (fig. 82), a female portrait that dates from around 1511. Close observation indicates that at a late stage Titian enlarged the parapet on which the sitter lays her left hand. This was presumably to provide the space into which he could insert the sitter's profile portrait in the guise of a carved cameo-like relief. It may be presumed that this change was sanctioned by the sitter; but in Titian's hands the rich vitality of the frontally posed woman's face as she compellingly engages the observer's gaze could hardly contrast more deliberately with the formal, almost clinically cool idealism of the profile. This demonstrates more clearly than any words Titian's view as to the representational superiority of painting over relief sculpture.

By the time Castiglione wrote his *Book of the Courtier*, it had become intellectually respectable to discuss the question of the relative superiority of painting and sculpture. The extent to which the visual arts had come to form suitable subject matter for men of letters to discuss is particularly well demonstrated in Castiglione's dialogue. The *paragone* was an issue worth debating not merely for painters such as Leonardo da Vinci in his writings, and Mantegna in his practice, but also for the courtiers of Guidobaldo da Montefeltro, Duke of Urbino. Moreover, both texts and paintings show how Renaissance artists also took up the challenge of the theoretical issues involved, and entered into the dialogue on the *paragone* alongside intellectuals like Alberti and Castiglione.

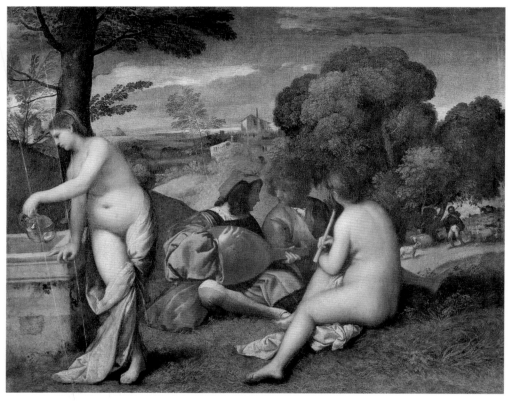

83　Giorgione, circle of, *Fête Champêtre* (*c.*1510). Oil on canvas. Paris, Louvre

Painting and Poetry

The *paragone* between painting and sculpture was an issue that increasingly concerned Renaissance writers on art. Whether a painting could communicate expressive meaning as effectively and as affectingly as a poem had, however, been a recurrent theme in intellectual debate from at least the time of Dante. In his celebrated comment on Giotto's new ascendancy over Cimabue in *Purgatorio* XI, Dante makes a clear comparison between these two painters and the two great poets of the *dolce stil nuovo*, Guido Guinizelli and Guido d'Arezzo:

> O empty glory of human powers, how briefly lasts the green on its top, unless it is followed by an age of dullness! In painting Cimabue thought to hold the field and now Giotto has the cry, so that the other's fame is dim; so has the one Guido taken from the other the glory of our tongue . . .[1]

This comparison was exploited by art theorists in their search for persuasive arguments in favour of the view that painting merited poetry's status as a liberal art. The classical foundation for the argument was the phrase 'ut pictura poesis' – 'as a painting, so a poem', an aphorism that sums up the more elaborate discussion of the theme by Horace in his *Ars poetica*.[2] This focused in particular on his view, expressed at the very start of the treatise, that painters and poets always have equal power of inventive imagination, or of poetic licence. The equal power of painting and poetry also to imitate nature derived from Aristotle's *Poetics* and other classical texts. Even before Dante, Durandus had reflected Horace's views in his late thirteenth-century *Rationale divinorum officiorum*. Articulating the issue with respect to biblical illustration, he wrote: 'Various stories of the Old and New Testaments can be portrayed as the painter pleases, for "painters and poets have always had equal privilege of attempting anything"'.[3] From this it follows that a painting and a poem have

equal value both in their ability to imitate nature (*mimesis*) and as exercises of the creative imagination (*fantasia*).

So potent was Horace's idea that it was collapsed into another aphorism by Petrarch, who in his *Trionfo della fama* described the epic poet Homer as 'il primo pintor delle memorie antiche' – the first painter in ancient memory.[4] Articulating the notion that painting, like poetry, should count among the liberal arts, Filippo Villani, writing in 1381–2, suggested that the talents of painters, especially in the imitation of nature, are not inferior to those who have mastered a liberal art:

> Many people judge – and not foolishly indeed – that painters are of a talent no lower than those whom the liberal arts have rendered *magistri*, since these latter may learn by means of study and instruction written rules of their arts while the painters derive such rules as they find in their art only from a profound natural talent and a tenacious memory . . .[5]

Fourteenth-century writers also praise both poets and painters for their ability to represent nature convincingly, and offer different critical angles on the 'ut pictura poesis' theme. Filippo Villani again, for example, made a more direct parallel along Horatian lines when he wrote of Giotto that he 'showed himself so far a rival of poetry that keen judges consider he painted what most poets represent in words'.[6] At the end of the century Cennino Cennini stressed the need for the painter to imitate nature; but he also asserted his right to invention. In the very first chapter of his *Craftsman's Handbook* he uses the *paragone* between painting and poetry as an argument for the exercise of imagination: since 'painting . . . calls for imagination, and skill of hand . . . it justly deserves to be enthroned next to theory, and to be crowned with poetry'.[7] Related ideas were developed in fifteenth-century texts, although the views of different writers vary. Lorenzo Valla, writing in 1442 and perhaps following the line taken by Alberti in *On Painting*, suggested that painting, sculpture and architecture are among the arts that 'most closely approximate to the liberal arts'.[8] In the introduction to the section on painting and painters in his *De viris illustribus* (*On Famous Men*) of 1456, Bartolomeo Fazio gave more detailed but comparable arguments:

> there is . . . a certain great affinity between painters and poets; a painting is indeed nothing else than a wordless poem. For truly almost equal attention is given by both to the invention and the arrangement of their work . . . It is as much the painter's task as the poet's to represent these properties of their subjects, and it is

in that very thing that the talent and capability of each is most recognised.[9]

Putting the comparison into the negative, Fazio asserts that 'paintings in which the emotions and feelings of the figures are not represented are like poems that are beautiful indeed, and tasteful, but languid and unmoving'. He comments on the 'close affinity between painters and poets' and that 'to Pisanello of Verona has been ascribed almost a poet's talent for painting the forms of things and representing feelings'.[10] Guarino da Verona too was enthusiastic about Pisanello's paintings: in his poem in praise of the artist he wrote: 'Why list your accomplishments one by one? Here as I write is their pattern: the noble gift you have sent me, a picture of my beloved Jerome, offers a wonderful example of your power and skill'.[11] Elsewhere, however, he sounded a discordant note. Writing to Leonello d'Este in 1443, he was clear in his comparison between text and image about the superiority of the written word, especially history writings, for spreading fame:

> Compare the means used in support of fame, and we see that written annals excel any picture and any statue . . . Pictures are dumb, but the voice of annals fills land and sea. Pictures and statues can be placed only in a few places, but annals pass easily across the whole world and can be multiplied.[12]

It was Alberti, of course, who in *On Painting*, written twenty years before Fazio's biographies of painters, first articulated at length the need for painters to learn from poets and to seek parity between painting and poetry. He wanted the painter 'as far as he is able to be learned in all the liberal arts', and so 'it will be of advantage if [he takes] pleasure in poets and orators, for these have many ornaments in common with the painter'.[13] Moreover, he advised

> the studious painter to make himself familiar with poets and orators and other men of letters, for he will not only obtain excellent ornaments from such learned minds, but he will also be assisted in those very inventions which in painting may gain him the greatest praise. The eminent painter Phidias used to say that he had learned from Homer how best to represent the majesty of Jupiter. I believe that we too may be richer and better painters from reading our poets . . .[14]

The relations between poets and painters are a recurrent theme in Alberti's writings. *On Painting* may have been modelled in structure on Horace's *Ars poetica*, in which the parallel between painting and

poetry originated. The latter is a three-part work in which part I deals with poetic content (perhaps the source for Alberti's 'rudiments' of painting), part II with forms and types of poetry (equivalent to Alberti's discussion of how to make an *istoria*), and part III with the poet himself, just as Alberti's third book discusses the painter himself, the content of his production, and his rewards.[15] For Alberti, painting should emulate the aims, intentions and methods of poetry. Like poetry, painting uses parts of the quadrivium – geometry and arithmetic – in its theoretical basis; therefore, like poetry, painting should rank as a liberal art. Soon after Alberti wrote, ideas similar to these were articulated in an official Neapolitan document, the charter of appointment in 1449 of Leonardo da Besozzo as Alfonso of Aragon's *familiaris* and court painter. Perhaps under the influence of Fazio, who was court historian to the King of Naples, it is declared in this charter that 'what is proper to historians and poets is also not foreign to painters, for there is evidence in many classical writings that poetry is nothing other than spoken painting'.[16] And seeking exemption from paying tax in Siena in 1507, Bernardo Pinturicchio also cited classical authority: Cicero had written that the Romans believed that painting was 'similar to the liberal arts, and concurrent with poetry'.[17]

At one point in *On Painting* Alberti appears to imply that painting may actually be superior to poetry in stimulating the imagination. After paraphrasing Lucian's description of the celebrated painting of 'Calumny' by Apelles, Alberti asks 'If this "historia" seizes the imagination when described in words, how much beauty and pleasure do you think it presented in the actual painting of that excellent artist?'[18] In a large number of notes on the subject written in preparation for his Treatise on Painting, Leonardo da Vinci makes plain that in his view painting is the superior, the nobler art. It is with Leonardo, indeed, that many of these ideas about painting and poetry crystallise, and few significant comments are made again on the subject in Renaissance theoretical writings until the middle of the sixteenth century. 'If you assert that painting is dumb poetry', Leonardo wrote, 'then the painter may call poetry blind painting . . . but painting remains the worthier in as much as it serves the nobler sense'[19] – in other words, the sense of sight. He insisted that the power of a painting that imitates nature to deceive the viewer is greater than that of a poem. 'We may justly claim that the difference between the science of painting and poetry is equivalent to that between a body and its cast shadow', he wrote; and again:

See what difference there is between hearing an extended account of something that pleases the eye and seeing it instantaneously, just

as natural things are seen. Yet the works of the poets must be read over a long span of time . . . but the work of the painter is instantaneously accessible to his spectators.[20]

To reinforce his view of the greater affective power of a painting, Leonardo wrote:

> if you were to describe the image of some deities, such writing would never be venerated in the same way as a painted goddess, since votive offerings and various prayers will continually be made to such a picture. Many generations from diverse regions and across the eastern seas will flock to it, and they will beg succour from such a painting but not from writing.[21]

In such ways as these early Renaissance writers on art strove to demonstrate the equality of painting and poetry, if not the superiority of painting over poetry, in affective power. That these ideas were part of the intellectual currency of early Renaissance painters' workshops is suggested by a paraphrase of Horace's view, that 'painters and poets always have had and always will have equal power', inscribed on the title-page of a sketchbook (fig. 84) in use in Benozzo Gozzoli's workshop probably in the 1460s.[22] Given the intellectuals'

84 Benozzo Gozzoli, title page of Gozzoli sketchbook (*c*.1460). Pen and ink on paper. Rotterdam, Museum Boijmans Van Beuningen

interest in the ideas revolving around Horace's 'ut pictura poesis', it is not surprising that numerous poems were written in praise of fifteenth-century painters, especially in court circles. Poets sometimes responded to their subjects by deploying literary styles and verbal images that match the paintings' visual qualities. Numerous sonnets and other poems, often of high quality and rich in florid descriptions of the paintings' naturalistic details, were written by court humanists in praise of late Gothic painters, especially Gentile da Fabriano and Pisanello, from the 1420s onwards. Guarino da Verona's poetic praise of Pisanello has already been cited. Pisanello also attracted poetic tributes from Tito Vespasiano Strozzi, Basinio da Parma and others – including, unusually, a Florentine, Leonardo Dati;[23] and Ulisse degli Aleotti wrote a sonnet on the celebrated competition in 1441 between Pisanello and Jacopo Bellini to produce the best portrait of Leonello d'Este, Marquis of Ferrara.[24] Tito Vespasiano Strozzi also wrote a long description of a painting by Cosmè Tura that echoes Tura's style in its ornate, fanciful language.[25] These are just a few early examples of a genre of poetry that became more common as the fifteenth century progressed.

Conversely, some Renaissance painters sought to exercise their inventive abilities by writing poetry themselves. They sought recognition as poets because, in spite of Alberti's defence of painting and Leonardo's arguments for the painter's affective superiority, throughout the early Renaissance poets were more highly regarded than painters in intellectual circles. Other painters, moreover, seem to have sought to demonstrate the superiority of their art by creating 'visual poems' – pictorial equivalents of the verbal imagery and rhythms of poetry. These two developments illustrate the increasingly close relationships in the later fifteenth century between poets and painters, and between poetry and painting.

Artists as Poets

By the turn of the fifteenth and sixteenth centuries literary men such as Castiglione were concerning themselves with issues of artistic practice, and conversely artists increasingly sought to make their position intellectually respect-worthy. The sculptor Giancristoforo Romano held his own against other courtiers in the debates recorded in *The Book of the Courtier*, and in the 1490s Leonardo da Vinci was probably more highly regarded as a courtier than as a painter in Ludovico Sforza's Milan. Some early Renaissance artists themselves aspired to write poetry, although their early products should perhaps be

described as 'verse' rather than 'poetry'. By the first decade of the
teenth century, however, some verse was being written by pairs
that does deserve to be called poetry. The contrast between the
viving fragments of poetry by Raphael and his father Giovanni Sa's
coarse *terze rime* suggests that it was artists of the generation at
reached maturity at the turn of the century who began to show h
verbal as well as pictorial achievement. Santi's *Cronaca rima* is,
nevertheless, an impressive achievement in terms of its length nd
comprehensiveness. Perhaps the first major attempt by a pain to
write poetry, it powerfully suggests Santi's determination and liary
ambition. The autograph manuscript is dated 1478, but the ole
work, a lengthy chronicle of the military and other activit of
Federigo da Montefeltro, Duke of Urbino, may not have been om-
pleted or fully proof-read by the time of Santi's death in 1494 It is
best known to the student of art history from those passages th deal
with the artists of Santi's day. These come in the 'Discussion o aint-
ing' in chapter 91, written after Santi had been deeply impre d by
the treasures of the Gonzaga palace, and especially Mantegn fres-
coes, during Federigo's visit there in 1482.[27] Santi chose t *terza
rime*, a verse form especially popular since Dante, as the ehicle
through which to present a manifesto of the Italianate style as pified
by Mantegna, who receives the greatest and lengthiest praise. e also
suggests that sculpture and painting have the same power a poetry
and history to bring immortal fame to men:

> Many things in the world can bring immortal
> Fame to a mortal, letters first of all,
> Which are founded in many solid bases.
> But two, it seems, will raise a man to heights,
> In poetry or history we sing
> Of anyone who gains some admiration.
> Sculpture, besides, and painting can preserve
> A mortal man present before us and
> True image of all noble family trees,
> And of these two arts I will dare to say
> Of what and how great genius and hard work
> They are . . .[28]

According to his biographer Antonio Manetti, Brunelleschi wrote
a group of sonnets in self-defence in his argument with Donatello
about the decoration of the Old Sacristy of S. Lorenzo in Florence,
and a number of sonnets by the architect still survive.[29] Although also
celebrated principally as an architect, Bramante, like Giovanni Santi,
was trained as a painter at the court of Urbino. He, too, tried his

hand at writing verse: thirty-three reasonably accomplished sonnets by him survive.[30] Another aspiring poet was the anonymous so-called Prospettivo Milanese, who however in his *Antiquarie prospettiche*, published in Rome around 1500, described himself as 'idioto', or unlearned. His verse in turn has been described as 'limping', and even 'atrocious'.[31] Be this as it may, his information about Roman collections of antiquities is valuable: he commented on classical sculpture in Rome, on Pollaiuolo's tomb of Pope Sixtus IV, and on his visit to the Domus Aurea and elsewhere to see the 'grotesques'. Albrecht Dürer also tried his hand at writing, but the quality of his verse scarcely higher than that of the Prospettivo Milanese. Dürer may have considered writing verses to accompany his New Testament woodcut series, and in 1509 he reported his friend Willibald Pirckheimer's criticism of some couplets that he had written in praise of Christ. Although he may have attended the Nuremberg 'School for Poets' run by Pirckheimer's father, Dürer's later poetic attempts concentrated on comic verse, but with perhaps only slightly more success.

It was of course the young Michelangelo who of all Renaissance artists wrote poetry of truest literary merit. He is indeed the only artist who can be said to have succeeded with the pen almost to the same degree as he did with the brush or with the chisel. His earliest poems, perhaps inspired in part by his close contact with the fine poets of Lorenzo 'the Magnificent' de' Medici's circle, date from the middle of the first decade of the sixteenth century, when he was around thirty years old. The six earliest poems are all sonnets: one dates from around 1510 and is addressed to Julius II, then his employer. Another of about this date, which is accompanied by a rapid, witty self-portrait sketch (fig. 85), describes in ironic detail the discomforts of painting the Sistine ceiling. Since this is one of the very few poems in which Michelangelo refers to his work as an artist, it is worth quoting in full:

> I've already grown a goitre at this drudgery –
> as the water gives the cats in Lombardy,
> or else it may be in some other country –
> which sticks my stomach by force beneath my chin.
> With my beard toward heaven, I feel my memory-box
> atop my hump; I'm getting a harpy's breast;
> and the brush that is always above my face,
> by dribbling down, makes it an ornate pavement.
> My loins have entered my belly, and I make
> my arse into a crupper as counterweight;
> without my eyes, my feet move aimlessly.

I o gia facto ūgozo īquesto stēto

chome fa lacqua agacti ī lonbardia

ouer daltro paese chessi chesisia

cha forza luetre apicha soctolmēto

L abarba · alcielo · ellamemoria sento

īsullo scrignio especto fo darpia

e spennel sopraluiso tuctavia

melfa gocciando ū richo pavimēto

E lobi entrati misō nella peccia

e fo delcul p chōtrapeso groppa

e passi sēza gliochi muouo īuano

D imāzi misalluga lachortoccia

e p piegarsi adietro siragroppa

e tēdomi comarcho soriano

p̄o fallace estrano

surgie iliuditio ch lamēte porta

ch mal sipra p cerboctana torta

lamia pictura morta

di fedi orma giouanni elmio onore

nō sēdo īloͬg bō ne io pictore

85 Michelangelo, sonnet and self-portrait sketch (c.1510). Pen and ink on paper. Florence, Biblioteca Laurenziana, Archivio Buonarroti, XIII, fol. 111

In front of me my hide is stretching out
and, to wrinkle up behind, it forms a knot,
and I am bent like a Syrian bow.
 Therefore the reasoning that my mind produces
Comes out unsound and strange,
for one shoots badly through a crooked barrel.
 Giovanni, from now on
defend my dead painting, and my honour,
since I'm not in a good position, nor a painter.[33]

Painting as Poetry

Given this interest in poetry, and the insistent references to painting
and poetry as equal arts, it is hardly surprising that by the turn of
the century, if not earlier, painters were both seeking inspiration in
poetry as a source for pictorial ideas, and seeking ways of producing
painted equivalents to poetry. Leonardo da Vinci wrote:

> The poet says that . . . the main substance of poetry [is] invention
> of the subject-matter and measurement in metre . . . the painter
> responds that he has the same obligations . . . , that is, invention
> and measure – invention of the subject that he must depict and
> measurement of the things painted, so that they should not be ill-
> proportioned.[34]

In, for example, the *Mona Lisa* he appears to be searching for
a pictorial language by which through invention and judicious 'mea-
surement of things painted' he could generate a poetic atmosphere,
both in the environment within which the sitter exists and in her own
emotional mood.

Sandro Botticelli had earlier responded warmly to the lyrical char-
acter of the neo-Petrarchan poetry of Angelo Poliziano and Lorenzo
de' Medici. Indeed, it remains a possibility that Poliziano provided a
poetic 'programme' for perhaps the earliest example of a conscious
striving to produce a 'poetic painting', Botticelli's *Primavera* (Flo-
rence, Uffizi).[35] Although there is no evidence that there was ever a
written programme for this work, its imagery is at least closely asso-
ciated with the ideas of Poliziano as articulated, for example, in his
Stanze per la Giostra di Giuliano de' Medici, written to celebrate a
tournament in 1475. The *Primavera* was painted not long after the
tournament as the backboard (*spalliera*) of a day-bed in Lorenzo di
Pierfrancesco de' Medici's Florentine palace. It is a large-scale and
unusually brilliantly executed example of the relatively new taste for

domestic furniture painted with classical subjects. But it differs from *spalliera* panels painted with mythological or Roman historical scenes in that its subject deliberately avoids narrative. It is, it seems, a 'visual poem' on the theme of Spring. Poliziano's *Stanze per la Giostra . . .* excerpts figures and motifs from classical texts and recombines them in a poetic evocation reminiscent of the style and imagery of Petrarch. Similarly, Botticelli brought together figures and images derived from classical texts by Horace, Seneca, Cicero and others and reinterpreted these in an original way – but in the light of Poliziano's poetry – to generate his own independent, poetic account of the passage of time through the spring months.

Responses to vernacular poetry stemming from the traditions of Virgil and Petrarch may also account for the 'poetic' paintings produced in Venice in the early decades of the sixteenth century. It was here that a mode of translating poetic mood into painted form was perhaps most fully developed. Palma Vecchio's *Portrait of a Poet* (fig. 86) can serve well as an exemplar. The sitter, who may be Ariosto, is identified as a poet by the laurel branch behind his head. He is informally, even languidly, posed and has a far-away, abstracted expression, suggestive perhaps of poetic inspiration. Jacopo de' Barbari wrote around 1501 that the painter needed to understand philosophy and music, and in addition that he needed a knowledge 'of poetry for the invention of a work'.[36] For Jacopo, who seems the first to have used the term in written form, *poesie* were artistic works based on poetic texts. By implication, the painter himself might be at liberty to devise his own 'poetic inventions', a licence given to Giovanni Bellini by Isabella d'Este, Marchioness of Mantua. She provided Perugino with a 'poetic invention', a detailed 'written description' of the 'battle of Chastity against Lasciviousness' that he was to paint for her (fig. 88).[37] To Bellini, however, she wrote, 'we will leave the poetic invention for you to make up if you do not want us to give it to you'.[38] This suggests that Isabella respected Bellini's sensitivity to the poetic in the development of his pictorial themes.

The increasing use of classical themes and subjects stimulated the inventiveness of early sixteenth-century painters and allowed them greater creative freedom. For example, Ovid's *Fasti* was used as the poetic source for bacchanalian subjects both for Piero di Cosimo's *Discovery of Honey* (fig. 87) and the *Misfortunes of Silenus* (Cambridge, Mass., Fogg Art Museum) painted for Giovanni Vespucci in Florence between 1505 and 1510,[39] and for Giovanni Bellini's *Feast of the Gods* (fig. 98), painted for Isabella d'Este's brother Alfonso in 1514.[40] Such large-scale works on classical themes may have developed out of secular painting for domestic purposes: in the first decade

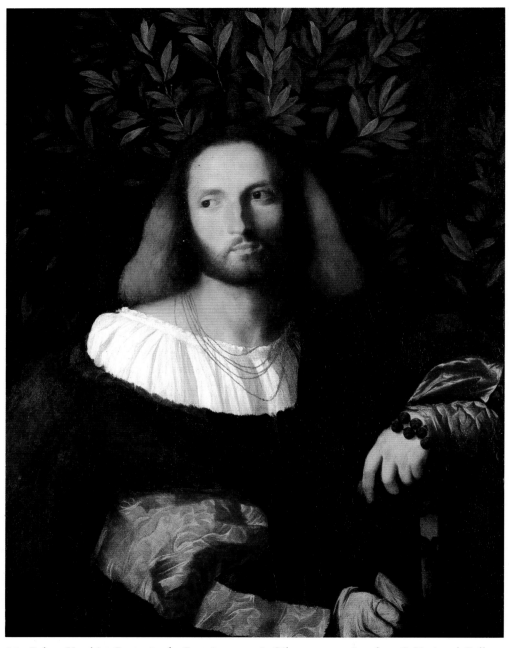

86 Palma Vecchio, *Portrait of a Poet* (1520–25). Oil on canvas. London, © National Gallery

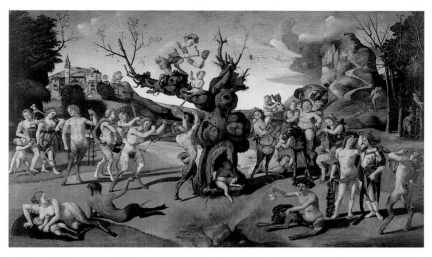

87 Piero di Cosimo, *Discovery of Honey* (*c*.1505–10). Oil on panel. Worcester, Mass., Art Museum

of the sixteenth century Cima da Conegliano painted a group of small panels, presumably for furniture decoration, on such themes as 'Endymion asleep'.[41] Paradoxically, however, it is not in a classical subject-painting such as Sebastiano del Piombo's *Death of Adonis* (Florence, Uffizi),[42] which was based in part on Ovid and in part on the *Hypnerotomachia polifili*, that we meet with the most elaborated 'visual poem'. In the first decade of the sixteenth century, and especially in the workshop of Giorgione, a new genre evolved in Venice. Giorgione's freedom to explore new pictorial interests without necessarily depicting predetermined subjects is suggested by Vasari's perplexed response to the frescoes painted in 1508 on the façade of the Fondaco de' Tedeschi in Venice. Here, Giorgione

> thought only of demonstrating his technique as a painter by representing various figures according to his own fancy. Indeed, there are no scenes to be found there with any order or representing the deeds of any distinguished person, of either the ancient or the modern world. And I for my part have never been able to understand his figures nor, for all my asking, have I ever found anyone who does.[43]

Giorgione was the first exponent of the apparently theme-less, intensely poetic picture intended primarily to evoke mood and atmosphere. On 8 November 1510, shortly after Giorgione's early death,

Isabella d'Este's agent Taddeo Albano wrote to her about 'a picture of a very beautiful and singular night scene . . . [and] you wanted to see if you could have it'. He continued that he had found two such night scenes, but neither was for sale.[44] These paintings apparently had no identifiable subject beyond the evocation of night: indeed, Giorgione seems to have inclined towards themes that gave him chances to depict special natural effects of lighting and weather, rather than specific narrative subjects – and seems to have had the freedom to explore such themes. The two classic examples of early sixteenth-century Venetian *poesie* are the *Tempesta* (Venice, Accademia) by Giorgione and the *Fête Champêtre* (fig. 83), variously attributed to painters in Giorgione's workshop around 1510.

In the latter case, the very difficulties of attribution are suggestive of the experimental character of the genre. It is as though the painter was searching for a pictorial and stylistic response to the atmospheric qualities of contemporary poetry, especially perhaps that of Jacopo Sannazaro, whose *Arcadia* was published in 1504. The pictorial tension generated between the women's nakedness and the fully-clothed men is defused when the painting is understood as a poetic evocation produced by the self-absorbed young men's words and music. We are perhaps invited to imagine that their song, or (we might think) their own 'poetic invention', revolves around the water-nymphs of Arcadia whose forms and whose ambient atmosphere their thoughts summon up before our eyes. Equally experimental is the mysteriously atmospheric landscape, which resonates with the idyllic, pastoral mood evoked by Sannazaro and in Bembo's *Gli asolani*. Although different in style, this landscape associates the *Fête Champêtre* with the *Tempesta*. As early as 1530 this celebrated painting was described by Marcantonio Michiel as 'the little landscape on canvas with the tempest with the gypsy and soldier', recognising that the painting's main focus is the stormy landscape.[45] If the figures may best be understood as merely a gypsy family, the sense is sharpened that a rustic idyll affected by the forces of nature now constitutes the principal subject of a 'poetic' painting.

Artistic Licence, Invention and *Fantasia*

Much of Cennino Cennini's *Craftsman's Handbook* reflects the recipe-book mentality of the late medieval artisan painter. Nevertheless, Cennino already articulated an awareness of the painter's inventive powers, believing that he was entitled to some licence in his interpretation of his subjects. The word *invenzione* (invention) does not find a place in Cennino's vocabulary, but he recognised the role of the imagination – *fantasia* – in artistic production. It is the exercise of these faculties in particular that by the end of the period under discussion led some artists to be hailed as creative individuals with quasi-divine powers: for Vasari, Leonardo da Vinci (for instance) was 'divinely inspired'.[1]

The 'occupation known as painting', wrote Cennino, '. . . calls for imagination [*fantasia*], and skill of hand, in order to discover things not seen, hiding themselves under the shadow of natural objects, and to fix them with the hand, presenting to plain sight what does not actually exist'.[2] Drawing on the usual analogy between poetry and painting, he continued: 'the poet . . . is free to compose . . . according to his inclination. In the same way, the painter is given freedom to compose a figure, standing, seated, half-man, half-horse, as he pleases, according to his imagination'. This image is memorable but improbable in painting as early as this: Cennino's 'half-man, half-horse' seems to anticipate Botticelli's *Pallas and the Centaur* (Florence, Uffizi) or the mythological paintings of Filippino Lippi or Piero di Cosimo at the end of the fifteenth century. But his use of such an unexpected example of *fantasia* highlights his claim for the painter's right to be able to invent 'according to his imagination'. Interestingly, it also echoes Lucian's description of the painting of a centaur family by Zeuxis, later recreated in one of the architectural reliefs in Botticelli's *Calumny of Apelles* (fig. 94), although no early vernacular translation of this text by Lucian has survived.[3] Cennino perhaps

came by his singular example of the exercise of *fantasia* in discussion with a humanist at the court of Francesco Novello da Carrara in Padua.

But this precocious reference to *fantasia*, and its related artistic independence, sits oddly beside the general insistence in fourteenth-century discussions of painting on the higher virtue of the imitation of nature. For Filippo Villani, writing around 1381–2, Giotto's principal skill and talent was that 'images formed by his brush agree so well with the lineaments of nature as to seem to the beholder to live and breathe'; and Giotto's followers, such as Stefano, 'nature's ape', 'brought about an art of painting that was once more a zealous imitator of nature, splendid and pleasing'.[4] In this Villani follows and expands on his uncle Giovanni's epigrammatic comment around 1340 that Giotto was 'the one who more than anyone else drew every figure and action naturally',[5] or Boccaccio's description of Giotto as

> a genius so sublime that there was nothing produced by Nature
> . . . that he could not depict to the life, whether his implement was
> a stylus, a pen, or a paintbrush: his depiction looked not like a
> copy but like the very thing, so that more often than not the
> viewer's eye was deceived, convinced that he was looking at the
> real object and not at his depiction of it . . .[6]

Boccaccio further wrote of Giotto's ability to paint things so naturalistically as to deceive the viewer into thinking them real, quoting another classical tag that 'he makes the dead seem dead and the living, living'. Elsewhere he cites the same skill – the vivid representation of natural things – as the mark of the true poet, recapitulating the *paragone* between painting and poetry.[7] At the end of the century the importance of the imitation of nature also entered the literature on the practice of painting. In an unusually rhetorical, metaphor-mixing piece of advice in his *Craftsman's Handbook* Cennino Cennini espoused nature as the primary source for the painter, and the imitation of nature as an essential skill:

> Mind you, the most perfect steersman that you can have, and the
> best helm, lie in the triumphal gateway of copying from nature.
> And this outdoes all other models; and always rely on this with a
> stout heart, especially as you begin to gain some judgment in
> draftsmanship. Do not fail, as you go on, to draw something every
> day . . .[8]

The criterion of truth to nature continued to be applied as a sign of excellence by humanistic commentators as late as the end of the fifteenth century. Masaccio, for example, was praised by Cristoforo Landino as 'a first-rate imitator of nature';[9] and Leonardo da Vinci

wrote that he 'showed to perfection in his work how those who take as their authority any other than nature, mistress of the masters, labour in vain'.[10] Leonardo often remarked on the primacy of nature. Of his proposed Treatise on Painting, he wrote that 'my little work will [remind] the painter of the rules and methods by which he may imitate with his art all . . . the works by which nature adorns the world'.[11] Addressing the painter as 'imitator of nature' he advised that he 'observe and pay attention to the variety of the lineaments of things'; and when it comes to copying others' works, he declared:

> I say to painters that no one should ever imitate the style of another because he will be called a nephew and not a child of nature with regard to art. Because things in nature exist in such abundance, we need and we ought rather to have recourse to nature than to those masters who have learned from her.[12]

But as we shall see, Leonardo was also one of the principal contributors to the debate on *fantasia*, and a powerful advocate for the artist's right to exercise his imagination. The importance for artists of their inventive independence was so great that it needed to be emphasised alongside their talent in the imitation of nature. However, few theoretical writings by artists survive, for they were not trained as literary men. Leonardo intended at the start of his Treatise to state his awareness of his difficulty in persuading readers that he should be taken seriously. 'I know that many will say that this is a useless work . . . I know well that, not being a man of letters, . . . some presumptuous people [will] belabour me with the allegation that I am a man without learning . . . they will say that since I do not have literary learning I cannot possibly express the things I wish to treat'.[13] But artists' comments that survive suggest that they did not always share the humanists' critical priorities. Perhaps the earliest writings on the artist that do not appear to be mere conventional rhetoric are the two inscriptions on Giovanni Pisano's pulpit in Pisa cathedral, completed in December 1311.[14] In the absence of any contextual evidence these inscriptions are extremely difficult to interpret. They do, however, suggest that Giovanni Pisano believed – exceptionally at this date, some eighty years earlier even than Cennino Cennini's treatise – that he deserved recognition as a creative artist and not merely as a craftsman. Moreover, he seems to have felt that he was consequently entitled to some licence to use his imagination and his inventive powers. The stories in the so-called 'Tagebuch' of Angelo Poliziano that comment on Donatello similarly suggest recognition of the sculptor's independence.[15] The lack of finish of the saints of Donatello's high altarpiece for the Basilica di S. Antonio in Padua may be evidence of the sculptor's licence to work with 'an intentional

negligence', or perhaps *sprezzatura*. Changes apparently made to the design of the exterior pulpit of Prato cathedral, and to the equestrian monument to Gattamelata at Padua, also suggest that Donatello had unusual freedom to alter agreed designs.

However, the twin concepts of *invenzione* and *fantasia* were articulated more by architects than by painters or sculptors during most of the fifteenth century. In his *Commentaries*, for example, Ghiberti does not suggest that he made use of 'invention': diligence was enough praise for his own work.[16] On the other hand, Antonio Manetti described Brunelleschi's church of S. Maria degli Angeli in Florence as showing great originality in its 'invenzione di qualita' while nevertheless being 'tutto al modo antico'.[17] Although Alberti advises painters 'openly and often to ask and listen to everybody's opinion, since it helps the painter, among other things, to find favour',[18] Brunelleschi is recorded by the engineer Mariano Taccola as saying: 'Do not share your *invenzioni* with many: share them only with the few who understand and love the sciences. To describe too much of one's inventions and achievements is one and the same thing as to debase your talents.'[19] Francesco di Giorgio Martini wrote: 'without *invenzione* it is impossible to be a good architect'.[20] *Invenzione* cannot, however, be learned: for Francesco di Giorgio it is an innate gift that depends on the artist's discretion and judgement (*discrezione e giudizio*), and he contrasts the standardised products of animals – a swallow's nest, or a spider's web – with the limitless variety of the inventions of man.

Humanist commentators in the fifteenth century showed more recognition than Boccaccio or Villani that the artist has an innate capacity for *invenzione*. In 1456 Bartolomeo Fazio compared the inventiveness of the painter and the poet:

> almost equal attention is given by both to the invention [*inventione*] and the arrangement [*disposizione*] of their work. No painter is accounted excellent who has not distinguished himself in representing the properties of his subjects as they exist in reality . . .[21]

Invenzione refers here to the subject and its treatment: artistic qualities such as composition, style or the handling of colour are questions merely of 'arrangement'. In reality, the fifteenth-century painter's freedom to demonstrate his own *invenzione* was limited. Guarino da Verona's written programme for the cycle of the Muses for Leonello d'Este was 'an *inventio* worthy of a prince',[22] and Isabella d'Este supplied a 'poetic invention' in written form to Perugino. Renaissance patrons seem to have felt strongly that the

subject matter and meaning of their commissioned paintings were not matters that could generally be left to the painter or sculptor.[23]

For Alberti, too, even though he 'spoke as a painter', *inventio* is a property specifically and only of the written 'historia':

> Literary men, who are full of information about many subjects, will be of great assistance in preparing the composition of a 'historia', and the great virtue of this consists primarily in its invention [*inventio*]. Indeed, invention is such that even by itself and without pictorial representation it can give pleasure.[24]

He cites Lucian's well-known description of Apelles' 'Calumny' 'so that painters may be advised of the need to take particular care in creating inventions of this kind'. Alberti once more adopted an essentially non-artistic position on the artist's power and licence to 'invent'. Nevertheless, the term *invenzione* continued to be applied by artists to the subjects rather than to the pictorialism of their works. For Filarete, the artist should be able to produce 'belle inventioni'; and aping Alberti he uses 'Apelle che trovo la Calumnia' as his example.[25] Even his use of the term *fantasia* is given a literary slant: Filarete says that his ideal architect should exert himself 'to learn letters' so as to investigate 'new fantasies and different moralities and allegories'.[26]

By the end of the fifteenth century painters' requests to be given artistic independence had become louder and were more fully heeded by patrons. The freedom that painters were sometimes given in the choice of subject and interpretation is an indication of the increasing respect in which they were held by potential patrons. When in 1497 Giovanni Bellini refused to paint a 'portrait' of Paris for Francesco Gonzaga, his patron invited him to choose his own subject:

> in recent days we sent you . . . a panel on which we wanted you to paint the city of Paris, and since you answer that you have never seen it, we are satisfied, and put it to your judgement that you put on it what you like.[27]

The results of Isabella d'Este's contrasting patronal attitudes towards Perugino and Giovanni Bellini show how one painter must have recognised the wisdom of agreeing to her requirements, however demanding and limiting they appeared, while the other could finally refuse to oblige. On 15 September 1502 Isabella wrote to Francesco Malatesta asking for his help in obtaining Perugino's agreement to paint a picture (fig. 88) for her *camerino*, variously referring to the subject matter as a story (*fabula*), an invention (*invenzione*) and 'our fantasy' (*fantasia*).[28] The lengthy directive that Isabella sent for inclu-

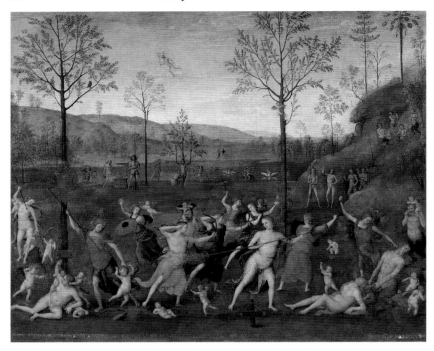

88 Pietro Perugino, *Battle of Love and Chastity* (1505). Distemper on linen.
Paris, Louvre

sion in the contract for this painting, signed in Florence by the
Umbrian painter Pietro Perugino on 19 January 1503, was based on
a 'poetic invention' for a 'battle of Chastity against Lasciviousness,
that is to say, Pallas and Diana fighting vigorously against Venus and
Cupid', composed for Isabella by Paride da Ceresara.[29] Precise
instructions were given as to which figures should be represented and
what they should all be doing. Moreover, she wrote, 'I am sending
you all these details in a small drawing, so that with both the written
description and the drawing you will be able to consider my wishes
in this matter'. Perugino accepted the commission but, perhaps pro-
crastinating, found a problem with the size of the figures, as given in
the drawing, in relation to the height of the picture. More than a year
later, on 19 February 1505, Isabella wrote to an agent that she had
gathered that

> Perugino is not following the scheme for our picture laid down in
> the drawing. He is doing a certain nude Venus and she was meant
> to be clothed and doing something different. And this is just to

show off the excellence of his art. . . . we beg you to examine [the drawing] well together with Perugino, and likewise the instructions that we sent him in writing. And do your utmost to prevent him departing from it, because by altering one figure he will pervert the whole sentiment of the fable . . .[30]

Owing to further delay, which caused her agent deep frustration, it was not until late June 1505 that Isabella finally took receipt of Perugino's painting. The whole episode shows Isabella's determination that her painter should be allowed no significant licence in his interpretation of her subject, the 'fable' rehearsed at such length by her adviser. This is in spite of the allowance in the original letter that 'if you think that perhaps there are too many figures in this for one picture, it is left to you to reduce them as you please, provided that you do not remove the principal basis, which consists of the four figures of Pallas, Diana, Venus and Cupid'.[31]

Although Perugino eventually, if with reservations, accepted the conditions that Isabella laid down for the *Battle of Love and Chastity*, other painters were not prepared to accept them. Giovanni Bellini and Leonardo da Vinci were perhaps not as needful as was Perugino of the patronage of an important figure within the Italian nobility of the time. Neither would accept such limiting instructions or compromise their artistic right to interpret a subject in visually the most appropriate and effective manner. They both, therefore, found themselves unable to fulfil Isabella d'Este's requests for paintings to join Mantegna's *Parnassus* (Paris, Louvre) in her *camerino*. The history of Isabella's ambition to possess a painting by Giovanni Bellini on a theme similar to Perugino's therefore followed a very different sequence of events.[32] On 5 March 1501 Michele Vianello, Isabella d'Este's agent in Venice, reported that he had told Giovanni Bellini that she desired that he paint her a story 'in the manner you wished';[33] but three months later he reported again that Bellini had said

> that in the story he cannot devise anything good out of the subject at all, and he takes it as badly as one can say, so that I doubt whether he will serve Your Excellency as you wish. So if it should seem better to you to allow him to do what he likes, I am most certain that Your Ladyship will be very much better served . . .[34]

Isabella replied that she was 'content to leave the subject to his judgement, so long as he paints some ancient story [*historia*] or fable [*fabula*] with a beautiful meaning'.[35] She allowed the painter more licence than was normal in the continuing hope that he would finally come up with a painting for her. Bellini responded that he would

invent 'a beautiful *fantasia* for the painting';[36] but another of
Isabella's agents in Venice, the musical instrument maker Lorenzo da
Pavia, reported a year later, on 31 August 1502:

> about the picture that Giovanni Bellini was meant to do, nothing
> whatsoever has been done . . . I always thought he would not do
> it. As I once told Your Excellency before, he is not a man to do
> stories [*non è omo per fare istorie*], and he gives his word to do
> them, but does nothing . . .[37]

On 15 September 1502 Isabella had to retreat yet further:

> As till now he has given us nothing but words, we beg that you
> will tell him in our name that we no longer care to have the picture,
> but that if instead he would paint a Nativity, we should be well
> content, as long as he does not keep us waiting any longer. We will
> count the 25 ducats which he has already received as half payment.
> This it appears to us, is really more than he deserves, but we are
> content to leave this to your judgement . . .[38]

The correspondence continued, with Isabella becoming more and
more impatient. Bellini objected to Isabella's proposal on the grounds
that St John the Baptist was out of place in a *Nativity*, and Isabella's
agent Michele Vianello reported that instead 'he will do a work with
the infant Christ and St John the Baptist and some distant views and
other fantasies [*et qualche luntani et altra fantaxie*], which would be
much better. So we left it at that: if this pleases your Ladyship please
let me know'.[39] With one further modification asked for by Isabella,
the painting was finally completed by 9 July 1504, when Isabella
wrote directly to Bellini outlining arrangements for its dispatch,
saying with a hint of irritation, 'if the picture which you have done
for us corresponds to your fame, as we hope, we shall be satisfied
and will forgive you the wrong which we reckon you have done us
by your slowness'.[40]

But Isabella was not satisfied: she still wanted a painting by
Bellini to hang in her studiolo 'near those of your brother-in-law
Mantegna', as she wrote to him on 19 October 1505, so 'it has
occurred to us to write begging you to consent to painting a picture,
and we will leave the poetic invention [*la inventiva poetica*] for
you to make up if you do not want us to give it to you'.[41] Having at
this point conceded full licence to Bellini, Isabella soon thought better
of it and asked the poet Pietro Bembo to provide an invention 'of dif-
ferent and elegant significance [*di vario et ellegante significato*]' to
complement her paintings by Mantegna.[42] Once more, however, this
proved too limiting for Bellini, for a little over two months

later Pietro Bembo wrote to her from Venice outlining the painter's objections:

> the invention, which you tell me I am to find for his drawing, must be adapted to the fantasy [*fantasia*] of the painter. He does not like to be given many written details which cramp his style; his way of working, as he says, is always to wander at will in his pictures, so that they can give satisfaction to himself as well as to the beholder . . .[43]

This lengthy exchange, and Isabella's ultimate lack of success in persuading Bellini to provide her with the type of painting that she sought from him, is a remarkable barometer of the changing relations between a patron and a painter at the beginning of the sixteenth century. Bellini was of course an old and highly regarded painter, whose livelihood depended on a Venetian clientèle that greatly valued his altarpieces and small devotional paintings. He could therefore afford to procrastinate over, and finally reject, a commission from one of the most important court patrons of the day. But this correspondence is important in showing the value that the painter himself gave to his freedom to invent, and to his need 'always to wander at will in his pictures' ('di sempre vagare a sua voglia nelle pitture').[44] Bellini was not prepared to accept the patron's *invenzione*, and would produce for Isabella only what he deemed appropriate to his inventive talents. This shows that Bellini had an unusual independence of choice – of both his subject matter and his patrons. Other examples exist, however, although undocumented, where similar choices may seem to have been made and permitted.

Isabella's approach to Leonardo da Vinci, which coincided with the start of her correspondence over Bellini's contribution to her *studiolo*, was also noticeably more cautious than her rather later approach to Perugino. She doubtless knew of Leonardo's preoccupations from her sister Beatrice's experience as Duchess of Milan during the 1490s, and also from Leonardo's visit to Mantua and the portrait drawing that he had made of her in 1500. Making no attempt to specify a 'fable', she wrote to Fra Pietro da Novellara, Vicar-General of the Carmelite order, in Florence on 27 March 1501:

> if you think [Leonardo, the Florentine painter] will be staying there for some time, Your Reverence might then sound him out as to whether he will take on a picture for our *studiolo*. And if he is pleased to do this, we will leave both the subject and the time of doing it to him . . .[45]

Fra Pietro replied on 3 April without much optimism that Leonardo

would feel able to undertake Isabella's commission, however much licence it offered him. Indeed, no further record of this project survives. On 14 May 1504 Isabella tried again, writing a careful, flattering letter directly to Leonardo asking him to undertake another: 'we have conceived the hope that something we have long desired might come true: to have something by your hand'. She reiterated this request in another letter five months later and followed this up by engaging Leonardo's uncle Alessandro Amadori to put pressure on the painter; but all to no avail.[46]

These cases show the difficulties that Isabella d'Este had when seeking to gather together 'pictures with a story by the excellent painters now in Italy', or even in persuading major painters of her day to produce for her other works not based on the 'poetic inventions' appropriate to the general moralising theme of her *camerino*. They suggest that artists were increasingly conscious of their freedom to choose their own interpretative mode, and to refuse to be limited to working within the tightly drawn limits of an intellectually complex – and visually less than satisfying – literary programme. The indications are that under certain circumstances the painter could now resist the pressure to work on the basis of an *invenzione*, in the sense of a 'fabula' or story provided for him by a patron or the patron's learned adviser. Conversely, the exercise of *fantasia* had by the turn of the century become a priority for the most successful and highly praised artists. It was perhaps more important to them than showing 'skill and talent' in the imitation of nature, which was more valued at the beginning of the quattrocento.

In the Proemium to his *Imagines*, Philostratus the Younger wrote that 'the art of painting has a certain kinship with the art of poetry . . . an element of *fantasia* is common to both'. Philostratus the Elder, a Greek sophist of the third century AD, had contrasted *mimesis* – the imitation of nature – with *fantasia* when he wrote that '*mimesis* can only create handiwork which it has seen, but *fantasia* equally that which it has not' – in other words, *fantasia* is the product of the imagination, not of experience. Although recognised early on by Cennini, this notion of *fantasia* does not crop up with any consistency or regularity in Renaissance writings. The eccentric Filarete, working for the Sforza in the court of Milan, makes play with the idea, however, stating that his houses of Virtue and Vice were the result of the exercise of his own *fantasia* alone.[47] The relatively secure environment of the court artist may at times have allowed him greater freedom for the exercise of his *fantasia*, and greater licence to produce works of his own choosing than the artist who depended for his livelihood on individual commissions. When in 1449 Sigismondo Malatesta wrote to Giovanni di Cosimo de' Medici in Florence asking him

to recommend a painter to work for him at his court in Rimini, he promised 'to give him an agreed salary, as high as he wishes [and] to treat him well, so that he will want to spend his life here', and that 'his agreed allowance will be paid punctually, even if he works solely for his own pleasure [*a suo piacere*]'.[48] The concept that an artist might have opportunities to work 'solely for his own pleasure' appears to be a stage in the direction of allowing him greater freedom to pursue his own interests. Leonardo da Vinci, employed at the Milanese court in the 1480s and 1490s, exploited his artistic freedom in innumerable ways. Few of these perhaps were immediately relevant to the production of paintings, although Leonardo might have argued that all were of critical importance in helping him to establish the theoretical and scientific foundations of his artistic practice. Mantegna, too, appears to have had a good deal of licence when in 1486 he embarked on the nine huge canvases of the *Triumphs of Caesar*. These were apparently not commissioned by his Gonzaga patrons, nor did they originally have any defined location or function: they seem to have constituted a large-scale vehicle for Mantegna to pursue his keen interest in exploring and faithfully reconstructing the classical Roman world. That other artists, whether working at court or not, also produced paintings intended solely to demonstrate their particular pictorial and often intellectual concerns is argued in a later chapter.

One of the most celebrated examples of a Renaissance painter's consciousness of his creative freedom is Raphael's commentary, in his letter to Baldassare Castiglione of 1514, on how he went about representing an ideal female nude. Referring to the figure of Galatea in the fresco that he had recently painted for Agostino Chigi in the Villa Farnesina in Rome (fig. 97), he alludes to the famous story – already paraphrased from Cicero and Pliny by Alberti in *On Painting* – of Zeuxis of Croton, who when painting a female nude selected and amalgamated the best features from five outstandingly beautiful girls.[49] 'In order to paint a fair one', Raphael wrote,

> I should need to see several fair ones . . . But as there is a shortage both of good judges and of beautiful women, I am making use of some sort of idea which comes into my mind. Whether this idea has any artistic excellence in itself, I do not know. But I do strive to attain it.[50]

Acceptance that the artist works from a mental image of the ideal, rather than merely from nature alone, both suggests Raphael's recognition that his creativity is an intellectual and also an inspired process, and provides a foundation stone on which the academic tradition came to be built during the early sixteenth century.

89 Sodoma, *Marriage of Alexander and Roxana* (*c*.1516–19). Fresco. Rome, Villa Farnesina

Chapter 9

Ekphrasis

The fresco of the *Marriage of Alexander and Roxana* (fig. 89), painted by Sodoma for Agostino Chigi's bedchamber in the Villa Farnesina in Rome, is based on Lucian's description of a painting by Apelles that celebrated this episode in the life of his patron Alexander the Great.[1] Distantly based on a drawing by Raphael, the work was fairly certainly completed to coincide with Chigi's marriage on 28 August 1519, under pressure from Pope Leo X, to his Venetian mistress, Francesca Ordeaschi, whom he had brought to Rome in 1511. The parallel between the two marriages shows Chigi in the flattering light of a Renaissance patron conscious of the classical past. Moreover, it also makes a direct comparison between Agostino Chigi and Alexander the Great, and by extension between Sodoma and Apelles. The relationship between Alexander and Apelles was cited by Castiglione as a paradigm of the high esteem in which painting and painters were held in classical times:

> we read that Alexander was so fond of Apelles of Ephesus that once, after he had had him portray one of his favourite mistresses, and then heard that the worthy painter had fallen desperately in love with her marvellous beauty, without a second thought he gave the woman to him: this was an act of generosity truly worthy of Alexander, to give away not only treasures and states but his own affections and desires; and it showed too, how deeply fond he was of Apelles . . .[2]

The implication is that the close relationship that existed between Alexander and Apelles, as described by Pliny and others, might well be emulated by Renaissance patrons in their behaviour towards their painters.

One way in which a patron could appear to be a 'new Alexander' was by commissioning painters to create their own reconstructions of paintings by Apelles. In turn, this could lead to ordering paintings that would 'recreate' lost classical paintings. These may have

been merely briefly noted in a text such as Pliny's *Natural History*, book 35. Many another was the subject of an elaborate *ekphrasis*, a description of a painting that the writer claimed to have seen – a literary form that became an important genre in the late antique period.[3]

It is hard now to judge whether these descriptions were indeed based on the visual experience of classical works, or were self-conscious literary exercises developed from the imagination. As far as the Renaissance is concerned, however, this does not matter, for there seems to have been no doubt in the fifteenth and early sixteenth centuries that these texts were faithful descriptions of works of art known to the classical writer. Emulation of the described qualities of these paintings brought intellectual prestige to both patrons and artists for the erudition they displayed in commissioning and in composing their works. This was partly because the described paintings had often been made by renowned classical artists. It was also partly perhaps because the literary conventions on which the genre of *ekphrasis* was founded resulted in descriptions that were both pictorially richly elaborate and often intellectually sophisticated. They therefore presented a stimulating challenge to Renaissance artists, as well as providing their patrons with the chance to own a 'classical' painting. The challenge to painters was twofold: first, to emulate in their work the complexity and beauty of the painting described, and second, to recreate as authentically as possible the classical world that, it was reasonably assumed, pervaded the original. The pictorial problems raised by this double challenge were unusually difficult to deal with, so it is not surprising that response to it by early Renaissance artists was limited to a small number of special cases.

The process by which an artist came to seek to recreate a whole classical painting from a description may have developed out of the growing interest in introducing into paintings images and pictorial ideas referred to in classical texts. Pliny recounts a famous story about the *trompe-l'oeil* qualities of the grapes in a painting by Zeuxis that were so lifelike that the birds mistook them for real grapes and flew down to peck at them.[4] Although Alberti did not fully approve of 'the early painter Demetrius . . . [who] was more devoted to representing the likeness of things than to beauty',[5] he did insist on the importance of the imitation of nature and he welcomed a dignified copiousness of natural forms in paintings. The combination of classical anecdote and early Renaissance mimesis theory perhaps led painters from the Squarcione circle such as Marco Zoppo to decorate their paintings (fig. 90) with abundant swags of flowers and fruit, as though to attract Zeuxis' birds. It was presumably the per-

90 Marco Zoppo, *Virgin and Child with Angels* (c.1455). Tempera on panel. Paris, Louvre

ceived erudition of this reference that led Raffaell Zovenzoni to write an epigram complimenting Zoppo on his *trompe l'oeil*:

> The fruits which Hercules handed to the Hesperides
> Your painted panel gave to me, O Zoppo.
> They deceived your own daughter, Marco, and no wonder
> Such fruits would draw Phidias' hand to them.[6]

91 Giorgio Schiavone, *Virgin and Child* (central panel of polyptych) (*c.*1460), detail: lower right-hand corner. Tempera on panel. London, © National Gallery

Similarly, Filarete paraphrased an anecdote about Giotto and Cimabue: 'And we read of Giotto that as a beginner he painted flies, and his master Cimabue was so taken in that he believed they were alive and started to chase them off with a rag'.[7] This story also perhaps encouraged painters in Squarcione's circle to indulge in *trompe-l'oeil* painting as a self-conscious display of painterly skill using the same example, such as the earwig at the foot of the Virgin's throne in Giorgio Schiavone's altarpiece of around 1460 (fig. 91) in the National Gallery in London. The profile faces to be seen in the clouds in Mantegna's *Pallas Expelling the Vices* (Paris, Louvre) are likewise probably a knowing reference to Lucretius's and others' comments about seeing recognisable forms in cloud formations.[8]

The late antique conventions for writing an *ekphrasis* were taken up in various different ways by Tuscan poets and others. Dante's descriptions of the sculptures carved on the wall of white marble just inside the gate into Purgatory show the strength of the poet's responses to the expressive qualities of works generated in his own imagination.[9] The figures are so naturalistically portrayed that his senses are deceived: he seems to hear both the Angel of the Annunciation's greeting and the Virgin's response; and he thinks at moments

that he can hear the singing of the choir that leads the Ark of the Covenant in procession, and at moments can smell the incense. In his *Amorosa visione*, Boccaccio describes in detail a series of five paintings that he sees in his dream.[10] For him, as for Dante, the heightened naturalism and expressiveness of these images deceive the senses of smell and hearing.

Once revived by fourteenth-century poets, the classical literary form of the *ekphrasis* was reused also by Renaissance writers. In *On Painting* Alberti provided a celebrated paraphrase of Lucian's *ekphrasis* of Apelles' 'Calumny'. This may have inspired his own ekphrastic descriptions of Giotto's *Navicella* (in which each figure shows 'such clear signs of his agitation in his face and entire body that their individual emotions are discernible in every one of them'), and of a Meleager sarcophagus in which 'those who are bearing the burden appear to be distressed and to strain with every limb, while in the dead man there is no member that does not seem completely lifeless'.[11] In the *Stanze per la Giostra di Giuliano de' Medici* of 1475–8 Angelo Poliziano described the reliefs cast by Vulcan for the doors of the Temple of Venus, offering his own interpretations of the meanings of gestures and expressions, and admiring the naturalistic qualities of the scenes. He also assumes the observer's fertile response to the scenes:

> Whatever the work of art does not possess within itself
> The imaginative mind understands clearly . . .[12]

It is hard to believe that Poliziano's description of Vulcan's relief of the 'Birth of Venus' was not known to Botticelli when he painted the same subject (fig. 92) some seven years later. Poliziano responded imaginatively to the naturalism that he perceived in his mental images of Vulcan's carvings. Botticelli, too, stimulates the observer's imagination by the movements and expressions of the figures, and by the treatment of detail in the billowing draperies, the waves and the scattered flowers. Taking his lead from Ovid's description of the birth of Venus, Poliziano wrote that in Vulcan's relief 'the sea and the foam appear to be real, the wind seems to blow', and 'you would seem to see trembling air in the hard stone'.[13] Botticelli's evocative recreation of the scene appears to be a creative poetic response stimulated by Poliziano. Titian's later *Venus Anadyomene* (fig. 93), on the other hand, and Raphael's in Cardinal Bibbiena's *stufetta*,[14] may simply be straightforward, descriptive visualisations of Ovid's story. More probably, however, these were conscious reconstructions of Apelles' 'Venus of Cos', based on the descriptions of Pliny and Cicero.[15]

Botticelli's ability to respond in an unusually sophisticated manner

92 Sandro Botticelli, *Birth of Venus* (c.1485). Tempera on linen. Florence, Uffizi

to a complex subject described in a classical *ekphrasis* shows clearly in his *Calumny of Apelles* (fig. 94). This is the earliest surviving painted reproduction of a classical description, albeit one mediated in part through Alberti. Lucian's dialogue on Calumny, which includes his description of Apelles' painting, was translated into Latin in 1408 by Guarino da Verona, so it was well known before Alberti paraphrased it in *On Painting*. For Alberti it is an ideal exemplar of his theory of *istoria*, and for this reason he sought to bring it into the more public domain of painters, who could not read the Greek original or often even Guarino's translation. But Botticelli did not reproduce Alberti's description entirely faithfully, perhaps believing that he was entitled to some licence in his interpretation of particular gestures or other details.[16] On the other hand, his small emendations to Alberti's paraphrase in fact suggest that he had access to another, more precise version of Lucian. This may suggest either that he was helped by a humanist of Lorenzo de' Medici's circle, or that he himself was sufficiently learned to understand the details of a Latin translation such as Guarino's.

Moreover, since Alberti offered no indication of the setting of Apelles' scene, Botticelli must have been guided by Lucian's text in devising the grand hallway of richly decorated architectural forms in which the allegorical group is placed. The architecture is decorated with both figure sculpture and reliefs, and in these reliefs, painted in

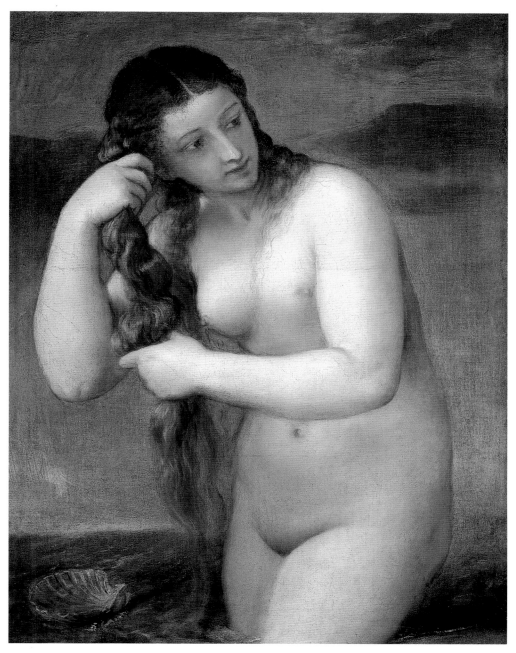

93 Titian, *Venus Anadyomene* (*c*.1525). Oil on canvas. Edinburgh, Duke of Sutherland Collection, on loan to the National Gallery of Scotland

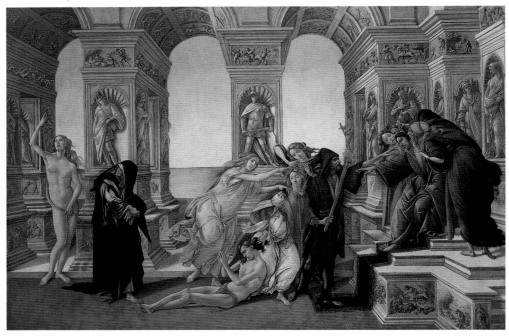

94 Sandro Botticelli, *Calumny of Apelles* (c.1495). Tempera on panel. Florence, Uffizi

monochrome with gold highlights as though cast in bronze, Botticelli shows further his interest in the notion of recreating pictorial works from written descriptions. One relief, on the inner left pier, shows the *Justice of Trajan*, a scene described by Dante in *Purgatorio* x. Another, of the *Centaur Family* on the plinth of the left-hand pier of the throne, derives from Zeuxis' painting of the Hippocentaur. This was described by Lucian in his dialogue *Zeuxis*, although Botticelli here changed the suckling babies of Lucian's description into young satyrs. Lucian's *ekphrasis* of Zeuxis' painting was variously represented in the 1490s;[17] here Botticelli shows it as a classical relief, as though seeking to demonstrate another facet of his skill in reproducing classical techniques.

In his slightly later drawing (fig. 95) of Apelles' 'Calumny', Mantegna also recreated the classical painting as though it had been a relief sculpture.[18] In his revisions of both Lucian's *ekphrasis* of Apelles' painting and Alberti's paraphrase, Mantegna seems to have sought to convey Apelles' moral point more convincingly. This he did by elaborating and emphasising the figures' physical characteristics to reflect their allegorical qualities. Judging by the direction of the

95 Andrea Mantegna, *Calumny of Apelles* (*c.*1505). Pen and ink on paper. London, © The British Museum

96 Girolamo Mocetto, after Mantegna, *Calumny of Apelles*. Engraving (*c.*1506). London, © The British Museum

figure-group's movement from right to left, he may from the first have intended his knowledgeable recreation of the classical painting to be reproduced as an engraving. Mantegna sought to show the figure-group as though a classical frieze, much as he later painted the *Intro-duction of the Cult of Cybele in Rome* (fig. 80) in monochrome figures against a flat background to emulate a classical marble relief. Unlike Botticelli, who constructed an inventive, Florentine, late fifteenth-century environment, Mantegna left his allegorical figures to speak Apelles' message alone. He cannot have intended, or antici-pated, that in the engraving (fig. 96) produced from his drawing, Girolamo Mocetto arbitrarily and absurdly would set the 'Calumny' figure-group, still moving from right to left, against a (reversed) view of the Campo di SS Giovanni e Paolo in Venice. Moreover, in the engraving two of the inscriptions are erroneously transcribed, so that the incorrectly identified figures make nonsense of Apelles' allegory, which Mantegna had so lucidly understood. Mocetto's misunder-standing throws light on the distinction between most early Renais-sance artists and those, like Mantegna, who strove consciously and hard to learn and understand more about the intellectual basis of their art. It should be borne in mind, in particular perhaps when con-sidering artists' engagement with literary texts, that the majority lacked the intellectual skills or pretensions of those who figure most prominently throughout this book.

For patrons at the turn of the century, the idea of owning 'recon-structed' classical paintings seems to have taken on a certain intel-lectual resonance, feeding their self-conscious pleasure in antiquarian erudition. Innocent VIII's Belvedere was appropriately decorated with imagery derived from classical descriptions of the decorative schemes in Roman imperial palaces and villas. These included illusionistic furnishings, curtains, a parrot in a cage and other similar incidental details recorded by Pliny; doubtless the recent discovery of the Golden House of Nero positively affected the decorative mode in which they were painted.[19] Given this taste, it is no surprise that clas-sical descriptions were also used as texts for paintings in the villa sub-urbana of Agostino Chigi, the immensely wealthy papal banker. Even before Sodoma based the Villa Farnesina bedchamber fresco on Lucian's *ekphrasis* of Apelles' marriage scene, Raphael had painted for Chigi the *Galatea* (fig. 97), which brings together an *ekphrasis* in Philostratus the Elder's *Imagines* with Angelo Poliziano's description of Vulcan's reliefs on the door to Venus's palace. Philostratus's description includes Galatea's swirling, wind-blown cape and identi-fies the female figures as the nereids, while Poliziano's accounts for the dolphin-driven shell-boat.[20]

97 Raphael,
Galatea (*c.*1512).
Fresco. Rome, Villa
Farnesina

 The paradigmatic recreation of classical paintings on the basis of *ekphraseis* during the Renaissance was the decoration of the so-called 'Camerino d'alabastro' of Alfonso d'Este. As this decoration evolved, Alfonso sought contributions from the most renowned artists in Italy, just as his sister Isabella had done a decade or more earlier for the paintings to decorate her *camerino* in the Castle at Mantua. He also sought to recreate a gallery of 'classical' paintings similar to that described by Philostratus the Elder in his *Imagines*. Philostratus opened his ekphrastic poem by telling of his visit to a villa outside Naples, when he was invited by some of the other guests to explain the paintings in their host's collection.[21] There follow more than sixty descriptions of paintings, intended, as he says, to instruct his readers 'to interpret paintings and to appreciate what is esteemed in them'. Whether or not these paintings actually existed beyond the somewhat overheated visual imagination of the writer is an open question. It does not, however, affect the issue of his intention, which was to instruct his readers on how they should respond to pictures. This text – and the similar one, also entitled *Imagines*, written by his grandson Philostratus the Younger – offered prototypes for many

descriptive writings about paintings in the Renaissance. They also provided stimuli to painters who understood them as faithful descriptions of the lifelike, expressive strengths of ancient paintings, and sought to emulate them in their own reconstructions of such paintings based on classical texts.

The last of the paintings for Isabella's *camerino* that Mantegna worked on, the *Comus* (Paris, Louvre), completed after his death by Lorenzo Costa, may have been based on an *ekphrasis* in Philostratus the Elder's *Imagines*, although Mantegna had licence to develop the original idea according to his *fantasia*.[22] Isabella's copy of Philostratus was available at the Mantuan court in the first years of the sixteenth century, and the *Imagines* of both the elder and younger Philostratus were translated into the vernacular for her in 1508.[23] This was presumably the text – indeed, the very volume – that Alfonso d'Este borrowed from his sister and which in a letter to him written in December 1515 she claimed he had already had for several years ('già più anni').[24] Earlier than this, however, Alfonso had commissioned from Giovanni Bellini the *Feast of the Gods* (fig. 98). This picture, delivered in 1514, later became the first of the series to hang in the Camerino d'alabastro, and dictated the scale and figure-size of the paintings later commissioned specifically for the room. Bellini had refused in 1504 to meet Isabella d'Este's request for a painting based on an allegorising text such as that written by Paride da Ceresara for Perugino, on the grounds (as he told Pietro Bembo) that he liked to 'wander at will through his paintings'. A little under ten years later, however, he was prepared to be controlled by the demands of a written text. The *Feast of the Gods* was based on one of the six 'fables or, in truth, histories' ('fabule o vero hystorie') that the court poet and humanist Mario Equicola proposed in October 1511 as themes for paintings in Alfonso's *studiolo*, as it was initially conceived. Equicola's text was itself based on the description of the feast of Bacchus in Ovid's *Fasti*; and it may be that it was to be matched by an 'Indian Triumph of Bacchus' commissioned from Raphael.[25]

Why Bellini took on this commission remains something of a mystery. His response to the Ovidian text shows that in comparison with his late brother-in-law, Mantegna, he was no antiquarian. He had in fact produced for Francesco Cornaro a pendant, the *Continence of Scipio* (Washington, DC, National Gallery of Art), to Mantegna's *Introduction of the Cult of Cybele in Rome* (fig. 80). The relatively limping, disjointed movement of this procession shows that he was not able to match Mantegna's convincing recreation of the classical world. The *Feast of the Gods* is no bacchanal: it is, rather, a quiet idyll in the early Renaissance mode, confirming Lorenzo da

98 Giovanni Bellini, *Feast of the Gods* (1514). Oil on canvas. Washington, DC, National Gallery of Art, Widener Collection

Pavia's view, in his letter of 31 August 1502 to Isabella d'Este, that 'Bellini is not a man to do stories'. It comes as no surprise that a decade later necessary 'corrections' had been made to it to bring it more into line with Alfonso's increasingly sybaritic tastes. Bellini himself, in all probability, was asked to lower the nymphs' necklines to reveal their breasts, and to make changes to the gods' attributes to increase the classical authenticity of the scene. A few years later, Titian superimposed a richly romantic landscape vignette over the left-hand side of the screen of trees that Bellini had originally painted behind all the figures, to bring it into harmony with the character of the backgrounds in the paintings based on classical *ekphraseis* that Titian himself had made for Alfonso's Camerino d'alabastro.[26]

99 Titian, *Worship of Venus* (1518–19). Oil on canvas. Madrid, Museo del Prado

Bellini's subject for the *Feast of the Gods* was not, of course, an *ekphrasis*, but rather an invented mythological narrative text based on Ovid. For the paintings made specifically for the Camerino d'alabastro, classical *ekphraseis* were chosen as the programmes. The *Worship of Venus* (fig. 99), ordered originally from Fra Bartolommeo in 1517 and painted after his death by the young Titian, was one of three paintings based on descriptions of classical paintings in both the elder and younger Philostratus's *Imagines*.[27] As is the nature of an *ekphrasis*, the text is richly elaborate and is too long to cite here; suffice it to say that it recounts in detail all the various activities of the *amorini* that Titian faithfully records. Fra Bartolommeo's drawing (fig. 100) of his proposed work shows that he planned a typical

100 Fra Bartolommeo, *Worship of Venus* (*c*.1516–17). Pen and ink on paper. Florence, Uffizi

Florentine Renaissance composition. But this does not satisfactorily suit the emphases in Philostratus's description of the classical painting on which it is based. Fra Bartolommeo brought the scene of the adoration of Venus by two nymphs (a relatively insignificant vignette in Philostratus) centre-stage, to provide the central axis around which his composition revolves. The classical painting that Philostratus described had a much looser composition: it focused on a broad landscape view strewn with playful *amorini* and apple trees. Reading the *ekphrasis* more intelligently, Titian replaced Fra Bartolommeo's composition with an asymmetrical design that reflects Philostratus's allegorical interpretation better, and perhaps also better suited the position in the Camerino d'alabastro allocated to his canvas. Titian's depiction of the games and other activities of the *amorini* follows Philostratus's extensive description of the variety of movements and actions faithfully. So much so, indeed, that his myriad putti almost overfill the long diagonal into pictorial depth, which is marked out by the line of trees. His solution to the problem posed by the prolix description in the text only just succeeds in being visually satisfying. This highlights the problems that classical ekphrastic descriptions posed for the Renaissance painter. By Philostratus's time the conventions of this literary genre favoured anecdotal complexity and

101 Perino del Vaga, *Hunt of Meleager* (*c.*1530). Pen and ink on paper. Chatsworth, Devonshire Collection, reproduced by permission of the Duke of Devonshire and the Chatsworth Settlement Trustees

elaboration over succinct and expressively persuasive description. The literal interpretation of an ekphrastic text set Titian and his contemporaries problems similar to those faced by Perugino when in his *Battle of Love and Chastity* (fig. 88) he strove to generate a visually satisfying pictorial composition out of Isabella d'Este's learned, moralising 'poetic invention'.

Raphael failed to produce the Ovidian 'Indian Triumph of Bacchus' that Alfonso commissioned from him in 1514. When Alfonso decided on the new scheme for a 'gallery' of pseudo-classical paintings this commission was replaced by one for a 'Hunt of Meleager', very probably to be based on an *ekphrasis* of Philostratus the Younger.[28] Once again, Raphael failed to execute this work before his death in 1520, but the composition is probably preserved in a drawing by his follower Perino del Vaga (fig. 101). Titian's third contribution, the *Bacchanal of the Andrians* (fig. 102), is his reinterpretation of another painting described by Philostratus the Elder.[29] Alfonso's desire here seems to have been for a more bacchanalian version of Philostratus's painting, for which Titian included a sleeping nymph at the right-

102 Titian, *Bacchanal of the Andrians* (*c*.1523–5). Oil on canvas. Madrid, Museo del Prado

hand corner, and introduced the contemporary French chanson that the central music-making figures are singing. Finally, Titian's *Bacchus and Ariadne* (London, National Gallery) is a literal visualisation of an *ekphrasis* by Catullus describing an embroidered bedspread made for the marriage of Peleus and Thetis. Commissioned in mid-1520, it is based on a new edition of the classical text that Battista Guarino dedicated to Alfonso d'Este at around the same time.[30] Isabella d'Este's scheme of decoration of her *camerino* revolved around moralising ideals of virtue and vice, set out in contemporary allegorical form in texts like the 'poetic invention' for Perugino. Some twenty years later her brother, by contrast, carefully selected classical *ekphraseis* to emphasise pleasure and recreation in a consciously

classicising picture-gallery. The artistic challenges set by this scheme, and the success with which Titian met them, formed a new chapter in the history of the Renaissance artist's wish to be granted the recognition gained by classical artists such as Apelles.

One reading of his *Tempesta* suggests that Giorgione depicted the storm as a cryptic attempt to establish himself as a 'new Apelles', responding to the challenge set by Pliny's account of the classical painter's representation of lightning.[31] Whether or not Giorgione deliberately based his poetic 'landscape of mood' on an *ekphrasis*, or indeed sought intellectual recognition by such means, remains an open question. But Renaissance painters often heard themselves praised as a 'new Apelles', or favourably compared with other great painters known from classical texts. Sometimes these references were linked directly with the association between Alexander the Great and Apelles: commenting around 1440 on Pisanello's portrait of Filippo Maria Visconti of Milan, Pier Candido Decembrio compared the sitter with Alexander the Great who wished, he wrote, to be portrayed by nobody other than by Apelles.[32] The agreement of 1488 between Marquis Francesco Gonzaga and Mantegna also draws a parallel between them and the patron-artist relationship of Alexander and Apelles.[33] Despite – or perhaps because of – the fact that no paintings by Apelles, Zeuxis or others survived, comparisons of painters with their classical predecessors became commonplace in fifteenth-century panegyrics. Already in the fourteenth century Petrarch had selected the sculptors Pygmalion and Polyclitus as rather unexpected comparisons for Simone Martini.[34] In 1436 the Milanese late Gothic sculptor Jacopino da Tradate, and a little later Jacopo Bellini, were compared, also surprisingly, with Praxiteles and Phidias respectively, despite the obvious contrasts between their works and the Quirinal *Horsetamers* which are inscribed with the classical sculptors' names.[35] Once the parallel between the fifteenth-century painter and Apelles had become established in verses in praise of Pisanello,[36] it was used of other painters. The *cassone* painter Apollonio di Giovanni was called 'the Tuscan Apelles' by Ugolino Verino,[37] although there is not much in the style of even the finest of the Florentine fifteenth-century furniture painters that prompts comparison with antiquity. Similarly, the observation of Ubertino Posculo in 1458 that Gentile da Fabriano's frescoes in Brescia were painted 'with as much art as Phidias or Polyclitos in marble or ivory, or Apelles the painter could produce' is no more than a panegyrist's commonplace.[38] Nevertheless, the parallels are likely to have pleased artists who cultivated their responses to both the visual and the literary heritage of the classical past. By 1500 a German humanist could use the same

comparison for Albrecht Dürer: in one of his epigrams on the painter, Konrad Celtis compares him with both Phidias and Apelles.[39] In his lengthy panegyric 'On giving praise to the City of Florence' written in 1488 Ugolino Verino draws several such parallels between living contemporaries and long-deceased classical precedents:

> Nor is our Verrocchio less than Phidias, and he
> Surpasses the Greek in one respect, for he both casts and
> paints . . .
> Nor was Theban Scopas or Praxiteles greater
> Than Desiderio was in marble that seems to breathe.
> And Sandro [Botticelli] I would not deem unworthy to be
> equated
> With Apelles, his name is known everywhere.
> Zeuxis of Heraclea, however you may have painted well,
> you fall,
> [Leonardo da] Vinci of Tuscany is hardly less than you in
> skill . . .[40]

During the fifteenth century interest grew in two classical literary traditions. Writings in praise of classical artists, which demonstrated their relatively high social and intellectual status, were emulated by the humanists. In turn, their praise of artists through classical parallels perhaps encouraged painters like Botticelli and Titian to seek pictorial means to 'reconstruct' works by classical painters. Such works were of necessity based on *ekphraseis* of classical paintings which offered prototypes and challenges to Renaissance patrons and artists alike. Just as Alfonso d'Este wished to recreate the sort of gallery of paintings described in the elder Philostratus' *Imagines*, painters working on commissions such as Alfonso's made the best of the opportunities that they were offered for presenting their visions of the art of the classical past.

✠BERNARDINVS
✠PICTORICIVS
PERVSINVS✠

Chapter 10

Self-portraiture

'Through painting', Alberti wrote in *On Painting*, 'the faces of the dead go on living for a very long time'.[1] But in their self-portraits early Renaissance artists, it seems, intended less to commemorate themselves for posterity than to assert in visual form their artistic and intellectual skills.[2] The ways in which the Renaissance artist portrayed himself are therefore useful indicators of his self-image and aspirations. The context in which he sets himself, the clothes he is wearing, the attributes he holds or displays, his manner, his gesture and his expression, may all be significant for our understanding of the character and development of artistic self-consciousness. The nature of the artist's self-image changes, of course, across our period and varies from place to place. These changes depend on a complex mix, impossible now to disentangle, of such factors as the individual artist's personality, his artistic and intellectual sources and stimuli, and the conditions of his employment. Certain artists who demonstrate a developed self-awareness through the medium of self-portraiture arise within unexpected social, political and cultural contexts. Albrecht Dürer, perhaps the most self-absorbed self-portraitist of the period, seems precocious in his sophisticated concern to project his image both as an artist and as an upwardly mobile member of society. In contrast, Leonardo da Vinci and Michelangelo were apparently hardly if at all interested in communicating their undoubted self-consciousness through scrutiny and representation of their own likenesses. Nevertheless, the range of early Renaissance self-portraits allows some general deductions to be made about artists' self-perception, the different ways this is shown and how these change during the period.

Two important problems arise at the outset. First, how can we know that a depicted figure is a portrait, let alone a self-portrait? And second, in what ways are we entitled to interpret such self-portraits? What may we reasonably deduce from them about the messages that artists wished to communicate about themselves and their social and

103 Bernardo Pinturicchio, *Annunciation* (1502), detail: self-portrait. Fresco. Spello, S. Maria Maggiore

cultural status? Some of the represented faces that may be accepted as self-portraits are not declared, self-evidently, to be so. Moreover, some interpretations of them may seem far-fetched. Many of the interpretations offered here are tentative: they are readings that may be (or that have been) proposed, but without any dogmatic belief in their necessity or correctness. Because of this, any general explanation for the growth of self-portraiture as a genre during the Renaissance period is bound to be problematical.

As to the first question posed in the previous paragraph, once more the evidence in many cases is shaky. It is certainly tempting to read a painting such as Titian's *Man in a Blue Sleeve* (London, National Gallery) as a self-portrait. But the tendency at least from the time of Vasari to identify a self-portrait merely because the sitter looks out of the picture towards the viewer is clearly facile. Certainly, through the very process of its production a self-portrait will usually exchange eye-contact with the observer. Moreover, the messages that an artist may wish to convey about himself may be communicated best through eye-contact. Numerous independent portraits that self-evidently cannot be self-portraits, however, such as Raphael's *Baldassare Castiglione* (Paris, Louvre) and Titian's *La Schiavona* (fig. 82), also look directly at the onlooker. Self-portrait medals, on the other hand, follow the almost invariable Italian convention by which the sitter is shown in profile; and there may be other self-portraits that remain undetected because the sitter does not look out at the observer. For example, a sculptural self-portrait bust by definition can share eye-contact only with a viewer who is in one particular position. This may be partly why relatively few sculpted self-portraits have ever been identified, despite the new popularity that the independent portrait bust gained during the Renaissance. The bronze bust of Mantegna (fig. 38) is a self-portrait, but this is only evidently the case because it forms part of his tomb monument. Moreover, sculpted self-portraits need to be explained more positively than painted self-portraits since they lack the colour that may make a portrait more easily identifiable. The bust of Lorenzo Ghiberti in the framing border of his second set of bronze doors for the Florence Baptistery (fig. 128) is more individualised than its companions, but it is definitely identifiable as a self-portrait only because it is juxtaposed with the sculptor's signature.

An associated issue is the natural tendency on the artist's part to reflect characteristics of his own physiognomy, expression and gesture in his works. 'Many painters paint figures resembling themselves', wrote Dürer;[3] and in one of the analogies with the visual arts that pepper his sermons, Savonarola wrote that the painter 'paints himself

as being a painter, that is, according to his concept [*concetto*]'.[4] 'Every painter depicts himself' ('ogni pittore dipinge sé') runs the fifteenth-century proverb, paraphrased by Savonarola, that commented on a compulsive weakness in human character. So for Leonardo da Vinci the painter's involuntary use of himself as a model was a defect of contemporary painting:

> You might deceive yourself and choose faces which conform to your own, for often, it seems, such conformities please us. If you were ugly you would choose faces which were not beautiful and would paint ugly faces, as do many painters . . .[5]

Paradoxically, however, his contemporary Gaspare Visconti suggested that Leonardo, too, could not avoid representing himself, despite his constant search for variety of movement and expression. In a sonnet composed for Bianca Maria Sforza sometime between January 1497 and March 1499, Visconti referred especially to the *Last Supper* at S. Maria delle Grazie:

> There is [a painter] nowadays who has so fixed
> in his conception [*idea*] the image of himself
> that when he wishes to paint someone else
> he often paints not the subject but himself.

> And not only his face, which is beautifully fair
> according to himself, but in his supreme art
> he forms with his brush his manners and his customs.[6]

There may therefore be many figures in Renaissance paintings that give the impression of being self-portraits by their striking individualisation but which should be seen merely as examples of 'automimesis'. What, for instance, should we make of figures like the young man at the right in the *Enthronement of St Peter* in the Brancacci chapel in the Carmine in Florence, often identified as a self-portrait of Masaccio, or the figure in a Carmelite habit at the left-hand side of the Barbadori altarpiece (Paris, Louvre) by Fra Filippo Lippi, or the man seen through the serving hatch in Dirk Bouts's *Supper at Emmaus* in Louvain? Although all look out with apparently meaningful expressions towards the observer, it may be prudent to regard them as merely cases of automimesis, given the absence of any hard evidence that they are self-portraits.

Secondary texts may sometimes help us to identify self-portraits. Some identifications do not predate Vasari's *Lives*, and in the absence of other evidence these can be accepted only with caution. After all, Vasari found a self-portrait of Simone Martini in the frescoes of the Spanish chapel of S. Maria Novella, which were in fact not painted

until more than twenty years after Simone's death.[7] Early Florentine sources before Vasari mention only three self-portraits, one by Giotto, one by Taddeo Gaddi in S. Croce and one by Orcagna on the Orsanmichele tabernacle.[8] Vasari, who habitually and probably over-enthusiastically identified faces in early Renaissance paintings as portraits, finds many more.[9] By Giotto, for example, he records self-portraits in the Lower Church at Assisi, at the church of the Annunziata at Gaeta, and in the Bargello in Florence. Of this last, Filippo Villani had declared around 1381–2 that Giotto painted 'with the help of mirrors himself and his contemporary the poet Dante Alighieri on a wall of the chapel of the Palazzo del Podestà'.[10] If all these portraits survived we would be in a better position to decide whether they indeed represented one and the same person, and perhaps also whether this was indeed Giotto. On balance, however, textual evidence alone is not sufficiently reliable for us to accept the genre of self-portraiture as dating from as early as this. Vasari's need of models for the woodcut 'portraits' of artists that introduce each of his *Lives* will have encouraged him to identify facial types as self-portraits. For this reason alone, it is probably wise once again not to accept self-portraits identified by Vasari unless other confirming evidence is available.

Some textual identifications are, however, closer in date to the self-portrait, and are probably more reliable. Giorgione's so-called *Portrait of the Artist as David* (fig. 107) of around 1508, for example, was already acknowledged as a self-portrait in Domenico Grimani's inventory of 1528.[11] But obviously the best evidence for pinning down a self-portrait is an inscription, such as the statement 'Opus Benotii' on the hat of one of the figures (fig. 109) in Benozzo Gozzoli's frescoes of the *Journey of the Magi* in the chapel of the Palazzo Medici in Florence, or the artist's name inscribed on the enamelled roundel self-portrait (fig. 104) of Jean Fouquet. Similarly, following the conventions of the Renaissance medallic art, the medals of Filarete (fig. 127) and Giovanni Boldù (fig. 130) bear inscriptions identifying the sitter. Unfortunately, not many identifications as definitive as these can be proposed: the identification as self-portraits of other possible cases, such as Jan van Eyck's *Man in a Red Turban* (fig. 115), remains problematical because their inscriptions are more cryptic in character.

The practice of including self-portraits in public images seems to have emerged tentatively during the fourteenth century. If the portrait-drawing that Simone Martini made of Petrarch's beloved Laura was more than a figment of the poet's imagination, the autonomous portrait also evolved in the mid-fourteenth century.[12] No

104 Jean Fouquet, *Self-portrait* (*c.*1450–60). Enamel. Paris, Louvre

autonomous self-portrait is however known before the early fifteenth
century. The earliest extant representation that is proposed as a self-
portrait in early texts is of Andrea Orcagna, as a supernumerary
figure at the right-hand side of the Apostles group in the *Death of
the Virgin* on the Orsanmichele tabernacle.[13] Although individualised,
this is not obviously a self-portrait. An early example of a painter
who seems to identify his image as a self-portrait through his attrib-
utes is a small portrait (fig. 105) in the border of Cola Petrucciolo's
frescoes in the choir of S. Domenico, Perugia. The sitter, who looks
directly at the observer, represents himself in 1400 (close in date to
the composition of Cennino Cennini's *Craftsman's Handbook*) as a
craftsman painter, unpretentiously clothed in an artisan's smock and
hat, and dipping his brush into the paint pot held in his left hand.[14]

105 Cola Petrucciolo, *Self-portrait* (*c*.1400), detail. Fresco. Perugia, S. Dome-
nico, choir frescoes

106 Taddeo di Bartolo, *Assumption of the Virgin* (1401), detail: St Thaddeus. Tempera on panel. Montepulciano, cathedral

107 Wenceslaus Hollar, after Giorgione, *Portrait of the Artist as David* (*c*.1505–10). Engraving (1650). London, British Museum

VERO RITRATTO DE GIORGONE DE CASTEL FRANCO
da luy fatto come lo celebra il libro del VASARI.

Also probably a self-portrait is the face of the painter's patron saint Judas Thaddeus (fig. 106) in Taddeo di Bartolo's *Assumption* altarpiece of 1401 (Montepulciano, cathedral).[15] This saint's face has more differentiated features and expression than any other, and his particularised gesturing is similar to the scholastic orator's technique of checking off points by counting on his fingers. The gesture could then precociously call attention to the analogy later drawn between painting and rhetoric, but is more probably an early signal of the painter's recognition of the importance to him of the hand that wields his brushes. A more celebrated and more secure example of an artist who identifies himself with a figure of the past is Giorgione's *Portrait of the Artist as David* (fig. 107). How this image should be interpreted is open to debate, but Giorgione may be proposing himself both as a young hero and as a liberator from tyranny. The head of Goliath and the armour that Giorgione wears refer to David's military triumph: perhaps Giorgione is visually manifesting his aspiration towards an artistic victory to free Venetian painting from the constraints of convention represented by Giovanni Bellini.

St Thaddeus's gesticulating hand in Taddeo di Bartolo's *Assumption* perhaps anticipates later self-portraitists' emphasis on the 'hand of the master'. Angelo Poliziano's epitaph inscription on the commemorative monument to Giotto erected by Lorenzo the Magnificent in the Duomo of Florence draws attention to the painter's *recta manus*, his dexterous hand.[16] By that time, this idea had become commonplace. A head in the crowd on the left wall of the chapel in the Palazzo Medici (fig. 108), frescoed some thirty years earlier, is identifiable as a self-portrait of Benozzo Gozzoli by direct comparison with the inscribed version on the opposite wall (fig. 109). Gozzoli looks towards the observer and lifts into view a strangely disembodied right hand. It is silhouetted against his companion's deep red clothing, to highlight the carefully defined gesture. Gozzoli seems both to invite the observer to recognise his skill as a painter and to claim that the fresco cycle is 'di sua propria mano' (by his own hand), a standard phrase in artistic contracts by which the patron emphasises his wish for autograph design work.[17] A similar emphasis on his hand is noteworthy in self-portrait drawings by Dürer. In the Erlangen drawing (fig. 110) of 1491, for instance, the prominent right hand shades the painter's expressively drawn eyes, as though to stress the critical importance to the artist of the co-ordination of eye and hand. In a drawing in New York, too, the position of his left hand, rather like that of Taddeo di Bartolo, shows how delicately he holds his pen as he makes his refined, perceptive drawing (fig. 111). Perhaps the classic instance of visual emphasis on

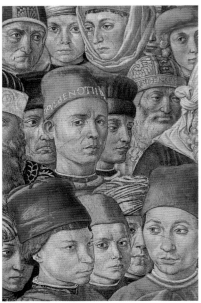

110 Albrecht Dürer, *Self-portrait* (c.1491). Pen and ink on paper.
Erlangen, Universitätsbibliothek Erlangen–Nürnberg

108 and 109 (*facing page top*) Benozzo Gozzoli, *Procession of the Magi* (1459), details with self-portrait. Fresco. Florence, Palazzo Medici, Chapel, west and east walls respectively

111 Albrecht Dürer, *Self-portrait* (1493). Pen and ink on paper. New York, The Metropolitan Museum of Art, Robert Lehman Collection, 1975

the painter's *recta manus* is Parmigianino's *Self-portrait in a Convex Mirror* in Vienna (fig. 112), where the artist exploited the distorting effect of his reflection in the mirror to force attention on his refined but proportionally greatly enlarged right hand. He also confidently calls attention to his artistic achievement in the face of the intentionally difficult circumstances that he set himself: painted on a convex circular panel, the self-portrait is used as a vehicle for the display of conspicuous skill. The inscription 'Jan van Eyck fuit hic' in the *Arnolfini Double Portrait* also identifies a self-portrait reflected in a circular convex mirror (fig. 113). This successful display of technical virtuosity is echoed in the equally virtuoso self-portrait, which is more playful than profound, painted as a reflection in the armour of St George in Jan van Eyck's *Virgin and Child of Chancellor Van der Paele* of 1436.

In a self-portrait probably of the 1440s (fig. 114), Lorenzo Vecchietta proposes another way in which the painter may call attention to his representational skills. The artist is shown looking through an opening in the marbled decoration of the dado around the choir of the Collegiata at Castiglione Olona and round towards the scene of the *Martyrdom of St Lawrence* that he had only recently frescoed on the wall above.[18] This artistic tribute to his patron saint calls attention to the painter's skill in deceiving the observer into thinking that

112 Francesco Parmigianino, *Self-portrait in a Convex Mirror* (1524). Oil on panel. Vienna, Kunsthistorisches Museum

he moves apparently through the solid wall. Vecchietta seems here to recognise consciously both his representational skill and the ingenuity of his *invenzione*. Another form of *trompe-l'oeil* was later used in self-portraits by both Pietro Perugino and Bernardino Pinturicchio to emphasise their painterly skills. Perugino's frescoed self-portrait of 1500 in the Collegio del Cambio in Perugia is represented as though an easel painting hung on one of the richly decorated pilasters dividing the principal scenes (fig. 116). Below it hangs a tablet inscribed with the self-conscious inscription: 'Pietro Perugino, celebrated painter. If the art of painting became lost, he would restore it. If it had never been invented, he alone could bring it to this point.'[19] Within the scene of the *Annunciation* in his fresco cycle at S. Maria Maggiore in Spello, Pinturicchio followed Perugino's precedent of

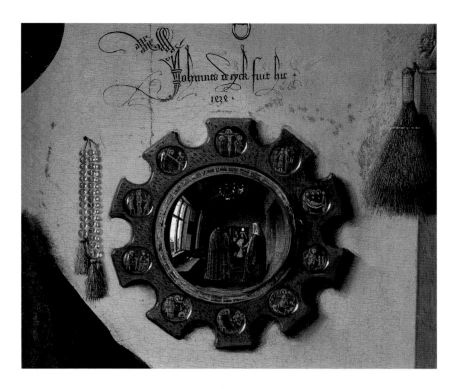

113 (*above*) Jan van Eyck,
Arnolfini Double Portrait
(1434), detail. Oil on panel.
London, © National Gallery

114 Lorenzo Vecchietta, *Self-
portrait* (*c.*1440–50), detail.
Fresco. Castiglione Olona,
Collegiata, dado of choir
frescoes

115 Jan van Eyck, *Man in a Red Turban* (1433). Oil on panel. London, © National Gallery

showing himself in a *trompe-l'oeil* easel painting below a shelf of domestic items painted with conscious skill in the Netherlandish manner (fig. 103). Hanging from the tablet bearing the artist's signature below are a pen and two brushes, the tools of his profession, much as they appear also in the decorative vocabulary on the commemorative monuments to Fra Filippo Lippi in Spoleto cathedral (fig. 41) and Andrea Bregno in S. Maria sopra Minerva, Rome (fig. 44).

The display of conspicuous skill was perhaps also the purpose of Jan van Eyck's *Man in a Red Turban* (fig. 115), which may be the earliest surviving autonomous self-portrait. Of incomparable quality of technique and execution, this portrait is inscribed with van Eyck's modest but also self-confident personal motto 'Als ich can' – 'as best I can' – which reappears on paintings signed by him, as on the Dresden *Virgin and Child with SS Michael and Catherine* and the Antwerp *Madonna of the Fountain*, and on a small tablet in the Berlin *Salvator Mundi*. The frequency with which the epigram is paired with his signature suggests that Jan van Eyck adopted it to describe his aspirations as a painter, and in the *Man with a Red Turban* it seems likely that the motto is meant to identify Jan as both sitter and

116 Pietro Perugino, *Self-portrait* (1500), Fresco. Perugia, Collegio del Cambio, fresco decoration, detail

PETRVS PERVSINVS EGREGIVS
PICTOR·

PERDITA SI FVERAT PINGENDI·
HIC REITVLIT ARTEM·
SI NVSQVAM INVENTA EST
HACTENVS· IPSE DEDIT·

117 Israhel van
Meckenem, *The
Artist and His Wife*
(*c.*1480). Engraving.
London, © The
British Museum

painter. Its presence suggests that the portrait may have been intended
as a self-promotional work, an elaborate, extended study in exact-
ness of observation and execution to be shown to current or prospec-
tive patrons as a sample of artistic and technical skill. Van Eyck's red
headgear provided him with a further challenge, that of depicting the
complex folds and texture of the cloth, and at the same time with a
vehicle for enhancing his self-image by showing off his costly and
lavish dress. The portrait demonstrates in particular van Eyck's extra-
ordinary ability to represent the finest details of his facial features
and textures, a skill of special interest to any client who sought to
have his portrait painted. The same sense of self-scrutiny is to be seen
in the small enamel roundel self-portrait by Jean Fouquet (fig. 104).
This too was perhaps made essentially as a careful and precise study,
from a model who was always available, to demonstrate his painterly
skills in a specialised technique.

 Jan van Eyck's portrait of Margarethe van Eyck (Bruges, Groeninge
Museum) indicates that the painter was also ready to use his wife as
a model for close scrutiny and study, and to make a parallel exem-
plar of his skills in female portraiture. Although van Eyck's portraits
of himself and of his wife are not strictly pendants, they suggest that
together they may also have functioned as domestic commemora-
tions. The portrait of 'the painter and his wife' is a new type that
became current in northern Europe in the fifteenth century. The ear-
liest certain example is the double portrait in an engraving by Israhel
van Meckenem of around 1480, inscribed 'figuracio facterum Israelis
et Ida suis uxoris IVM' (fig. 117).[20] Perhaps this print was a cele-
bration of the artist in his domestic context for circulation among
friends, rather as today some people send snapshots of their family
as Christmas cards. The most elaborate domestic double portrait of

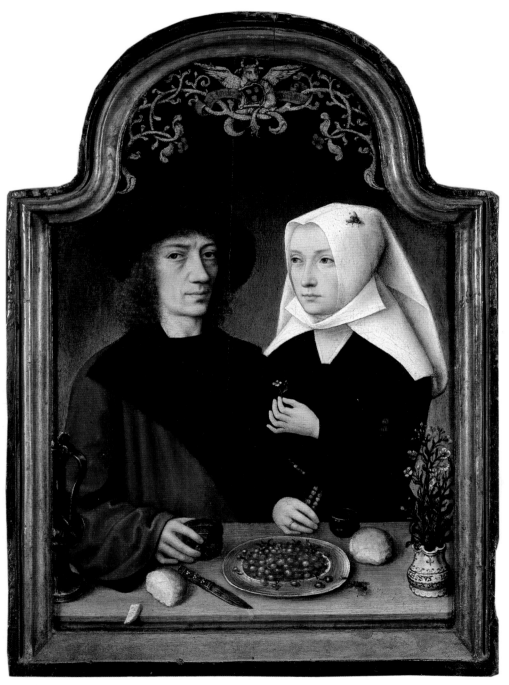

118 Master of Frankfurt, *The Artist and His Wife* (1496). Oil on panel. Antwerp, Koninklijk Museum voor Schone Kunsten

119 Albrecht Dürer, *Self-portrait at the Age of Thirteen* (1484).
Pen and ink on paper. Vienna, Graphische Sammlung Albertina

the artist and his wife in our period, however, is by the so-called
Master of Frankfurt (fig. 118).[21] Beneath the coat-of-arms of the
Antwerp painters' guild, the couple sit at table; the painter shows off
his mimetic skill in still-life painting in the depiction of flies, one of
which has alighted on the unblemished whiteness of the woman's
headgear. This detail is uncannily reminiscent of Filarete's story about
Cimabue, Giotto and the fly, and as in Schiavone's *Virgin and Child*
(fig. 91) the still-life precision of these insects appears gratuitous. The
Master of Frankfurt shows off not only his painterly skills but also
his prosperity, in the clothes that he and his wife wear, in the

120 Albrecht Dürer the Elder, *Self-portrait as a Goldsmith* (c.1484).
Pen and ink on paper. Vienna, Graphische Sammlung Albertina

tablewear and especially in the maiolica jug holding the bunch from which his wife has just picked her flower.

A final example of what might be termed 'domestic' self-portraiture is the pair of self-portrait drawings made in 1484 by Dürer and his father. Dürer's precociously young self-portrait (fig. 119), drawn when he was aged 13, was perhaps made in emulation of, and as the pendant to, his father's self-portrait drawing (fig. 120).[22] If the hand-held statuette is the attribute of Dürer the elder as a goldsmith, Dürer the younger's pointing hand is perhaps once again the *recta manus* of the painter in waiting. A later Dürer self-

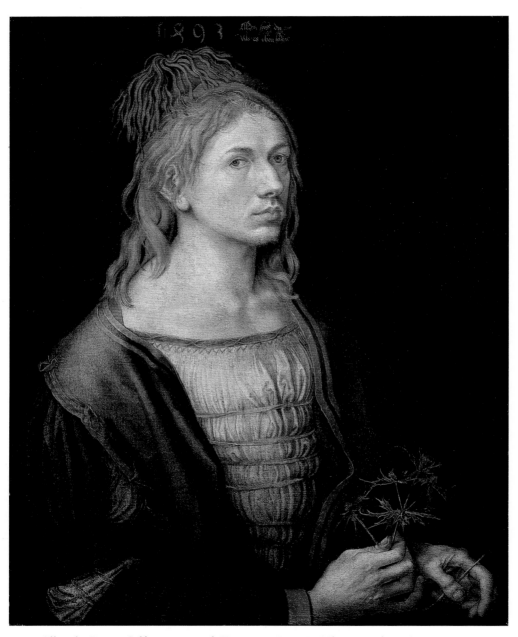

121 Albrecht Dürer, *Self-portrait with Eryngium* (1493). Oil on panel. Paris, Louvre

122 Lysippus the Younger, self-portrait medal (*c.*1471–84).
Bronze. London, © The British Museum

portrait (fig. 121), dated 1493, seems to have a more defined domestic function, since it was probably presented to his wife-to-be, Agnes, as a token of their betrothal. Dürer offers the viewer – presumably Agnes herself – a sprig of eryngium, traditionally considered an aphrodisiac and associated with success in love, and concedes in the inscription that 'my affairs will go as it stands above'.[23]

An apparently informal, Italian domestic self-portrait, made in a form that invites reproduction and circulation, was also perhaps intended to convey an intimate message. This unusual single-sided medal (fig. 122), which may have been intended to be cast in silver, is of Lysippus the Younger, the anonymous medallist active in Sixtus IV's Rome who nick-named himself after the celebrated ancient Greek bronze sculptor. On the obverse is the sculptor's portrait and an inscription that suggests that the reverse was to have been burnished like a mirror: 'Admire on one side your own beautiful face, and on the other that of your servant.'[24] This was perhaps intended to be understood literally as a tribute from the medallist to his beloved; and the medallic form allowed Lysippus the Younger to cast an 'edition', so that he could offer this same message to more than one recipient.

Benozzo Gozzoli used the vehicle of self-portraiture to make declarations about his awareness of his talents and about his position with respect to his patrons. Three self-portraits by Gozzoli can still be persuasively identified, and it seems likely that he executed more than this. The eulogistic tone of the inscription on his *Joseph in Egypt* fresco in the Camposanto, Pisa, reflects the esteem in which he was held by patrons.[25] Probably held in high regard were the speed and brilliance of his technique, the inventive novelty of his narrative treatment, and the precision and naturalism of his depiction of detail – not least in portraiture. The Camposanto frescoes are now all but destroyed; but in stating that 'This is the work of Benozzo: by his art their visages live: / O gods above, endow them with a voice as in life', the inscription appears to refer precisely to portraits in the *Joseph* scene. This was probably visually associated with, amongst others, a self-portrait set into the crowd. There certainly is a self-portrait in the scene of *St Augustine's Departure for Milan* in the fresco cycle that Gozzoli completed in the church of S. Agostino in San Gimignano in 1465. This can be identified partly by comparison with the inscribed self-portrait in the Palazzo Medici chapel frescoes, but also partly from its juxtaposition with the inscription, written on a scroll borne aloft by angels inspired by classical Victories, that describes Benozzo as 'worthy' (*insignem*).[26] This self-portrait is painted on one whole *giornata* out of only eight for the whole scene, a clear indication of the importance that Gozzoli attached to representing himself, his dress and his deportment in a manner presumably consonant with his perceived self-esteem.

But it is in the Palazzo Medici chapel frescoes that the most remarkable Gozzoli self-portraits are to be found. One of these (fig. 108), as we have seen, highlights the painter's *recta manus*; in the other (fig. 109) he appears to signal the favour with which he was regarded by the Medici. He shows himself among the group of Medici family, friends and partisans who follow Cosimo and his son Piero at the head of the procession behind the young King. Gozzoli stands in the second rank immediately above the portraits of Piero di Cosimo de' Medici's two sons Lorenzo and Giuliano, as though seeking direct visual association with the younger members of the Medici family. He wears a fine deep-red doublet and a red hat, inscribed 'Opus Benotii' which, in the punning spirit of that time, might suggest a wish that he and his fresco cycle should be *ben noti* – noted well by observers. Taken together, the Palazzo Medici self-portraits suggest Gozzoli's consciousness of the privilege of working for the Medici, and his wish that the artistic skill and quality of his work for them should be recognised.

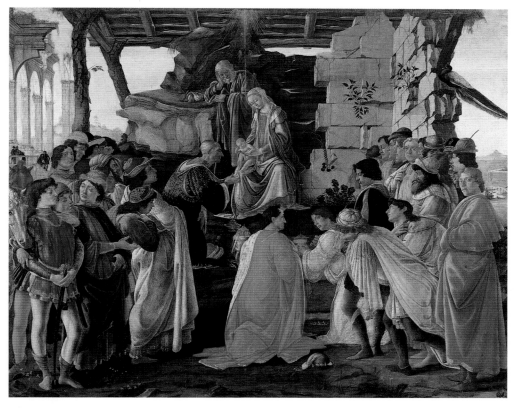

123 Sandro Botticelli, *Adoration of the Magi* (*c*.1472–5). Tempera on panel. Florence, Uffizi

A similar desire to be associated with the Medici family, perhaps with a view to the possibility of future patronage, may explain the figure robed in yellow at the right-hand end of the figure group in Botticelli's Uffizi *Adoration of the Magi* (figs 123 and 124). This is usually taken to be a self-portrait, and if indeed it is, Botticelli showed himself in the company of several members of the Medici family who are represented as the Magi and their immediate cortège.[27] In this he may also have been responding to the attitude of the altarpiece's patron, the wheeler-dealer financier Guasparre del Lama, towards the Medici. Del Lama seems to have had portraits of the Medici included in the hope thereby of currying favour with the leaders of the banking community of Florence. By his presence and in his body-language as he glances towards the observer and gestures towards the adoration group, the figure identified as Botticelli expresses his wish to be

125 Peter Parler, self-portrait bust (*c.*1392). Stone. Prague, St Vitus, choir triforium

noticed. He holds a bold, almost swaggeringly rhetorical pose, and draws attention to himself by the deep brown and yellow of his robes which, enfolding him in thick loops of fabric, contrast tellingly with the colour cadences of the figures following the Magi. The supple twist of his head as he looks round and slightly downwards towards the onlooker emphasises the sense that Botticelli was confidently in control of his art. He seems also deliberately to contrast himself with the foreground figure at the left edge of the painting, who is generally identified as Giuliano de' Medici. Not entitled to carry a sword or to dress in the courtly doublet and hose worn by this figure, Botticelli yet appears to take up more space and to present a firmer, more definite presence that captures the observer's attention in a more demanding way than his opposite number.

Gozzoli's and Botticelli's self-portraits are the visual means by which the artists sought to gain public recognition of their association with a powerful household. As early as around 1392, Peter Parler carved a self-portrait (fig. 125) to be placed among the portraits of Wenceslas IV of Bohemia and his family on the choir triforium of St Vitus, Prague, in recognition of his status as *familiaris* to the emperor.[28] In his description of the ideal city of Sforzinda, designed

124 Detail of fig. 123

in words for his patron the Duke of Milan in his *Treatise on Architecture*, Filarete included himself alongside his fictional prince and his son in a group of carved figures to be set on the bridge at the harbour entrance.[29] A visual parallel to this notion can be found in the illumination (fig. 126) on parchment stuck on to the inside cover of Federigo da Montefeltro's copy of Cristoforo Landino's *Disputationes camaldulenses*, but probably originally the dedication picture in the copy of Francesco di Giorgio Martini's *Treatise on Architecture* presented to Federigo da Montefeltro around 1480.[30] Here Francesco di Giorgio represents himself deferentially looking up at the Duke of Urbino, a conceit that had the classical precedent of Phidias, who showed himself with Pericles on the shield of Athena Parthenos in the Parthenon. This is just one example, well known in the Renaissance, of the mutual respect held between princes and artists in the ancient world.[31] Predictably, artists more conscious of classical precedent than perhaps was Gozzoli drew the analogies more clearly. Even the inscription on the large dedication tablet of the Camera Picta in the Castello at Mantua seems to represent Mantegna's presence alongside the numerous portraits of Ludovico Gonzaga, Marquis of Mantua, his family and friends. Mantegna did not portray himself alongside his patrons: his self-portrait appears as a witty detail in the decoration of one of the painted pilasters.[32] But he dedicated the Camera Picta frescoes to them in a punning inscription that emphasises both his self-conscious modesty and his artistic self-confidence: 'For the illustrious Lodovico, second Marquis of Mantua, best of princes and most unvanquished in faith, and for his illustrious wife Barbara incomparable glory of womankind his Andrea Mantegna of Padua completed this slight [or 'fine', or 'subtle'] work [*opus hoc tenue*] in the year 1474.'[33]

Mantegna's principal self-portrait (fig. 38) is, however, a far more serious affair. Probably around 1490 he cast the bronze self-portrait bust, cut off at the shoulders in a true *all'antica* form,[34] that was later incorporated into his funerary chapel. Self-portraiture in the prestigious material of bronze had appeared before, in medals and in the border decoration of bronze doors, but never on this scale or with this classicising ostentation. In this case the material alone carries resonances both of Mantegna's consciousness of his artistic status and of his wish to display his social aspirations in a demonstration of his growing wealth. It also suggests his desire that the observer should draw a parallel between him and his Gonzaga patrons, for the main precedent for this *all'antica* bronze bust was the one (perhaps modelled by Leon Battista Alberti) representing his patron in the Camera Picta frescoes, Ludovico Gonzaga.[35]

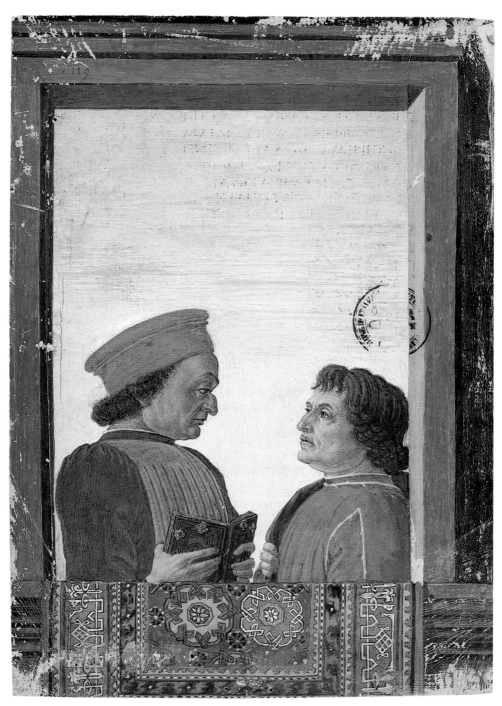

126 Francesco di Giorgio Martini, *Self-portrait with Federigo da Montefeltro* (*c.*1480).
Illumination on vellum. Rome, Biblioteca Apostolica Vaticana, cod. Urb. Lat. 508, inside cover

127 Filarete (Antonio Averlino), self-portrait medal (*c.*1460–66), obverse and reverse. Bronze.
London, Victoria and Albert Museum

Other self-portraits of the middle of the fifteenth century, a time
when the artist's awareness of the value of his skills, both practical
and intellectual, was emerging towards greater consciousness and
articulation, may convey similar messages. Filarete also expressed
his loyalty to his Milanese patron in a self-portrait medal (fig. 127)
of an unusual oval shape. He perhaps made this as a self-
recommendation to Galeazzo Maria Sforza on the latter's accession
to the duchy in 1466.[36] By their very nature and functions portrait
medals not only allow messages about individuals to be communi-
cated, but indeed require that they should be. On obverses the way
that sitters are represented may encode messages about them. On
each reverse an image is shown that through its style, iconography,
allegorical implications and associated inscription usually offers a
commentary on the person shown on the obverse. The self-portrait
on the obverse of Filarete's medal is a straightforward representation
in pure profile, as in his younger self-portrait on the bronze doors of
Old St Peter's. The complex imagery of the reverse, one of the earli-
est in a long series of allegories of the court artist, has prompted a
number of different, but not necessarily contradictory interpretations.
The inscription emphasises the obligations of the artist as *familiaris*
at court to his prince: 'Just as the sun nurtures the bee, so the prince

offers us preferment.'[37] The image of the bee on which the brightness and warmth of the princely sun shines, here shown as a swarm attached to a tree with Filarete himself cutting open the trunk to allow honey to flow out, may allude to the artist's industry and talent.[38] A further reference in this elaborate allegorical image may be to Filarete's aspirations to serve the Duke of Milan as an architect, given the well-known analogy between the bee and the architect as builders.[39]

Filarete was unmatched in the middle of the century in his consciousness of the value of self-portraiture and associated imagery for publicising his intellectual and social position. He incorporated two self-portraits into the decoration of the bronze doors of St Peter's cast for Pope Eugenius IV between 1435 and 1445. The first is a profile portrait closely based on Roman coins and medals. It invites the observer to recognise the parallel with other medallion copies of Roman emperor coins that are set into the doors' rich acanthus framing. It is a small medal, 59 mm in diameter, let into the centre of the bottom border of the left leaf of the doors; its reverse is in the same position on the right leaf, and both have signature inscriptions.[40] This relatively straightforward, classicising self-portrait medallion has parallels in other bronze doors. In the framing borders of his second pair of doors for the Baptistery in Florence Lorenzo Ghiberti inserted a classicising *imago clipeata* portrait (fig. 128) closely linked with his self-laudatory signature inscription: 'Made by the wondrous skill of Lorenzo di Cione Ghiberti'.[41] Reflecting these precedents, Guglielmo Monaco later inserted a self-portrait, in profile and inscribed 'Guillelmus Monacus me fecit', in a

128 Lorenzo Ghiberti, self-portrait bust (*c.*1447–8). Bronze. Florence, Baptistery, East Doors

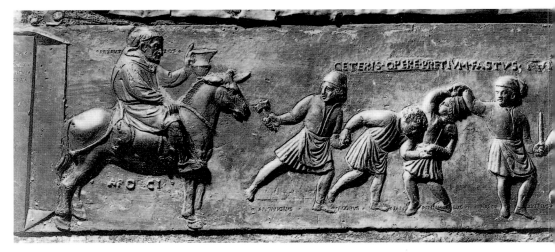

129 Filarete, *Self-portrait with Workshop Assistants* (1445). Bronze. Rome, St Peter's, bronze doors

roundel at the base of the bronze doors that he cast in the mid-1470s for the Castel Nuovo in Naples.[42]

 Filarete's second acknowledgement of his work on the important commission of bronze doors for the greatest church in Christendom is the extraordinary relief (fig. 129) attached to the inside of the door

130 (*below and facing page*) Giovanni Boldù, two self-portrait medals (1458), obverses and reverses. Bronze. Paris, Louvre, and London, Victoria and Albert Museum

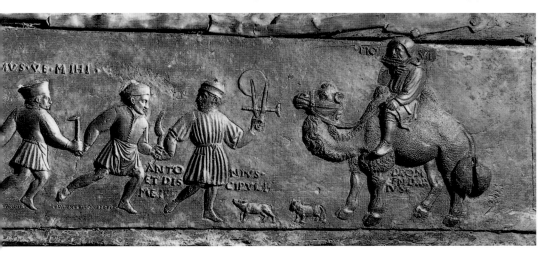

at floor level. To complement the inscription 'Antonius et discepuli miei' and date 'die ultimo iulii 1445', the sculptor shows himself as leader of his workshop in a cryptic signature that, like the reverse of his self-portrait medal, is allegorical in form. Filarete and his assistants perform a dance, spirited in comparison with the subdued, elegant choreography standard in courtly dance of the time. This anticipates his description of building activity in his ideal city of Sforzinda:

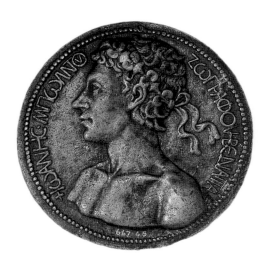

if all are to work together at the same time, the first as well as the
last, it will have to be like a dance. The first dances like the last if
they have a good leader and good music.[43]

Although set in an inconspicuous position, this allegorical relief
shows Filarete seeking to present himself as an active and respected
workshop manager, contented perhaps with the *ars et ingenium* of
his work.

Two further self-portrait medals (fig. 130), dated 1458 (the year
before Benozzo Gozzoli painted his self-portraits in the Palazzo
Medici chapel frescoes) are by the otherwise little-known Venetian
painter Giovanni Boldù. These also allegorise the artist's situation,
but this time primarily in classicising terms. This associates Boldù
firmly with the antiquarian interests of his compatriot Jacopo Bellini
and Bellini's Paduan son-in-law, Andrea Mantegna. On the obverses
Boldù portrays himself in one case fashionably clothed in a tall hat
and brocade doublet, with an inscription in Hebrew (fig. 130a), and
in the second, nude (fig. 130c). This latter image is transparently
all'antica: the bust is cut off at shoulder level and the anatomical form
and musculature of his torso are finely described with keen interest
in its heroic qualities. He wears an ivy wreath, and the signature
inscription is written in pretentious, though faulty, Greek.[44] The
reverses of Boldù's two medals show allegorical images of the
memento mori theme, meditations on death presented in humanist,
classicising terms. In the reverse of the nude self-portrait a nude youth
– again the artist, presumably – and the genius of Death, both clearly
based on classical sources, sit on either side contemplating a large
skull (fig. 130d). In the other reverse the artist sits meditatively
between Faith and Penitence (fig. 130b). In both, the artist holds his
head in his hand in a pose suggestive of melancholy – the pose later
adopted by Dürer in his classic exposition of this theme in the *Melen-
colia I* engraving (fig. 140). Writing in 1443 to Leonello d'Este,
Guarino da Verona suggested that paintings and statues were not the
best ways of guaranteeing fame since they were neither portable nor
provided with inscriptions.[45] Although his aim was to reassert by con-
trast the greater power of the written word, he might have agreed
that medals could disseminate individuals' fame much better than
paintings. With their autobiographical, moralising images, Boldù's
medals should perhaps be seen in this light. By setting himself both
in a classicising and in a contemporary, Christian context, he appears
to make a two-pronged statement in his medals. He was first com-
menting on his intellectual awareness of the classical world, gained
perhaps through contact with the humanists of Venice or Padua
whom he may have consulted about his medallic imagery. Second, he

131 Domenico
Ghirlandaio,
*Expulsion
of Joachim*
(1485–90), detail.
Fresco. Florence,
S. Maria Novella,
Tornabuoni chapel

seems to wish that his melancholic life should be permanently commemorated in moralising images both Christian and *all'antica.*

The technique of making a statement through visual comparison, as in Botticelli's self-portrait in the Uffizi *Adoration of the Magi,* is exploited with stronger intellectual resonance in Domenico Ghirlandaio's self-portrait (fig. 131) in the *Expulsion of Joachim* in the Tornabuoni chapel, S. Maria Novella.[46] Like Filarete in the St Peter's doors relief, Ghirlandaio represents himself here as the *bottega* master standing alongside his two assistants – his brother Davide and Sebastiano Mainardi – and a third figure, traditionally identified as Alesso Baldovinetti. By his position and carriage Ghirlandaio makes it very clear that he was in charge of the project. He stands in a heroic pose boldly occupying the foreground space, and his forceful, strongly featured face is turned to look directly out of the painting. At first it might seem that he exchanges glances with the onlooker, but actually he looks out well above the heads of observers standing on the floor of the chapel. He has in fact depicted himself staring at the wall opposite, where in the equivalent position

in the fresco of the *Annunciation to Zacharias* Cristoforo Landino, Marsilio Ficino, Angelo Poliziano and Gentile de' Becchi are depicted. These were the four principal humanists active in Lorenzo de' Medici's intellectual circle. The positions of the two groups of painters and humanists were intended to invite direct comparison. Whereas the mostly ageing humanists wear scholarly but sober dress and withdraw somewhat into their contained group, Ghirlandaio's confidently outgoing, open pose suggests by contrast the youthful and vigorous state of the art of painting in Florence around 1490. It is as though Ghirlandaio sought to assert in visual terms the validity of Leonardo da Vinci's near-contemporary views on the superiority of painting over literary activity, as when he wrote that 'painting remains the worthier in as much as it . . . remakes the forms and figures of nature with greater truth than the poet'.[47] By comparing the painters of his workshop favourably with eminent humanists, Ghirlandaio reflected the growing acceptance that painting was an activity of intellectual value. Moreover, his outgoing, almost swaggering carriage is recognisably the manner of a man who had the effrontery to scratch his name in the classical decorations of Nero's Domus Aurea.

Many of the ideas about social and intellectual status that fifteenth-century artists appear to put forward in their self-portraits are brought together in Dürer's self-portraits of 1498 (fig. 132) and 1500 (fig. 133), and in the *Rosenkranzfest* altarpiece of 1505–6 (fig. 1). Although there are self-portrait medals, no surviving Italian quattrocento panel paintings are identifiably self-portraits. All of the Italian painted examples so far considered are details from frescoes. The now-lost Kraków *Portrait of a Young Man* (fig. 32) painted by Raphael around 1512 is probably the earliest-known Italian easel painting that can be identified as a self-portrait. This may be merely a question of survival; but it does seem that in northern Europe the tradition was different. Self-portraits such as Jan van Eyck's (fig. 115) or Dürer's (fig. 121) were probably personal, perhaps very private works, although they might also have served as promotional paintings to demonstrate artistic skill and imagination to prospective patrons. Dürer's painting of 1498 (fig. 132) has an unusually precise signature-inscription declaring: 'This I painted after my own image. I was twenty-six years old.'[48] Dürer presents himself in fashionable dress and against a window-frame designed in an Italianate style novel in Nuremberg at this date. In the *Rosenkranzfest* altarpiece, too, he dresses opulently in light brown fur (fig. 1). As noted earlier, the dress worn by painters in their self-portraits is sometimes a valuable indication of how they wish the observer to understand their

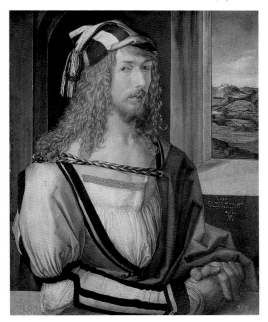

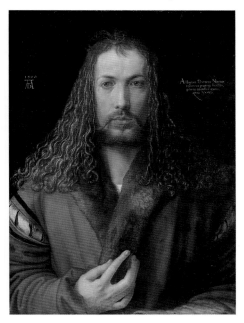

132 Albrecht Dürer, *Self-portrait* (1498). Oil on panel. Madrid, Museo del Prado

133 Albrecht Dürer, *Self-portrait* (1500). Oil on panel. Munich, Alte Pinakothek

status. In the 'signed' self-portrait of the Palazzo Medici chapel (fig. 109), Gozzoli wears a brocade doublet and a fashionable, perhaps velvet-covered, conical hat. Ghirlandaio wears a flowing red mantle over a bright-blue robe in his self-portrait in the *Resuscitation* scene in the Sassetti chapel in S. Trinita, Florence; and the sitter identifiable as Jan van Eyck wears a splendid turban-like headscarf and a rich black, fur-trimmed robe in the London portrait (fig. 115). In the extraordinary self-portrait of 1500 (fig. 133), Dürer is dressed in the fur-trimmed coat worn by patricians and humanists. No earlier self-portrait has such sober yet refined and expensive dress as this: it is 'a statement about status, a badge of wealth, power and distinction'.[49] The sophisticated Latin and the Italianate, humanistic lettering of the inscription – 'I, Albrecht Dürer of Nuremberg made [*effingebam*] this image of myself with colours at the age of twenty-eight' – indicates the intellectual level to which Dürer aspired.[50] The use of the verb 'effingere', rather than the usual 'pingere', echoes the language of Dürer's humanist friend Konrad Celtis in his epigrams in praise of the painter.[51] The symmetrical composition and the stark

frontality of the pose deliberately recalls the iconography of the Salvator Mundi. Dürer's raised right hand refers to the painter's *recta manus* which produced the technical brilliance of execution that emphasises his virtuosity as a painter. It also resembles a blessing gesture, contributing to his self-representation as Christ which acknowledges the painter's God-given creative skill. This anticipates by some fifty years Vasari's description of Michelangelo as an artist sent into the world by the 'benign ruler of heaven', and who 'would be acclaimed as divine'.[52] In Dürer's conception the self-portrait has matured from being a vehicle for acknowledging artistic and intellectual skills into the artist's recognition of his divinely-inspired creativity.

The steps from this supremely self-confident statement to Dürer's disturbing image of the melancholy of the artist 'born under Saturn' in the *Melencolia I* engraving included a remarkable self-portrait drawing (fig. 134) of the painter naked. Dürer's scrutiny of himself in ill health suggests a growing obsession with his physical condition. He emphasises the thinness of his almost emaciated body, and his pointing gesture directs attention to the state of his spleen, which he diagrammatically indicated in yellow; an inscription declares that 'where the yellow spot is, to which I point with my finger, there it hurts'.[53] By 1514 his concern over these symptoms of bodily decay perhaps combined with the streak of the melancholic innate in his temperament to stimulate him to produce the highly complex *Melencolia I* engraving. This has, exaggeratedly perhaps, been seen as a sort of artistic testament, a 'spiritual self-portrait':[54] with greater caution it should best be understood as an opportunity seized by Dürer to explore the concept of artistic genius.

Dürer's mature self-portraits emphasise and explore his self-image as a creative artist. Autonomous self-portraits by Italian painters early in the sixteenth century lay stress more on the issue of the painter's social status. Raphael's ambition, in part fulfilled through his friendship with Castiglione, to establish himself as the paradigmatic artist-courtier seems to lie behind the image, generally and I think rightly understood as a self-portrait (fig. 32), in the lost painting, formerly in Kraków.[55] Two earlier images, a very early grey chalk drawing in the Ashmolean, which may be compared with Dürer's drawing of himself aged thirteen, and a panel-painting from early in Raphael's Florentine period, have been considered to be self-portraits; but there is no secure evidence for this. Like Dürer's self-portrait of 1498, the lost Kraków portrait shows the painter in rich dress – indeed, in the finery of the courtier Raphael self-consciously displays his elegance and his social aspirations. Dürer's and Raphael's

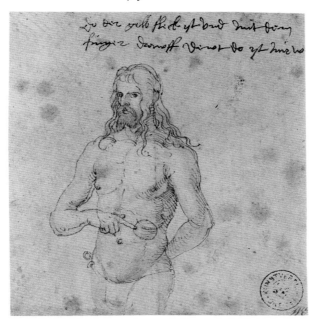

134 Albrecht Dürer, *Self-portrait* (*c.*1512–14).
Pen, ink and brush on paper. Bremen, Kunsthalle

self-portraits appear to draw together the principal aspirations that early Renaissance artists demonstrate in their self-portraits. Many may have been primarily displays of technical skill with the brush, perhaps with an eye to impressing potential clients or patrons. A recurrent theme in Renaissance self-portraiture is the artist's *recta manus*, emphasising the manual dexterity of his painterly skill. Some offer glimpses into the artist's domestic environment – his living space, his dress or his possessions – with attendant suggestions of his rising social status and expectations. Some, again, are vehicles for suggesting the artist's intellectual skills or aspirations: they demonstrate his knowing concern with antiquarianism, or his understanding of allegory, or his desire to be rated alongside humanists. Few Renaissance self-portraits, if any, are likely to have been simply depictions of the individual: the self-portrait is a natural medium by which the artist can communicate aspects of his self-image. During the early Renaissance these usually had to do with his aspirations towards social and intellectual advancement; and self-portraiture shows that these aspirations were progressively more elaborately and forthrightly demonstrated.

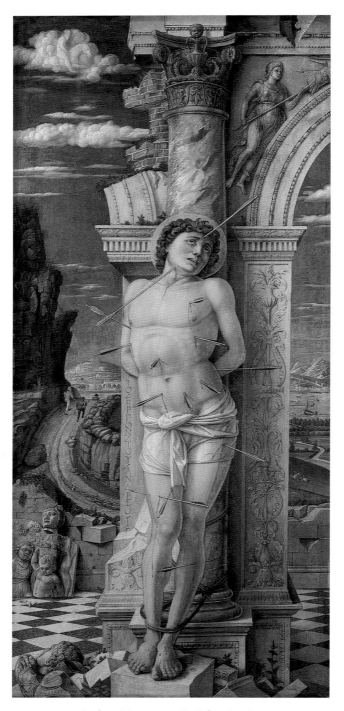

135 Andrea Mantegna, *St Sebastian* (*c*.1460).
Tempera on panel. Vienna, Kunsthistorisches Museum

Artists' Display

Renaissance artists sometimes produced works intended primarily to serve as demonstration pieces. They may have wished to display both their skills in technique and craftsmanship, and their intellectual concerns and abilities. A noteworthy example of this type of work, from the very end of our period, is Parmigianino's *Self-portrait in a Convex Mirror* (fig. 112). Vasari writes that Parmigianino took this panel, and others, with him to Rome, where Pope Clement VII and his court were 'struck with astonishment' at the painter's tremendous skill and ingenuity.[1] For the most part, Renaissance paintings were produced for specific purposes on commission, or were mass-produced in quantity for the open market. Autonomous self-portraits, however, were presumably usually personal works made for and retained by artists themselves: these could be shown to prospective patrons to impress them with the artist's qualities. But there is also a genre of works that were made by the artist either perhaps for his own pictorial or intellectual exercise, or more probably to demonstrate particular skills to potential patrons with an eye to attracting more commissions or greater public recognition. A few may have been entirely experimental, with no thought towards financial gain. At the beginning of book III of *On Painting* Alberti advised: 'the aim of the painter is to obtain praise, favour and good-will for his work much more than riches'.[2] The artist could perhaps best gain such recognition by consciously displaying his *ars et ingenium* (skill and talent) in the double sense of this phrase, of technical ability and pictorial inventiveness. And these 'display pieces' might also incorporate demonstrations of the artist's understanding of, and ability to grapple with, intellectual concerns current in artistic circles of his time.

Piero della Francesca's *Flagellation* (fig. 136) might be one such painting, for it is both a brilliant display of artistic skills and a perplexing work in terms of its subject and iconography. It gives the impression that the painter sought to demonstrate on a single panel his knowledge and understanding both of Albertian pictorial princi-

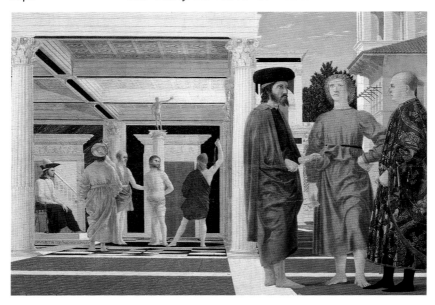

136 Piero della Francesca, *Flagellation* (*c*.1455–60). Tempera on panel. Urbino,
Palazzo Ducale

ples and of Eyckian intricacy of detail and surface texture. It has been
identified as one of the 'many very beautiful panel pictures with little
figures' that, according to Vasari, Piero made for the Duke of Urbino,
by implication as demonstrations of his painterly skills.[3] But the *Fla-
gellation* is painted in tempera, not in oil, which suggests that it dates
from earlier in the artist's career than the time of his association with
Urbino. No evidence survives as to its original setting or function. A
range of attempts has been made to identify the figures in the right
foreground, in the light of the 'Flagellation' subject on the left. That
none of these iconographic explanations has yet found general accep-
tance may suggest that none of these figures originally had an indi-
vidual identity, or any necessary iconographical connection with the
subject. Conversely, had Piero intended the observer to associate them
with the Flagellation, he would surely have provided clearer clues to
their identities. A more economical explanation is that while the left-
hand side of the panel comprises a brilliant exercise in perspectival
spatial projection, which Piero justified by peopling it with figures
who enact the Flagellation, the figures at the right are merely types
whose existence is justified by the skills that Piero showed in
painting them.

Piero's contribution, both theoretical and pictorial, to Renaissance perspective was an important one, and the construction of pictorial space in the *Flagellation* is perhaps the most precise and sophisticated of all surviving examples.[4] In this respect Piero seems to take up the challenge of another demonstration of conspicuous skill in perspective construction, Donatello's *Feast of Herod* relief in Lille.[5] Like the *Flagellation*, this small, delicately carved marble relief has no obvious function or setting. Usually dated to the mid-1430s, it may show Donatello's response to the method of perspective construction described in Alberti's *On Painting*, dedicated to the sculptor amongst others in 1436. The spatial projection of the left-hand side of Piero's *Flagellation* is a clear as mathematics can make it: it is the equivalent in practice to the mathematics of Piero's treatise *On Perspective for Painting*. The foreshortening of the complex floor pattern is a *tour de force*, and because the architecture is on a relatively small scale the vaulting provides a second, fully accurate perspective layout. Irrational only is a feature of the lighting: the pool of brighter light cast into the vault space above Christ's head can be intended only to distinguish him from the surrounding figures and to show that he is in touch with the supernatural. On the right, however, the lack of definition of the distance and scale of the palace building at the back to the right suggests that the triad of figures belong to a different physical and temporal world.

In his *On Perspective for Painting* Piero agrees with Alberti in defining the first two of the three parts of painting as circumscription (for Piero, *disegno*), and composition (for Piero, *commensuratio*). But for him, the third part is coloration (*colorare*) rather than Alberti's 'reception of light'.[6] Alberti was preoccupied with issues of light and shade, and his discussion of colour is relatively traditional and insignificant. For Piero, however, colour subsumes tonality and adds a further essential dimension to his pictorialism. This is paradigmatically evident in the *Flagellation*, where colour and texture are explored and displayed in the figures at the right, to complement as it were the exploration of pictorial space on the left. We seem to be invited to see them not as pertinent to the Flagellation, but as patterns of Pieresque figures, each to be individually admired for the qualities of figural treatment bestowed on him by the painter. The right-hand figure, perhaps a rich man of the merchant class, wears a sumptuous blue and gold velvet brocade. A close parallel to this fabric is that worn by Chancellor Rolin in Jan van Eyck's votive painting in the Louvre, Paris. It is astonishing that without the advantages of van Eyck's oil technique Piero could represent so faithfully the brocade pattern, the colours as they vary according to the change

in scintillating lighting, and most particularly the naturalistic textures of velvet and gold thread. Likewise, Piero convincingly shows the folds of the heavy, differently textured fabrics worn by the other two men falling thickly over their forms, and also carefully contrasts the textures of their curling hair with the finer, more bristly hair of the beard of the man to the left of the group. Piero's *Flagellation* seems literally to be a 'masterpiece' in the sense that it was made specifically to demonstrate the range of his abilities. He shows here both his intellectual prowess, in the perspectival setting for the narrative, and his purely painterly skills in handling colour and texture in the three probably unrelated figures to the right.

The claim that this painting is a 'display piece' of Piero's intellectual and artistic skills is strengthened by its apparent iconographical ambiguity. But works that may be 'display pieces' of this sort are usually more difficult to identify as such. Preliminary hints towards what we might look for may however be found here, or once again in Parmigianino's *Self-portrait* (fig. 112). A number of criteria can be suggested to guide us. First, clearly, the work must lack any documentary or other textual history that provides it with a named patron or a specific, intended purpose or setting. Second, it is likely that the work will be either relatively small, or relatively cheap – made with inexpensive materials that the artist could afford for experimental purposes – or both. And third, and most importantly, it has to show conspicuously some special skills in pictorial representation or execution, or in intellectual pursuit, or both.

Very occasionally an artist consciously declared his technical prowess, as when in 1506 Albrecht Dürer inscribed his *Christ among the Doctors* (fig. 137) 'Opus quinque dierum'. The admission by an artist that he had worked for only five days on a painting might have been to excuse a rough finish. Here, however, it is a signal of Dürer's pride in the conspicuous brilliance of his oil-painting technique. Through his inscription Dürer almost arrogantly emphasised his *facilità*, the concentrated rapidity with which he worked. That it was painted in Rome, according to the original full inscription 'A.D.F(ECIT).ROME' recorded in two early copies, suggests further challenges.[7] Dürer perhaps needed to complete a showpiece during a short visit to the Holy City, a painting that would demonstrate the ease and fluency of his technique. In the Leonardesque contrast between the young Christ's exquisite grace and the doctors' grotesque physiognomical deformities, moreover, his chosen subject offered him the chance to show to a literate and visually discerning public his understanding of an Italian aesthetic ideal of beauty versus ugliness.

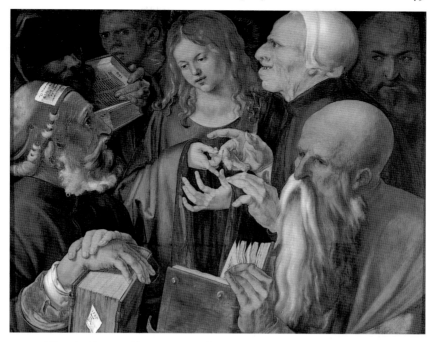

137 Albrecht Dürer, *Christ among the Doctors* (1506). Oil on panel. Madrid,
© Museo Thyssen-Bornemisza

Artistic and Intellectual Display through Printmaking

Dürer was perhaps the most self-aware of all Renaissance artists, the
one most concerned to use his works to publicise his technical and
intellectual abilities. It was through the medium of the copper-plate
engraving that he most frequently sought to display his extraordinary
artistic powers. He chose the engraved print for this purpose essen-
tially, of course, to take advantage of its breadth of distribution, but
it also proved to be a vehicle of particular value in exhibiting his tech-
nical brilliance. The intellectual concerns that Dürer examined and
disseminated in this medium were those that generally preoccupied
the Renaissance artist: questions of perspective, light and shade, and
human anatomy. Study of these issues did not require colour: indeed,
they could perhaps be explored and demonstrated better without the
distraction of colour. But in fact in his most polished exercises in
engraving Dürer handled his medium with such technical sophistica-
tion that he could create textural effects that substituted well for the
absence of colour. This is shown by the fully convincing representa-

tion of surfaces in the *Melencolia I* (fig. 140) and in the *St Jerome in His Study* (fig. 141) of 1514, two of Dürer's most brilliant exercises in pictorialism in the medium of engraving.

These are two of the second group of *meisterstiche* (master-engravings) that Dürer produced as demonstrations of his artistic skills. The *meisterstiche* may have been not only virtuoso showpieces but also benchmarks, in a sense, of his abilities at that time, against which he could test his later development in technique and pictorial invention. The first group, dating between 1502 and 1504, map out his progress to date.[8] In the *Vision of St Eustace* (fig. 138) Dürer states his position with regard to the 'imitation of nature', an artistic issue dear to the hearts of Italian Renaissance art theorists such as Alberti and Leonardo da Vinci. He chose the subject of St Eustace so as to have the opportunity to show with loving and immaculate care his knowledge of the natural world of plants and animals. Coincidentally, Pisanello had earlier exploited the need to populate the setting for this legend with late Gothic model-book animals and birds in his version on panel now in the National Gallery, London. As in that painting, in Dürer's case too the result seems claustrophobic – or so he himself might have felt, looking back on it while working twelve years later on the *St Jerome*. Plants and animals are set all over the surface in a manner reminiscent of early Florentine prints such as the *Creation of the World* (fig. 16), which itself was intended in part as a compendium of 'model-book' animal studies for artists' reuse. The *St Eustace* engraving therefore lacks a persuasively demonstrated spatial setting. Despite the finesse of detail that allows us to identify the species of each natural form, colour would in this case have added helpful clarity. Used in conjunction with tonal gradient, colour might have helped to define the positioning of the objects within three-dimensional space, as well as across the surface of the print. But Dürer's primary intention in this engraving was perhaps to demonstrate his representational skills, his growing ability in defining surface textures, and the range of his knowledge of the morphology of the natural world.

The second print in the early group of *meisterstiche*, the *Adam and Eve* (fig. 139) of 1504, is a display piece in an essentially different mode. In the *St Eustace* Dürer visually grappled with the 'imitation of nature'. Through his *Adam and Eve*, on the other hand, he set out his manifesto on ideal human form. This is a fully contemplated Renaissance exercise in human proportions and the depiction of anatomy, based on his experience of the ideals of human form that he learned both from his first visit to Italy in 1497 and from his knowledge of Italian works, and especially prints. Starting from the

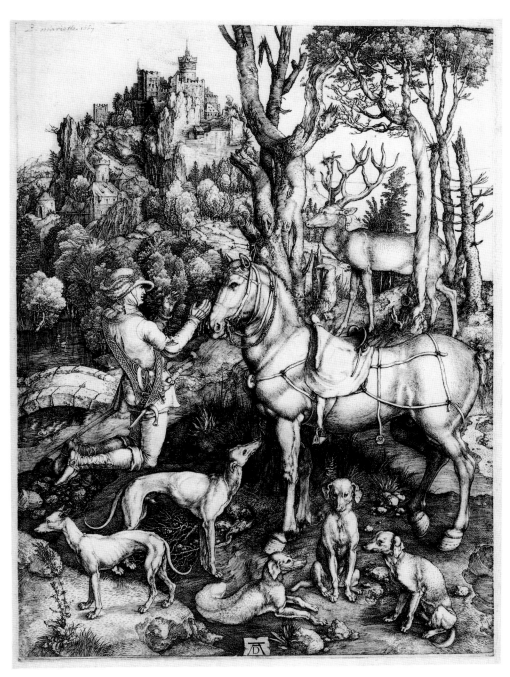

138 Albrecht Dürer, *Vision of St Eustace* (*c.*1502). Engraving. London, © The British Museum

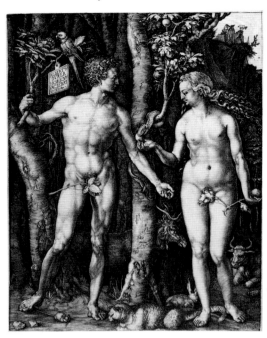

139 Albrecht
Dürer, *Adam and
Eve* (1504).
Engraving. London,
© The British
Museum

Apollo Belvedere, presumably known to him from prints or draw-
ings, and perhaps through his contact with Jacopo de' Barbari, he
developed his version of the heroic male nude in the very years that
Michelangelo was carving his *David*. Similarly, Dürer's ideal of the
female nude evolved shortly before Leonardo started to explore the
figural composition of his lost *Leda and the Swan*. The nude Adam
has both a theoretical and a visual background. In his early prepara-
tory drawings Dürer was concerned with the issue of ideal human
proportions explored earlier in Renaissance theoretical texts in the
light of Vitruvius' recommendations. For his articulation of Adam's
surface musculature Dürer was indebted in part to Antonio Pol-
laiuolo. That he knew Pollaiuolo's *Battle of the Nudes* engraving (fig.
18) or other Pollaiuolo circle prints is evident from several of his early
engravings, but his principal source here was Andrea Mantegna. He
had probably seen some of Mantegna's work in the original and he
also knew some of his engravings, as is clear from his copy-drawing
(Vienna, Albertina) of Mantegna's *Battle of the Sea Gods*. The figure
of Eve in Dürer's *Adam and Eve* owes less, however, to Italian treat-
ments of the ideal female nude, although she may reflect the nudes
in engravings by Jacopo de' Barbari, whom Dürer knew in Nurem-

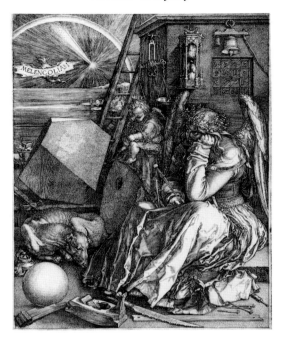

140 Albrecht Dürer, *Melencolia I* (1514). Engraving. London, © The British Museum

berg. Perhaps Dürer sought here to establish his own ideal of a northern European female nude form, less dependent on Italian conventions than in the case of the Adam. Nevertheless, the *Adam and Eve* stands as Dürer's principal response to the debate on ideal human form that was conducted in both theoretical and visual contexts during the early Renaissance. It is no surprise that he engraved the image to ensure wide circulation of this exemplary artistic statement.

Other early engravings by Dürer could be thought of as examples of self-conscious pictorial and intellectual display, but it is through the second group of *meisterstiche* that in 1513–14 he sets out his mature artistic manifesto.[9] The *Melencolia I* (fig. 140) appears to be a complex allegorical statement about the Artist as Genius. Melancholy sits, surrounded by symbols of the liberal arts – mathematics, geometry, astronomy, and architecture – in a pose suggestive of the despair (symbolised by the bat) brought on by the Platonic 'divine frenzy' of the creative artist. The sophisticated philosophical ideas underlying this image, combined with the elaborate symbolism and intricate engraving technique shown here and in the other *meisterstiche* of this group, demonstrate that by 1514 Dürer had fulfilled his

intellectual aspirations to a greater degree than perhaps any other Renaissance artist. Its companion, the *St Jerome in His Study* (fig. 141), is less strident but no less complex in visual terms. By taking as his subject a familiar image of the humanist scholar, Dürer appealed directly to his intellectual peers. He generated a sophisticated interior filled with subtly detailed forms that resonate with values and meanings appropriate to the principal theme of the engraving. The perspective scheme, one of his most precisely drawn, is strikingly similar in viewpoint and layout to the left-hand side of Piero della Francesca's *Flagellation*. Dürer sought to demonstrate his knowledge of the skill which was for Alberti the most important that the Renaissance artist could develop: as Alberti wrote, 'I wish him above all to have a good knowledge of geometry'.[10] The natural light that streams through the windows to the left casts a range of different shadows which help to establish spatial recession and the location of objects within the space. The virtuoso way in which Dürer exploited tonal gradients in the essentially graphic medium of engraving is remarkable for its subtlety and variety. Finally, he achieved a delicacy of surface textural effects that extrapolates from the range of textures in his earlier *St Eustace*, and that once more seems to defy the limitations of his medium. As a complementary pair, the *Melencolia I* and the *St Jerome* acknowledge the differences in the creative lives of artist and humanist respectively, but nevertheless draw them together in their common status and activities as intellectuals.

Dürer was not, of course, the first to recognise that, despite its lack of colour, the engraving was an ideal vehicle through which an artist could spread his reputation. Indeed, this must have been the primary purpose of the largest plate engraved in the fifteenth century, and around 1470 perhaps the first major exercise in artistic self-advertisement, Antonio Pollaiuolo's *Battle of the Nudes* (fig. 18). This plate was 'improved' after the first state had been printed, which may suggest that Pollaiuolo did not immediately recognise its potential as a disseminator of artistic ideas.[11] On the other hand, the self-consciously placed signature – the first on an Italian engraving – indicates Pollaiuolo's desire to make his authorship clear to the user. Learning from such German contemporaries as the Master ES, who regularly added his monogram to his engraved plates, Pollaiuolo realised the importance to his reputation of complementing the intellectual content of his exploration of nude form with a conspicuous and, in his case, learned inscription. His use of Latin for his signature, which is written on a classicising *tabula ansata*, also demonstrates the intellectual level of the audience toward which he directed

141　Albrecht Dürer, *St Jerome in His Study* (1514). Engraving. London, © The British Museum

his engraving, and to which he himself aspired. Not surprisingly, the motif of the Latin inscription on a tablet was taken up by Dürer for his monogram on his manifesto-like *Adam and Eve* engraving (fig. 139). Pollaiuolo's *Battle* engraving is a clear and early example of the Renaissance artist displaying his academic credentials for general circulation. Earlier engravings had been produced to convey practical artistic messages. Pollaiuolo's, however, for the first time positively asserts the artist's demand to be taken seriously as an intellectual, both by the inscription and through its elaborate, academic treatment of human muscular anatomy.

Mantegna also used the medium of printmaking to circulate his artistic ideas and ideals, but here the issue is more complex. One of the earliest of Mantegna's prints, the *Entombment* (fig. 17), was probably intended as a visual exposition of Alberti's theory of *istoria*. However, the original function of this print is uncertain, because it seems not to be a true engraving but rather a drypoint.[12] This technique does not provide a run of near-identical impressions, which implies that Mantegna was not concerned to issue an edition for wide circulation. Drypoint is, however, a versatile medium for artistic experiment in monochrome. Mantegna probably therefore used drypoint in the *Entombment* as a vehicle with which to pursue his linked preoccupations with light and shade, and with rendering form through variations in tonality. Further, whether or not reproducible in quantity for circulation, the *Entombment* print demonstrates Mantegna's commitment to putting Albertian narrative theory into practice. As we have already seen, he later followed this visualisation of *istoria* with a drawing (fig. 95) based on Alberti's gloss on Lucian's *ekphrasis* of Apelles' 'Calumny', presumably intending this to be produced in engraved form for circulation. In the *Entombment* he made use of a relatively inexpensive, new technique in an experimental manner, a technique moreover that may have encouraged him to develop his interest in monochromatism. A constant preoccupation from that time onwards, this resulted in the monochrome paintings (fig. 78) that challenged sculpture in Mantegna's individual visual contribution to the *paragone* debate.

Later prints indicate that Mantegna more consciously exploited engraving to circulate virtuoso representations of his pictorial and intellectual skills. One group of these prints suggests that, inspired perhaps by precedents by such German printmakers as the Master ES, he proposed a series of 'Life of Christ' subjects, perhaps based on those that he painted for the chapel in the Gonzaga castle at Mantua in the early 1460s. As a demonstration of his artistic abilities, perhaps the most impressive of these is the *Flagellation* (fig.

142 Andrea Mantegna, *Flagellation* (*c*.1470). Engraving. London, © The British Museum

142), another curious echo, this time in subject matter, of Piero della Francesca's painting. With the carefully conceived Albertian chequerboard floor, Mantegna showed his wider public his ability in handling perspective. By the use of cast shadows he consciously demonstrated the consistent strength and direction of the lighting, and in the figures his growing understanding of human anatomy under dramatic stress. An appeal to the classicising interests of contemporary intellectuals, which Mantegna shared, may best explain the pair of plates engraved with a *Battle of the Seagods* (fig. 143), and the pendant pair of *Bacchanal* prints. These all show Mantegna engaging with the exercising issue of reconstructing classical art and its thematic content. Moreover, here he started to work with allegorising subject matter, used later in his career for drawings that were engraved by assistants such as Giovanni Antonio da Brescia.[13] Prints such as these were both arenas for Mantegna's explorations of classicising subjects and compositions, and at the same time display pieces intended to impress humanistic observers with his artistic talents and intellectual sophistication.

Many prints made after drawings by Raphael may have had the same purpose. The prime example is Marcantonio Raimondi's

143 Andrea Mantegna, *Battle of the Seagods* (*c.*1470–80). Engraving, two plates. Chatsworth, The Devonshire Collection. Reproduced by permission of the Duke of Devonshire and the Chatsworth Settlement Trustees

engraving of the *Massacre of the Innocents* (fig. 144), where the engraver added a townscape backdrop to a Raphael figure drawing, much as Mocetto set Mantegna's frieze-like *Calumny of Apelles* drawing into a Venetian context (fig. 96). Raphael's group is a conscious display of prowess in figure drawing and in constructing a dramatic narrative. It was designed to impress a Roman public that had seen little of his work during the two or three years that he had already spent in Rome working in the Stanza della Segnatura in the Vatican.[14] Surviving preliminary drawings show that Raphael strove to generate a rich variety of figure-types and movements. He was concerned to demonstrate his ability to depict anatomy under stress and torsion, his understanding of decorum in pose and expression, and his instinct for narrative drama. Raphael commissioned Marcantonio's engraving to be circulated among potential patrons, to show his abilities in figure drawing as an alternative to Michelangelo just at

the moment when, with the unveiling of the Sistine chapel ceiling, the latter's extraordinary powers were becoming known. Other engravings by Marcantonio based on Raphael drawings may also have been intended to enhance Raphael's reputation as an intellectual artist. The multi-composition plate entitled *Quos Ego* shows a series of mythological scenes that demonstrate Raphael's abilities as an interpreter of classical texts, and the *Judgement of Paris* indicates his interest in disseminating in print form a 'classical' painting reconstructed from an *ekphrasis* by Philostratus.[15]

Drawings as Display Pieces

Earlier still in the Renaissance, before copper-plate engraving had become a standard means of circulating artistic ideas, drawings had already been made as exempla of artistic prowess. This best explains the anonymous mid-fifteenth-century Florentine sheet of *Eleven*

144 Marcantonio Raimondi, after Raphael, *Massacre of the Innocents* (1511). Engraving. London, © The British Museum

Nude Figures (fig. 145), drawn in wash with white heightening on blue paper.[16] Although the artistic quality of this damaged sheet is not high, it is an intriguing, self-conscious composition in which the draughtsman seems to be tackling the same issues as Raphael in his *Massacre of the Innocents*. Because it is lacks a subject, however, it seems even more contrived, even more a precocious academic exercise, than Raphael's engraving. Perspectival geometry was included by Alberti among 'the first rudiments of the art of painting',[17] and the carefully constructed dodecagonal platform on which the eleven nude figures are set out was, it seems, deliberately intended to demonstrate the draughtsman's ability in showing a complex, foreshortened geometric structure. By extension the figures were also intended as demonstrations of the draughtsman's skills as a figure designer, and of the range of sculptural models in his workshop. Several are loosely based on classical formulae, such as the 'Marsyas' type third from the left and the figure leaning on a stave with his legs crossed; others are more freely invented to show different poses or movements. The grouped figures are drawn with emphasised contours and lit with white highlights, rather pedantically responding to Alberti's 'circum-

scription' and the 'reception of light'. The result is an artificial composition that apparently has no purpose other than to exhibit the draughtsman's belief in his grasp of the essential features of the new, Albertian art of painting.

This sheet shows only modest abilities compared with those of Antonio Pollaiuolo. He, too, used the relatively inexpensive medium of drawing, as well as engraving as in the *Battle of the Nudes*, to display his notable strengths as a figure draughtsman. A drawing akin to the *Eleven Nude Figures* sheet, and another precursor of Raphael's figure drawings and *Massacre of the Innocents* engraving, is *A Prisoner Led Before a Judge* by Pollaiuolo (fig. 146). As in the *Battle of the Nudes* engraving, Pollaiuolo does not obviously depict any particular subject in this unusually large, finely finished sheet. It is a virtuoso display of pen-and-ink figure drawing. Pollaiuolo was not concerned to demonstrate skill as a perspectivist: set against a plain background, a series of nude figures shows his extraordinary ability to generate convincingly lifelike, dynamic poses and movements through contour alone, without the need for substantial internal modelling. There is no evidence that Pollaiuolo made this drawing as a finished draft to be engraved, unlike another highly finished drawing, Mantegna's *Ignorance and the Fall of Humanity* (London, British Museum).[18] Nor is it as evidently as Mantegna's signed and dated drawing of *Judith with the Head of Holofernes* (Florence,

145 Florentine, *c.*1470, *Eleven Nude Figures*. Pen, ink, wash and white heightening on paper. Stockholm, Nationalmuseum

146 Antonio Pollaiuolo, *A Prisoner Led Before a Judge* (?*c.*1470). Pen, ink and wash on paper. London, © The British Museum

Uffizi) a finished work intended as an autonomous monochrome picture.[19] Perhaps the best explanation for this large sheet is that, like the Pollaiuolo *cartone* owned by Francesco Squarcione, it was a workshop property, but one kept to be shown to visitors to the *bottega* as a manifesto, as it were, of the Pollaiuolo style in figure drawing.

Examples of drawings used as indicators of an artist's skills date from the beginning of the quattrocento. The late Gothic model-book may have functioned in part as a repository of natural forms that patrons could choose from when ordering their richly decorated illuminated manuscripts. Around 1400 Bartolommeo di Bertozzo offered to show his patron Francesco di Marco Datini 'moltti esempj di charte', apparently a sample book by which the draughtsman advertised his craftsmanship.[20] Jacopo Bellini's two books of drawings offer a parallel. These drawings served a range of purposes, of which perhaps the most important was that they established a yardstick of the workshop's quality and practice in pictorial design. Unlike Pollaiuolo or Raphael, whose principal preoccupation in a characteristically Central Italian manner was with figure drawing, Jacopo Bellini concentrated on compositional drawing. His virtuoso displays are often primarily concerned with perspective (fig. 10) and with the creation of elaborate pictorial spaces that dwarf the figures and

the narrative. Sometimes he screened the narrative space from the observer by interposing grand though archaeologically wayward reconstructions of classical triumphal arches.[21] At other times he set the narrative in a panoramic landscape, seeking solutions to the problem of charting spatial recession and experimenting with landscape forms. Bellini used other drawings as vehicles for showing his antiquarian erudition, either recording inscriptions or designs of classical funerary monuments (fig. 54) or creating imaginary, frieze-like processional groups such as the *Triumphal Procession of Bacchus* (fig. 147). In these Bellini appears to seek to show not so much skill as a figure draughtsman but rather his abilities in handling secular-subject figure groups. His two books of drawings were intended primarily as workshop materials, judging by the care with which they were bequeathed to the next generation of the family, as recorded in the wills of Jacopo's wife Anna and son Gentile. But they may also have served the more public purpose within the workshop of displaying the artistic tradition that is so fully recorded within their covers.

147 Jacopo Bellini, *Triumphal Procession of Bacchus* (*c.*1450). Pen and ink on parchment. Paris, Louvre, Bellini book of drawings, fol. 36

Conspicuous Achievement in Display Paintings

Jacopo Bellini's drawings, Antonio Pollaiuolo's drawings and engravings, Raphael's designs engraved by Marcantonio, and Dürer's *meisterstiche* engravings are only some of the more evident examples of pieces of work produced as displays, generally for public consumption, of artists' talents. As works on paper they were, moreover, relatively inexpensive to produce. They are all on an unusually large scale for their media at this time, and many of the drawings have in common an unusually high degree of finish. They were presumably considered well worth the investment of time, but they all lack qualities in which some Renaissance painters may have felt they needed to demonstrate skill. These might include the handling of colour, skill in using painting techniques to produce specific effects of texture or of miniaturist detail, and the interpretation in paint of unusual, intellectually sophisticated subject matter. A group of Renaissance paintings that, like Piero della Francesca's *Flagellation*, have proved difficult to explain in meaning or function may perhaps best be placed in the same category as Pollaiuolo's *Battle of the Nudes* engraving or Dürer's *St Jerome in His Study* as conscious displays of the artists' talents.

Antonello da Messina's *St Jerome in His Study* (fig. 148) is generally regarded as one of the artist's earlier paintings, predating Dürer's engraved version perhaps by more than half a century. It may have been produced as early as 1460 while Antonello was resident in Naples and working for King Ferrante. If so, that it was recorded by Marcantonio Michiel in the Venetian collection of Messer Antonio Pasqualino in 1529 suggests that Antonello took it with him to Venice when he travelled there in 1475.[22] It follows that the painting was not commissioned by a Neapolitan patron, but rather was made by Antonello for his own purposes. Small and therefore easily transportable, but exquisitely finished and miniaturist in its fine detail, it is a showpiece of the Netherlandish technique and treatment in which Antonello specialised. Even as late as 1529 Michiel was evidently still much impressed by the painting's naturalism, writing that 'the little landscape is natural, very detailed and highly finished', and in conclusion that 'it is well in perspective; all the work – its finish, colouring, drawing, strength, and relief – is perfect'. The *St Jerome* can well be explained as an exercise in self-promotion, a jewel-like object on a popular humanistic theme to show Antonello's prospective patrons the character and quality of his artistic achievement. It has all the characteristics of minute precision of representation, rich colours and convincing surface textures that are among the features

148 Antonello da Messina, *St Jerome in His Study* (?c.1460). Oil on panel. London, © National Gallery

of Netherlandish paintings especially praised in the brief biographies of Jan van Eyck and Rogier van der Weyden written by Bartolomeo Fazio in 1456.[23]

In his *St Jerome* Antonello responded to the growing enthusiasm for Netherlandish art and technique in sophisticated patronal circles. But these qualities are consciously integrated into a composition saturated with the intellectual concerns of Albertian painting. Behind the northern, *trompe-l'oeil* stone door-frame, the interior is constructed using a geometrical perspective almost as sophisticated as Piero della Francesca's. The subtle transitions from light to shade in the groin-vaulted aisle that St Jerome's lion wanders through exploit a full tonal range. They suggest that Antonello was concerned to show his skill in representing interior lighting effects in contrast with the brilliant lighting of the landscape seen through the windows behind. It may well have been Antonello's intention also to impress on observers and potential patrons that he could not have achieved those tonal effects without a refined understanding of Eyckian oil technique. Nor could he otherwise have represented with such minute precision the details of the distant landscape, the books and paraphernalia of St Jerome's study, or the brass bowl and the birds that stand on the worn step leading into the interior. The whole painting seems to be a compendium of what the late fifteenth-century painter who can combine all that is best in the Eyckian and the Albertian traditions has on offer for his clients.

This painting suggests that Antonello considered it worthwhile to invest time and expense in producing a small-scale panel painting (and not just prints or drawings) to demonstrate his particular skills. As one of the most self-conscious publicists among Renaissance artists, Mantegna also probably subscribed to this view. The best candidates as painted manifestoes in his work are perhaps the *St George* (fig. 149) and the early *St Sebastian* (fig. 135). If any faith can be placed in Vasari's observation (in the early, 1550 edition of the *Lives*) that '[Mantegna] made in San Zeno in Verona the panel for the main altar, about which they say that he produced as a demonstration a very beautiful figure, since he greatly wished to undertake that work',[24] either of these paintings might be that 'very beautiful figure', although both are often considered to date rather later. It is also sometimes suggested that the *St Sebastian* is the 'operetta' commissioned by Jacopo Antonio Marcello, to complete which Mantegna on 14 March 1459 needed only 'eight or ten days' more.[25] Be this as it may, both the *St George* and the *St Sebastian* are very small panels on which Mantegna was able nevertheless to display a wide range of pictorial interests and abilities. Some of these correspond precisely

149 Andrea Mantegna, *St George* (*c*.1460). Tempera on panel. Venice, Accademia

with the skills displayed by Antonello in his *St Jerome*, which may date from much the same time. In the *St Sebastian* Mantegna exploits a technique of Netherlandish finesse, especially noticeable in the landscape with its bright, clear lighting and sharply focused detail, and in his careful attention to colour and texture in the materials from which the architectural ruin was constructed. In the Venice *St George* he explored the reflections of light from metallic surfaces, much as

Jan van Eyck reflected his self-portrait in the armour of St George in the *Virgin and Child of Canon van der Paele* in Bruges. If in these panels Mantegna explored *trompe-l'oeil* effects using bright light rather than a rich tonal range, however, he also demonstrated various of the more intellectual qualities that Alberti sought to encourage in the early Renaissance painter. His St Sebastian stands before a carefully and accurately calculated perspectival chequerboard floor which is scattered with fragments of classical statuary. By juxtaposing these with the sculptural form of St Sebastian's wracked body Mantegna perhaps sought, as proposed earlier, to suggest the superior naturalism of painted forms over similar classical forms carved in marble. The horseman who rides out of a cloud at the top left is generally recognised as a conscious, inventive allusion to classical comment, notably in Lucretius, about the random shapes that clouds may take up.[26] Finally, the signature in Greek lettering serves both for Mantegna himself and for the (presumably 'ancient Greek') craftsman 'originally' responsible for the decorative carved revetment that over time has fallen away from the core of the pier. This suggests that Mantegna was making a deliberate *paragone* between the ancient craftsman and the modern painter. Given these indications of Mantegna's intellectual pretensions in this small panel, his Greek signature may also be understood as a self-confident acknowledgment that he possessed the artistic and intellectual skills of a 'new Apelles'.

Like Antonello's and Mantegna's panels, Botticelli's *Calumny of Apelles* (fig. 94) may also fall into this category of display piece. According to Vasari, Botticelli gave this panel painting to his friend Antonio Segni.[27] If this was indeed so, it was presumably not a commissioned painting, but one that Botticelli was at liberty to give away. This might have occurred shortly after the painting was made when, in the mid-1490s, Botticelli came under the influence of Savonarola who sought to destroy secular paintings in the 'bonfires of the vanities'. Compared with other secular works by Botticelli that, to judge from their scale and dimensions, served as decorative paintings for furniture in domestic interiors, the *Calumny* is a small painting with no obvious public function. Indeed, except that it is in tempera on panel it compares in scale and character most directly with such drawings as Pollaiuolo's *A Prisoner Led Before a Judge* (fig. 146) and Mantegna's highly finished *Ignorance and the Fall of Humanity* (London, British Museum). Like a drawing, it has a relatively subdued palette lacking in such expensive pigments as ultramarine and tending towards the monochrome. Like Apelles' original version of the subject, it might of course have been painted as a riposte to a baseless accusation. It seems more probable, however, that Botticelli's

primary purpose here was to demonstrate his skill in dealing with a classical, allegorical theme.

The *Calumny of Apelles* has already been considered as a precocious example of the reconstruction of a classical painting on the basis of an *ekphrasis*. Now we may see it as the outcome of Botticelli's wish, like Mantegna, to be seen self-evidently as a new Apelles. The *Calumny* offered Botticelli the chance to display a range of artistic skills. As in most of the works discussed earlier in this chapter, one of these skills was in the perspectival construction of pictorial space. Botticelli devised a grand-scale arcaded hall, carefully articulating the perspective scheme with deliberately obtrusive barrel vaults and exaggerated mouldings in the cornices and pier bases. Within this carefully defined but limited space the figures are set out in a frieze reminiscent of a classical relief. In the figures Botticelli took full advantage of the opportunities that the subject offered for depicting a variety of types, poses and movements, and a range of expressive emotions in the faces. Vasari wrote that Botticelli was 'a very agile-minded young man',[28] and above all else the *Calumny* gave him opportunities to exercise his intellectual muscles. He strove to interpret his written text in a pseudo-classical manner, setting the allegory within an architectural environment richly articulated with figure sculpture and reliefs. The allegory's setting is constructed in a romanticising, late quattrocento architectural style. By choosing this idiom rather than one that consciously emulated the classical past, which might have seemed appropriate to his ancient Greek subject matter, Botticelli perhaps sought to introduce a *paragone* between the ancient and the modern. This aim is echoed in his reproductions, as though in bronze relief sculpture, of paintings of his own that are thus open for comparison with 'recreations' of classical paintings. The relief on the left inner pier podium shows the scene of the *Justice of Trajan*, described by Dante on the wall of marble with relief carvings of *Purgatorio* x. Botticelli had already recreated this from Dante's description in one of his drawings for the illustrated Dante made probably for Lorenzo di Pierfrancesco de' Medici. Similarly self-referential are the three scenes from Boccaccio's *Story of Nastagio degli Onesti* in the first row of caissons in the left arch vault. Two of these paraphrase compositions in the series of panels he had painted for Giannozzo Pucci's wedding in 1483.[29]

The row of niched figures echoes the exterior of Orsanmichele in Florence and centrally focuses on a Donatellesque *St George*. This and the *Judith* in the niche behind the enthroned king perhaps acknowledge the importance of such figures in the iconography of Florentine republicanism. But they and their companions also pay tribute to recent Florentine achievements in figure sculpture. Botti-

celli perhaps exploited this painted sculpture to comment on the *paragone* between painting and sculpture that Leonardo da Vinci was writing about at this time. But it also echoes the architecture of its setting in proposing a second *paragone* between contemporary (figure) sculpture and ancient (relief) sculpture. Some of the reliefs, represented as bronzes set into marble friezes and plinths, illustrate mythological legends, such as Apollo and Daphne. Others continue the main theme of *ekphrasis*, being based on descriptions of sculpture both in ancient and in modern vernacular texts. This is a singularly self-conscious performance that can be seen, as Botticelli presumably intended, to reflect an impressive and erudite range of sources both classical and contemporary, textual and visual.

Some of the works discussed in this chapter have proved to be among the most difficult of the period to explain. These are perhaps the most obvious examples that may best be understood as demonstration works. They are unlikely to be the only ones. Parmigianino's *Self-portrait in a Convex Mirror* (fig. 112) might alert us to the possibility that in other cases a self-portrait served not only as the record of an artist's features or self-image, but also as an advertisement of the character and qualities of his art. Another possible example, as noted earlier, is Jan van Eyck's *Man in a Red Turban* (fig. 115): his motto 'Als ich can' may in itself be read as the painter's quietly satisfied acknowledgment of his skills. A third is Dürer's *Self-portrait* of 1500 (fig. 133) which, it has recently been suggested, 'would never have left the house in the artist's lifetime, [and] would have been used not only as a display piece to show Dürer's ability to prospective clients, but also as a teaching demonstration for his students'.[30] But however much painterly skill is involved in producing a self-portrait, it could seldom provide the painter with the chance to display the full range of his artistic concerns or intellectual aspirations. To demonstrate these best he needed a vehicle that would offer him opportunities to explore the construction of pictorial space, to show his skills as a figure draughtsman, and perhaps also to display his command over his medium and technique. The medium of engraving allowed him to distribute his publicity material, rather than to require a visit to his *bottega* for his work to be appreciated and evaluated. Finally, since he was in charge of choosing his own subject matter, he could when appropriate provide himself with a vehicle to show off his erudition. Works that can be distinguished as 'display pieces' show excellently therefore the developing aspirations of the Renaissance artist, both in demonstrating his artistic skills and in his engagement with the intellectual and scholarly concerns of his peers, the practitioners of the liberal arts.

Conclusion: The Reputation of the Renaissance Artist

The category of paintings here called 'display pieces' indicates what artists considered were significant about their own talents. They wished others, and perhaps especially potential patrons, to realise that these were the particular pictorial characteristics and qualities that they could offer. But what did others in the societies within which the Renaissance painter moved think of them? This concluding chapter will review some of the evidence that indicates how the Renaissance artist was regarded by his contemporaries, and how his reputation for intellectual activity evolved during the early Renaissance.

'Here I am a gentleman, at home only a parasite', wrote Dürer to his humanist friend Willibald Pirckheimer from Venice in 1506.[1] This is perhaps a pessimistic assessment of his reputation in Nuremberg. He belonged there to a well-established intellectual group around Pirckheimer and Konrad Celtis, and three years later was appointed to sit on the city's Great Council. Moreover, his German compatriots in Venice also seem to have regarded him highly. At the very date of his letter to Pirckheimer he depicted himself opulently dressed in furs and velvets (fig. 1) in his lavish *Rosenkranzfest* altarpiece for S. Bartolommeo di Rialto, the German community's church in Venice. But his caustic tone suggests that Dürer registered a contrast in the way that painters were treated north and south of the Alps. His remark sharpens our awareness of the Italian – in this case, specifically the Venetian – artist's growing social status. The leading artists of Venice could aspire to an established, salaried civic position, the *sansaria*, held at the time of Dürer's visit by both Gentile and Giovanni Bellini. This gave the painter at the top of his profession recognition, in both social and intellectual circles, and relative freedom to pursue his artistic interests. The established court artist too might be a gentleman: as Leonardo da Vinci put it, he 'may dress

himself in whatever clothes he pleases' and could pursue activities other than the purely artistic.[2] Of Leonardo, perhaps the paradigmatic court artist at the time that Dürer was in Venice, Castiglione wrote in *The Book of the Courtier* that he 'despises the art for which he has so rare a talent [*e rarissimo*] and has set himself to study philosophy; and in this he has strange notions [*concetti*] and fanciful revelations [*nuove chimere*] that, if he tried to paint them, for all his skill he couldn't.'[3]

Visual evidence reviewed in earlier chapters also shows that during the early Renaissance, and especially during the last quarter of the fifteenth and the first quarter of the sixteenth centuries, the artist's self-awareness and belief in his artistic abilities and intellectual powers developed rapidly. Since artists tended not to write, little textual evidence of artists' views of themselves, and of their social, intellectual and artistic status, survives to complement and to control interpretation of the visual material. Lorenzo Ghiberti's self-portrait (fig. 128) on his second bronze doors indicates early on both his self-regard and his recognition within his society. This may be reflected in his apparent licence to reject Leonardo Bruni's programme for the second doors. It is moreover echoed by the resonances of the remark in his *Commentaries*, written as early as the 1450s, that 'few things have been done of any importance in our territory that were not designed and arranged by my hand'.[4] On the other hand, this may be read merely as self-justification, just as Leonardo da Vinci's claim in his celebrated letter to Ludovico Sforza of Milan around 1481 or 1482 – 'in painting I can do everything possible as well as any other, whosoever he may be' – may be little more than a self-conscious effort at persuasion.[5] However, references to himself in Mantegna's letters do suggest that he valued himself highly. He evidently expected that his salary, his living conditions and the respect in which he was held at the Gonzaga court should reflect this estimation. He wrote, for example, from Rome in 1489 to Francesco Gonzaga: 'I pray you not to forget your Andrea Mantegna, and not let him lose his salary, granted me so many years ago by [your] illustrious house . . . I put it to you strongly that it is needed.'[6] Mantegna's reputation was, after all, already high enough by the 1480s for him to receive visits to his house and workshop from no less a person than Lorenzo 'the Magnificent' de' Medici in 1483, who came to look at paintings and antiquities in Mantegna's collection, and from Ercole d'Este, Duke of Ferrara, who in 1486 visited him to see 'the Triumphs of Caesar, which Mantegna is painting, which he liked very much'.[7]

Some of the comments written by artists about themselves may

suggest that the Renaissance artist developed in self-confidence as he began more fully and regularly to recognise his intellectual and creative status. Dürer's concern with his physical condition is clearly shown by his nude self-portrait drawing (fig. 134). His complementary concern for recognition of the artist's creative individuality is declared in the *Melencolia I* engraving (fig. 140) of 1514. This is perhaps the earliest transparent indication of an artist's acceptance, and his wish to communicate his acceptance, of the implications of being 'born under Saturn'. At the end of his career the Florentine painter Pontormo became obsessively and morbidly concerned with his health, recording in his diaries minute details about his digestive and other physiological systems. But no artists' writings of this sort survive from the fifteenth century. For his own purposes Vasari dwelt in an exaggerated way on his anecdotes about artists' obsessiveness. Uccello's single-minded preoccupation with perspective, however, which led him to end up 'solitary, eccentric, melancholy and poor', or Piero di Cosimo's 'odd and whimsical' character,[8] are not documented in biographical writings by their contemporaries. But in letters and other miscellaneous texts occasional references to artists' personalities do appear. Comments such as these suggest that, progressively during the Renaissance, patrons and others came to acknowledge that the true artist was one who did, and should, exercise creative imagination and individuality in producing his works. Following this came some recognition that such creativity might be accompanied by personality traits that meant that the artist needed, and deserved, to be treated with respect. Evidence suggests that it came to be recognised that the artist and his personality might at times require delicate handling.

In the mid-fifteenth century respect for creativity may have been shown mainly by acknowledging that some value should be attached to the artist's skill. Borso d'Este, Duke of Ferrara, recommended his presumed half-brother Baldassare to Galeazzo Maria Sforza as 'a suitable and respectable kind of person and also because he is good at his craft . . .'.[9] However, in 1470 the same Duke Borso dismissed the claim of his court artist Francesco del Cossa for increased pay, submitted on the grounds that he deserved better remuneration than 'the most miserable assistant in Ferrara', with a curt 'let him be content with the set fee'.[10] On the other hand, in his letter to Filippo Strozzi in 1498, Filippino Lippi reported that Cardinal Carafa, for whom he decorated a chapel in S. Maria sopra Minerva in Rome between 1488 and 1493, had awarded him 250 florins 'for his mastery alone'.[11] As already noted, in 1449 Sigismondo Malatesta guaranteed to pay a Florentine artist an annual salary 'even if he

works solely for his own pleasure'.[12] At much the same date Antonino Pieruzzi, prior of S. Marco and later archbishop of Florence, wrote that 'painters fairly reasonably demand to be paid ... not solely according to the quantity of their work, but rather according to their diligence and their greater expertise in the art'.[13] 'Diligence' is a creatively neutral term, but Pieruzzi's notion of reward for 'greater expertise in the art' suggests a clerical recognition of the painter's special sensibilities. A similar view of artistic achievement is suggested by Carlo de' Medici's view, expressed in a letter to his half-brother Giovanni in 1455, that Pisanello's medals should be valued more 'for their novelty than for their usefulness'.[14] Offering a more evolved echo of this view, the Nuremberg councillor Jakob Muffel wrote in 1521 about the specially minted coin to be presented to the Emperor Maximilian I, that 'it is not the value of the coin that should be considered but the skill and art with which it is made'.[15] He seems to suggest that it is not only the artist's craftsmanship but also his creative input that should be recognised and valued.

This builds upon the growing acknowledgment, and indeed appreciation, of the individuality of an artist's style. The idea of a personal style was already articulated by Cennino Cennini, when he wrote in his *Craftsman's Handbook* about how the novice should establish his own style during his apprenticeship.[16] Early in 1457 the painter Pietro da Milano appeared as a witness for Andrea Mantegna, in a dispute over his payment for the Ovetari chapel frescoes. The court record states that Pietro da Milano 'knows that these paintings are by the hand of the said master Andrea. And that, among painters, it is always known by whose hand any painting is, especially when it is by the hand of any established master.'[17] Court artists such as Mantegna and perhaps especially Cosmè Tura, who worked for the Este of Ferrara from 1460 to 1480, developed richly personal stylistic traits. Artists' exercise of inventiveness, of their *fantasia*, was positively encouraged by their princely patrons. The increase in the diversity of art practice and styles in Italy during the fifteenth century may be explained in part by competition among the princes. The early Renaissance prince sought novelty in the works he commissioned, and was perhaps eager to foster his artists' creative talents. He encouraged an originality of artistic temperament that replaced, in the court context, the traditions of craft practice encoded at the beginning of the century in Cennini's *Craftsman's Handbook*.

In parallel, the varying qualities of different painterly styles were recognised and defined in written appraisals of early Renaissance artists. In 1481 Cristoforo Landino developed a vocabulary of critical terms, refined for the date, to differentiate between the styles

of earlier fifteenth-century artists. Masaccio's style, for example, was 'pure and without ornateness' ('puro senza ornato'), Fra Angelico's was blithe ('vezzoso'), ornate ('ornato') and pious ('devoto'), whereas Fra Filippo Lippi's was graceful and ornate ('grazioso' and 'ornato').[18] A decade later Ludovico Sforza's agent weighed up the qualities of painters then working in Florence, appraising Botticelli as having 'a manly air', Filippino Lippi 'a gentler air' and Perugino 'an angelic air, very gentle'.[19] A contemporary of Antonio Pollaiuolo indicated his appreciation of the individual style that that artist consciously sought to develop by writing on the drawing of a 'Nude man seen from front, side and back' (fig. 28): 'This is the work of the excellent and famous Florentine painter and outstanding sculptor Antonio, son of Jacopo. When he depicts man, look how marvellously he shows the limbs.'[20] Of Lorenzo Costa, the Mantuan court painter, the humanist Battista Fiera wrote that his style was most suitable for 'cosmetic softness and blandishments.'[21] On 14 May 1505 Isabella d'Este wrote to Leonardo da Vinci, 'we beg you . . . to do a youthful Christ . . . executed with that sweetness and soft ethereal charm which is the peculiar excellence of your art'.[22] Isabella's use of the phrase 'quella dolceza et suavità di aiere' is a further significant case of a patron's recognition of the special stylistic properties that make an artist's work individual and valuable. The developing discrimination of what might be termed embryonic pictorial analysis is indicated by the thematic and stylistic categories that Giovanni Santi distinguishes for comment in his stanzas on Mantegna:

> One sees that first of all he has a grasp
> > Of great Drawing, which is the true foundation
> > Of painting, then, second, in him comes
> A glowing adornment of Invention . . .

> And no man ever took or used the brush
> > Or other pencil, who was a clear successor
> > Of ancient times, as he is, with such truth,
> Nor with a greater beauty. [He has]
> > Gone beyond them all in that grace of his . . .

> And then his diligence, his lovely colour,
> > With all its planes and various distances,
> Movement in drawing, and he astonishes
> > All who see and note his foreshortening . . .

> Perspective, which brings on in its train
> > Arithmetic, also geometry,
> > And great architecture turns to it.

A further indication of the growing prestige of the artist during the Renaissance is provided by cases in which patrons act as collectors, and show more concern ·that they have works by highly reputed artists than that they have particular subjects represented. In 1442 Alfonso of Aragon directed his bailiff-general Berenguer Mercades to find him a painting by Jan van Eyck. What subject the painting showed was unimportant; but as it happened Mercades found him a 'St George and the Dragon', an appropriate subject because his burial chapel at Poblet in Catalonia was dedicated to St George, whom he had adopted as protector during the campaign to win Naples in 1442–3.[23] The painting, which was shipped from Bruges to Naples via Barcelona in 1444, was described by Pietro Summonte in his letter to Marcantonio Michiel of 1524.[24] It evidently had all the qualities of verisimilitude, visual effect, fine detail and expressiveness especially valued in Netherlandish paintings by Italian court patrons.

A similar interest primarily in painters rather than in the works he owned is shown by the Florentine merchant Giovanni Rucellai. Around 1470 he listed in his *Zibaldone* the artists by whom he had paintings, not the subjects or other details of those works.[25] He was evidently concerned to record that he possessed examples by most of the major Florentine painters of his time. Pope Pius II seems, similarly, to have been anxious to obtain altarpieces by each of four 'illustrious Sienese artists' of the day.[26] When commissioning paintings for the side altars of his new cathedral at Pienza in 1462–3, he aimed not for uniformity in form and style but for the diversity that different artists could provide, as though to create a 'gallery' in which the painters' different abilities could be discerned and compared. This idea of comparison, a *paragone*, between contemporary artists seems also to have dictated Isabella d'Este's attempts to commission a painting from each of the major painters of her time for her *camerino* in the Castello of Mantua. Her desire to be able to make – potentially unfavourable – comparisons between these works was evident to Giovanni Bellini, who refused her request for a painted *favola* partly on the grounds that 'he knows your Ladyship will judge it in comparison with the work of Master Andrea [Mantegna]'.[27] Isabella herself indeed compared Perugino's contribution (fig. 88) unfavourably with Mantegna's: in her letter of thanks she somewhat ungraciously wrote, 'if it had been more carefully finished, it would have been more to your honour and our satisfaction, since it is hung near those of Mantegna, which are painted with rare delicacy'.[28] Her correspondence with Cecilia Gallerani in 1498 also shows her wish to make a comparison between portraits by Giovanni Bellini and Leonardo da Vinci.[29]

By the end of the fifteenth century patrons and commentators also began to show an awareness that a painter's creative *fantasia* might to an extent reflect a temperamental personality. Niccolò dell'Arca died in penury and abject misery, according to the Dominican Fra Giovanni Borselli, writing after Niccolò's death in 1494, because

> he was fanciful and uncivilized in his ways, and was so rough that he drove everybody off. Most of the time he was in want even of necessities, but he was thickheaded and wouldn't accept the advice of his friends.[30]

This seems to find a later parallel in Vasari's comment about Piero di Cosimo that 'through his brutish ways he was held...to be a madman' – an assessment that may, after all, be at least an echo of the truth.[31] Francesco Gonzaga, Marquis of Mantua, excused his court painter Mantegna, who had objected that painting a small picture for the Duchess of Milan was a manuscript illuminator's job, not a painter's, saying that 'these recognised masters have something of the fanciful about them, and it is best to take from them what one can get'.[32] Another indication that patrons became increasingly aware that they had to tread carefully if they were to get the best out of their temperamental artists comes in Piero Soderini's letter recommending Michelangelo to the Cardinal of Volterra on 27 November 1506: 'he is a fine young man, and in his skills he is unique in Italy, and perhaps even in the universe . . . he is of a manner that with fine words and cherishing he will do everything that he can: you need to show him affection and do him favours'.[33]

Several comments recorded in Isabella d'Este's correspondence similarly acknowledge that painters could be unpredictable and might need to be handled carefully if the desired result was to be achieved. Writing to Paride da Ceresara on 10 November 1504, Isabella showed her impatience with Perugino:

> we do not know who finds the slowness of these painters more wearisome, we who fail to have our camerino finished, or you who have to devise new schemes every day which then, because of the bizarre ways of these painters, are neither done as soon nor drawn in entirety as we would have wished . . .[34]

Perugino's unaccommodating behaviour was also noted by Agostino Strozzi, writing to Isabella on 22 February 1505:

> you will understand that my utmost solicitude and diligence have not been lacking. But the behaviour of this man [i.e. Perugino], unknown to me formerly, I fear will make me seem a liar to Your

Illustrious Ladyship. It is already about a fortnight since he left Florence, and I cannot discover where he has gone nor when he is going to return . . . And [when he does return] he intends to finish the work hastily and spoil it, which will cause me unbelievable annoyance and displeasure, because he . . . had intended . . . to apply himself with the requisite diligence and to spend the time reasonably needed on it. I do not know what more to say or promise to Your Ladyship . . . I do not know what to say of this man, who does not seem to have the wit to make any distinction between one person and another. I shall be very astonished if art can accomplish in him what nature has been incapable of showing.[35]

Leonardo da Vinci was no easier to deal with, as Fra Pietro da Novellara suggested in his letter of 3 April 1501 to Isabella d'Este:

from what I hear Leonardo's life is changeable and very erratic, so that he seems to live just from one day to the next . . . He is working hard on geometry and has absolutely no patience to spare for painting. . . .[36]

Eleven days later he reported again to Isabella that Leonardo's 'mathematical experiments have so distracted him from painting that he cannot bear the sight of a paintbrush'. From these reports of Leonardo's character and preoccupations Isabella seems to have realised that she had to approach him gently if she was to have any chance of success. The same is true, as we saw in chapter 8, of her handling of Giovanni Bellini in the protracted negotiations with him for paintings for her *camerino*.

The correspondence between Isabella d'Este, her agents and her painters is a singular survival. We cannot now know to what extent her ways of negotiating were characteristic of early sixteenth-century patrons' or collectors' dealings with artists, or whether they were unusually stimulated by the special characteristics of Isabella's artistic tastes, her acquisitive temperament and her financial circumstances in Mantua. Nevertheless, these letters do throw light on a series of developments in the artist's position that are corroborated by other isolated pieces of evidence. Isabella needed to cajole her painters to produce the paintings she asked for. She was prepared to compromise in matters of subject in order to acquire works by acknowledged masters. And conversely, her frustration at the delays suggests that painters felt increasingly free to procrastinate or to refuse to cooperate at all. During the first two decades of the sixteenth century artists gained increasing licence to act indepen-

dently. More artists, such as Leonardo da Vinci in Milan and Gian-cristoforo Romano in Urbino, were accepted into the circle of princely courtiers. They exercised their intellectual acumen in cultured debate, music-making and other courtly pursuits. A painter such as Giorgione was in a position to produce 'poetic' works for connoisseur-patrons who 'had them painted for their own enjoyment',[37] night scenes rather than subject paintings with some instructive meaning. It is clear from his self-portraits that a painter such as Dürer fully and self-consciously recognised his independent creativity; and he also exploited the technique of engraving more single-mindedly than did his predecessors to show as wide a public as possible the intellectually sophisticated qualities of his art. In all these respects, and in numerous others touched upon in this book, early Renaissance artists pointed out to their intellectual contemporaries that painting and sculpture justifiably counted, alongside poetry, rhetoric and their companions, as liberal arts.

Notes

Chapter 1

1 Castiglione/Bull (1967), 96, 100–01. *The Book of the Courtier* (*Il Cortigiano*) purports to record discussions at the court of Guidobaldo da Montefeltro of Urbino between 1504 and 1508 but it was not completed until 1516–18 and not published until 1527. That it quickly became a book that aspiring intellectuals – including painters – needed to read is suggested by its appearance in the list of books left in Florence by Rosso Fiorentino when he departed for France in 1529.

2 Four separate notes proposed for inclusion in the *Trattato* were brought together in this paragraph in Kemp and Walker eds (1989), 46.

3 See below, chapter 7.

4 Chambers (1970), 150.

5 'Not even the best of artists has any conception / that a single marble block does not contain / within its excess . . .'; Saslow (1991), 302 no. 151.

6 Alberti/Grayson (1972), 95, para. 53.

7 Alberti/Grayson (1972), 95, para. 53.

8 Rubin (1995), passim.

9 Vasari/Bull, (1965–87), I, 325–442; for instance with regard to his apprenticeship in Ghirlandaio's workshop, on 327–30; Condivi (1553)/Wohl and Wohl (1976), 9–10.

10 Vasari/Bull, (1965–87), I, 57–81.

11 Vasari/Bull, (1965–87), II, 48–57, on 55.

12 For 'parsimony', see Baxandall (1985), 120.

Chapter 2

1 Gilbert (1980), 100. King René has sometimes, although implausibly, been credited with the illuminations in the original manuscript of his own text, *Le Cuer d'amours espris* (Vienna, Staatsbibliothek, Cod. 2597).

2 Cole (1995), 33–4.

3 Castiglione/Bull (1967), 96–7.

4 The epitaph reads: Picturae ad quam puerum sors detulerat studio inter seria non abstinuit; Malaguzzi-Valeri (1915–29), III, 75; Wittkower (1950), 12.

5 Vasari/Bull (1965–87), I, 326–7.

6 Landau and Parshall (1994), 100 and 293; Hind (1938–48), V, 90–91 n. 1.

7 Alberti/Grayson (1972), 37, para. 1.

8 Baxandall (1971), 127.

9 Warnke (1993), 39 and n. 153.

10 Alberti/Grayson (1972), 63–4, paras 27–8.

11 Pliny the Elder, *Natural History*, books 34–5; trans Rackham (1952), passim, esp. 274–371.

12 Castiglione/Bull (1967), 97.

13 Manetti/Saalman (1970), 38.

14 Vasari/Gaunt (1963), III, 183.

15 Vasari/Bull (1965–87), I, 255.

16 Grendler (1995); Banker (1992).

17 Maginnis (1997), 153.

18 Alberti/Grayson (1972), 33.

19 Jones and Penny (1983), 199; Thoenes (1986).

20 Signorini (1996).

21 Field (1997), 69–71.

22 Hutchison (1990), 111.

23 Hutchison (1990), 23.

24 Jones and Penny (1983), 204.

25 Kemp and Walker (1989), 9.

26 Reti (1968).

27 Landau and Parshall (1994), 12–13 and 375 n. 38.

28 Carl (1987).

29 Shearman (1992), 246–7.

30 Cendali (1922), 183–4.

31 Onians (1971).

32 Cavallaro and Parlato eds (1988), 125–6 cat. 36.

33 Lightbown (1986), 78–80 and 408; Martineau ed. (1992), 11.

34 Dhanens (1980), 182–7 and 382.

35 Scher ed. (1994), 102–3 cat. 27.

36 Cordellier ed. (1996), 209–10 cat. 111; Scher ed. (1994), 44–6 cat. 4.

37 Lightbown (1978), I, 130–38 and II, 99–101.

38 ARS VTINAM MORES ANIMVMQVE EFFINGERE POSSES PVLCHRIOR IN TERRIS NVLLA TABELLA FORET; Pope-Hennessy (1966), 24–8.

39 HAEC FERE QVVM GEMITVS TVRGENTIA LVMINA PROMANT BELLINI POTERAT FLERE IOANNIS OPUS: this text may be a paraphrase of a line in Propertius; Robertson (1968), 55; Goffen (1989), 71–2 and fig. 49.

40 NIL NISI DIVINUM STABILE EST; CETERA FUMUS; Elam (1981), 24; Lightbown (1986), 444–5 and pl. 130.

41 Wisdom of Solomon, 7, 29 and 26; see Purtle (1982), 37.

42 Pini and Milanesi (1876), I, no. 27.

43 Krautheimer and Krautheimer-Hess (1956), pl. 11a.

44 Weiss (1969), 161.

45 Scher ed. (1994), 121 cat. 36.

46 Pini and Milanesi (1876), no. 14 and, for Leonardo, Kemp ed. (1989), cats 9, 18, 25 and others.

47 Pini and Milanesi (1876), nos 28 and 22.

48 Petrioli Tofani ed. (1992), 61 cat. 2.18; and see below, chapter 3, p. 66 and n. 38.

49 Pini and Milanesi (1876), no. 30; Wohl (1981), 14–15, 339–40 and frontispiece.

50 Pini and Milanesi (1876), no. 41; Ruda (1993), 28–9 and pl. 9.

51 Pini and Milanesi (1876), no. 72; for the drawing, see Ames-Lewis (1981), 134, pl. 121.

52 Grendler (1995), 169–70; the manuscript is Florence, Bibl. Laurenziana, Ashburnham 280.

53 Pini and Milanesi (1876), no. 80; Kristeller (1902), 542 doc. 88; see also his letter of 13 July 1506 to Isabella d'Este, in Martineau ed. (1992), 26 fig. 8.

54 Pini and Milanesi (1876), no. 60; for Bertoldo's letter, see Chambers (1970), 102–4; for Michelangelo, see Saslow (1991), 70–72 no. 5.

55 Ghiberti/Morisani (1947), 2 [my translation].

56 Gaurico/Chastel and Klein (1969), 62–3; Burke (1974), 68.

57 Alberti/Grayson (1972), 95, para. 53.

58 Cennini/Thompson (1933), 16 and 3 respectively.

59 Kemp and Walker (1989), 197.

60 Kemp and Walker (1989), 14.

61 Hutchison (1990), 81.

62 Field (1997), 16.

63 Manetti/Saalman (1970), 42–4.

64 Christiansen (1982), 96–9 cat. IX and pl. 38.

65 See respectively, for example, Joannides (1993), 356–68, especially 360–65 and pl. 132, and Bennett and Wilkins (1984), 161–5. For extensive analysis of the S. Maria Novella *Trinity*, see Field (1997), ch. 3, 43–59. For Alberti's explanation of perspective, see Alberti/Grayson (1972), part I, 37–59, paras 1–24.

66 Joannides (1993), 290–91 and pl. 168.

67 For the Pisanello drawing, see Cordellier ed. (1996), 127–35 cat. 71; on Jacopo Bellini, see Degenhart and Schmitt (1984), passim, and Eisler (1989), especially 443–8.

68 Vasari/Bull (1965–87), I, 95.

69 On Fouquet and the Chevalier Hours, see Schaefer (1994), 40–137.

70 Cennini/Thompson (1933), 2–3.

71 Cennini/Thompson (1933), 3.

72 Cennini/Thompson (1933), 64–5.

73 Gilbert (1980), 100–01; Thomas (1995), 66–7 and 78–9.

74 Cennino/Thompson (1933), 15.

75 Gilbert (1980), 163.

76 Gilbert (1980), 156.

77 Tietze and Tietze-Conrat (1944), 6.

78 For Pisanello, Cordellier ed. (1996), passim; for Jacopo Bellini, Eisler (1989), passim.

79 Scheller (1995), passim, and especially 276–302 cats 26–8.

80 *Giovannino de'Grassi . . .* (1961), passim.

81 Frimmel (1888), 108; Scheller (1995), 21.

82 Milanesi (1854), II, 120.

83 Ames-Lewis (1981), 87; Tietze and Tietze-Conrat (1944), 66–7.

84 Cordellier ed. (1996), 300–01 cat. 193 (for Pinturicchio) and 70 cat. 29, 273 cat. 176 and 299 cat. 190 (for Carpaccio).

85 The two surviving books of drawings were referred to in the will of 1471 of Jacopo's wife, Anna, among '. . . omnes libros de dessignijs . . .'; Eisler (1989), 532; Gilbert (1980), 39.

86 Carl (1983), 507–54; Alberti/Grayson (1972), 67–73, paras 31–4.

87 Egger (1905–6); also Shearman (1977), 107–46; Nesselrath, in Prinz and Seidel eds (1996), 175–98.

88 Cavallaro and Parlato eds (1988), passim; and see below, chapter 5.

89 Hind (1938–48), I, 177–82 cats C.II.1–12.

90 Vasari/Bull (1965–87), I, 329 and II, 253 respectively.

91 Hind (1938–48), I, 44–5 cat. A.I.48, and II, pl. 47.

92 Hind (1938–48), I, 44–5 cat. A.I.48 and 61 cat. A.II.1, for example.

93 Landau and Parshall (1994), 355.

94 As proposed by Baxandall (1971), 133–4.

95 Landau and Parshall (1994), 68–71; Landau (1992); for an alternative view, see Boorsch (1992).

96 Perosa ed. (1980), I, 23–4; Gilbert (1980), 112.

97 Evans (1986).

98 Armstrong (1968), 155–67.

99 Lightbown (1986), 19.

100 Landau and Parshall (1994), 55.

101 Bartrum ed. (1995), 125–6 cats 120–21.

102 Bartsch XIV, 331; on Raimondi's engravings, see Landau and Parshall (1994), passim.

103 Codex Escurialensis, fols 53 and 64; Egger (1905–6), pp. 130–31 and 154–5 respectively; Bober and Rubinstein (1986), 71–2 no. 28.

104 Allison (1993–4); Radcliffe (1981).

105 Pope-Hennessy (1980), 233–4 cat. 3; Avery (1984), 168.

106 Alberti/Grayson (1972), 101, para. 58.

107 Ragghianti and Dalli Regoli (1975), passim; Ames-Lewis (1981), 91–123.

108 Cennini/Thompson (1933), 4.

109 Kemp and Walker (1989), 199.

110 Cennini/Thompson (1933), 16; for 'reception of light', Alberti/Grayson (1972), 87–9, para. 46.

111 Gilbert (1980), 89; see also Filarete/Spencer (1965), I, 315, fols 184r–v.

112 Vasari/Bull (1965–87), I, 196 and Vasari/Gaunt (1963), II, 287, respectively.

113 Cennini/Thompson (1933), 16: 'Have a sort of pouch made of pasteboard, or just thin wood . . . this is good for you to keep your drawings in, and likewise to hold the paper on for drawing.'

114 Knapp (1903), 275.

115 Ames-Lewis (1981), 151, pl. 150.

116 Gilbert (1980), 88.

117 Lightbown (1986), 18.

118 Campori (1885), 541.

119 '. . . omnia laboraria de Zessio, de marmore et de relevijs . . .': Eisler (1989), 532; Gilbert (1980), 36.

120 '3 teste et uno piè di gesso' (item 269); '2 mani di cera et una testa di cera' (item 270); he also had '3 gessi d'Apollo' (item 268) among which might have been a plaster statuette after the *Apollo Belvedere*; Coor (1961), 107 and 159.

121 '63 Pezzi fra teste piedi et torzi di gesso'; Knapp (1903), 275.

122 '7 teste di giesso di relievo'; Hind (1938–48), I, 304–9 (appendix).

123 Fusco (1982).

124 Ames-Lewis (1995).

125 Vasari/Bull (1965–87), I, 239; Fusco (1982), 183 n. 23.

126 Akker (1991), fig. 33.

127 Weiss (1969), 180.

128 Cust (1906), 304–6; Milanesi (1854), III, 56; Hill (1906).

129 Gilbert (1980), 34.

130 Gilbert (1980), 210.

131 'unum studium magnum in domo, cum relevis, designis et aliis rebus intus; unum studium parvum in domo dita "a relevis", cum omnibus rebus intus, spectantibus ad artem pictoriae, et picturis existentibus in eum;' Fiocco (1958–9).

132 Lightbown (1986), 19.

133 Horne (1908), 360–63 docs 46 and 55.

134 Wackernagel/Luchs (1981), 272.

135 Barocchi ed. (1992), passim; Elam (1992).

136 Vasari/Gaunt (1963), II, 208.

137 Kemp/Walker (1989), 200.

138 Kemp/Walker (1989), 197 and 196 respectively.

139 Rubin (1995), 94.

Chapter 3

1 Brenzoni (1952), 68.

2 Kemp (1981), 131, 169–70.

3 In the dedicatory letter of L. Pacioli, *De divina proportione*, Milan 1509; Kemp (1997), 248.

4 Warnke (1993), 9–10.

5 'pictor et domesticus familiarissimus Domine Joanne Regine'; Rolfs (1910), 63.

6 Warnke (1993), 56.

7 Warnke (1993), 31–2.

8 Kristeller (1902), 518 doc. 14; Warnke (1993), 116.

9 Warnke (1993), 57.

10 Warnke (1993), 164–5.

11 Warnke (1993), 156.

12 Fiocco (1966).
13 Warnke (1993), 57 and 168.
14 Elam (1981), 16 and 25 n. 9.
15 '. . . dice che anche lui se fece fare conte, et spera il privilegio'; Kristeller (1902), 526 doc. 41; Warnke (1993), 157 n. 59.
16 Signorini (1974).
17 Elam (1981), 16.
18 Vasari/Bull (1965–87), I, 245.
19 'few artists could boast such nominal honours in the fifteenth century, but few would have striven so hard to obtain them': Elam (1981), 16.
20 Warnke (1993), 76.
21 Warnke (1993), 119 and 168.
22 Warnke (1993), 33–4.
23 Vaccarino (1950), 14.
24 Warnke (1993), 32.
25 Warnke (1993), 80.
26 Warnke (1993), 78.
27 Warnke (1993), 7.
28 See his letters, in Milanesi (1854), I, 294–307, 385ff.; Warnke (1993), 18.
29 Warnke (1993), 78.
30 Warnke (1993), 78.
31 Condivi/Wohl and Wohl (1976), 37.
32 d'Arco (1857), II, 19; Warnke (1993), 209.
33 *Jean Gossaert dit Mabuse* (1965), 373–5 and cats 45–8.
34 Burke (1974), 83.
35 Warnke (1993), 79.
36 'pour aucunes matières secretes'; Laborde (1849–52), I, 229, 242, 251 and 350; Duverger (1977), 175–6.
37 Warnke (1993), 221.
38 'Vo esere uno buono disegnatore e doventare uno buono architettore'; Petrioli Tofani ed. (1992), 61 cat. 2.18.
39 Vasari/Gaunt (1963), III, 55 (life of Baccio d'Agnolo).
40 White (1987), 52.
41 Malaguzzi Valeri (1915–29), II, 12.
42 Schofield (n.d. [1991]).
43 Jones and Penny (1983), 215.
44 Kristeller (1902), 520 doc. 19.
45 Bianconi (1953), 34; Warnke (1993), 127.
46 Rosenthal (1962); Campagnari (1975); Elam (1981), 15.
47 Letter of Isabella d'Este to Francesco Gonzaga, 10 July 1496; Cartwright (1904), I, 126; Lightbown (1986), 180.
48 Elam (1981), 25 n. 7.
49 Vasari/Bull (1965–87), I, 186.
50 Hutchison (1990), 98.
51 Warnke (1993), 117.
52 Martindale (1972), 23.

53 Warnke (1993), 31.
54 Warnke (1993), 129.
55 Vespasiano/Waters and Waters (1963), 224.
56 Vasari/Bull (1965–87), II, 329.
57 Vasari/Gaunt (1963), II, 148–9.
58 Vasari/Gaunt (1963), I, 221.
59 Cennini/Thompson (1933), 91.
60 *Natural History*, 35, 120; Pliny/Rackham (1952), 348–9.
61 *Natural History*, 35, 62; Pliny/Rackham (1952), 306–9.
62 *Natural History*, 35, 71; Pliny/Rackham (1952), 314–15; Athanasius of Naukratis, *The Mysteries of the Kitchen*, XII, 543–4.
63 Kemp and Walker (1989), 38–9.
64 Hutchison (1990), 65.
65 'Exegit quinquemestri spatio. Albertus Dürer Germanus'; Hutchison (1990), 88.
66 Hutchison (1990), 95.
67 'venne a vedermi lavorar de una buona voglia'; Warnke (1993), 204.
68 Panofsky (1953), I, 179.
69 *Jean Gossaert dit Mabuse* (1965), 378–9; Warnke (1993), 233.
70 Landau and Parshall (1994), 210–11.
71 Filarete/Spencer (1965), I, 80 (fol. 46v).
72 Warnke (1993), 204.
73 Gundersheimer (1976), 8.
74 Gilbert (1980), 95–6.
75 Elam (1981), 20; Lightbown (1986), 462–3; Martineau ed. (1992), 435 cat. 140.
76 '. . . la sua Magnificentia se dirico a casa de Andrea Mantegna: dove la vite cum grande piacere alcune picture desso Andrea, et certe teste di relevo cum molte altre cose antique, che pare molto se ne deletti . . .'; Kristeller (1902), 541 doc. 86.
77 'qualche operette': Kristeller (1902), 542 doc. 88.
78 Huizinga (1955), 261; Warnke (1993), 40.
79 'ad ipsum dominum Leonellum . . . Pisani nomine Divi Julij Cesaris effigem detulit et presentavit'; Salmi (1957); Cordellier ed. (1996), 136 cat. 73.
80 'una capsa quadra in forma di libro, dov' Giulio Cesare in uno quadretto di legno con le cornici dorate'.
81 Kristeller (1902), 550 doc. 112; Warnke (1993), 148.
82 Alberti/Grayson (1972), 55.
83 Kristeller (1902), 551–3 doc. 115.
84 Schmidt (1961), 141 doc. 18; Warnke (1993), 148–9.
85 Vasari/Gaunt (1963), III, 288.
86 Christiansen (1967); Hutchison (1990), 183.

87	Warnke (1993), 99–100.

88	Lightbown (1978), I, 125–6; Vasari/Bull (1965–87), I, 231.

89	Hirst (1988), 111–17.

90	*Natural History*, 35, 36–62; Pliny/Rackham (1952), 308–9.

91	Alberti/Grayson (1972), 61, para. 25.

92	'Una testa di tucto rilievo antica'; (item 183) and 'Un'altra testa di bambino di marmo anticho' (item 184); Coor (1961), 157.

93	Cust (1906), 304–6 and 337 n. 31; Milanesi (1854), III, 56; Hill (1906).

94	Salmi (1957); Weiss (1969), 171–2.

95	'con la punta dil naso di cera': Brown (1969); Fortini Brown (1996), 118.

96	A. Luzio and R. Renier, 'Il lusso di Isabella d'Este', *Nuova antologia*, ser. 4, LXIV (1896), 319.

97	'Qui Paphiam nudis Venerem vidisse papillis / optet in antiquo marmore Praxitelis / Bellini pluteum Gentilis quaerat, ubi stans / trunca licet membris, vivit imago, suis'; Fortini Brown (1996), 118.

98	'la mia cara Faustina da marmo anticha'; P. Kristeller (1902), 577 doc. 174; Fletcher (1981), 54; Chambers and Martineau eds (1981), 170 cat. 122; for translation, see Gilbert (1980), 14.

99	Caglioti (1993) and (1994).

100	'molte anticaglie di marmo e di bronzo'; Albertini/Murray (1972), unpaginated.

101	Weiss (1969), 180–81; Krautheimer and Krautheimer-Hess (1956), 305 n. 51; Bober and Rubinstein (1986), 127 no. 94.

102	Gilbert (1980), 207–8.

103	Milanesi (1854), II, 189; Weiss (1969), 181 n. 4.

104	Weiss (1969), 114.

105	'sono assai cose antique di Roma'; Albertini/Murray (1972), unpaginated.

106	'figura marmorea de donna vestita intiera, senza la testa e mani, è anticha, et solea esser in bottegha da Tullio Lombardo, ritratta da lui più volte in più sue opere'; Chambers, Pullan and Fletcher (1992), 425; Luchs (1995), 24 and 131–2 nn. 155–6.

107	'omnes statuas, figuras et ymagines suas, cuiuscumque materie seu metalli, sunt existentes in studio domus sua in qua ipse abitat'; Maddano (1989); in brief, Bober and Rubinstein (1986), 471.

108	'Poscia in casa dun certo mastandrea/ve un nudo corpo senza braze collo / che mai visto non ho miglior diprea' (stanza 13);

109	Govi (1876); cited in Bober and Rubinstein (1986), 166–8 no. 132.

109	Schmitt (1970): App. I: Umbrian Sketchbook *c*.1500, fol. 10v.

110	On fols 42, 44v and 34v–35r respectively; Schweikhart (1986), 96–100 and fig. 25, 104–7 and fig. 28, and 86–7 and fig. 18 respectively: Bober (1957), fig. 45.

111	Codex Wolfegg fols 46v–47r: Schweickhart (1986), 112–13 and fig. 30; for the Chantilly sheet, Musée Condé F.R.24, Bober and Rubinstein (1986), 195 and pl. 194a.

112	Ferrari (1992), I, 11–12.

113	Bober and Rubinstein (1986), 186–7 no. 154.

114	Huizinga (1955), 261.

115	Warnke (1993), 21 and 230.

116	Warnke (1993), 230.

117	Gordon ed. (1974), 166–7 and 343 n. 7 (letter LXXXIV); Bennett and Wilkins (1984), 55–6.

118	Bennett and Wilkins (1984), 55.

119	Gilbert (1980), 119–20.

120	Rossi (1888), 409–11; Weiss (1969), 196.

121	Kristeller (1902), 527, doc. 45; Cole (1995), 42.

122	Ferrari (1992), I, 33–4.

123	Nelson (1991).

124	Weiss (1969), 190 and 200.

125	Bober and Rubinstein (1986), 152–5.

126	Cole (1995), 164.

127	Fletcher (1981), 54; Beltrami (1919), 70–71.

128	Fletcher (1981), 54; Venturi (1888), 108.

129	Fletcher (1981), 53.

Chapter 4

1	Vasari/Bull (1965–87), I, 207 and 222–3 respectively.

2	Vasari/Gaunt (1963), II, 358: 'D. O. M. Antonius pictor, praecipuum Messanae suae et Siciliae totius ornamentum, hac humo contegitur. Non solum suis picturis, in quibus singulare Artificium et venustas fuit, sed et quod coloribus oleo miscendis splendorem et perpetuitatem primus italicae picturae contulit sommu semper artificium studio celebratus'.

3	Vasari/Gaunt (1963), II, 24; for the inscription, see Cole Ahl (1996), 194.

4	Vasari/Gaunt (1963), II, 26.

5	Cole Ahl (1996), 195.

6	Pope-Hennessy (1969), 2 and 24.

7	Vasari/Bull (1965–87), I, 238.

8	Butterfield (1994), 47–67.

9 Vasari/Bull (1965–87), II, 31. Similarly, Vasari wrote of Andrea del Verrocchio's entombment that 'It was Lorenzo [di Credi] who brought his remains from Venice and laid them in Sant'Ambrogio, in the tomb of Michele di Cione over whose monument are carved the words: *Ser Michaelis di Cionis et suorum*; and then: *Hic ossa jacent Andreae Verrocchii qui obiit Venetiis* MCC-CCLXXXVIII.'

10 'fu sepolto a San Zane Polo in la soa arca, dove etiam è sepulto Zentil Belin suo fradelo etiam optimo pytor': Sanudo/Fulin (1879–1903), XXIII, 256.

11 Vasari/Bull (1965–87), I, 172; 'Quantum Philippus architectus arte Daedalaea valuerit cum huius celeberrimi templi mira testudo tum plures machinae divino ingenio abeo adinventae esse possunt. Quapropter ob eximias sui animi dotes singularesque virtutes XV. Kal. Maias anno MCCCCXLVI eius B.M. corpus in hac humo supposita grata patria seppeliri iussit'.

12 Vasari/Bull (1965–87), I, 81. The inscription reads:

Ille ego sum, per quem pictura extincta
 revixit,
 Cui quam recta manus, tam fuit et
 facilis.
Naturae deerat nostrae quod defuit arti:
 Plus licuit nulli pingere, nec melius.
Miraris turrim egregiam sacro aere
 sonantem?
 Haec quoque de modulo crevit ad astra
 meo.
Denique sum Jottus, quid opus fuit illa
 referre?
 Hoc nomen longi carminis instarerit;

'That man am I, by whose accomplishment / The painter's art was raised from the dead. / My hand as ready was as it was sure; / What my skill lacked, Nature lack'd too; no one / Was privileg'd more fully life to paint / Or better paint. Dost thou admire a tower / In beauty echoing with sacred chime? / By my design this too reach'd for the stars / But I am Giotto; why recite these deeds? / My name alone is worth a long-drawn ode.'

13 Vasari/Bull (1965–87), I, 81.

14 Migliore (1684/1976), 18–19 and 37.

15 Vasari/Gaunt (1963), II, 60.

16 '. . . molte sepolture di Uomini illustri, massimamente quella del Cecca famoso Architetto dell'eta sua . . . Ed alla Parete eravi il busto del medesimo'; Richa

17 (1754–62), II, 14; Paatz and Paatz (1940–54), IV, 670.

17 Vasari/Gaunt (1963), II, 60.

18 Migliore (1684/1976), 270.

19 On de Santi, see in brief Moretti (1992), [unpaginated].

20 Hic jacet vene. pictor. Fr. Jo. de Flor. Ord[in]is. P[re]dicato 14LV

Non mihi sit laudi quod eram velut alter
 Apelles
Sed quod lucra tuis omnia Christe dabam
Altera nam terris opera extant altera caelo
Urbs me Ioannem flos tulit etruriae.

See also Vasari/Bull (1965–87), I, 207.

21 Vasari/Bull (1965–87), I, 222–3:

Conditus his ego sum picture fama
 Philippus
Nulli ignotas meae est gratia mira manus
Artifices potuit digitis animare colores
Sperataque animos fallere voce diu
Ipsa meis stupuit natura expressa figuris
Meque suis fassa est artibus esse parem.
Marmoreo tumolo Medices Laurentius hic
 me
Condidit, ante humili pulvere tectus eram.

22 Nelson (1991), 44–6.

23 See chapter 5, p. 130 and fig. 66.

24 Gerstenberg (1966), 100 and 105–6.

25 Ettlinger (1971), 173.

26 'Antonius Pullarius patria Florentinus, pictor insignis, qui duor. pont. Xisti et Innocentii aerea moniment. miro opific. expressit, re famil. composita ex test. hic se cum Petro fratre cond voluit. Vixit an. LXXII. Obiit an. Sal. M.IID'; translation from Vasari/Bull (1965–87), II, 77.

27 'Andreae Bregno ex osten. agri comens. Statuario celeberrimo cognomento Polycleto qui primus celandi artem abolitam ad exemplar maior in usum exercitationemq[ue]. Revocavit vix an. LXXXV M V.D.vi [i.e. 6 May 1503]. Bartholomeus Biollis regesti pont magister exec. et Catharina uxor Pos. MDVI'; Davies (1910), 284.

28 Vasari later reported: 'he was buried in the church of San Lorenzo, near Cosimo's own tomb, as he himself had directed, so that just as he had always been near to Cosimo in spirit while alive so his body might be near him after death': Vasari/Bull (1965–87), II, 187.

29 Lightbown (1980), II, 327–8.

30 This has the Baldovinetti family coat-of-arms with a lion rampant, and the simple

inscription 'Baldovinetti. Al / essi Baldovinett / is. et. suor 1480'; Kennedy (1938), 187 and pl. 159.

31 Krautheimer and Krautheimer-Hess (1956), 9 and 377 doc. 82.

32 Vasari/Bull (1965–87), I, 122.

33 'El mio corpo vog[l]io sia sepulto in linclaustro e San Stefano in una mia archa che ho in caxa fata, qual archa sia messa o alto o abasso': Puppi (1972), 100–03; Luchs (1995), 96.

34 'quam sibi construi fecit in Ecclesia hospitalis Sancti Marie della Schala de Senis . . .'; Milanesi (1854), II, 368; Pope-Hennessy (1971), 307; Torriti (1977), 360; van Os (1977).

35 'quando Idio mi presti vita . . .'; Milanesi (1854), II, 368.

36 Pope-Hennessy (1971), 306–7.

37 Torriti (1977), 360–61. The bronze is signed by Vecchietta the painter – 'Opus Laurentii Petri pictoris al Vechietta de Senis. MCCCCLXXVI p[er] sui devotione fecit hoc' – while the altarpiece seems originally to have been signed by Vecchietta the sculptor: 'Opus Laurentii scultoris alias Elvechietta ob suam devotionem'.

38 van Os (1977), 454.

39 Ruhmer (1958), 1.

40 Kristeller (1902), 510–12 doc. 163 and 518–19 doc. 175; Lightbown (1986), 248–50; Pastore ed. (1986), passim.

41 Lightbown (1986), 131–2. Mantegna's son Ludovico ended a letter to Isabella d'Este written on 12 November 1507 as follows: 'conclude che gli si solleciti lo sborso [di 100 ducati], dovendo collocare nella cappella il busto in bronzo di [suo] padre'. This suggests that by the time of his death Mantegna intended that the bust should form part of his tomb-monument. See also Signorini, in Pastore ed. (1986), 23–42.

42 Chambers and Martineau eds (1981), 121–2 cat. 30; Martineau ed. (1992), 90 cat. 1.

43 Pliny, 35, 71; Pliny/Rackham (1952), 314–15.

44 '. . . sepultus est humi in phano divi Andreae, ubi aeneum capitis eius simulacrum visitur, quod suis sibi conflaverat manibus'; Chambers and Martineau eds (1981), 121.

45 According to the eighteenth-century Mantuan chronicler Amadei; Lightbown (1986), 455–6 cat. 62; Martineau ed. (1992), 90 cat. 1.

46 'Esse parem / hunc noris / si non prepo / nis apelli / aenea Ma[n]tiniae / qui simulacra / vides'; Martineau ed. (1992), 90 cat. 1.

47 It is dated 'MDXVI M[ensis] OC[tobris] die XX', or 20 October 1516; and the decoration is also dated 1516, below the canvas of *Judith and Holofernes*.

48 Lightbown (1986), 248–50; Martineau ed. (1992), 253–4 cat. 64.

49 Golzio (1936), 120; Jones and Penny (1983), 246.

50 'Detto Raphaello honoratissimamente e stato sepolto a la Rothonda ove lui ha ordinato chel se glie fazi a sua memoria una sepoltura da mille ducati et altri ha lassato per dottare la capella ove sarà della sepolta'; Golzio (1936), 114ff.; Buddensieg (1968).

51 Vasari/Bull (1965–87), I, 320.

52 Vasari/Bull (1965–87), I, 284.

53 'RAPHAELI SANCTIO IOAN F URBINAT PICTORI EMINENTISS VETERVMQ AEMULO CVIVS SPIRANTEIS PROPE IMAGINEIS SI CONTEMPLERE NATVRAE ATQVE ARTIS FOEDVS FACILE INSPEXERIS IVLII II ET LEONIS X PONTT MAXX PICTVRAE ET ARCHITECT OPERIBVS GLORIAM AVXIT VIXIT AV XXXVII INTEGER INTEGROS QVO DIE NATVS EST EO ESSE DESIIT VIII ID APRIL MDXX. ILLE HIC EST RAPHAEL TIMVIT QVO SOSPITE VINCI RERVM MAGNA PARENS ET MORIENTE MORI; Vasari/Bull (1965–87), I, 323.

Chapter 5

1 Weiss (1969), x.

2 Willemsen (1953), passim.

3 Ames-Lewis (1997), passim.

4 Ghiberti/Morisani (1947), 56.

5 Weiss (1969), 22–4 and pl. 5; the manuscript is Biblioteca Apostolica Vaticana, MS Chigi I.VII.259.

6 Schmitt (1974), 206–9, pls 67, 70–71, 73 and 75, illustrates a mid-fourteeth-century copy of Suetonius (Fermo, Biblioteca Communale, MS 81). Another example is a much-damaged manuscript illuminated perhaps by Pisanello and others in the years 1450–55 (Turin, Biblioteca Nazionale, MS E.III.19), for which see Cavallaro and Parlato eds (1988) 76–8 cat. 14, and Cordellier ed. (1996), 138–40 cat. 75.

7 Mellini (1965), 25–32 and figs 1–15.

8 Rubinstein (1958), especially 189–206.

9 Mommsen (1952), especially 107–13.

10 Weiss (1969), 171–2; Salmi (1957); Cordellier ed. (1996), 136 cat. 73.

11 Cordellier ed. (1996), 126–7 cat. 70.

12 Fittscher (1985); Cavallaro and Parlato eds (1988), 74 fig. 21.

13 Spencer (1979); Cavallaro and Parlato eds (1988), 80–82, cats 16–19; Parlato (1988).

14 Hill (1911); Weiss (1969), 173–4; Cavallaro and Parlato eds (1988), 84, cat. 21; on Cristoforo di Geremia, see Scher ed. (1994), 119–20; on Boldù see also Scher ed. (1994), 102–3, and Fortini Brown (1996), 232–4 and pls 256–7.

15 Paris fol. 44; see Degenhart and Schmitt (1984), pl. 52.

16 For example, Paris, fol. 93v (Degenhart and Schmitt (1984), pl. 115) and London, rectos of fols 61–5.

17 Paris, fols 44 and 45; see Degenhart and Schmitt (1984), pls 52–3; Fortini Brown (1992).

18 Fortini Brown (1996), 122–3 and pls 127, 129–31.

19 For example, Degenhart and Schmitt (1984), pls 4, 25, 31, 40, 48 and 118.

20 Degenhart and Schmitt (1960); Cavallaro (1988). For the Quaratesi Altarpiece, see Christiansen (1982), 43–7 and 102–5.

21 Berlin, Kupferstichkabinett 1359 and Milan, Ambrosiana 214 inf fol. 10v: Cavallaro and Parlato eds (1988), 215 cat. 63 and 211–2 cat. 61 respectively.

22 Cole Ahl (1996), 6 and pl. 1; Nesselrath (1988), 197 and fig. 61.

23 Ames-Lewis (1995).

24 Cavallaro and Parlato eds (1988), 237 cat. 83 and tav. VIII.

25 Pasti (1988).

26 Ames-Lewis (1981), 94, pl. 72; Cavallaro and Parlato eds (1988), 137, fig. 38.

27 Cavallaro and Parlato eds (1988), 235–6 cat. 82.

28 Cavallaro and Parlato eds (1988), 232–3 cat. 80.

29 For the Chatsworth drawings, see Cavallaro and Parlato eds (1988), 187–9 cat. 58, and for Milan, Ambrosiana F. 265 inf 91, by the Ambrosiana Master, ibid., 155–6 cat. 49.

30 Ambrosiana F. 265 inf 91 verso; Bober (1957), fig. 45; Bober and Rubinstein (1986), 64–5 no. 21; and see above, chapter 3, p. 84.

31 'uno libro di disegnij dj roma, in papiro'; Ames-Lewis (1984), 376 item 152.

32 Weiss (1969), 68–70.

33 Fortini Brown (1996), 121.

34 '. . . certe sculture antiche, le quale la più parte sono battaglie di centauri, di fauni et di satiri, così ancora d'uomini et di femmine accavallo et appié, et altre cose simili . . .'; Brown (1973).

35 Martineau ed. (1992), 445–8 cat. 145.

36 Greenstein (1992), 66–70.

37 Knabenshue (1959); Lightbown (1986), 41–2.

38 Lightbown (1986), 100 and 416; Elam (1981), 18.

39 Radcliffe (1981), 46.

40 Martindale (1979), passim; Lightbown (1986), 140–53, 424–33; Hope (1992); for good recent illustrations, see Martineau ed. (1992), 357–72 cats 108–15.

41 Kristeller (1902), doc. 149 on p. 564.

42 Kristeller (1902), 523–4; Gilbert (1980), 179–81; doubt has recently been cast on whether this event in fact took place (Billanovich (1989)), but even as fiction Feliciano's account is suggestive of an archaeologically motivated approach to the past with which Mantegna sympathised.

43 Dacos (1969), passim.

44 Dacos (1962).

45 Govi (1876), 49ff.; translation in Gilbert (1980), 102–3.

46 Falb (1902), fols 39r and v, 40, 43, for example; Hülsen (1910), fol. 11v.

47 Egger (1905–6), fols 6, 10r and v, 12v, 14r and v, 15, 32, 34v, 58 and 60, for example; also Nesselrath (1996).

48 Shoemaker (1997); Nelson (1991), 44–6.

49 Schulz (1962).

50 Dacos (1969), 63 and fig. 80.

51 Vasari/Bull (1965–87), II, 83.

52 Chambers (1970), 25–9, doc. 15.

53 Redig de Campos (1983), especially 231 fig. 10.

54 Bober and Rubinstein (1986), 152–5.

55 Shearman (1977), 136–7; in general Winner (1974).

56 Radcliffe (1981); Allison (1993–4).

57 Radcliffe (1981), 46; Chambers and Martineau eds (1981), 134–6 cats 53–4.

58 'D[omina]/ISABEL/LA/M[antua]E/MAR[chionissa]'; Chambers and Martineau eds (1981), 136, and cf. Radcliffe (1981), 47–9.

59 'Dilettosi anco di contraffare i conii delle medaglie antiche . . .' Vasari/Bettarini and Barocchi (1971–93), III, 77; translation in Vasari/Bull (1965–87), I, 106.

60 For this episode, see recently Hirst and Dunkerton eds (1994), 20–23.

61 '...chi lo tene antiquo e chi moderno; qualunque se sia è tenuto et è perfectissimo'; Hirst and Dunkerton eds (1994), 73 n. 26.

62 Luchs (1995), 27.

63 Luchs (1995), 26–7, 108.

64 Luchs (1995), 108 and 175 n. 18; see the differing views of Fittschen and Paul, in Settis ed. (1985), 381–412 and 413–39 at 429 respectively.

65 Radcliffe (1981), 48; Chambers and Martineau eds (1981), 170–71 cat. 123.

66 Vasari/Bull (1965–87), I, 180.

67 Chambers (1970), 104–6; Seymour (1971), 174–5; Vasari/Bull (1965–87), I, 180; for the attribution to Mino, see Caglioti (1993) and (1994); and further, Rubinstein (1998), 85–8.

68 Brown (1969); Fortini Brown (1996), 118.

69 Luchs (1995), 26; Pincus (1979); Fortini Brown (1996), 247.

70 Bartsch, XIII, 100 no. 41; Bober and Rubinstein (1986), 167 no. 132; Ladendorf (1953), 51ff. and pls 19–24, illustrating engravings also by Marcantonio Raimondi and Cristoforo Robetta.

71 Bober and Rubinstein (1986), 51, no. 1, citing Govi (1876); Egger (1905–6), 135–9 (fol. 56); Schweickhart (1986), 109–11 fig. 30 (Codex Wolfegg fol. 46v).

72 Bartsch, XIII.15 and XIV.353 respectively.

73 Bober and Rubinstein (1986), 152–5, no. 122.

74 Nesselrath (1986); Jones and Penny (1983), 199–202.

75 Jones and Penny (1983), 203 pl. 219.

Chapter 6

1 Kemp and Walker (1989), 19.

2 Land (1994), 30

3 Castiglione/Bull (1967), 97–8.

4 Alberti/Grayson (1972), 61, para. 26.

5 Baxandall (1971), 104.

6 Ghiberti/Morisani (1947) 3 [my translation].

7 Alberti/Grayson (1972), 65, para. 27

8 Alberti/Grayson (1972), 101, para. 58.

9 Gilbert (1980), 88.

10 Chambers (1970), 47–8; Krautheimer and Krautheimer-Hess (1956), 169–73 and 372–3 document 52.

11 Gilbert (1980), 86.

12 Alberti/Grayson (1972), 55, para. 19.

13 Kemp and Walker (1989), 42.

14 Kemp and Walker (1989), 42.

15 Gilbert (1980), 89–90; Spencer (1965), I, 309 (book 23, fol. 181r).

16 Kemp and Walker (1989), 38.

17 Kemp and Walker (1989), 44–5.

18 Kemp and Walker (1989), 40.

19 Kemp and Walker (1989), 39–40.

20 Castiglione/Bull (1967), 98.

21 Posner (1974), 11–15.

22 Castiglione/Bull (1967), 98.

23 Lomazzo/Klein (1974), 51

24 Castiglione/Bull (1967), 99.

25 Vasari/Bull (1965–87), I, 25.

26 '...la pictura e cosa caduca et instabele, la scolture e molto piu senza comparatione, et non da paragonarsi con pictura per niun modo: perche degli anticui se ritrova fina alli nostri tempi delle sue scolture, et picture veramente nulla si poi vedere'; Luchs (1995), 157 n. 94; Puppi (1972).

27 Castiglione/Bull (1967), 97.

28 Greenstein (1992), 89–92; Jones (1987); Lightbown (1986), colour pl.VI.

29 Martineau ed. (1992), 394–9, and 411–12 cats. 133–4.

30 Alberti/Grayson (1972), 89, para. 46.

31 Vasari/Bull (1965–87), I, 242.

32 '...ha ancor cum dolci e grati/Modi il rilievo per che alla scultura/Mostrar quanto idea el cielo e i dolci fati...'; for translation, see Gilbert (1980), 97.

33 Martineau ed. (1992), 412–16, cat. 135.

34 Martineau and Hope eds (1983), 363 cat. S 7.

35 Avery (1997), 224–7.

36 Vasari/Bull (1965–87), I, 275–6.

37 Klein and Zerner (1966), 16; also Luchs (1995), 75.

38 Baxandall (1971), 103–9.

Chapter 7

1 Dante, *Purgatorio* XI, 91–8; Dante/Sinclair (1939), 147.

2 'pictoribus atque poetis quidlibet audendi semper fuit aequas potestas'; Horace, *Ars poetica*, 1–10; Land (1994), 4.

3 Tatarkiewicz (1970), 177.

4 Petrarch, *Triumph of Fame*, III, 15; Land (1994), 5.

5 Baxandall (1971), 71; Warnke (1993), 41–3.

6 Baxandall (1971), 71.

7 Cennini/Thompson (1933), 1–2.
8 Baxandall (1971), 117.
9 Baxandall (1971), 103.
10 'ingegno prope poetico'; Baxandall (1971), 107 and 166.
11 Baxandall (1971), 92.
12 Warnke (1993), 87.
13 Alberti/Grayson (1972), 95, para. 53.
14 Alberti/Grayson (1972), 97, para. 54.
15 Westfall (1969).
16 Warnke (1993), 56.
17 Milanesi (1854–6), III, 33; Warnke (1993), 64.
18 Alberti/Grayson (1972), 97, para. 53.
19 Kemp and Walker (1989), 20.
20 Kemp and Walker (1989), 23.
21 Kemp and Walker (1989), 28.
22 PICTURAS ATQUE POETIS SEMPER FUIT ET ERIT EQUA POTESTAS; Ames-Lewis (1995), 401; Land (1994), 111.
23 Baxandall (1971), 93; Gilbert (1980), 173–4.
24 Gilbert (1980), 174.
25 Gilbert (1980), 187–8.
26 The manuscript is Biblioteca Apostolica Vaticana, Ottob. Lat. 1305.
27 Bek (1969).
28 Gilbert (1980), 97.
29 Manetti/Saalman (1970), 108; Battisti (1976), 323–8.
30 Beltrami (1884), passim.
31 By Gilbert (1980), 102 and Weiss (1969), 84 respectively; Govi (1876); above, chapter 5, pp. 128–9.
32 Hutchison (1990), 120, and ibid., 55, on Dürer's authorship of 'quite a large quantity of truly dreadful poetry'.
33 Saslow (1991), 70–72 no. 5, with small variations in the translation; de Tolnay (1975–80), I, 126 no. 174r.
34 Kemp and Walker (1989), 33.
35 Lightbown (1978), I, 70–81 and II, 51–3 cat. B.39; Dempsey (1992), passim and colour pls 1–16.
36 'la poesia per la inventione de la hopera'; Hope (1994), 55.
37 Chambers (1970), 135–8; see chapter 9, below.
38 Chambers (1970), 130; Land (1994), 106.
39 Fermor (1993), 81–6 and illus. 28–9.
40 Holberton (1987).
41 Humfrey (1983), 54–60; cat. 120 and pl. 138.
42 Hirst (1981), 37–9 and pl. 45.
43 Vasari/Bull (1965–87), I, 274–5.

44 Chambers (1970), 149–50.
45 Settis (1990), passim; Holberton (1995).

Chapter 8

1 Vasari/Bull (1965–87), I, 255.
2 Cennini/Thompson (1933), 1; Summers (1981), 190–91.
3 'and among his other daring feats Zeuxis painted a female centaur . . .'; Holberton (1995), 393.
4 Baxandall (1971), 71; Land (1994), 6–10.
5 'quegli che piu trasse ogni figura e atti al naturale'; Frisch (1971), 75.
6 Boccaccio/Waldman (1993), 394; also Land (1994), 6.
7 *Genealogia deorum* XIV, 17.
8 Cennini/Thompson (1933), 15.
9 'optimo imitatore di natura'; Baxandall (1972), 118–19; Gilbert (1980), 191.
10 Kemp and Walker (1989), 193.
11 Kemp and Walker (1989), 193.
12 Kemp and Walker (1989), 193–4.
13 Kemp and Walker (1989), 9.
14 Pope-Hennessy (1986), 177–8. The first of these lengthy inscriptions includes self-laudatory clauses such as 'Giovanni . . . is endowed above all others with command of the pure art of sculpture', 'to Giovanni remain the honours of praise', and 'Christ have mercy on the man to whom such gifts were given'; Ames-Lewis (1997), 81–4.
15 Wesselski (1929), 27–8; Janson (1981), 357–60.
16 Gilbert (1980), 84: Ghiberti executed his first pair of bronze doors 'with great diligence'; ibid., 86: the *St Stephen* for the Arte della Lana '. . . was made with the greatest diligence, according to the rule with my works'.
17 'invenzione di qualità', 'tutto al modo antico'; Manetti/Saalman (1970), 103.
18 Alberti/Grayson (1972), 105, para. 62.
19 Prager (1968).
20 Francesco di Giorgio Martini/Maltese (1967), I, 4.
21 Baxandall (1971), 103.
22 Baxandall (1971), 158.
23 Kemp (1977), 358.
24 Alberti/Grayson (1972), 95 para 53.
25 Filarete/Spencer (1965), I, 315 (book 24, fol. 184v).
26 '. . . in lettere ancora s'ingegnava d'intendere, e di nuove fantasie e di varie moralità e virtù invistigare'; Filarete/Spencer (1965), I, 199 (book 15, fol. 114r).

27 Gilbert (1980), 141; Cole (1995), 34.
28 Chambers (1970), 134.
29 Chambers (1970), 136–7; Land (1994), 103.
30 Chambers (1970), 140.
31 Chambers (1970), 137.
32 Chambers (1970), 125–33; Land (1994), 102–10.
33 Chambers (1970), 126.
34 Chambers (1970), 127.
35 Chambers (1970), 127.
36 'una bela fantasia cercha al quadro'; Land (1994), 104.
37 Holberton (1987), 62.
38 Chambers (1970), 128.
39 Chambers (1970), 128–9; Land (1994), 106.
40 Chambers (1970), 129.
41 Chambers (1970), 130; Land (1994), 106.
42 Land (1994), 106.
43 Chambers (1970), 131–2.
44 Land (1994), 107.
45 Chambers (1970), 144.
46 Chambers (1970), 147–8.
47 Filarete/Spencer (1965), I, 245 (book 18, fol. 142v).
48 Warnke (1993), 44.
49 Alberti/Grayson (1972), 99, para. 56; his sources were Cicero, *De inventione*, II, I, 1–3 and Pliny, 35, 64.
50 Klein and Zerner (1966), 33.

Chapter 9

1 Hayum (1966); Jones and Penny (1983), 179–80.
2 Castiglione/Bull (1967), 100.
3 Land (1994), 27–48.
4 Pliny, *Natural History*, 35, 65–6; Pliny/Rackham (1952), 308–11.
5 Alberti/Grayson (1972), 99, para. 55.
6 Gilbert (1980), 187.
7 Gilbert (1980), 90; this in turn may echo, or may deliberately recreate, a topos in an *ekphrasis* in Philostratus' *Imagines* (1.23) on a painting of *Narcissus* that 'shows such regard for realism that it even shows drops of dew dripping from the flowers and a bee settling on the flowers – whether a real bee has been deceived by the painted flower or whether we are to be deceived into thinking a painted bee is real, I do not know . . .'; Land (1994), 30.
8 Martineau ed. (1992), 428–30 cat. 136; Janson (1961).
9 Dante, *Purgatorio* X, 28–96; Dante/Sinclair (1939), 130–37.
10 Boccaccio, *Amorosa visione*, cantos IV–XXXVII; Land (1994), 61–4.
11 Alberti/Grayson (1972), 78, para. 42, and 73, para. 37, respectively.
12 'e quanto l'arte intra sé non comprende, / la mente imaginando chiaro intende . . .'; A. Poliziano, *Stanze cominciate per la giostra del magnifico Giuliano de' Medici*, I, 97–119, at 119; in Poliziano (1968), 65–73 (*Stanze* I, 97–119); Land (1994), 66.
13 A. Poliziano, *Stanze cominciate per la giostra del magnifico Giuliano de' Medici*, I, 100–03, in Poliziano (1968), 65–7; Land (1994), 65.
14 Redig de Campos (1983), 231 and fig. 10.
15 Heckscher (1956); Hope (1994), 56.
16 Lightbown (1978), I, 122–6 and II, 87–92.
17 Holberton (1995), 393 and 402 n. 65; Marek (1985), 9.
18 Mantegna perhaps saw his drawing as 'an annotated copy of a scene found on a sculptural high relief'; it is '. . . a quintessentially archaeological operation of reconstructing a lost pictorial invention'; Greenstein (1992), 63–5.
19 Schulz (1962); Dacos (1969), passim.
20 Jones and Penny (1983), 93–100.
21 Land (1994), 27–36.
22 Philostratus I, 2; Lightbown (1986), 443–4.
23 Land (1994), 123.
24 Holberton (1987), 61.
25 Ovid, *Fasti*, I, 393–4; Holberton (1987), 62.
26 Brown (1993).
27 The text for the *Worship of Venus* was Philostratus the Elder, *Imagines* I, 6, in the Demetrius Moscus translation of 1508; Marek (1985), App. II, 135.
28 *Imagines* XV; Marek (1985), App. II, 123.
29 *Imagines* I, 25; see Marek (1985), App. II, 135–6.
30 Hope (1994), 55–6; Holberton (1987), 59–60.
31 Pliny, *Natural History* 35, 96; Pliny/Rackham (1952), 332–3; Settis (1990), 64; Holberton (1995), 398.
32 Warnke (1993), 40.
33 Kristeller (1902), 486–7, doc. 52; Elam (1981), 15.
34 Petrarch, Sonnets 68 and 77 respectively; Land (1994), 81–2.
35 Meyer (1897–1900), I, 63; and Gilbert (1980), 174 respectively.
36 Brenzoni (1952), 60; Gilbert (1980), 173.
37 Gilbert (1980), 190.
38 Gilbert (1980), 179.
39 Hutchison (1990), 68.
40 Gilbert (1980), 192–3; Horne (1908), 306.

Chapter 10

1 Alberti/Grayson (1972), 61, para. 25.
2 Recent discussion in Schweikhart (1993) and Woods-Marsden (1998).
3 Campbell (1990), 14.
4 Gilbert (1980), 159; Kemp (1976); Zöllner (1992).
5 Kemp and Walker (1989), 204.
6 Kemp (1985).
7 Vasari/Gaunt (1963), I, 134.
8 Murray (1959), 85, 66 and 125 respectively.
9 Hope (1985).
10 Baxandall (1971), 71.
11 Pignatti (1971), 158.
12 Petrarch, Sonnets 68 and 77; see Frisch (1971), 89–90.
13 Ghiberti, *Commentarii*; see Gilbert (1980), 79.
14 Schweikhart (1993), 13.
15 Symeonides (1965), 90–91, 210–11, and frontispiece; Ladner (1983).
16 Vasari/Bull (1965–87), I, 81; and above, chapter 4, p. 92; Barolsky (1995).
17 O'Malley (1998).
18 van Os (1977).
19 PETRUS PERUSINUS EGREGIUS PICTOR PERDITA SI FUERAT PINGENDI HIC RETTULIT ARTEM. SI NUSQUAM INVENTA EST, HAC TENUS IPSE DEDIT.; Scarpellini (1984), 98.
20 Lehrs (1908–34), IX, 1; Landau and Parshall (1994), 57.
21 Dated 1496; Campbell (1990), 55.
22 Dürer the younger's drawing was later inscribed by him: 'I drew this myself from a mirror in the year 1484, when I was still a child. Albrecht Dürer'; Hutchison (1990), 24.
23 'My sach die gat / Als es oben schtat'; Hutchison (1990), 39.
24 DI LA IL BEL VISO: E QUI IL TVO SERVO MIRA; Scher ed. (1994), 121.
25 For the inscription, see chapter 4, p. 90.
26 ELOQUII SACRI DOCTOR PARISINUS ET INGENS / GEMIGNANIACI FAMA DECUSQUE SOLI / HOC PROPRIO SUMPTU DOMINICUS ILLE SACELLUM / INSIGNEM IUSSIT PINGERE BENOTIUM. M..CCCC..LXV; Cole Ahl (1996), 124–6, 140, 260, and pl. 150.
27 Hatfield (1976), 31–2 and 100; Lightbown (1978), I, 46.
28 Schwarz (1992); Warnke (1993), 111.
29 Filarete/Spencer (1965), I, 191 (book 14, fol. 109v).
30 The manuscript is Biblioteca Apostolica Vaticara; Cod. Urb. Lat. 508; Weller (1943), 192–3.
31 Ladner (1983), 79.
32 Cole (1995), 37, fig. 27; Signorini (1976).
33 ILL. LODOVICO II M. M. / PRINCIPI OPTIMO AC / FIDE INVICTISSIMO / ET ILL. BARBARAE EIUS / CONIVGI MVLIERVM GLOR. / INCOM-·PARABILI / SVVS ANDREAS MANTINIA / PATAVVS OPVS HOC TENVE / AD EORV DECVS ABSOLVIT / AN[N]O MCCCCLXXIIII.; Lightbown (1986), 415 cat. 20; Elam (1981), 18.
34 Chambers and Martineau eds (1981), 121–2 cat. 30; Martineau ed. (1992), 90 cat. 1.
35 Chambers and Martineau eds (1981), 117 cat. 28.
36 Cavallaro and Parlato eds (1988), 133–4 cat. 42; Schweikhart (1993), 21.
37 UT SOL AUGET APES SIC NOBIS COMMODA PRINCEPS; Warnke (1993), 55 and n. 209.
38 Compare Filarete's statement that the bee 'signifies intelligence. This is a noble and just animal and has great symbolic value'; Filarete/Spencer (1965), I, 235 (book 17, fol. 136r).
39 Rumpf (1964).
40 ANTNIUS. PETRI. DE. FLORENTIA.FECIT. MCCCCXLV (obverse) and OPV/S/ANTO/NII (reverse); Spencer (1979); Cavallaro and Parlato eds (1988), 134 cat. 42a.
41 LAURENTIUS CIONIS DE GHIBERTIS MIRA ARTE FABRICATUM; Vasari/Bull (1965–87), I, 122.
42 Cole (1995), 63–5 and fig. 47; Welch (1997), 231.
43 Filarete/Spencer (1965), I, 41 (book 4, fol. 23r); Eisler (1972).
44 Scher ed. (1994), 102–3; Sheard ed. (1978), cat. 80. The Greek inscription is given in chapter 2, p. 22.
45 Warnke (1993), 87; cited in chapter 7, p. 165.
46 Simons (1987).
47 Kemp and Walker (1989), 20–21.
48 'Das malt ich nach meiner gestalt / Ich war sex und zwenzig Jor alt / Albrecht Dürer'; Hutchison (1990), 65–6.
49 Koerner (1993), 171.
50 'Albertus Durerus Noricus / ipsum me pro-prijs sic effin / gebam coloribus aetatis / anno XXVIII'; Hutchison (1990), 67–8.
51 Wuttke (1980) 73.
52 Vasari/Bull (1965–87), I, 325.
53 'Do wo der gelb fleck ist vnd mit dem finger drawff dewt do is mir we'; Panofsky (1943), I, 171.

54 Panofsky (1943), I, 110; Kemp in Murray ed. (1989), 32–4 and 40–42; Hutchison (1990), 67–8.
55 Walek (1991); Rogers (1997), 97–8.

Chapter 11

1 Vasari/Bull (1965–87), II, 187–9.
2 Alberti/Grayson (1972), 95 para. 52.
3 Vasari/Bull (1965–87), I, 192.
4 Field (1997), 99–101.
5 Bennett and Wilkins (1984), 140–41.
6 Alberti/Grayson (1972), 67, paras 30–31; Piero della Francesca/Fasola (1942), 63–4.
7 This evidence indicates that the panel was signed 'A.D.F[ecit], ROMAE'; Hutchison (1990), 89.
8 Landau and Parshall (1994), 310–15.
9 Hutchison (1990), 115–18.
10 Alberti/Grayson (1972), 95, para. 53.
11 Landau and Parshall (1994), 73–4
12 Landau and Parshall (1994), 68–70; Landau (1992).
13 Lightbown (1986), chapter XV, 234–41; Boorsch (1992); for the Bacchanal engravings, see Martineau ed. (1992), 279–81 cats 74–5.
14 Ames-Lewis (1986), 4–8.
15 For these prints, see Jones and Penny (1983), 183 pl. 194 and 175 pl. 186 respectively.
16 Petrioli Tofani ed. (1992), 154–5 cat. 7.9.
17 Alberti/Grayson (1972), 59, para.23.
18 Martineau ed. (1992), 451–3 cat. 147.
19 Ames-Lewis (1981), 4, pl. 2.
20 Scheller (1995), 21.
21 Degenhart and Schmitt (1984), pls 4 (fol. 8) and 40 (fol. 35).
22 Frimmel (1888), 98–100; Klein and Zerner (1966), 29–30; Chambers, Pullan and Fletcher (1992), 427; Humfrey (1995), 72 and n. 21.
23 Baxandall (1971), 106–7 and 108–9 respectively.
24 '. . . fece a San Zeno in Verona la tavola dello altar maggiore, de la quale dicono che e'lavorò per mostra una figura bellissima, avando gran voluntà di condurre tal lavoro'; Vasari/Bettarini and Barocchi (1971), III (testo), 552.
25 Lightbown (1986), 78–80 and 408.
26 Lucretius, *De rerum natura* IV, 132ff., 735ff.; see Lightbown (1986), 80.

27 Vasari/Bull (1965–87), I, 231.
28 Vasari/Bull (1965–87), I, 224.
29 Lightbown (1978), II, 47–51 cats 335–8.
30 Hutchison (1990), 68.

Chapter 12

1 Hutchison (1990), 95, letter 10.
2 Kemp and Walker (1989), 39.
3 Castiglione/Bull (1967), 149; see also Posner (1974), 4.
4 Gilbert (1980), 88.
5 Kemp and Walker (1989), 252.
6 Gilbert (1980), 13.
7 Elam (1981), 20 and 22.
8 Vasari/Bull (1965–87), I, 95, and II, 114.
9 Cole (1995), 33–4.
10 Gilbert (1980), 9–10.
11 Chambers (1970), 24–5.
12 Cole (1995), 38; Warnke (1993), 44.
13 Gilbert (1980), 148.
14 Weiss (1969), 171–2; Warnke (1993), 100.
15 Warnke (1993), 79–80.
16 Cennini/Thompson (1933), 14–15.
17 Gilbert (1980), 32.
18 Baxandall (1972), 122–3, 147–50 and 128–33 respectively.
19 Gilbert (1980), 139; Chambers (1970), 152–3.
20 Ames-Lewis (1981), 104.
21 Cole (1995), 168.
22 Chambers (1970), 147; Land (1994), 116.
23 Cole (1995), 51.
24 Nicolini (1923), 125.
25 Perosa (1980), I, 23–4.
26 Pius II/Gragg and Gabel (1959), 287.
27 Chambers (1970), 126–7.
28 Chambers (1970), 143.
29 Land (1994), 112.
30 Gilbert (1980), 218.
31 Vasari/Bull (1965–87), II, 114 and 107.
32 Cole (1995), 42.
33 '. . . lui essere bravo giovane, et nel mestieri suo l'unico in Italia, forse etiam in universo . . . lui è di modo che colle buone parole et colla carezza, se li fanno, farà ogni cosa; bisogna mostrargli amore, e farli favore . . .'; Warnke (1993), 251.
34 Chambers (1970), 140.
35 Chambers (1970), 141–2.
36 Chambers (1970), 145.
37 Chambers (1970), 149–50.

Bibliography

Akker, P. van den, *Sporen van Vaardigheid*, Abcoude, 1991

Alberti, L. B., *Leon Battista Alberti On painting and On Sculpture*, ed. and trans. C. Grayson, London, 1972

Albertini, F. degli, *Memoriale di molte statue et picture* ... (1510), in ed. Murray (1972), [unpaginated]

Allison, A. H., 'The Bronzes of Pier Jacopo Alari Bonacolsi, called Antico', *Jahrbuch der Kunsthistorisches Sammlungen in Wien*, LXXXIX–XC (1993–4), 35–310

Ames-Lewis, F., *Drawing in Early Renaissance Italy*, New Haven and London, 1981

Ames-Lewis, F., *The Library and Manuscripts of Piero di Cosimo de' Medici*, New York, 1984

Ames-Lewis, F., *The Draftsman Raphael*, New Haven and London, 1986

Ames-Lewis, F., ed., *Nine Lectures on Leonardo da Vinci*, London, n.d. [1991]

Ames-Lewis, F., ed., *New Interpretations of Venetian Renaissance Painting*, London, 1994

Ames-Lewis, F., 'Benozzo Gozzoli's Rotterdam Sketchbook Revisited', *Master Drawings*, XXXIII (1995), 388–404

Ames-Lewis, F., *Tuscan Marble Carving 1250–1350. Sculpture and Civic Pride*, Aldershot, 1997

Ames-Lewis, F. and M. Rogers, eds, *Concepts of Beauty in Renaissance Art*, Aldershot, 1997

d'Arco, C., *Delle arti e degli artefici di Mantova*, 2 vols, Mantua, 1857

Armstrong, L. A., 'Copies of Pollaiuolo's Battling Nudes', *Art Quarterly*, XXXI (1968), 155–67

Avery, C., ' "*La cera sempre aspetta*". Wax Sketch-Models for Sculpture', *Apollo*, CXIX (1984), 166–76

Avery, C., *Bernini. Genius of the Baroque*, London, 1997

Banker, J. R., 'Piero della Francesca's Friend and Translator. Maestro Matteo di ser Paolo d'Anghiari', *Rivista d'Arte*, VIII (1992), 331–40

Barocchi, P., ed., *Il Giardino di San Marco. Maestri e compagni del giovane Michelangelo*, exh. cat. (Florence, Casa Buonarroti), Florence, 1992

Barolsky, P., 'The Artist's Hand', in Ladis and Wood eds (1995), 5–24

Bartrum, G., ed., *German Renaissance Prints*, exh. cat. (London, British Museum), London, 1995

Bartsch, A., *The Illustrated Bartsch*, 164 vols, University Park, PA, and New York, 1971

Battisti, E., *Filippo Brunelleschi*, Milan, 1976

Baxandall, M., *Giotto and the Orators*, Oxford, 1971

Baxandall, M., *Painting and Experience in Fifteenth-Century Italy*, Oxford, 1972

Baxandall, M., *Patterns of Intention. On the Historical Explanation of Pictures*, New Haven and London, 1985

Bek, L., 'Giovanni Santi's "Disputa de la Pictura" – A Polemical Treatise', *Analecta Romana Instituta Danici*, V (1969), 75–102

Beltrami, L., *Documenti e memorie riguardanti le vita e le opere di Leonardo da Vinci*, Milan, 1919

Bennett, B. and D. Wilkins, *Donatello*, Oxford, 1984

Bianconi, P., *Tutta la pittura di Cosmè Tura*, Milan, 1953

Billanovich, M., 'Intorno alla "Iubilatio" di Felice Feliciano', *Italia Medioevale e Umanistica*, XXXII (1989), 351–8

Bober, P. P., *Drawings After the Antique by Amico Aspertini. Sketchbooks in the British Museum*, London, 1957

Bober, P. P. and R. Rubinstein, *Renaissance Artists and Antique Sculpture*, London, 1986

Boccaccio, G., *Decamerone*, trans. G. Waldman, Oxford, 1993

Boorsch, S., 'Mantegna and His Printmakers', in Martineau ed. (1992), 56–66

Brenzoni, R., *Pisanello pittore*, Florence, 1952

Brown, C. M., '"Una testa di Platone antica con la punta dil naso di cera". Unpublished Negotiations between Isabella d'Este and Niccolò and Giovanni Bellini', *Art Bulletin*, LI (1969), 372–7

Brown, C. M., 'Gleanings from the Gonzaga Documents in Mantua – Giancristoforo Romano and Andrea Mantegna', *Mitteilungen des Kunsthistorischen Institutes in Florenz*, XVII (1973), 158–9

Brown, C. M., 'Isabella d'Este's Collection of Antiquities', in Clough ed. (1976), 324–52

Brown, C. M., 'The Art and Antiquities Collections of Isabella d'Este Gonzaga', in Lawrence ed. (1997), 53–71

Brown, D. A., 'The *Pentimenti* in *The Feast of the Gods*', in Manca ed. (1993), 289–300

Buddensieg, T., 'Raphaels Grab', in Buddensieg and Winner eds (1968), 45–70

Buddensieg, T. and M. Winner, eds, *Munuscula disciplinorum. Kunsthistorische Studien, Hans Kauffmann zum 70. Geburtstag*, Berlin, 1968

Burke, P., *Tradition and Innovation in Renaissance Italy*, London, 1974

Caglioti, F., 'Due "restauratori" per le antichità dei primi Medici. Mino da Fiesole, Andrea del Verrocchio e il "Marsia" rosso degli Uffizi', *Prospettiva*, LXXII (1993), 17–42 and LXXIII–LXXIV (1994), 74–96

Campagnari, R., 'La Casa del Mantegna', *Civiltà Mantovana*, IX (1975), 44–60

Campbell, L., *Renaissance Portraits*, New Haven and London, 1990

Campori, G., 'I pittori degli Estensi nel secolo XV', *Atti e Memorie della R. Deputazione di Storia Patria per le Province Modenese*, ser. 3, III/2 (1885), 525–604

Carducci, G., ed., *Angelo Poliziano. Le Stanze, L'Orfeo e le Rime*, Bologna, 1912

Carl, D., 'Documenti inediti su Maso Finiguerra e la sua famiglia', *Annali della Scuola Normale Superiore di Pisa*, serie III, XIII (1983), 507–54

Carl, D., 'Das Inventar der Werkstatt von Filippino Lippi aus dem Jahre 1504', *Mitteilungen der Kunsthistorischen Institutes in Florenz*, XXXI (1987), 373–91

Cartwright, J., *Isabella d'Este, Marchioness of Mantua, 1474–1539. A Study of the Renaissance*, 2 vols, London, 1904

Castiglione, B., *The Book of the Courtier*, trans. G. Bull, Harmondsworth, 1967

Cavallaro, A., 'Studio e gusto dell'antico nel Pisanello', in Cavallaro and Parlato eds (1988), 89–92

Cavallaro, A. and E. Parlato, eds, *Da Pisanello alla nascita dei Musei Capitolini. L'Antico a Roma alla vigilia del Rinascimento*, exh. cat. (Rome, Musei Capitolini), Rome, 1988

Cavalli-Björkman, G., ed., *Bacchanals by Titian and Rubens*, Stockholm, 1987

Cendali, L., *Giuliano e Benedetto da Maiano*, San Cassiano, 1922

Cennini, C., *Il libro dell'arte. The Craftsman's Handbook*, ed. and trans. D. V. Thompson, New Haven, 1933

Chambers, D. S., *Patrons and Artists in the Italian Renaissance*, London, 1970

Chambers, D. S. and J. Martineau, eds, *Splendours of the Gonzaga*, exh. cat. (London, Victoria and Albert Museum), London, 1981

Chambers, D. S., B. Pullan and J. Fletcher, *Venice. A Documentary History*, Oxford, 1992

Christiansen, C., 'Dürer's "4 Apostles" and the Dedication as a Form of Renaissance Art Patronage', *Renaissance Quarterly*, XX (1967), 325–34

Christiansen, K., *Gentile da Fabriano*, London, 1982

Clough, C., ed., *Cultural Aspects of the Italian Renaissance. Essays in Honour of Paul Oskar Kristeller*, Manchester, 1976

Cole, A., *Art of the Italian Renaissance Courts*, New York and London, 1995

Cole Ahl, D., *Benozzo Gozzoli*, New Haven and London, 1996

Condivi, A., *Life of Michelangelo Buonarroti* (1553), trans. A. S. Wohl and ed. H. Wohl, Oxford, 1976

Coor, G., *Neroccio de' Landi (1447–1500)*, Princeton, NJ, 1961

Cordellier, D., ed., *Pisanello. Le peinteur de sept vertus*, exh. cat. (Paris, Musée du Louvre), Paris, 1996

Cust, R. H. H., *Giovanni Antonio Bazzi, called Sodoma*, London, 1906

Dacos, N., 'Ghirlandaio et l'antique', *Bulletin de l'Institut historique belge de Rome*, XXXIV (1962), 419–55

Dacos, N., *La Découverte de la Domus Aurea et la formation des grotesques à la Renaissance*, London and Leiden, 1969

Dante Alighieri, *Purgatorio*, trans J. D. Sinclair, Oxford, 1939

Davies, G. S., *Renascence. The Sculptured Tombs of the Fifteenth Century in Rome*, London, 1910

Degenhart, B. and A. Schmitt, 'Gentile da Fabriano und die Anfänge der Antikerstudiums', *Münchner Jahrbuch für Bildenden Kunst*, XI (1960), 59–151

Degenhart, B. and A. Schmitt, *Jacopo Bellini. The Louvre Album of Drawings*, New York, 1984

Dempsey, C., *The Portrayal of Love: Botticelli's* Primavera *and Humanist Culture at the time of Lorenzo the Magnificent*, Princeton, NJ, 1992

Deuchler, F., M. Flury-Lemberg and K. Obarsky, eds, *Von Angesicht zu Angesicht. Porträtstudien. Michael Stettler zum 70. Geburtstag*, Bern, 1983

Dhanens, E., *Hubert and Jan van Eyck*, Antwerp, n.d. [1980]

Duverger, J., 'Jan van Eyck as a Court Painter', *The Connoisseur*, CXCIV (1977), 172–9

Egger, H., *Codex Escurialensis. Ein Skizzenbuch aus der Werkstatt Domenico Ghirlandaios*, 2 vols, Vienna, 1905–6

Eisler, C., *The Genius of Jacopo Bellini*, London, 1989

Eisler, J., 'Remarks on some aspects of Francesco di Giorgio's Trattato', *Acta Historiae Artium*, XVIII (1972), 193–231

Elam, C., 'Mantegna at Mantua', in Chambers and Martineau eds (1981), 15–25

Elam, C., 'Lorenzo de' Medici's Sculpture Garden', *Mitteilungen des Kunsthistorischen Institutes in Florenz*, XXXVI (1992), 41–83

Ettlinger, L., *Antonio and Piero Pollaiuolo*, London, 1971

Evans, M. L., 'Pollaiuolo, Dürer and the Master IAM of Zwolle', *Print Quarterly*, III (1986), 109–16

Falb, R., *Il Taccuino senese di Giuliano da San Gallo*, Siena and Florence, 1902

Fermor, S., *Piero di Cosimo. Fiction, Invention and* Fantasia, London, 1993

Ferrari, D., *Giulio Romano. Repertorio di fonti documentarie*, Rome, 1992

Field, J. V., *The Invention of Infinity. Mathematics and Art in the Renaissance*, Oxford, 1997

Fiocco, G., 'Il museo imaginario di Francesco Squarcione', *Atti e memorie dell'Accademia Patavina di Scienze, Lettere ed Arti*, LXXI (iii) (1958–9), 59–72

Fiocco, G., 'Il mito di Dello Delli', *Festschrift Edoardo Arslan*, 2 vols, Milan, 1966, I, 341–9

Fittscher, K., 'Sul ruolo del ritratto antico nell'arte italiana', in Settis ed. (1985), 381–412

Fletcher, J., 'Isabella d'Este, Patron and Collector', in Chambers and Martineau eds (1981), 51–63

Fortini Brown, P., 'The Antiquarianism of Jacopo Bellini', *Artibus et Historiae*, XXVI (1992), 65–84

Fortini Brown, P., *Venice and Antiquity*, New Haven and London, 1996

Francesco di Giorgio Martini, *Trattati*, ed. C. Maltese, 2 vols, Milan, 1967

Frimmel, T., *Der Anonimo Morelliano (Marcanton Michiels Notizia d'opere del Disegno)*, Vienna, 1888

Frisch, T. G., ed., *Gothic Art 1140–c.1450. Sources and Documents*, Englewood Cliffs, NJ, 1971

Frommel, C. L. and M. Winner, eds, *Raffaello a Roma. Il convegno del 1983*, Rome, 1986

Fusco, L., 'The Use of Sculptural Models by Painters in Fifteenth-Century Italy', *Art Bulletin*, LXIV (1982), 175–94

Garfagnini, G., ed., *Giorgio Vasari. Tra decorazione ambientale e storiografia artistica*, Florence, 1985

Gaurico, P., *De sculptura*, trans. and eds A. Chastel and R. Klein, Geneva, 1969

Gerstenberg, K., *Die deutschen Bauermeisterbildnisse des Mittelalters*, Berlin, 1966

Ghiberti, L., *Commentari*, ed. O. Morisani, Naples, 1947

Gilbert, C., ed., *Italian Art 1400–1500. Sources and Documents*, Englewood Cliffs, NJ, 1980

Giovannino de' Grassi. Taccuino di disegni: codice della Biblioteca Civica di Bergamo, Monumenta Bergomensia, 5, Milan, 1961

Goffen, R., *Giovanni Bellini*, New Haven and London, 1989

Goldner, G. and C. Bambach, eds, *The Drawings of Filippino Lippi and His Circle*, exh. cat. (New York, Metropolitan Museum of Art), New York, 1997

Golzio, V., *Raffaello nei documenti*, Vatican City, 1936

Gordon, P. W. G., ed. and trans., *Two Renaissance Book Hunters. The Letters of Poggius Bracciolini to Nicolaus de Niccolis*, New York, 1974

Govi, G., 'Intorno a un opuscolo rarissimo della fine del secolo XV intitolato *Antiquarie Prospettiche Romane* composte per Prospettivo Milanese Dipintore', *Atti della R. Accademia dei Lincei*, ser. II, III (1876), 39–66

Greenstein, J. M., *Mantegna and Painting as Historical Narrative*, Chicago and London, 1992

Grendler, P., 'What Piero Learned in School: Fifteenth-Century Vernacular Education', in Lavin ed. (1995), 161–74

Gundersheimer, W., 'The Patronage of Ercole I d'Este', *Journal of Medieval and Renaissance Studies*, VI (1976), 1–19

Hatfield, R., *Botticelli's Uffizi 'Adoration'. A Study in Pictorial Content*, Princeton, NJ, 1976

Hayum, A. M., 'A New Dating for Sodoma's Frescoes in the Villa Farnesina', *Art Bulletin*, XLVIII (1966), 215–17

Heckscher, W. S. 'The Anadyomene in the Medieval Tradition', *Netherlands Yearbook of Art History*, VII (1956), 1–39

Hill, G. F., 'Sodoma's Collection of Antiques', *Journal of Hellenic Studies*, XXVI (1906), 288–9

Hill, G.F., 'Classical Influence on the Italian Medal', *Burlington Magazine*, XVIII (1911), 259–68

Hind, A. M., *Early Italian Engraving*, 7 vols, London, 1938–48

Hirst, M., *Michelangelo and His Drawings*, New Haven and London, 1988

Hirst, M., *Sebastiano del Piombo*, Oxford, 1981

Hirst, M. and J. Dunkerton, eds, *The Young Michelangelo*, exh. cat. (London, National Gallery), London, 1994

Holberton, P., 'The Choice of Texts for the Camerino Pictures', in Cavalli-Björkman ed. (1987), 57–66

Holberton, P., 'Giorgione's *Tempest* or "Little Landscape with the Storm with the Gypsy". More on the Gypsy, and a Reassessment', *Art History*, XVIII (1995), 383–403

Hope, C., 'Historical Portraits in the "Lives" and in the Frescoes of Giorgio Vasari', in Garfagnini ed. (1985), 321–38

Hope, C., 'The Triumphs of Caesar' in Martineau ed. (1992), 350–56

Hope, C., 'Classical Antiquity in Venetian Renaissance Subject-Matter' in Ames-Lewis ed. (1994), 51–62

Horne, H. P., *Alessandro Filipepi, Commonly Called Botticelli*, London, 1908

Huizinga, J., *The Waning of the Middle Ages*, Harmondsworth, 1955

Hülsen, C., *Il libro di Giuliano da Sangallo (Cod. Vat. Barb. Lat. 4424)*, Leipzig, 1910

Humfrey, P., *Cima da Conegliano*, Cambridge, 1983

Humfrey, P., *Painting in Renaissance Venice*, New Haven and London, 1995

Hutchison, J. C., *Albrecht Dürer. A Biography*, Princeton, 1990

"Il se rendit en Italie". Etudes offerts à André Chastel, Rome, 1987

Janson, H. W., 'The Image Made by Chance in Renaissance Thought', in Meiss ed. (1961), 254–66

Janson, H. W., 'The Birth of "Artistic Licence". The Dissatisfied Patron in the Early Renaissance', in Lytle and Orgel eds (1981), 344–53

Jean Gossaert dit Mabuse, exh. cat. (Rotterdam–Bruges), Rotterdam, 1965

Joannides, P., *Masaccio and Masolino*, London, 1993

Jones, R., 'Mantegna and Materials', *I Tatti Studies. Essays in the Renaissance*, II (1987), 71–90

Jones, R. and N. Penny, *Raphael*, New Haven and London, 1983

Kemp, M., ' "Ogni dipintore dipinge se". A Neoplatonic Echo in Leonardo's Art Theory?', in Clough ed. (1976), 311–23

Kemp, M., 'From Mimesis to Fantasia. The Quattrocento Vocabulary of Creation, Inspiration and Genius in the Visual Arts', *Viator*, VIII (1977), 347–98

Kemp, M., *Leonardo da Vinci. The Marvellous Works of Nature and Man*, London, 1981

Kemp, M., 'Leonardo da Vinci. Science and the Poetic Impulse', *Journal of the Royal Society of Arts*, XXXIII (1985), 196–214

Kemp, M., ed., *Leonardo da Vinci*, exh. cat. (London, Hayward Gallery), London, 1989

Kemp, M., 'The "Super-Artist" as Genius. The Sixteenth-Century View', in Murray ed. (1989), 32–53

Kemp, M., *Behind the Picture. Art and Evidence in the Italian Renaissance*, New Haven and London, 1997

Kemp, M. and M. Walker, eds, *Leonardo on Painting*, New Haven and London, 1989

Kennedy, R. Wedgwood, *Alessio Baldovinetti*, New Haven, 1938

Kent, F. W. and P. Simons, eds, *Patronage, Art and Society in Renaissance Italy*, Oxford, 1987

Klein, R. and H. Zerner, eds, *Italian Art 1500–1600. Sources and Documents*, Englewood Cliffs, NJ, 1966

Knabenshue, P. D., 'Ancient and Medieval Elements in Mantegna's "Trial of St James"', *Art Bullletin*, XLI (1959), 59–73

Knapp, F., *Fra Bartolommeo della Porta und die Schule von San Marco*, Halle am Seele, 1903

Koerner, J., *The Moment of Self-Portraiture in German Renaissance Art*, Chicago, 1993

Krautheimer, R. and T. Krautheimer-Hess, *Lorenzo Ghiberti*, Princeton, 1956

Kristeller, P., *Andrea Mantegna*, Berlin and Leipzig, 1902

Laborde, L. de, *Les Ducs de Bourgogne*, 3 vols, Paris, 1849–52

Ladendorf, H., *Antikenstudium und Antikenkopie*, Berlin, 1953

Ladis, A. and C. Wood, eds, *The Craft of Art. Originality and Industry in the Italian Renaissance and Baroque Workshop*, Athens, GA, and London, 1995

Ladner, G., 'Die Anfänge des Kryptoporträts', in Deuchler, Flury-Lemberg and Obarsky eds (1983), 78–97

Land, N., *The Viewer as Poet. The Renaissance Response to Art*, University Park, PA, 1994

Landau, D., 'Mantegna as Printmaker', in Martineau ed. (1992), 44–54

Landau, D. and P. Parshall, *The Renaissance Print*, New Haven and London, 1994

Lavin, I. and R. Plummer, eds, *Studies in Late Medieval and Renaissance Painting in Honor of Millard Meiss*, 2 vols, New York, 1977

Lavin, M. A., ed., *Piero della Francesca and His Legacy* (Washington, DC, National Gallery of Art *Studies in the History of Art*, 48) Washington, DC, 1995

Lawrence, C., ed., *Women and Art in Early Modern Europe. Patrons, Collectors and Connoisseurs*, University Park, PA, 1997

Lehrs, M., *Geschichte und kritischer Katalog des deutschen, niederländischen und französischen Kupferstichs im XV. Jahrhundert*, 16 vols, Vienna, 1908–34

Lightbown, R., *Sandro Botticelli*, 2 vols, London 1978

Lightbown, R., *Donatello and Michelozzo*, 2 vols, London, 1980

Lightbown, R., *Mantegna*, London, 1986

Lomazzo, G. P., *Idea dello Tempio della Pittura*, ed. R. Klein, 2 vols, Florence, 1974

Luchs, A., *Tullio Lombardo and Ideal Portrait Sculpture in Renaissance Venice, 1490–1530*, Cambridge and New York, 1995

Lytle, G. F. and S. Orgel, eds, *Patronage in the Renaissance*, Princeton, NJ, 1981

Maddano, S., '"Andrea scarpellino" antiquario. Lo studio dell'Antico nella bottega di Andrea Bregno', in Squarzina ed. (1989), 229–47

Maginnis, H. B., *Painting in the Age of Giotto. A Historical Reevaluation*, University Park, PA, 1997

Malaguzzi-Valeri, F., *La corte di Lodovico il Moro*, 3 vols, Milan, 1915–29

Manca, J., ed., *Titian '500* (Washington, DC, National Gallery of Art, *Studies in the History of Art*, 45), Washington, DC, 1993

Manetti, A., *The Life of Brunelleschi by Antonio di Tuccio Manetti*, ed. H. Saalman, University Park, PA, and London, 1970

Marchand, E. and A. Wright, eds, *With and Without the Medici. Studies in Tuscan Art and Patronage 1434–1530*, Aldershot, 1998

Marek, M. J., *Ekphrasis und Herrscherallegorie. Antike Bildebeschreibungen in Werk Titians und Leonardos*, Worms, 1985

Martindale, A., *The Rise of the Artist in the Middle Ages and the Early Renaissance*, London, 1972

Martindale, A., *The Triumphs of Caesar by Andrea Mantegna in the Collection of H.M. the Queen at Hampton Court*, London, 1979

Martineau, J., ed., *Andrea Mantegna*, exh. cat. (London, Royal Academy of Arts), London, 1992

Martineau, J. and C. Hope, eds, *The Genius of Venice, 1500–1600*, exh. cat. (London, Royal Academy of Arts), London, 1983

Meiss, M., ed., *De artibus opuscula XL. Essays in Honor of Erwin Panofsky*, New York, 1961

Mellini, G. L., *Altichiero e Jacopo Avanzi*, Milan, 1965

Meyer, A. G., *Oberitalien Frührenaissance. Bauten und Bildwerke der Lombardei*, 2 vols, Berlin, 1897–1900

Migliore, L. del, *Firenze città nobilissima illustrata*, Florence, 1684; repr. Bologna, 1976

Milanesi, G., *Documenti per la storia dell'arte senese*, 3 vols, Siena, 1854–6

Mommsen, T. E., 'Petrarch and the Decoration of the Sala Virorum Illustrium in Padua', *Art Bulletin*, XXXIV (1952), 95–116

Moretti, L., *The Church of the Madonna dell'Orto in Venice*, Venice, 1992

Moskowitz, A., *The Sculpture of Andrea and Nino Pisano*, Cambridge, 1986

Murray, P., *An Index of Attributions Made in Tuscan Sources before Vasari*, Florence, 1959

Murray, P., ed., *Five Early Guides to Rome and Florence*, Farnborough, 1972

Murray, P., ed., *Genius. The History of an Idea*, Oxford, 1989

Nelson, J., 'Aggiunte alla cronologia di Filippino Lippi', *Rivista d'Arte*, XLIII (1991), 33–57

Nesselrath, A., 'Raphael's Archaeological Method', in Frommel and Winner eds (1986), 357–71

Nesselrath, A., 'Simboli di Roma', in Cavallaro and Parlato eds (1988), 195–205

Nesselrath, A., 'Il *Codice Escurialensis*', in Prinz and Seidel eds (1996), 175–98

Nicolini, F., 'Pietro Summonte, Marcantonio Michiel e l'arte napoletana del Rinascimento, parte seconda. La lettera del Summonte al Michiel sull'arte napoletana', *Napoli Nobilissima*, n.s. III (1923), 121–46 and 159–72

O'Malley, M., 'Late Fifteenth- and Early Sixteenth-Century Painting Contracts and the Stipulated Use of the Painter's Hand', in Marchand and Wright eds (1998), 155–78

Onians, J., 'Alberti and ΦΙΛΑΡΕΤΗ', *Journal of the Warburg and Courtauld Institutes*, XXXIV (1971), 96–114

Paatz, W. and E. Paatz, *Die Kirchen von Florenz. Ein kunstgeschichtliches Handbuch*, 6 vols, Frankfurt am Main, 1940–54

Panofsky, E., *Albrecht Dürer*, 2 vols, Princeton, NJ, 1943

Panofsky, E., *Early Netherlandish Painting. Its Origins and Character*, 2 vols, New York, 1953

Parlato, E., 'Il gusto all'antica di Filarete scultore', in Cavallaro and Parlato eds (1988), 115–23

Pasti, S., 'Nicolò V, l'Angelico e le antichità di Roma di Benozzo Gozzoli', in Cavallaro and Parlato eds (1988), 135–43

Pastore, G., ed., *La Cappella del Mantegna in Sant'Andrea a Mantova*, Mantua, 1986

Paul, E., 'Falsificazioni di antichità in Italia dal Rinascimento alla fine del XVIII secolo', in Settis ed. (1985), 413–39

Perosa, A., ed., *Giovanni Rucellai e il suo Zibaldone*, 2 vols, I: 'Il Zibaldone Quaresimale', Florence, 1980

Petrioli Tofani, A., ed., *Il disegno fiorentino del tempo di Lorenzo il Magnifico*, exh. cat. (Florence, Uffizi), Florence, 1992

Piero della Francesca, *De prospectiva pingendi*, ed. G. N. Fasola, 1942

Pignatti, T., *Giorgione*, London, 1971

Pincus, D., 'Tullio Lombardo as a Restorer of Antiquities', *Arte Veneta*, XXXIII (1979), 29–42

Pini, C. and G. Milanesi, *La scrittura di artisti italiani (sec. XIV–XVII)*, 3 vols, Florence, 1876

Pius II, *The Secret Memoirs of a Renaissance Pope*, trans. F. A. Gragg and L. C. Gabel, New York, 1959

Pliny the Elder, *Natural History, Books 33–35*, trans. H. Rackham (Loeb Classical Library), Cambridge, MA, and London, 1952

Poeschke, J., ed., *Italienische Frührenaissance und nordeuropäisches Mittelalter*, Munich, 1993

Poliziano, A., *Stanze per la Giostra. Orfeo, Rime*, ed. B. Maier, Novara, 1968

Pope-Hennessy, J., *The Portrait in the Renaissance*, London, 1966

Pope-Hennessy, J., *Paolo Uccello*, Oxford, 1969

Pope-Hennessy, J., *Italian Renaissance Sculpture*, London, 1971

Pope-Hennessy, J., *Luca della Robbia*, Oxford, 1980

Pope-Hennessy, J., *Italian Gothic Sculpture*, 3rd ed., Oxford, 1986

Posner, K. W.-G., *Leonardo and Central Italian Art: 1515–1550*, New York, 1974

Prager, F., 'A Manuscript of Taccola, Quoting Brunelleschi on Problems of Inven-

tors and Builders', *Proceedings of the American Philosophical Society*, CXII (1968), 131–49

Prinz, W. and M. Seidel, eds, *Domenico Ghirlandaio 1449–1494. Atti del Convegno*, Florence, 1996

Puppi, L., 'Per Tullio Lombardo', *Arte Lombarda*, XXXVI (1972), 100–03 and 128

Purtle, C. J., *The Marian Paintings of Jan van Eyck*, Princeton, NJ, 1982

Radcliffe, A., 'Antico and the Mantuan bronze', in Chambers and Martineau eds (1981), 46–9

Ragghianti, C. and G. Dalli Regoli, *Firenze 1470–1480. Disegni dal Modello*, Pisa, 1975

Redig de Campos, D., 'La Stufetta del Cardinale Bibbiena in Vaticano e il suo restauro', *Römisches Jahrbuch für Kunstgeschichte*, XX (1983), 221–40

Reti, L., 'The Two Unpublished Manuscripts of Leonardo da Vinci in the Biblioteca Nacional of Madrid – II', *Burlington Magazine*, CX (1968), 81–9

Richa, G., *Notizie istoriche delle chiese fiorentine divise ne'suoi quartieri*, 10 vols, Florence, 1754–62

Robertson, G., *Giovanni Bellini*, Oxford, 1968

Rogers, M., 'The Artist as Beauty', in Ames-Lewis and Rogers eds (1997), 93–106

Rolfs, W., *Geschichte der malerei Neapels*, Leipzig, 1910

Rosenthal, E., 'The House of Andrea Mantegna in Mantua', *Gazette des Beaux-Arts*, LX (1962), 327–49

Rossi, U., 'Cristoforo Geremia', *Archivio storico dell'arte*, I (1888), 404–11

Rubin, P., *Giorgio Vasari. Art and History*, New Haven and London, 1995

Rubinstein, N., 'Political Ideas in Sienese Art. The Frescoes of Ambrogio Lorenzetti and Taddeo di Bartolo in the Palazzo Pubblico', *Journal of the Warburg and Courtauld Institutes*, XXI (1958), 179–207

Rubinstein, R., 'Lorenzo de'Medici's Sculpture of Apollo and Marsyas, Bacchic Imagery and the Triumph of Bacchus and Ariadne', in Marchand and Wright eds (1998), 79–105

Ruda, J., *Fra Filippo Lippi*, London, 1993

Ruhmer, E., *Tura. Paintings and Drawings*, London, 1958

Rumpf, A., 'Bienen als Baumeister', *Jahrbuch der Berliner Museen*, VI (1964), 5–8

Salmi, M., 'La "divi Julii effigies" del Pisanello', *Commentarii*, VIII (1957), 91–5

Sanudo, M., *I diarii*, ed. R. Fulin, 58 vols, Venice, 1879–1903

Saslow, J. M., *The Poetry of Michelangelo. An Annotated Translation*, New Haven and London, 1991

Scarpellini, P., *Perugino*, Milan, 1984

Schaefer, C., *Jean Fouquet: An der Schwelle zur Renaissance*, Berlin and Basel, 1994

Scheller, R. W., *Exemplum. Model-Book Drawings and the Practice of Artistic Transmission in the Middle Ages (ca.900–ca.1470)*, Amsterdam, 1995

Scher, S., ed., *The Currency of Fame. Portrait Medals of the Renaissance*, exh. cat. (Washington, DC, National Gallery of Art, and Edinburgh, National Gallery of Scotland), Washington, DC, 1994

Schmidt, U., 'Francesco Bonsignori', *Münchner Jahrbuch der Bildende Kunst*, XII (1961), 73–152

Schmitt, A., 'Romische Antikensammlungen im spiegel eines Musterbuch der Renaissance', *Münchner Jahrbuch der Bildenden Kunst*, XXI (1970), 99–129

Schmitt, A., 'Zur wiederbelegung der Antike im Trecento', *Mitteilungen des Kunsthistorischen Institutes in Florenz*, XVIII (1974), 167–218

Schofield, R., 'Leonardo and Architecture', in Ames-Lewis ed. (n.d. [1991]), 88–95

Schulz, J., 'Pinturicchio and the Revival of Antiquity', *Journal of the Warburg and Courtauld Institutes*, XXV (1962), 35–55

Schwarz, M. V., 'Peter Parler im Veitsdom. Neue Überlegungen zum Prager Büstenzyklus', in ed. Winner (1992), 55–84

Schweikhart, G., *Der Codex Wolfegg. Zeichnungen nach der Antike von Amico Aspertini*, London, 1986

Schweikhart, G., 'Das Selbstbildnis im 15. Jahrhundert', in Poeschke ed. (1993), 11–39

Settis, S., ed., *Memoria dell'antico nell'arte italiana*, 3 vols, II: 'I generi e i temi ritrovati', Turin, 1985

Settis, S., *Giorgione's* Tempesta. *Interpreting the Hidden Subject*, London, 1990

Seymour, C., *The Sculpture of Verrocchio*, London, 1971

Sheard, W. S., ed., *Antiquity in the Renaissance*, exh. cat. (Smith College Museum of Art), Northampton, MA, 1978

Shearman, J., 'Raphael, Rome and the Codex Escurialensis', *Master Drawings*, XV (1977), 107–46

Shearman, J., 'Alfonso d'Este's Camerino', in *"Il se rendit en Italie"* (1987), 209–30

Shearman, J., *'Only Connect . . .'. Art and the Spectator in the Italian Renaissance*, Princeton, NJ, 1992

Shoemaker, I., 'Filippino and His Antique Sources' in Goldner and Bambach eds (1997), 29–36

Signorini, R., 'Federico III e Cristiano I nella Camera degli Sposi del Mantegna', *Mitteilungen des Kunsthistorischen Institutes in Florenz*, XVIII (1974), 227–50

Signorini, R., 'L'autorittrato del Mantegna nella Camera degli Sposi', *Mitteilungen des Kunsthistorischen Institutes in Florenz*, XX (1976), 205–12

Signorini, R., 'Il monumento celebrative di Andrea Mantegna', in Pastore ed. (1986), 23–42

Signorini, R., 'New Findings about Andrea Mantegna. His Son Ludovico's Postmortem Inventory (1510)', *Journal of the Warburg and Courtauld Institutes*, LIX (1996), 103–18

Simons, P., 'Patronage in the Tornaquinci Chapel, Santa Maria Novella, Florence', in Kent and Simons eds (1987), 221–50

Spencer, J. R., 'Filarete, the Medallist of the Roman Emperors', *Art Bulletin*, LXI (1979), 551–61

Spencer, J. R., trans., *Filarete's Treatise on Architecture*, 2 vols, New Haven and London, 1965

Squarzina, S. D., ed., *Roma, centro ideale della cultura dell'Antico nei secoli XV e XVI*, Milan, 1989

Summers, D., *Michelangelo and the Language of Art*, Princeton, NJ, 1981

Symeonides, S., *Taddeo di Bartolo*, Siena, 1965

Tatarkiewicz, W., *History of Aesthetics*, Mouton, 1970

Thoenes, C., 'La "lettera" a Leone X', in Frommel and Winner eds (1986), 373–81

Thomas, A., *The Painter's Practice in Renaissance Tuscany*, Cambridge, 1995

Tietze, H. and E. Tietze-Conrat, *The Drawings of the Venetian Painters in the 15th and 16th Centuries*, New York, 1944

Tolnay, C. de, *Corpus dei disegni di Michelangelo*, 4 vols, Novara, 1975–80

Torriti, P., *La Pinacoteca nazionale di Siena. I dipinti dal XII al XV secoli*, Genoa, 1977

Vaccarino, P., *Nanni di Banco*, Florence, 1950

van Os, H., 'Vecchietta and the Persona of the Renaissance Artist', in Lavin and Plummer eds (1977), I, 445–54

Vasari, G., *Lives of the Artists*, trans. A. B. Hinds, ed. W. Gaunt, 4 vols, London, 1963

Vasari, G., *Lives of the Artists*, trans. G. Bull, 2 vols, Harmondsworth, 1965–87

Vasari, G., *Giorgio Vasari, Le Vite*, eds R. Bettarini and P. Barocchi, 6 vols, Florence, 1971–93

Venturi, A., 'Gian Cristoforo Romano', *Archivio storico dell'arte*, I (1888), 49–59, 107–18 and 148–58

Vespasiano da Bisticci, *Renaissance Princes, Popes, and Prelates*, trans. W. G. Waters and E. Waters, New York, 1963

Wackernagel, M., *The World of the Florentine Renaissance Artist*, ed. and trans. A. Luchs, Princeton, NJ, 1981

Walek, J., 'The Czartoryski "Portrait of a Youth" by Raphael', *Artibus et Historiae*, XXIV (1991), 201–25

Warnke, M., 'Filaretes Selbstbildnisse. Das geschenkte Selbst', in Winner ed. (1992), 101–12

Warnke, M., *The Court Artist*, London, 1993

Weiss, R., *The Renaissance Discovery of Classical Antiquity*, Oxford, 1969

Welch, E. S., *Art and Society in Italy 1350–1500*, Oxford, 1997

Weller, A. S., *Francesco di Giorgio 1439–1501*, Chicago, 1943

Wesselski, A., *Angelo Polizianos Tagebuch zum ersten Mal herausgegeben*, Jena, 1929

Westfall, C. W., 'Painting and the Liberal Arts. Alberti's View', *Journal of the History of Ideas*, XXX (1969), 487–506

White, J., *Art and Architecture in Italy 1250–1400*, Harmondsworth, 1987

Willemsen, K. A., *Kaiser Friedrichs II. Triumphator zu Capua*, Wiesbaden, 1953

Winner, M., 'Zum Nachleben des Laokoön in der Renaissance', *Jahrbuch der Berliner Museen*, XVI (1974), 83–121

Winner, M., ed., *Der Künstler über sich in seinem Werk*, Weinheim, 1992

Wittkower, R., 'The Artist and the Liberal Arts', *Eidos*, I, 1950

Wittkower, R. and D. Wittkower, *Born under Saturn. The Character and Conduct of Artists*, London, 1963

Wohl, H., *The Paintings of Domenico Veneziano*, London, 1981

Woods-Marsden, J., *Renaissance Self-Portraiture. The Visual Construction of Identity and the Social Status of the Artist*, New Haven and London, 1998

Wuttke, D., 'Durer und Celtis. Von der Bedeutung des Jahres 1500 für den deutschen Humanismus: "Jahrhundertfeier als symbolische Form"', *Journal of Medieval and Renaissance Studies*, X (1980), 73–129

Zöllner, F., ' "Ogni Pittore Dipinge Sé". Leonardo da Vinci and "Automimesis"', in Winner ed. (1992), 137–49

Photograph Credits

Index

Abacus school 19, 20, 30, 31, 35
Accademia del Disegno 59
Accademia leonardi vinci 58, 59
Accademia Platonica 59
Agostino di Duccio 27
Agostino Veneziano, engraving of Bandinelli's
 'Academia' 59, fig. 30
Albano, Taddeo 3, 176
Alberti, Leon Battista 18, 20, 102, 161, 232,
 250
 De re aedificatoria 21
 ideal painter of 6
 On Painting ix, 5, 6, 13, 18, 20, 30, 46, 63,
 110, 141, 142–5, 147, 148, 164, 180
 on the aim of the painter 245
 'circumscription' 38, 247, 260–61
 'composition' 247
 dedications of 20, 33, 78, 143
 on Demetrius 190
 on drawing after sculpture 46–7, 48
 on the education of the painter 30, 34
 geometrical perspective in 9, 31, 247, 260
 on Giotto's *Navicella* 193
 on *inventio* 181
 istoria in 42, 256
 on Lucian's *ekphrasis* of Apelles 166,
 181, 193, 194, 256
 on the painter and geometry 254
 on painters and poets 165–6, 168
 on portraits 209
 primacy of painting 144
 'reception of light' 48, 52, 155, 247, 261
 theoretical foundation for painters 143
 on Zeuxis 79, 187
 On Sculpture 145
 pictorial principles of 245–6
 S. Andrea, Mantua 102–6
 S. Sebastiano, Mantua 68
Albertini, Francesco 81
Aleotti, Ulisse degli 168
Alexander the Great 78, 134, 189, 206
Alfonso of Aragon, King of Naples 17, 62, 85,

166, 276
Altdorfer, Albrecht 40–42, 65
 Battle of Alexander (Munich, Altepinakothek)
 65
Altichiero, Jacopo 5
 frescoes in Palazzo Carrara, Padua 112
 frescoes in Palazzo Scaligero, Verona 111,
 fig. 49
Amadori, Alessandro 186
Ambrosiana Master, the 124
Ambrosiana sketchbook, the 118–19, fig. 56
Andrea del Sarto, tomb of (formerly Florence,
 SS Annunziata) 93
Angelico, Fra 14, 33, 94–5, 119
 Landino on 275
 prior of convent of S. Domenico, Fiesole 95
 St Lawrence before Decius (Vatican, St
 Nicholas chapel) 121
 tomb of (Rome, S. Maria sopra Minerva)
 89, 93–5
d'Anghiari, Matteo di Ser Paolo 21
d'Anjou, René, King of Naples 17, 71, 85,
 280n
Anjou
 Queen Joanna of 62
 King Robert of 62
Antico (Pier Jacopo Alari Bonacolsi) 86, 131,
 155
 ability to empathise with classical past 132
 'classical' busts of 134
 restoration of classical statuary 136
 small bronze *Apollo Belvedere* 3, 46, 131–2,
 136, 154, fig. 68
 Hercules and Antaeus (Vienna,
 Kunsthistorisches Museum) 132
 Meleager (London, Victoria and Albert
 Museum) 131
 Spinario, for Isabella d'Este 132
 small bronzes for Bishop Ludovico Gonzaga
 46, 78, 132, 134, 154
antiquarianism 109, 128
Antonello da Messina 89–90

Eyckian oil technique of 266
St Jerome in His Study 264, 266–8, fig. 148
Antoninus Pius, Emperor 140
Antonio Maria della Mirandola, Count 132
Apelles 78, 134, 189, 206–7
 'Calumny' of 166, 181, 194, 196, 198, 256, 268
 'Marriage of Alexander and Roxana' by 189, 198
 'Venus of Cos' by 131, 193
Apollo Belvedere 252
 acquired by Cardinal Giuliano della Rovere 81
 drawing after (Codex Escurialensis) 44
 engraving after (Raimondi circle) 44, 132, fig. 21
 restoration by Montorsoli 132
 small bronze after (Antico) 3, 46, 131–2, fig. 68
Apollonio di Giovanni 206
Appian 126
Archimedes 21, 78
architecture, as a liberal art 4, 66
Ariosto 173
Aristotle, *Poetics* 163
Arnolfo di Cambio 67
ars et ingenium (skill and talent) 238, 245
artist(s) and intellectual life 1
 as advisers on art 61, 85–7
 apprenticeship of 35
 archaeological attitudes of 109, 123–4
 as architects 66–70
 aspiration towards status of 'liberal arts' 9
 civic responsibilities of 64–5
 as collectors 61, 79–85
 as courtiers 1, 168, 272, 279
 as craftsmen 2, 3
 creative skill of 242
 as diplomats and spies 65–6
 and Domus Aurea decorations 128–31
 dress of 61, 70–74, 271–2
 education of 30–31
 engagement with classical sculpture 134–5
 gifts to patrons 76–9
 handwriting of 26–30
 houses of 61, 68–70
 as imitator of nature 179
 inventories of 21–2
 knowledge of Latin 19–26
 obsessiveness of 273
 social status of 242
 and study of geometry 31
 titles of 61, 62–4
 training of 60
 visits from patrons 74–6
 wills of 37

Aspertini, Amico, Codex Wolfegg 84, 85
 drawing after *Adonis* sarcophagus 84, fig. 37
 drawing after Roman *Jupiter* 137, fig. 74 a and b
Assisi, S. Francesco, Lower Church 212
Athanasius of Naukratis 72
Athens, Parthenon, shield of Athena Parthenos 232
Augustus, Emperor 78
Averlino, Antonio, *see* Filarete
Avignon 65

Baldassare del Milanese 132
Baldini, Baccio, engravings of 39–40
 Libyan Sibyl engraving 39, fig. 14
Bandinelli, Baccio 140
 'Academia . . . in Roma' of 59, fig. 30
Baldovinetti, Alessio 239
 tomb of (Florence, S. Ambrogio) 100
Barcelona 276
Barbari, Jacopo de' 42, 173, 252
Bartolommeo di Bertozzo 262
Bartolommeo, Fra 6
 inventory of 52, 53
 workshop properties of 55
 Worship of Venus drawing 202–3, fig. 100
Barzizza, Gasparino 36
Basinio da Parma 168
Beauneveu, André 85
Beham, Barthel 44
Bellini family
 Anna 91
 bequest of 53, 80, 136, 263, 281n
 bust of Plato in 80, 136
 Gentile 19, 263, 271
 drawings of, used by Pinturicchio 37
 inheritance of 53, 80
 owned classical statuette of *Venus* 80
 portrait of Sultan Mehmet II 64
 titles of 63–4
 tomb of (formerly Venice, SS Giovanni e Paolo) 91
 Giovanni 19, 215, 271
 Christ the Redeemer (London, National Gallery) 118
 Continence of Scipio (Washington, DC, National Gallery of Art) 200
 Feast of the Gods 173, 200–02, fig. 98
 and Isabella d'Este 173, 181, 183, 200, 276, 278
 Nativity, for Isabella d'Este 184
 and Niccolò Bellini 80, 136
 Pietà (Milan, Brera) 25–6
 tomb of (formerly Venice, SS Giovanni e Paolo) 91

Jacopo 19, 33, 91, 206
 antiquarian interests of 238
 archaeological curiosity of 116, 118
 books of drawings of 37–8, 262–4
 daughter of, married Andrea Mantegna
 118
 drawings of Roman tombs 116–18, 263,
 fig. 54
 Nativity drawing 32, 262, fig. 10
 portrait of Leonello d'Este 168
 records of Roman coins 115, fig. 54
 Triumphal Procession of Bacchus drawing
 263, fig. 147
 workshop plaster casts of 53
Belvedere Torso
 owned by Andrea Bregno 83–4, fig. 36
 engraving after (Giovanni Antonio da Brescia)
 137, fig. 72
Bembo, Pietro 106, 184–5, 200
 Gli asolani 176
Bernini, Gianlorenzo, bust of Charles I 158
Bertoldo di Giovanni 30, 58, 62
Bicci di Lorenzo 27
Bicharano, Francesco 36
Biondo, Flavio
 Roma instaurata 124
 Roma triumphans 126
Boccaccio, Giovanni 180
 Amorosa visione 193
 Decamerone 22, 269
 on Giotto 178
 writings of 21
Boldù, Giovanni, self-portrait medals 22, 114,
 212, 238–9, fig. 130
Bologna, S. Petronio 64
Boltraffio, Giovanni Antonio 17
Bon family 19
Bonsignori, Francesco 78
Borgia, Cesare 132
Borselli, Fra Giovanni 277
Botticelli, Sandro 22–3, 172–3
 Adoration of the Magi 229–31, 239, figs
 123–4
 Birth of Venus 193, fig. 92
 Calumny of Apelles 14, 79, 177, 194–6,
 268–70, fig. 94
 compared with Apelles 207, 269
 illustrated Dante 269
 Ludovico Sforza's agent on 275
 Mystic Nativity (London, National Gallery)
 23
 paintings for Giannozzo Pucci 269
 Pallas and the Centaur (Florence, Uffizi)
 177
 Primavera (Florence, Uffizi) 172
 and Savonarola 268

 self-portrait of 229, 231, fig. 124
 workshop of 58
Bouts, Dirk, *Supper at Emmaus* (Louvain) 211
Bracciolini, Poggio 27, 85
Bramante, Donato 19–20, 67, 68, 169
 Palazzo Caprini, Rome 70
Bregno
 Andrea 100
 collection of antiquities 82–5
 Adonis sarcophagus (Mantua) 84, 124
 Altar of Augustus (Vatican) 84
 Belvedere Torso 83–4, fig. 36
 tomb of (Rome, S. Maria sopra Minerva)
 97–100, 220, fig. 44
 Caterina 83
Brescia, S. Salvatore, tomb of Metellia Prima
 116–18
Bruges 276
Brunelleschi, Filippo 5, 145
 as dedicatee of Alberti's *On Painting* 20, 33
 education of 19
 as goldsmith and bronze sculptor 67
 on *invenzioni* 180
 painting of Florence Baptistery 31
 perspective of 31–2, 147
 as poet 169
 S. Maria degli Angeli, Florence 180
 tomb and cenotaph of, Florence cathedral
 91
Bruni, Leonardo 145, 272
Brussels 71
Buggiano 91
Burgkmair, Hans, *Weisskönig* engraving 75,
 fig. 32
Burgundy, court of 9

Calvo, Fabio Marco 21
Campagnola
 Girolamo 17
 Giulio 17, 18, 22
Candida 64
Capua, Triumphal Gateway of Frederick II
 110
Caradosso 86
Carafa, Cardinal Oliviero 273
Carmignano, near Padua, Roman tomb at 116
Carpaccio, Vittore, *Portrait of a Young Knight*
 37, fig. 12
Carrara
 Francesco I da, court of, in Padua 178
 palace of 112
 Francesco II da 4, 5
 Francesco I and II da, coins of 112, fig. 50
Casalini, Marco, of Rovigo 153
Castagno, Andrea del 11
Castelfranco di Sopra 65

Castiglione, Baldassare 1, 20, 86, 161, 168
 friendship with Raphael 242
 ideal courtier of 72
 The Book of the Courtier 1, 18, 22, 161,
 168, 280n
 on Alexander the Great and Apelles 189
 on Leonardo da Vinci 272
 on painting and drawing 17, 18
 on the *paragone* 143–4, 150–53
 on Raphael 152
Castiglione Olona, Collegiata 217
Catullus, *ekphrasis* of, as source for Titian
 205
Cavael, Jacques 71
Cavalieri, Tommaso de' 79
Cavalli, Gian Marco 126
Cecca, Il, tomb (formerly Florence, S. Pier
 Scheraggio) 92–3
Celtis, Konrad 21, 206–7, 241, 271
Cennini, Cennino 6, 13, 164
 The Craftsman's Handbook ix, 5–6, 7, 57,
 61, 141, 177, 213
 on drawing 36, 48
 on *fantasia* 6, 177–8
 on the imitation of nature 164, 178
 on the painter's apprenticeship 35, 274
 on the painter's conduct 30–31
 on the painter's dress 71–2
 on painting and poetry 164
 pasteboard pouch in 50
 reusable boxwood panel in 47
Cesariano 67
Charles V, Emperor 8
Charles VIII, King of France 64, 66
Chellini, Giovanni 79
Chigi
 Agostino, Villa Farnesina of 189, 198
 Sigismondo 74
Ciampolini, Giovanni 85, 86, 137
Cicero 131, 166, 173, 187, 193
Ciecho, Maestro 20
Cima da Conegliano 173–5
Cimabue 163, 192, 224
Ciriaco d'Ancona 81
Civitali, Matteo 81–2
Clement VII, Pope 245
Codex Escurialensis 38–9, 44, 129, 137, fig.
 65
Commodus, Emperor 123
Condivi, Ascanio 11, 132
Constantine the Great, Emperor 119, 140
Cornaro, Francesco 157, 200
Corvinus, Matthias, King of Hungary 63, 66
Cossa, Francesco del 273
Costa, Lorenzo 200, 275

Cristoforo di Geremia 86, 114
 Constantine medallion 114, fig. 53
 restoration of *Marcus Aurelius* 123, 135
Crivelli, Carlo 64
 Madonna della Rondine (London, National
 Gallery) 64
Cronaca, il (Simone del Pollaiuolo) 70, 91

Dacher, Gebhart 65
Dalmata, Giovanni 63
Dante Alighieri 3, 163
 portrait of, by Giotto 212
 on sculpture 192–3, 196, 269
 works of 21, 22, 169
 illustrated by Botticelli 269
Dati, Leonardo 168
Datini, Francesco di Marco 262
Decembrio, Pier Candido 206
Delli, Dello 63, 71
Demetrius 190
Dente, Marco 140
Desiderio da Settignano 148, 207
Domenico Veneziano 11, 27, 33
Domitian, sestertius of 115, fig. 54
Donatello 12, 18, 67, 179
 altarpiece for S. Antonio, Padua 179
 and antiquities 85–6
 Ascension and Giving of the Keys 147–8,
 fig. 77
 bronze *David* (Florence, Bargello) 14
 bronze pulpits (Florence, S. Lorenzo) 33
 burial of, in S. Lorenzo, Florence 100
 collection of antiquities 81
 as dedicatee of Alberti's *On Painting* 20
 drawings of 46
 dress of 71
 Feast of Herod (Lille) 247
 Feast of Herod (Siena, Baptistery font) 32,
 147
 house of 69
 (?) restoration of Medici *Marsyas* 135, fig.
 70
 rilievo schiacciato ('squashed relief') of
 147–8, 153
 roundels in Old Sacristy, S. Lorenzo, Florence
 148, 169
 Virgin and Child with Angels (London,
 Victoria and Albert Museum) 79
Donato degli Albanzani 112
Donatus, Latin grammar of 21
drawings after the antique 56, 124
Durandus, *Rationale divinorum officiorum*
 163
Dürer
 Agnes 227

Albrecht 6, 8, 79
 Abduction of the Sabine Women drawing
 43–4, fig. 20
 Christ among the Doctors 248, fig. 137
 compared with Phidias and Apelles 206–7
 concern with human anatomy 249–50,
 252
 concern with intellectual status 8, 254
 copies after Mantegna engravings 44, 252
 dress of 74
 engravings of 40, 249, 279
 Adam and Eve 250–53, 256, fig. 139
 light and shade in 249, 254
 meisterstiche 6, 250, 253, 264
 Melencolia I 238, 242, 253–4, 273, fig.
 140
 St Jerome in His Study 250, 254, 264,
 fig. 141
 Vision of St Eustace 250, 254, fig. 138
 Four Apostles (Munich, Alte Pinakothek)
 78–9
 as *Genannter* in Nuremberg 65
 house of 70
 intellectual activity of 8, 249
 and Jacopo de' Barbari 252–3
 knowledge of Latin 21
 letters to Pirckheimer 31, 74, 271
 oil-painting technique of 248
 on painters representing themselves 210
 and perspective 31, 249, 254
 as poet 170
 and Pollaiuolo 43, 158
 as printmaker 8
 Rosenkranzfest altarpiece 74, 240, 271,
 fig. 1 (detail)
 self-awareness of 249
 self-portraits of 209, 242–3, 279
 Self-portrait (1493) 225–7, 240, fig.
 121
 Self-portrait (1498) 74, 240, 242, fig.
 131
 Self-portrait (1500) 74, 240–41, 270,
 fig. 132
 self-portrait drawing (Bremen) 242,
 273, fig. 134
 self-portrait drawing (Erlangen) 215,
 fig. 110
 self-portrait drawing (New York) 215,
 fig. 111
 self-portrait drawing (Vienna) 225,
 291n, fig. 119
 signatures of 23
 social status of 8
Albrecht, the Elder, self-portrait drawing
 225, fig. 120

Dyck, Anthony van, triple portrait of Charles I
 158

ekphrasis 189–207, 269–70
engravings, copper-plate, uses of 39–46,
 249–59
Equicola, Mario 200
d'Este family 274
 Alfonso 7, 173, 200–01, 205, 207
 Camerino d'alabastro of 157, 199–205
 Baldassare 17, 273
 Beatrice, wife of Ludovico Sforza 61, 185
 Borso 17, 273
 Ercole 76, 272
 Isabella, wife of Francesco Gonzaga 3, 61,
 127, 136, 201
 bronzi finti of, by Mantegna 154
 camerino of 183, 186, 199–200, 205, 276
 correspondence of 277–8
 and Giorgione 176
 and Giovanni Bellini 173, 181, 183–5,
 200, 278
 and Leonardo da Vinci 183, 185–6, 275,
 278
 acquired Michelangelo's *Sleeping Cupid*
 132–3
 and Perugino 173, 180, 181–3, 185
 'poetic inventions' of 173, 180, 182, 184,
 186, 204, 205
 purchase of bust of Faustina the Elder 80,
 86
 purchase of bust of Plato 80
 small bronzes for, by Antico 132
 Leonello 78, 112, 165, 180, 238
 portraits of, by Pisanello and Jacopo Bellini
 168
 Niccolò III 17
Euclid 21
Eugenius IV, Pope 235
Eyck
 Hubert and Jan van, Ghent altarpiece 26,
 fig. 6 (detail)
 Jan van 8, 66, 74, 266
 Arnolfini Double Portrait 217, fig. 113
 (detail)
 knowledge of Latin 26
 Madonna of Chancellor Rolin (Paris,
 Louvre) 247
 Madonna of the Fountain (Antwerp) 220
 Man in a Red Turban (?self-portrait) 212,
 220–22, 240–41, 270, fig. 115
 Margarethe van Eyck (Bruges) 222
 oil technique of 247, 266
 painting of 'women . . . emerging from the
 bath' 159

Portrait of Tymotheos (London, National Gallery) 22
'St George and the Dragon' (lost) 276
Salvator Mundi (Berlin) 220
surface textures of 245
Virgin and Child of Chancellor Van der Paele (Bruges) 217, 268
Virgin and Child with Saints (Dresden) 220

familiaris 61, 62, 231, 234
Famulus 72
Fancelli, Luca 68
fantasia 177–8, 179–81, 185–6, 200, 274, 277
Fazio, Bartolommeo 166
on van Eyck and van der Weyden 266
On Famous Men 12, 164–5
on the painter and the poet 180
on Pisanello 165
Federigo da Montefeltro 65, 76, 169, 232, 246
Feliciano, Felice 128, 287n
Epigrammaticon . . . 124
Feltre, Vittorino da 18
school of, the Casa Giocosa 18, 19
Ferdinand, Prince of Capua (later Ferdinand II, King of Naples) 64
Ferrante, King of Naples 63, 264
Ferrara, d'Este court of 6, 7, 9, 12, 17
Ferrara/Florence, Council of 22
Ficino, Marsilio 59, 240
Fiera, Battista 275
figure drawings 47, 48, 53
Filarete (Antonio Averlino) 22, 235, 291n
archaeological interests of 123
self-portrait medal 212, 234–5, fig. 127
self-portrait medallion (Rome, St Peters, bronze doors) 114, 234–5
Self-portrait with Workshop Assistants 236–8, fig. 129
small bronze *Marcus Aurelius* 79, 123, 131, fig. 60
Treatise on Architecture 6, 67, 232
on the artist's house 68–9
description of Sforzinda 231–2
on the exercise of *fantasia* 186
on Giotto and Cimabue 192, 224
on *invenzione* 181
on the *paragone* 149–50
on the use of a lay-figure 48
Ulysses and Iro (bronze plaque) 22, fig. 3
understanding of Greek and Latin 22
visit of Duke of Milan to workshop of 75
(workshop) medallions of Roman emperors 113–14, 132, fig. 52
Filibert of Savoy 66

Finiguerra, Maso, workshop of
books of drawings of 38
figure-drawings of 38, 47
Seated Boy Drawing (Florence Uffizi) 27, 66, fig. 8
Seated Boy Drawing (London, British Museum) 47, fig. 22
Florence 5, 6, 9, 65
Baptistery
doors of 5
Andrea Pisano's doors 145
Ghiberti's first doors 145
second doors 5, 33, 37, 92, 145, 210, 235
painting of, by Brunelleschi 31
Bargello 212
cathedral 67
altarpieces project 46
artists' cenotaphs 91–2, 97, 102, 215
Compagnia di SS Annunziata 22
Giardino di S. Marco 58, 59, 60, 62
Guilds of
Arte di Calimala (Clothworkers' Guild) 145
Arte della Lana (Wool Guild) 69
Arte della Seta (Silk Guild) 19
Stoneworkers' Guild 64–5
Orsanmichele 269
tabernacle of 212, 213
Palazzo Medici
chapel decoration 30, 215, 228
courtyard 81
Piazza S. Marco 58
S. Lorenzo
bronze pulpits of 33
burial of Donatello in 100
Old Sacristy decoration 148, 169
S. Maria degli Angeli 180
S. Maria Novella, frescoes
by Ghirlandaio 38, 129, 239–40
by Filippino Lippi 130
by Masaccio 32
in Spanish Chapel 211–12
by Uccello 33
S. Trinita, frescoes by Ghirlandaio 38
Florentine, c.1470
Creation of the World engraving 40, 250, fig. 16
Eleven Nude Figures drawing 33, 55, 259–61, fig. 145
Fogolino, Marcello and Agostino 66
Fouquet, Jean 8, 13, 33
Chevalier Hours (Paris, Bibliothèque Nationale) 33
self-portrait roundel 212, 222, fig. 104
Franchi, Rossello di Jacopo 27

François I, King of France 8
Frederick II, Emperor 110
Frederick III, Emperor 63, 65, 114
Froissart, Jean 85

Gaddi, Taddeo 212
Gaeta, SS Annunziata 212
Gallerani, Cecilia 276
Gauricus, Pomponius 30
Genga, Girolamo 74
Gentile da Fabriano 33, 62, 69, 71, 118
 Adoration of the Magi (Florence, Uffizi) 31
 (?) draughtsman of Ambrosiana sketchbook
 118–19, fig. 56
 frescoes in Brescia 206
 frescoes in Doge's Palace, Venice 71
 Presentation (Paris, Louvre) 31
 Quaratesi altarpiece, predella 118
Gentile de' Becchi 240
Ghiberti, Lorenzo 5, 30, 37, 132
 as architect of Strozzi sacristy, S. Trinita,
 Florence 67
 collection of antiquities 81
 Letto di Policleto 81, 82, cf. fig. 35
 Commentaries 5, 12, 26, 141, 272
 on the education of the artist 30
 on favours done to artists 52, 145
 on the primacy of drawing 144, 153
 on a 'Venus' by Lysippus 110
 written in the vernacular 20–21
 as dedicatee of Alberti's *On Painting* 20
 diligence of 180, 289n
 drawings of 46
 Florence, Baptistery
 first bronze doors of 145, 289n
 Christ among the Doctors fig. 76a
 second bronze doors of 5, 145, 147
 programme by Bruni for 145, 272
 self-portrait 92, 210, 235, 272, fig. 128
 Story of Isaac 33, fig. 76b
 Story of Noah 37
 handwriting of 26, fig. 7
 knowledge of Latin 20
 and pictorial relief 147
 St John the Baptist (Florence, Orsanmichele)
 26–7
 St Stephen (Florence, Orsanmichele) 289n
 tomb of (Florence, S. Croce) 100–01
Ghirlandaio
 Davide 239
 Domenico
 and the Domus Aurea decorations 128–9,
 fig. 65
 drapery study for the Louvre *Visitation*
 52, fig. 26
 drawings after the antique 38

frescoes in Florence 38
 Annunciation to Zacharias (S. Maria
 Novella) 240
 Birth of the Virgin (S. Maria Novella)
 52, 129
 Expulsion of Joachim (S. Maria Novella)
 239, fig. 131 (detail)
 Resuscitation of the Spini Child (S.
 Trinita) 241
fresco in Sistine Chapel, Vatican 128
Giovanna Tornabuoni 25, figs 2 and 5
self-portraits of 239–40, 241, fig. 131
studies of drapery 51, fig. 25
use of lay-figure 52
use of model-book drawings 38
Virgin and Child with Saints altarpiece
 (Florence, Uffizi) 51–2
workshop of 17, 40
 Codex Escurialensis 38–9, 44, 129,
 137, fig. 65
Giorgione 3, 175–6, 215, 279
 (circle of) *Fête Champêtre* 176, fig. 83
 paragone demonstration 158–9
 Portrait of the Artist as David 212, 215, fig.
 107
 Tempesta (Venice, Accademia) 14, 176, 206
Giotto 5
 Boccaccio on 178
 as *capomaestro* of Florence cathedral 67
 cenotaph of, Florence cathedral 92, 95, 215
 Dante on 163
 as *familiaris* to Robert of Anjou 62
 Filarete on 192, 224
 Filippo Villani on 164, 178
 Navicella (Rome, St Peter's) 193
 self-portraits of 212
Giovanni Andrea di Fiore 80
Giovanni Antonio da Brescia 140, 257
 engraving after *Belvedere Torso* 137, fig. 72
Giovanni da Padova 128
Giovanni de Santi, tomb of, in Madonna
 dell'Orto, Venice 93
 Madonna dell'Orto 93
Giovannino de' Grassi 37
Giuliano da Sangallo 86, 137–40
 collection of 81–2
 drawings after the antique 129
Giulio Romano 81, 85, 86
Giusto d'Andrea 35
Gonzaga family 78, 102, 187, 232
 archive of 12
 Barbara, wife of Ludovico 232
 Bishop Ludovico 46, 78, 132, 154
 Cardinal Francesco 86
 Federigo 76, 126
 Francesco 63, 66, 68, 105

and Giovanni Bellini 181
 and Mantegna 76, 78, 206, 272, 277
Gianfrancesco 61, 78
Gianfrancesco, Lord of Ródigo 131
Ludovico 102, 125, 232
 bust of 232
 and Cristoforo di Geremia 86
 and Mantegna 62, 63, 68
 Margherita, wife of Leonello d'Este 78
Gossaert, Jan 66, 74–5
Gozzoli, Benozzo 232
 archaeological instincts of 121, 136
 drawings after the antique 39
 frescoes in the Camposanto, Pisa 33
 Joseph in Egypt 90, 228
 Marriage of Isaac and Rebecca, sinopia for
 33, fig. 11
 frescoes at Certaldo 35
 frescoes in S. Agostino, San Gimignano 30,
 35
 St Augustine's Departure for Milan 228
 handwriting of 27–30
 perspective of 33, fig. 11
 Rotterdam sketchbook of 119
 self-portraits in frescoes, Palazzo Medici,
 Florence 212, 215, 228, 238, 241, figs
 108–9
 self-portraiture of 228, 231
 studies of casts of feet 55–6, fig. 29
 study of nude female torso 121–3, fig. 59
 study after Quirinal *Horsetamers* 119, fig.
 57
 study of Trajanic relief at SS Apostoli, Rome
 119–21, fig. 58
 tomb of, Camposanto, Pisa 90
 workshop of 58
Granacci, Francesco 56, 58, 91
Grimani
 Cardinal Domenico 131, 212
 Cardinal Giovanni, bequest to Venice of
 134
Guarino, Battista 205
Guarino da Verona 194
 on classical practitioners of painting 18
 on Pisanello 165, 168
 programme for Muses cycle 180
 on the superiority of the written word 165,
 238
Guido d'Arezzo 163
Guidobaldo da Montefeltro 161, 280n
Guinizelli, Guido 163

Henry VIII, King of England 8, 66
Holbein, Hans, *The Duchess of Milan* (London,
 National Gallery) 66
Homer 164, 165
 Odyssey 22

Horace 173
 Ars poetica 163–4, 165–6, 167–8
 Hypnerotomachia polifili, the 175

imitation of nature, the 178, 186, 250
Innocent VIII, Pope, Belvedere of in Vatican
 198
 chapel decorated by Mantegna (lost) 63, 66,
 77, 125
invenzione 177, 180–81, 185–6
Isabella of Portugal 66

Jacobello del Fiore 36
Jacopino da Tradate 206
Jacquet de Lyon 85
Jean, duc de Berry 77–8, 85
'Johanes de francfordia' 42
Josephus 21, 125
Julius II, Pope 66, 67, 86, 107, 170

Lama, Guasparre del 229
Landino, Cristoforo 178, 240, 274–5
 Disputationes camaldulenses 232
Landshut, St Martin 97
Laocoön, the 86, 131
 restoration of 137–40
 wax model, by Jacopo Sansovino 131
Lascaris, Gian Giorgio, 'Pyrgoteles' 134
Laura, portrait of 212
Laurana, Francesco 66, 71
Leo X, Pope 6, 64, 107, 140, 189
Leonardo da Besozzo 62
Leonardo da Vinci 1–2, 8, 17, 20, 58, 65–6,
 209
 his 'Accademia leonardi vinci' 58, 59
 as adviser for Isabella d'Este 86
 as architect 67–8
 as art theorist 250
 artistic freedom of 187
 artistic intentions of 13
 Castiglione on 272
 compared with Zeuxis 207
 as courtier 61, 168, 272, 279
 death of 6
 drapery studies in brush on linen 51
 drawing of 'Neptune' 3, 79
 education of 19
 handwriting of 27
 and Isabella d'Este 183, 185–6, 275, 276,
 278
 knowledge of Latin 21, 22
 Last Supper (Milan, S. Maria delle Grazie)
 211
 Leda and the Swan (lost) 252
 letter to Ludovico Sforza 272
 on Masaccio 178–9
 Mona Lisa (Paris, Louvre) 13, 172

as musician 61
sfumato of 152
'Treatise on painting' 142, 166, 179
 on figure drawing 47–8
 on figure sculpture 151, 153, 157
 on the imitation of nature 179
 on low relief sculpture 146, 151
 on the painter's dress 72, 271–2
 on the painter's training 59
 on painting faces 211
 on painting's not being a 'mechanical art'
 1–2, 14
 on painting's superiority over poetry 2,
 166–7, 168, 172, 240
 on painting's superiority over sculpture
 142, 150–53, 161, 270
 on perspective 31, 34, 147
 Vasari on 19, 177
Leoni, Leone 81
'liberal arts', the 1, 9, 14, 60, 63, 86, 164,
 279
Limbourg brothers 77–8
Lippi
 Filippino 19, 177
 as adviser on classical sculpture 86
 design of tomb of Fra Filippi Lippi 96–7,
 130, fig. 41
 drawings of Domus Aurea murals
 129–30, fig. 66
 figure drawings by 47, fig. 23
 frescoes in Carafa Chapel, S. Maria sopra
 Minerva, Rome 86, 129, 273
 frescoes in Strozzi Chapel, S. Maria
 Novella, Florence 130
 inventory of 21
 knowledge of Latin 22
 letter to Filippo Strozzi 273
 Ludovico Sforza's agent on 275
 Filippo, Fra 19, 27, 33, 35, 96–7
 Barbadori altarpiece (Paris, Louvre) 211
 Landino on 275
 tomb of, Spoleto cathedral 89, 95–7, 220,
 fig. 41
 workshop of, drapery studies 50, fig. 24
Livy 21
Lodovico da Canossa, Count 143, 150
Lomazzo, Giampaolo 152
Lombardo family 19
 Antonio 157
 Forge of Vulcan 157, fig. 81
 Tullio 82, 134
 all'antica style of 134
 (?) Bust of Marcus Aurelius (Naples) 134,
 fig. 69
 on the *paragone* 153
 Prudence (Vendramin tomb, Venice, SS
 Giovanni e Paolo) 82

restoration of Hellenistic *Muse* 136, fig. 71
 will and tomb of 101
Lorenzetti
 Ambrogio
 drawing of Lysippan 'Venus' 110
 frescoes in Palazzo Pubblico, Siena 110
 Pietro 20
Lorenzetto, *Madonna del Sasso* (Rome,
 Pantheon) 106
Lorenzo da Pavia 184, 200–01
Lorenzo di Credi 50, 285n
Louis XI, King of France 64
Louis d'Orléans, Duke of Touraine 85
Lucian
 on Apelles' 'Calumny' 166, 181, 194–6, 256
 on Apelles 'Marriage of Alexander and
 Roxana' 189
 on Zeuxis 177, 196
Lucretius 192, 268
Luther, Martin, pamphlets of 21
Lysippus 110
Lysippus the Younger 27, 114, 134
 medal of Pope Sixtus IV 114
 self-portrait medal 27, 227, fig. 122

Magagni, Girolamo 56
Maiano, da, family 19
 Benedetto 92
 models for S. Croce pulpit 46
 Giovanni and Benedetto
 books of 22
 knowledge of Latin 22
Mainardi, Sebastiano 239
Malatesta, Sigismondo 186–7, 273–4
Manetti, Antonio
 on Brunelleschi's education 19
 on Brunelleschi as poet 169
 on painting of Florentine Baptistery 31
 on S. Maria degli Angeli, Florence 180
Mansionario, Giovanni, *Historia imperialis*
 110
Mantegna
 Andrea 17, 274
 as adviser on antiquities 86
 antiquarian interests of 104, 136, 238
 archaeological accuracy of 118, 124,
 125–6
 as architect 68
 assertive personality of 106
 boat trip on Lake Garda 127–8
 bronzi finti of 154–5
 brother-in-law to Giovanni Bellini 184,
 200
 bust of Faustina the Elder 76–7, 80, fig.
 34
 Camera Picta, Castello, Mantua 126, 169,
 232

dedication tablet 232
self-portrait in 232
vault roundels 126, fig. 64
Circumcision (Florence, Uffizi) 153, 155
collection of antiquities 79, 81
as connoisseur of antiquities 86
decoration of chapel in Castello, Mantua 256
decoration of chapel in Belvedere, Vatican 63, 66, 77, 125
as diplomat 66
drawings of
Calumny of Apelles drawing 196–8, 258, 290n, fig. 95
engraving after, by Mocetto 198, 258, fig. 96
Ignorance and the Fall of Humanity (London, British Museum) 261, 268
Judith with the Head of Holofernes (Florence, Uffizi) 261–2
engravings of 41–2
Bacchanal 257
Battle of the Sea-Gods 44, 252, 257, fig. 143
Entombment 42, 256, fig. 17
Flagellation 256–7, fig. 142
as *familiaris* 62
fantasia of 200
and Francesco Gonzaga 76, 78, 206, 272, 277
frescoes in Ovetari Chapel, Padua 33
St James before Herod 118, 126, fig. 55
funerary chapel of 101, 102, 104–6, fig. 47
Baptism 105
Families of Christ and St John 105
gifts to Lorenzo de' Medici 77, 78
Giovanni Santi on 156–7, 169, 275
house of 68–9, 70, 76, 81, fig. 31
intellectual aspirations of 20, 268
knowledge of Latin 20, 22
letter to Lorenzo de' Medici 30, fig. 9
letters to his Gonzaga patrons 272
and Ludovico Gonzaga 62, 63, 68
married to Jacopo Bellini's daughter 118
materials, depiction of 153, 157
monochromatic paintings of 153, 156, 256
as new Apelles 268–9
owned drawings after the Antique 124–5
paintings of
Agony in the Garden (Tours) 125–6, fig. 63 (detail)
Judith, listed in 1492 Medici inventory 76
Judith and Dido 155–6, fig. 78

Introduction of the Cult of Cybele 157, 198, 200, fig. 80
Madonna of the Quarries (Florence, Uffizi) 77
Madonna della Vittoria (Paris, Louvre) 68
St George 266–8, fig. 149
St Sebastian (Paris, Louvre) 55, 155, fig. 79 (detail)
St Sebastian (Venice, Ca d'Oro) 26, 78
St Sebastian (Vienna) 22, 123, 126, 155, 266–8, fig. 135
Triumphs of Caesar (Hampton Court) 126–7, 187
Verona, S. Zeno, altarpiece 125, 292n
paintings of, for Isabella d'Este 276
Comus (Paris, Louvre) 200
Pallas Expelling the Vices (Paris, Louvre) 192
Parnassus (Paris, Louvre) 183
and the *paragone* 155, 161, 256
and perspective 33, 257
'professore de antiquità' 126
seals of 63
self-portrait bust 102, 104–5, 210, 232, fig. 38
as source for Dürer 252
Squarcione on 156
study after a Trajanic relief 125, fig. 62
titles of 63
tomb of 101
understanding of Roman techniques 126
Vasari on 63, 156, 266
visits to his workshop 76, 272
Francesco 105
Ludovico 20, 286n
Mantua
Casa Giocosa at 18, 19
Castello, Camera Picta 126, 169, 232
camerino of Isabella d'Este in 183, 186, 199–200, 205, 276
chapel of 256
Gonzaga court of 6, 9, 12, 17, 85, 141, 169, 272
house of Giulio Romano 81
house of Mantegna 68–9, 70, 76, 81, fig. 31
S. Andrea, funerary chapel of Mantegna 102–6
S. Sebastiano 68
Marcanova, Giovanni 118
Marcello, Jacopo Antonio 266
Marcus Aurelius
drawings after 119, 123, 124, fig. 61
restoration of, by Cristoforo di Geremia 123, 135
small bronze of, by Filarete 79, 123, fig. 60

Marsilio, Antonio 106
Martial 25
Martin V, Pope 62
Martini
 Francesco di Giorgio 65, 66
 architectural treatise of 67, 68–9, 180,
 232
 self-portrait of 232, fig. 126
 Simone 65, 206, 211, 212
Masaccio 20, 145–6, 178
 as dedicatee of Alberti's *On Painting* 20
 Enthronement of St Peter (Florence, S. Maria
 del Carmine) 211
 handwriting of 27
 Landino on 275
 Trinity (Florence, S. Maria Novella) 32
Masolino, *Feast of Herod* (Castiglione Olona)
 32
Master ES, engravings of 39–40, 254, 256
 St John the Evangelist engraving 39, fig. 13
Master of Frankfurt, *The Artist and his Wife*
 222–5, fig. 118
Master PM, *Adam and Eve* engraving 43, fig.
 19
Maximilian I, Emperor 75, 274
Mazzoni, Guido 64
Meckenem, Israhel van, *The Artist and his Wife*
 engraving 222, fig. 117
Medici, de', family 65, 228–9
 archive in Florence 12
 Carlo di Cosimo 80, 274
 Cosimo 'il Vecchio' 67, 71, 89, 100, 136,
 228
 Duke Cosimo I 11, 59, 89
 Giovanni di Cosimo 80, 186–7, 274
 Giovanni di Lorenzo (later Pope Leo X) 60
 Giuliano di Piero 228, 231
 Lorenzo di Pierfrancesco 132, 172, 269
 Lorenzo di Piero, 'the Magnificent' 9, 30,
 65, 78, 228
 and Bertoldo di Giovanni 30, 58, 62
 circle of 170, 194, 240
 collection of antiquities 81, 86
 commissioned artists' tombs 89, 91–2, 95,
 97, 215
 Giardino di S. Marco of 58–9
 poetry of 172
 visit to Mantegna 76, 79, 272
 Piero di Cosimo, 'the Gouty' 27, 69, 79,
 100, 123, 124
Mercades, Berenguer 276
Metrodorus 18
Michelangelo 6, 8, 10–11, 66, 209
 adviser on the *Laocoön* 86, 131, 137–40
 twelve apostles for Florence cathedral 69
 Condivi on 11, 132

copy after Schongauer 40
David (Florence, Accademia) 69–70, 252
drawings for Sebastiano del Piombo 152
education and training of 17, 58
handwriting of 30, fig. 85
house of 70
on the *paragone* 152
Piero Soderini on 277
poems of 3, 20, 170–72, fig. 85
presentation drawings by 79
Sistine Chapel ceiling decoration 258–9
Sleeping Cupid (lost) 132–4
Taddei Tondo (London, Royal Academy) 79
Vasari on 10
Michele 'figlio di Bartolommeo barbiere da
 Vicenza' 58
Michelino da Besozzo 37
Michelozzo di Bartolommeo 67
Michiel
 Andrea 64
 Marcantonio 37, 82, 276
 on Antonello's *St Jerome in His Study*
 264
 on the death of Raphael 106
 on Giorgione's *Tempesta* 176
Migliorotti, Atalante 65
Milan
 house of Leone Leoni 81
 Sforza court of 9, 12, 61, 168, 186–7
Mino da Fiesole 136
Mocetto, Girolamo, *Calumny of Apelles*
 engraving 198, 258, fig. 96
model-book drawings 37–8, 40, 250
Monaco, Guglielmo 63, 235–6
Montagnana Fiorentina 65
Montorsoli, restoration of *Apollo Belvedere*
 132
Muffel, Jakob 274

Nanni di Banco 64, 65
 Assumption of the Virgin (Florence cathedral,
 Porta della Mandorla) 65
 Four Crowned Saints (Florence,
 Orsanmichele) 65
Nanni di Miniato 85–6
Naples 65, 276
 Aragonese court of 9
 Castel Nuovo, bronze doors of 63, 236
Neri di Bicci 35
Nero, Emperor, Domus Aurea (Golden House)
 of 72, 96, 128–31, 140, 170, 198, 240
Neroccio de' Landi, inventory of 53, 80
Neudörfer, Johann 75
Niccoli, Niccolò 85
Niccolò dell'Arca 277
Niccolò di Alemanna 53

Niccolò fu Michele di San Lio 36–7
Nicholas V, Pope 119
numismatics, interest in 114–15
Nuremberg 65, 70, 74, 79, 240
 'School for Poets' in 170

Odoni, Andrea 82
Orcagna, Andrea 212, 213
Ordeaschi, Francesca 189
Orvieto cathedral
 façade reliefs 110
 frescoes in Cappella di S. Brizio 131
Ovid 21, 175
 on the birth of Venus 193
 Fasti 173, 200

Pacher, Michael, St Wolfgang altarpiece 43
Pacioli, Luca 61
Padua 9
 Carrara court of 4, 5, 6, 110, 178
painter(s), see artist(s)
painting(s)
 and poetry 1–2, 178, 180
 as activity of princes and emperors 18
 worthy of a courtier 17
 challenge of sculpture 151–2
 as functional objects 3
 as liberal art 163, 166
 as mechanical art 1–2
 principles of 18
 as 'works of art' 3
painting and sculpture
 as liberal arts 63, 141, 279
 as mechanical arts 66–7
 paragone between 141–61, 270
Palma Vecchio, Portrait of a Poet 173, fig. 86
paragone between ancient and modern 132,
 134, 268, 269–70
 painting and poetry 1–2, 178, 180
 painting and sculpture 141–61, 270
Paride da Ceresara 182, 200, 277
Parler, Peter, self-portrait bust of 231, fig. 125
Parmigianino, Francesco
 Self-portrait in a Convex Mirror 72, 217,
 245, 248, 270, fig. 112
Parrhasius 72, 105
Pasqualino, Messer Antonio 264
Pasti, Matteo de' 27
Pavia, Certosa, façade plinth decoration 114
Pericles 232
Perino del Vaga, Hunt of Meleager drawing
 204, fig. 101
Perotti, Niccolò, Latin primer of 20, 22
perspective, geometric 9, 13, 14
 in Alberti's On Painting 9, 31, 247, 260
 in Brunelleschi 31–2, 147

 in Piero della Francesca 33, 246–7, 248,
 266
Perugia
 Collegio del Cambio 218
 S. Domenico 213
Perugino, Pietro 65, 173, 200, 277
 Battle of Love and Chastity 173, 182–3,
 204, 276, fig. 88
 and Isabella d'Este 181–3, 185, 205, 276,
 277
 Ludovico Sforza's agent on 275
 self-portrait of 218, fig. 116
Peruzzi, Baldassare 106
Petrarch, Francesco 4–6, 110, 173, 212
 legacy in Padua 7
 on Simone Martini 206
 his portrait of Laura 212
 works of 21
 Africa 110
 De viris illustribus 112
Petrucciolo, Cola, self-portrait of 213, fig. 105
Phidias 119, 165, 206–7, 232
Philip the Fair, Duke of Burgundy 66, 74–5
Philip the Good, Duke of Burgundy 66, 74
Philostratus the Elder, Imagines 142, 199–200,
 207, 259, 290n
 on mimesis and fantasia 186
 on the paragone 142
 as source for Raphael's Galatea 193
 for Titian's Bacchanal 204
 for Titian's Worship of Venus 202–3
Philostratus the Younger, Imagines 186,
 199–200, 202, 204
Pia, Emilia 143
Piancaldoli 93
Pico, Pandolfo 106
Pienza, cathedral altarpieces 276
Piero di Cosimo 177, 273
 Discovery of Honey 173, fig. 87
 Misfortunes of Silenus (Cambridge, Mass.,
 Fogg Art Museum) 173
Piero della Francesca 14
 education of 20
 Flagellation (Urbino) 13, 33, 245–8, 254,
 257, 264, fig. 136
 handling of colour and texture 248
 and perspective 33, 246–7, 248, 266
 On Perspective in Painting 6, 20, 21, 33,
 247
 disegno, commensuratio and colorare 247
 as town councillor 65
 Trattato d'abaco 30
 use of clay models 50
Piero da Vinci, Ser 19
Pietro da Milano 63, 274
Pietro da Novellara, Fra 185, 278

Pieruzzi, Antonino 274
Pino, Paolo, *Dialogue on Painting* 159
Pinturicchio, Bernardino
 and the Domus Aurea decorations 128, 130,
 fig. 67
 frescoes in Borgia Apartments, Vatican 37
 frescoes in Bufalini Chapel, Aracoeli, Rome
 130
 frescoes in Castel S. Angelo, Rome 131
 frescoes in Piccolomini Library, Siena
 cathedral 37, 131
 frescoes in S. Maria Maggiore, Spello 218
 self-portrait of 218–20, fig. 103
Pirckheimer, Willibald 31, 74, 170, 271
Pisanello, Antonio 18, 286n
 collection of silver coins 80
 Diva Faustina drawing 112–13, fig. 51
 drawings of 37, 111
 after the antique 39, 113, 118
 as *familiaris* 61
 gift to Leonello d'Este 78, 112
 image of 'Julius Caesar' 112
 medals of 274
 Emperor John VIII Palaeologus 22, 111,
 fig. 4
 perspective drawing (Paris, Louvre) 32
 portrait of Filippo Maria Visconti 206
 portrait of Leonello d'Este (Bergamo) 168
 praise of 165, 168, 206
 Vision of St Eustace (London, National
 Gallery) 250
 workshop drawings 118
Pisano
 Andrea, bronze doors of 145
 Giovanni, Pisa cathedral pulpit 110
 inscriptions on 179, 289n
 Nicola, Pisa Baptistery pulpit 110
 workshop of 67
Pistoia, S. Domenico 90
Pius II, Pope 276
Plato 18
 bust of, in Bellini collection 80, 136
Pliny the Elder 18, 87, 198
 on Apelles 131, 189, 193, 206
 Natural History 21, 22, 72, 190
 on Zeuxis 79, 187, 190
Pliny the Younger, Laurentian villa of 69
Plutarch 126
Poblet, Catalonia, burial chapel of Alfonso of
 Aragon 276
poesie 173, 176
poetry, as liberal art 2
Poggio a Caiano, Villa Medici 76
Poliziano Angelo 172, 215, 240
 epitaphs for artists' cenotaphs 89, 92, 95,
 215

Stanze per la Giostra 172–3, 193, 198
so-called Tagebuch of 179
Polyclitus 81, 100, 206
Pollaiuolo
 Antonio 52, 58, 261, 264, 275
 Battle of the Nudes engraving 42, 158,
 252, 254–6, 261, 264, fig. 18
 cartonum, owned by Squarcione 43, 262
 figure-drawing of 262
 figure-types of 44, 159
 Hercules and the Giants, engraving after
 42–3
 bronze *Fluting Marsyas* (attrib.) 55, fig.
 27
 as 'maestro di disegno' 42
 'Nude man seen from front, side and back'
 drawing 53, fig. 28
 inscription on 275
 A Prisoner Led Before a Judge drawing
 261, 268, fig. 146
 tomb of Sixtus IV (Rome, St Peter's) 170
 will of 97
 Antonio and Piero, workshop of 58
 tomb of, in S. Pietro in Vincoli, Rome 97,
 fig. 43
Pontormo, Jacopo 40, 273
Posculo, Ubertino 206
Prague, St Vitus 231
Praxiteles 119, 132, 206, 207
Propertius 281n
Prospettivo Milanese, the 83, 128–9, 137, 170
Ptolemy 21
Pucci, Giannozzo 269
Pygmalion 206
Pyrrho 18

Quercia, Jacopo della 37, 64, 65, 81

Raffaello da Montelupo 93
Raimondi, Marcantonio, engravings by 264
 (circle of) *Apollo Belvedere* 44, 132, fig. 21
 Judgement of Paris 259
 Massacre of the Innocents 257–8, fig. 144
 Quos Ego 259
Raphael 6, 8, 126, 152
 'archaeological method' of 140
 as architect of St Peter's 68
 Baldassare Castiglione (Paris, Louvre) 210
 as courtier 1, 242
 death of 6, 106
 drawing of Roman ruins 140, fig. 75
 drawings for engraving 264
 Massacre of the Innocents, drawings for
 257–8, 260
 epitaph of, by Pietro Bembo 106–7
 figure-drawing of 262

friendship with Castiglione 242
Galatea 187, 198, fig. 97
'Hunt of Meleager' 204
'Indian Triumph of Bacchus' 200, 204
intellectual status of 140, 259
knowledge of Latin 21
letter to Baldassare Castiglione 187
letter to Pope Leo X 7, 20, 140
poetry of 169
'prefect of antiquities' 140
purchase of Palazzo Caprini 70, 106
(?) self-portrait drawing (Oxford, Ashmolean)
 242
(?) *Self-portrait* (Florence, Uffizi) 242
(?) *Self-portrait* (lost, formerly Kraków) 72,
 240, 242-3, fig. 32
Stanza della Segnatura decoration 258
survey of ancient Rome 140
stufetta of Cardinal Bibbiena (Vatican) 131,
 140, 193
tomb of, in the Pantheon, Rome 101, 106-8
Transfiguration (Vatican, Pinacoteca) 152
'recta manus' of the painter 215, 217, 225,
 228, 242
Regensburg 65
Regiomontanus 70
Riario, Cardinal Raffaello 132
Riemenschneider, Tilman 65
rilievo schiacciato ('squashed relief') 147-8
Rimini, Tempio Malatestiano 27
Robbia, della, family 19
 Andrea 91
 Luca 91
 as dedicatee of Alberti's *On Painting* 20
 Florence cathedral altarpieces project 46
Roberti, Ercole de' 76
Roman, of Hellenistic type, *Jupiter* (Naples)
 137, fig. 73
Roman, c.1460, drawing after *Marcus Aurelius*
 123, fig. 61
Romano, Giancristoforo 86, 137-40
 as adviser to Isabella d'Este 61, 86
 as courtier/debater in *The Book of the
 Courtier* 61, 143-4, 151-2, 168, 279
Rome
 Arch of Constantine, reliefs of 140
 Castel S. Angelo, frescoes 131
 Domus Aurea (Golden House) of Nero 72,
 96, 128-31, 140, 170, 198, 240
 Marcus Aurelius 119, 123
 Palazzo Caprini, the 'House of Raphael' 70,
 106
 Pantheon, tomb of Raphael 101, 106-8
 papal court of 12
 of Pope Sixtus IV 27, 227
 Quirinal *Horsetamers* 118-19, 206

Renaissance papacy of 7
SS Apostoli, della Rovere palace 81
S. Maria in Aracoeli, Bufalini Chapel 120
S. Maria sopra Minerva
 Carafa chapel 86, 129-30
 tomb of Andrea Bregno 97-100, 220, fig.
 44
 tomb of Fra Angelico 89, 93-5, fig. 40
St Peter's 67
 bronze doors 114, 234-8
S. Pietro in Vincoli
 garden of Giuliano della Rovere 132
 tomb of the Pollaiuolo brothers 97, fig.
 43
Trajan's Column, drawings after 124, 125
Villa Farnesina 189, 198
Rosselli, Francesco, inventory of 21, 53
Rosso Fiorentino, inventory of 21-2, 280n
Rovere, Cardinal Giuliano della (later Pope
 Julius II) 44, 81
 garden at S. Pietro in Vincoli 132
Rucellai, Giovanni, *Zibaldone* of 42, 276

Samuele da Tradate 128
San Gimignano, S. Agostino, frescoes by
 Gozzoli 30, 35, 228
Sannazaro, Jacopo, *Arcadia* 176
Sansovino, Jacopo 71, 131
Santi, Giovanni 13
 Cronaca rimata ('rhymed chronicle') 6, 20,
 169
 on Federigo da Montefeltro 76
 on Mantegna 76, 156-7, 169, 275
 on King René d'Anjou 17
Sanudo, Marin 91
Sanvito, Bartolommeo 30
Savonarola
 Fra Girolamo 36, 79, 210-11, 268
 Michele 57-8
Scardeone 105, 156
Schiavone, Giorgio, *Virgin and Child* 192,
 224, fig. 91 (detail)
Schongauer, Martin, engravings of 40, fig. 15
Scopas 207
sculptor(s), *see* artist(s)
Sebastiano del Piombo 151-2
 Death of Adonis (Florence, Uffizi) 175
 Raising of Lazarus (London, National
 Gallery) 152
Segni, Antonio 3, 79, 268
Seneca 173
Sforza
 Bianca Maria 211
 Francesco 149-50, 232
 Galeazzo Maria 75, 234, 273
 Ludovico, il Moro 61, 66, 86, 168, 272

agent of, comments on painters 275
Siena 66
 cathedral, Piccolomini Library frescoes 37,
 131
 Fonte Gaia 110
 Palazzo Pubblico 112
 Spedale della Scala 67, 101–2
Signorelli, Luca 65, 71, 129
 frescoes in Cappella di S. Brizio, Orvieto
 131
Sixtus IV, Pope 27, 81, 114, 123, 227
Socrates 18
Soderini, Piero 277
Sodoma
 gift to Pope Leo X 78
 inventory of 56, 80
 Marriage of Alexander and Roxana 189,
 198, fig. 89
 title of 64
Solari, Cristoforo, *Venus* and *Apollo Belvedere*
 134
Spagnoli, Battista 105
Spoleto, cathedral, tomb of Fra Filippo Lippi
 89, 95–7, 130, 220, fig. 41
sprezzatura 180
Squarcialupi, Antonio 92
Squarcione, Francesco 43, 52
 casts after sculpture, for study 52, 55
 circle of 190, 192
 criticism of Mantegna 156
 owned Pollaiuolo *cartonum* 43, 262
 studium of 58
 workshop training curriculum 57
Stefano, 'nature's ape' 178
Stethaimer, Hans, tomb of, in St Martin,
 Landshut 97, fig. 42
Strozzi family
 Agostino 277–8
 Filippo 273
 Palla 69
 Tito Vespasiano 168
Suetonius, *The Twelve Caesars* 111, 286n
Summonte, Pietro 276
Syracuse, King of 78

Taccola, Mariano 180
Taddei, Taddeo 79
Taddeo di Bartolo, *Assumption* altarpiece
 (Montepulciano) 215, fig. 106 (detail)
 frescoes in Palazzo Pubblico, Siena 112
 self-portrait of 215, fig. 106
three-dimensional models 46–57
 cast drapery model 52
 the lay-figure or manikin 47, 48, 52
 in wax, clay, plaster, terracotta or bronze
 47, 79–80

live models 47
Titian 7, 204–7
 Bacchanal of the Andrians 204–5, fig. 102
 Bacchus and Ariadne (London, National
 Gallery) 205
 La Schiavona 161, 210, fig. 82
 Man in a Blue Sleeve (London, National
 Gallery) 210
 paintings for Alfonso d'Este 7, 201
 Venus Anadyomene 193, fig. 93
 Worship of Venus 202–3, fig. 99
Torrigiano, Pietro 58
Tovaglia, Andrea 125
Trajan, Emperor 140
Trento 66
Tura, Cosmè 102
 house of 68
 praise of 168
 style of 168, 274

Uccello, Paolo
 The Flood (Florence, S. Maria Novella) 33
 and perspective 32–3, 273
 tomb of, formerly S. Spirito, Florence 90–91
Urbino, Montefeltro court of 12, 21, 143,
 169

valet de chambre 61, 62, 71
Valla, Lorenzo 93, 164
Vanni, Andrea 62, 65
Varchi, Benedetto, lectures on the *paragone*
 142, 144, 148, 152, 159
Vasari, Giorgio
 on Antonello da Messina 89–90
 on artists as architects 7
 on Benozzo Gozzoli 90
 as biographer 11
 on Botticelli 268–9
 on Bramante 19
 on Castagno 11
 on Il Cecca 92–3
 on Domenico Veneziano 11
 on Donatello 12, 69, 135, 285n
 on Ghiberti 101, 132
 on Giorgione 158–9, 175
 on Giotto 11
 on Leonardo da Vinci 19, 177
 Lives of the Artists 10, 89, 211
 woodcut portraits in 212
 on Lorenzo di Credi 50
 on Luca della Robbia 91
 on Mantegna 63, 156, 266
 on Michelangelo 10–11
 on Parmigianino 245
 on Piero della Francesca 50, 246
 on Piero di Cosimo 273, 277

on Pinturicchio 130–31
on Pontormo 40
on the primacy of drawing 152–3
on Raphael 106
on Sansovino 71
on Signorelli 71
on Simone Martini 211
on Sodoma 78
on Torrigiano 58–9
on Uccello 32, 273
on Venetian artists 11
on Verrocchio 56, 285n
Vatican
Belvedere, chapel decorated by Mantegna 63, 66, 77, 125
decoration of 198
sculpture court 81
Borgia Apartments, fresco decoration of 37
St Nicholas chapel frescoes 121
Stanza della Segnatura 258
Vecchietta, Lorenzo di Pietro 67
funerary chapel of 101–2
Risen Christ 102, 286n, fig. 45
Virgin and Child with Saints 102, 286n, fig. 46
self-portrait of 217–18, fig. 114
Vendramin, Gabriele 37
Venice 7, 9
Campo di SS Giovanni e Paolo 198
Doge's Palace, frescoes by Gentile da Fabriano (lost) 71
Fondaco de' Tedeschi decoration 175
S. Bartolommeo di Rialto 271

Verino, Ugolino 206, 207
Verona, Palazzo Scaligero, frescoes 111, fig. 49
Verrocchio
Andrea del 136, 207, 285n
workshop of 50, 56
drapery studies in brush on linen 51
Tommaso 136
Vespasiano da Bisticci 71
Vespucci, Giovanni 173
Vianello, Michele 183
Villani, Filippo 164, 178, 180, 212
Virgil 173
Vischer, Peter 75
Visconti, Gaspare 211
Vitruvius 78
De Architectura 21, 22, 126
on human proportions 252
Vittorino da Feltre 18
school of, the Casa Giocosa 18, 19
Volterra, Cardinal of 277

Wenceslas IV of Bohemia 231
Weyden, Rogier van der 8, 12, 71, 266
Würzburg 65

Ypres 71

Zeuxis 72, 79, 190, 206–7
painting of a centaur family 177, 196, 289n
Zoppo, Marco, drawings of 43, 52
Virgin and Child with Angels 190–91, fig. 90
Zovenzoni, Raffaello 80, 191